ART and the
END of APARTHEID

ART and the
END of APARTHEID

JOHN PEFFER

University of Minnesota Press
Minneapolis
London

Publication of this book has been aided by a grant from the Millard Meiss Publication Fund of the College Art Association.

The writing of this book was supported as a project of the Creative Capital/Warhol Foundation Arts Writers Grant Program.

Excerpts of poetry by Léopold Sédar Senghor from *The Collected Poetry,* translated by Melvin Dixon (Charlottesville: University of Virginia Press, 1991), 8–9, 270–71; copyright 1991 University of Virginia Press; reprinted with permission of the University of Virginia Press.

Quotations from *Yakhal'inkomo* and "The Three Mothers" reprinted with permission from Mongane Serote.

Portions of chapter 2 and chapter 9 were previously published as "Animal Bodies/Absent Bodies: Disfigurement in Art after Soweto," *Third Text* 62, 17, 1 (March 2003): 71–83. Chapter 4 previously appeared as "Mellow Yellow: Image, Violence, and Play in Apartheid South Africa," in *Violence and Non-Violence: African Perspectives,* ed. Pal Alhuwalia, Louise Bethlehem, and Ruth Ginio (London: Routledge, 2006); reprinted with permission of Cengage Learning Services Ltd. Chapter 7 was previously published as "Resurfacing: Durant Sihlali," *Critical Interventions* 1, no. 1 (Summer 2007). Chapter 8 was previously published as "Censorship and Iconoclasm— Unsettling Monuments," *RES: Anthropology and Aesthetics* 48 (Autumn 2005): 45–60; copyright by the President and Fellows of Harvard College; reprinted by permission of the Peabody Museum Press, Harvard University.

Every effort was made to obtain permission to reproduce material in this book. If any proper acknowledgment has not been included, we encourage copyright holders to notify the publisher.

Published by the University of Minnesota Press
111 Third Avenue South, Suite 290
Minneapolis, MN 55401-2520
http://www.upress.umn.edu

Library of Congress Cataloging-in-Publication Data

Peffer, John.
 Art and the end of apartheid / John Peffer.
 p. cm.
 Includes bibliographical references and index.
 ISBN 978-0-8166-5001-9 (hc : alk. paper) — ISBN 978-0-8166-5002-6 (pb : alk. paper)
 1. Art, South African—20th century. 2. Art, Black—South Africa—20th century. 3. Apartheid and art.
 4. Modernism (Art)—South Africa. 5. Art and society—South Africa—History—20th century. I. Title.
 N7392.2.P44 2009
 709.68'09045—dc22

 2008046015

Printed in the United States of America on acid-free paper

The University of Minnesota is an equal-opportunity educator and employer.

18 17 16 15 14 13 12 11 10 09 10 9 8 7 6 5 4 3 2 1

For Susan, with love,
and for Ashley, who got me started.

CONTENTS

PREFACE

When I was in high school in Cleveland during the 1980s, I was struck by the images on American television of white police chasing down black protesters in the South African townships. Later, as an undergraduate at Indiana University, I was involved in protests to encourage American companies and universities to divest their interests in South Africa. In support of the antiapartheid movement on campus, I curated an exhibition of South African graphic art with the assistance of a South African Fulbright Scholar, Ashley Ward. At the time I was convinced that a history of the protest art movement would be a valuable contribution to the struggle in South Africa with which I had come to identify. After graduation, and a year working at a performance art space in Washington, D.C., I applied to the Department of Art History and Archaeology at Columbia University to study modern art, theory, and African art. Through Presidents and Faculty Fellowships at Columbia, and with a departmental predoctoral research grant, I was able to visit South Africa for the first time during December 1991. Support from the Columbia College African Civilizations Task Force helped me return during the summer of 1992. Although I did little during those first visits besides socialize with artists and political activists, travel the country, and otherwise try to get my (alternately bewildered and inebriated) bearings in a foreign land, I was also able to witness firsthand apartheid in the throes of its death. During those years the transition to democracy had only just begun; though many exiles had returned, political prisoners were being released, and bans were being lifted on opposition

parties, much of the authoritarian state apparatus of apartheid continued as before. The mood of the country was somber, if cautiously optimistic, and the threat of out-of-control violence and civil war loomed in everyone's mind. When I returned to South Africa just after the elections of 1994, the psychology of the country had shifted to euphoria, even self-amazement at what had been achieved. Also, there was a profound change in people's everyday behavior, something not always noted by those who came to do research after 1994. I noticed this change in attitude in the small interactions of everyday life: the look straight in the eyes at the supermarket or when passing on the sidewalk. The general feeling was that this moment was a sort of blank slate. The people of the new nation could, like artists, create their country in any image they chose. Studio artists, too, did not hold back from making their own suggestions about what the look of the new South Africa could be.

This book is about art during the period leading up to the official end of white separatist rule in 1994. In addition to artists' monographs and survey- or collection-based anthologies, over the past several years a number of books on South Africa have explored in depth the first black art schools at Polly Street (Elza Miles) and Rorke's Drift (Elizabeth Rankin and Philippa Hobbs), as well as the politics of culture after the first elections (Annie Coombes). Although I examine art from before and after, my main interest is in the two decades preceding 1994. These years were pivotal for South African artists. It was a time when progressive artists attempted, before the fact, to define what "postapartheid" might mean. The history of this seminal moment set the stage for the better-known art that has come out of South Africa and that has featured prominently on the international contemporary art market since 1994. One of the motivating factors behind my study has been my belief that thoughtful research into South Africa's earlier art history ought to be a critical component of a more inclusive, global history of art, one that expands on and even challenges the Eurocentric assumptions about art and modernity common in books on the history of art.

The present text has been extensively revised and supplemented since its origins as my doctoral dissertation, including substantial reinterpretations and expanded conclusions about key events. Where the dissertation strayed at length on the problem of abstraction in art, this book frames that scenario as only one aspect within the broader crisis of representation and imagination in South Africa during the apartheid years. My study situates the struggle for a nonracial aesthetic practice in South Africa within overlapping contexts of the modernist reception of indigenous approaches to art, the draconian racial policy of the apartheid state, a culture of militancy and street violence, and the bipolar polemical discourse of the late cold war. I explore the common iconographies of struggle among committed artists, the racialization of the art field and the social field, and artists' attempts to find ways out of these confines.

Throughout this study I argue that art practice in South Africa often pushed in a direction that most politicians and activists would catch up with much later, after 1989, when the government and its opponents had already begun negotiating an end to apartheid. From the 1930s and well into the 1990s, the art scene, particularly the black art scene, was one place where black and white, rich and poor, could meet and together form the kernel of a different society. Of course these relations were not always peaceful. There were many paternalisms, jealousies, and misunderstandings, but the model for working and living in a nonracial manner, despite or without apartheid, existed predominantly in the arts. The arts became a relatively safe area where the kinds of cross-racial interaction that peaked in the 1950s around the jazz and writing scenes of bohemian Sophiatown and District Six, and were effectively stamped out by the South African government by the 1960s, could be preserved and developed.

Three related themes run throughout my writing. First, I am concerned with examining the ways that the struggle against apartheid impacted the social milieus and the choices of representational forms available to black artists. Second, I am interested in the development of modernist art among black artists in South Africa within its own social and aesthetic contexts. Third, I seek to excavate (and reinterpret) the local context in terms of a cosmopolitan and nonracial art practice. This larger perspective on the social life and aesthetics of South African art is what I term a "grey area." Grey areas were, both literally and proverbially, where much of the hard labor of undermining apartheid was performed. These grey areas were also the location of the development of the black modernist art scene in South Africa.

My primary research consisted of interviews and archival work over an eleven-month period during 1994–95, as a Fulbright IIE Doctoral Dissertation Scholar in Johannesburg and Cape Town. This was supplemented by shorter reconnaissance trips during October 1997 and January 2002, and interviews with South African artists living in or visiting the New York City area. I also worked in the South African periodical collection at the Sterling Memorial Library at Yale University during the summer of 2000 and at the Melville J. Herskovits Library of African Studies while I was visiting assistant professor of African art history at Northwestern University from 2003 to 2005. During 1995 I was given office space as a visiting scholar at the Institute for Advanced Social Research (IASR) at the University of the Witwatersrand. The director of IASR, Charles van Onselen, generously invited me into the regular seminars held at the institute and on more than one occasion set my head straight on the politics of culture and the politics of academia in South Africa. The University of Cape Town African Studies Institute also gave freely of its resources when I was a visiting scholar there during August–September 1995.

My writing makes use of methodological tools from several disciplines: art history (iconographic analysis), anthropology (cultural critique), urban studies,

oral history, philosophy and literary criticism (poststructuralism), and anticolonial studies. My training is in traditional African art, modernist art history, and critical theory, and my writing seeks to bridge these areas of scholarship by engaging the construction of identity, tracing the multivalence of imagery, and thinking of visual culture in a nonhierarchical manner. Toward this end, I allow the artists in my study to exemplify, through their art and words, the social context, the contradictions, and the contingencies of contemporary African art, the aesthetic conventions of modernism, and the urgent concerns of the liberation struggle in South Africa.

No book is written without collaborators, even if an individual is claimed as author. In a work like this that leans so heavily on interviews, many voices challenge each other for authority within the text; I have tried to give each of these voices a fair hearing. Interviews and conversations with the following persons conducted between 1991 and 2007 have informed my perspective on the South African art scene, though not all are referred to by name in my text: Sholto Ainslie, Brenda Atkinson, Lungile Bam, Wayne Barker, Willie Bester, Randy Bloom, Willard Boepple, Willem Boshoff, Peter Bradley, John Brandt, Richman Buthelezi, Pitso Chimzima, Lionel Davis, Bongiwe Dhlomo, Okwui Enwezor, Lorna Ferguson, Lauri Firstenberg, Abrie Fourie, Kendell Geers, Linda Givon, David Goldblatt, Gerard Haag, Fernand Haenggi, Salah Hassan, Steven Hobbs, Sydney Holo, Patrick Holo, Derrick Joubert, Stan Kahn, Sue Kaplan, Wynand Kok, David Koloane, Andrew Lindsay, Robert Loder, Annette Loubser, Esther Mahlangu, Billy Mandindi, Lisa Mannhardt, Bhekisani Manyoni, Louis Maqhubela, Simon Masilo, Pat Mautloa, Napo Mokoena, Tumelo Mosaka, Victor Mpopo, Rudzani Nemasetoni, Agrippa Nhlapo, Bra Charles Nkosi, Tony Nkotsi, Olu Oguibe, Thabiso Phokompe, Mario Pissarra, Ephraim Ramabya, Mark Read, Trent Read, Steven Risi, Steven Sack, Charlotte Schaer, Joachim Schönfeldt, Helen Sebidi, Judy Seidman, Moses Seleko, Sydney Selepe, Sipho Sepamla, Wally Serote, Durant Sihlali, Cecil Skotnes, Velile Soha, Paul Stopforth, Sandy Summerfield-Burnett, Marlaine Tosoni, Andrew Tshabangu, Dominic Tshabangu, Mike van Graan, Claude van Lingen, Minnette Vari, Cameron Vuyiye, Ian Waldek, Robert Weinek, Sue Williamson, Nhlanhla Xaba, Gavin Younge, and Ephraim Ziqubu.

At IASR I made the acquaintance of photographer Santu Mofokeng, whose art has done as much for my thinking about the relationship between the quotidian and political uses of images as any of the texts or interviews examined in this study. Adam Ashforth shared important contacts with his close friends in Johannesburg, some of whom, like Mofokeng, also became my confidants during my stay. Mpho Mathebula and Thabo Mfete went everywhere with me in the townships, kept me out of danger, provided a running criticism of my interpretations of what I was seeing, and annoyed me by referring to me (tongue in cheek) as "Baas John." Selope Maaga traveled with me to Cape Town and regaled me

with stories of being a young artist struggling for survival in Soweto. His words and those of Agrippa Nhlapo inspired my study of children and resistance art in chapter 4. These men (as well as Wayne Barker and Andrew Lindsay, with whom I shared a house in Troyeville) took me into their social circuit in Soweto and into the grey heart of the bohemias of Johannesburg. Through them, and with Nicole Ridgway and Abrie Fourie, I learned almost everything I know on an interpersonal level about South Africa. I am also grateful to Gary van Wyk and Lisa Brittan, the first of many to show me what South African hospitality was all about.

Patrick McNaughton, Diane Pelrine, and Roy Sieber supported my South African work even long after I moved from under their wings at Indiana University. At Columbia University, Marcia Wright gave constant guidance and helped me stay employed as a graduate student teacher during the long lean years between fieldwork and dissertation write-up. Suzanne Blier brought me to Columbia and has supported my research ever since. Barry Bergdoll, Joseph Connors, Jonathan Crary, Johanna Drucker, David Freedberg, Andreas Huyssen, Tallie Kampen, Sylvère Lotringer, Mohammed Mbodj, Keith Moxey, Molly Nesbit, Gayatri Spivak, and especially Zoë Strother and Michael Taussig were all inspirational during my years at Columbia. Jean Kennedy Wolford gave me encouragement back when she and Janet Stanley were practically the only ones who carried the torch for modern African art. Those days are gone now, but Janet Stanley continues to be a beacon for me. Okwui Enwezor and Sidney Kasfir have also given regular encouragement. This book was written over several years when I was a visiting professor at Dartmouth College, Smith College, Northwestern University, the University of California, Santa Cruz, and Case Western Reserve University. I am thankful for the critical encouragement of my many students and colleagues at these institutions.

The archival research for this book would not have been possible without the dedicated assistance of Elizabeth Botten, Joseph Caruso, David Easterbrook, Janet Stanley, Amy Staples, and the valuable collections of South African–related material at the National Museum for African Art Library, The Melville Herskovitz Africana Library, the Columbia University Library, the Yale University Libraries, and the Archives of American Art. I owe a debt of gratitude to Omar Badsha at South African History Online; Particia Davison at Iziko/the South African National Museums; Linda Givon at the Goodman Gallery; Jeannine Howse and Clive Kellner at the Johannesburg Art Gallery; Judy Seidman at the South African History Archive; Warren Siebrits for help with image reproduction and rights; and South Photo archive. Grants from the Andy Warhol Foundation and the College Art Association supported the final editing and publication of this book.

Various chapter drafts were read by Rasheed Araeen, Omar Badsha, Louise Bethlehem, Suzanne Blier, Richard Dyer, Lauri Firstenberg, Abrie Fourie, Ruth

Ginio, Katy Hope, Elza Miles, Anitra Nettleton, Chika Okeke, Esther Pasztory, Francesco Pellizzi, Colin Richards, Elizabeth Schneider, Judy Seidman, Catherine Soussloff, Zoë Strother, Michael Taussig, Marcia Wright, and Diana Wylie. Their lucid observations and suggestions, both small and comprehensive, especially those of Steven Nelson and Sylvester Ogbechie, helped me reshape my arguments for the better. Sylvester Ogbechie has been a lightning rod for the academic study of modernism in Africa, and his constant friendship has sustained me throughout the ups and downs of the writing process. I am grateful for the commitment to this project of Richard Morrison and his team at the University of Minnesota Press, especially Adam Brunner, Davu Seru, Laura Westlund, and Mary Byers.

My good friends Mike and Panchi, Lisa and Mark opened their homes and their hearts to me during research visits to Chicago and Washington, D.C. Clive Bradley was a most gracious host whenever I passed through London during the early years of this project.

Susan Greenspan has been my constant refuge and companion. Without her, and without the unconditional support of my family—Allison, Bill, Dave, David, Elizabeth, Howard, Karen, Lisa, Mary, Melinda, Mike, Sarah, Scott, Steven, Tom, and Vivi—this book would never have been possible.

INTRODUCTION:
ART, HISTORY, AND APARTHEID

Art and the End of Apartheid examines the development of an oppositional, non-racial aesthetic practice in South Africa in the decades preceding the first democratic elections in 1994. My chapters alternate between historical overviews; individual case studies of artists; and analyses of aesthetic trends in popular art, late modernist art, and photography. Throughout, I highlight the historic predicament of urban-based black artists, their relations with white artists, and their struggle for cultural and political representation through art. My intention is to point to intersections among the many areas of artistic practice, in order to develop as full a picture as possible of the state of South African progressive culture on the eve of the transition to democracy. At the end of apartheid and at the end of the cold war, modern artists in South African cities revolutionized the idea of community and developed novel forms of everyday resistance to government censorship and racial discrimination. They defied official racial boundaries by situating their practice in geographic and aesthetic "grey areas." They worked in multiracial, peripheral, urban zones and with hybrid aesthetics. In particular, the period from 1976 to 1994 that immediately predated the current international interest in South African art prepared the ground for the art that followed the transition to democracy, but its history is less well known.

Whereas most African countries achieved their independence from European colonial occupation by the 1960s, South Africa had to wait until 1994 for majority rule. In 1910 the British colonies in the Cape and Natal united with the Boer

republics of the Transvaal and Orange Free State to form the Union of South Africa. In 1961, the year following independence from colonial rule for most of the rest of the continent, South Africa resisted majority rule, left the Commonwealth, and declared itself the Republic of South Africa. The late 1970s, following the uprising in Soweto, witnessed the buildup to eventual democratization. Unlike the rest of Africa, whose independence era encompassed the late 1950s to the early 1970s, South Africa's liberation dates to the period following 1976. Despite the difference in dates, many of the signature aspects of art that anticipates the postcolonial were the same in South Africa and elsewhere on the continent: the backward glance to invented traditions, the flattening of traditional ritual arts into design elements, and the euphoria of reconstruction. In other respects, art in South Africa was unlike art elsewhere because of its heavily socialist struggle rhetoric and the local history of extreme racialism.

The apartheid era in South Africa began in 1948, with the coming to power of the Afrikaner-dominated National Party and its promotion of an ideology of racial and ethnic separatism. It was officially ended in 1994, when the African National Congress took a majority of parliamentary seats in South Africa's first democratic election. Still, it would be a misunderstanding to view the legal structure of apartheid, or its psychological and social effects, as beginning suddenly and fully in 1948 or as ending abruptly with the change of regime in 1994. Apartheid was a development of earlier tendencies of the state, and it took thirty years to put in place, only to disintegrate from then on. Much of the separatist legislation enacted after 1948 merely hardened a model for white minority rule in Africa that was derived from nineteenth-century British colonial policies. These included the removal of African families from their farms and placing them in "native reserves"; the segregation of living, working, and recreational spaces within cities; the classification of Africans as "temporary sojourners" within cities; and a range of laws restricting interactions between the races, including the separation of public services and amenities ("petty apartheid"). It was not until the 1950s that the National Party, having consolidated its power base, was able to introduce a succession of acts that further restricted the mobility, sexual freedom, and economic rights of "nonwhite" South Africans, including the Population Registration Act, the Group Areas Act, the Immorality Act, and the Suppression of Communism Act, all from 1950, and the Pass Laws Act of 1952, which formalized the reference book, an identity document (ridiculed as the *dompas*, or "dumb pass") that all black adults were required to carry.

It is equally difficult to establish a firm end date. Rory Bester and Katarina Pierre, for instance, have problematized the notion of a "postapartheid."[1] What was the end of apartheid, they ask. Was it President Frederik Willem de Klerk's lifting of the ban on political organizations and his release of political prisoners in 1990? Was it the earlier repeal of petty apartheid laws during the 1980s? Was it

the election of 1994, or the enactment of a new constitution in 1996? And what of that apartheid of the mind, the scars in the internal landscape of those who built, benefited from, or were apartheid's victims—the ingrained attitudes about race that tend to get reiterated during these supposedly different times? Is apartheid not truly banished until the problems of a nation with a majority living in poverty are solved? Without meaning to declare apartheid in all its manifestations completely over, this book aims to understand the institutional and political pressures as well as the means of production of visual culture by mostly black (and some white) artists in South Africa before and during apartheid, and especially during the critical period between 1976 and 1994. This was a period when the desires of marginalized social groups seemed particularly poised to acquire political expression through cultural expression, and it was a time when the struggle for art was synonymous with the struggle for the end of apartheid.

The state made clear its willingness to use brutal force when police fired on pass laws demonstrators at Sharpeville in 1960, and by 1963 much of the leadership of South Africa's liberation movement had been incarcerated, banned, assassinated, or forced to go into exile. The police crackdown on remaining expressions of resistance was particularly severe. During a decade that witnessed the success of independence movements throughout the rest of the African continent, any hope for democracy in South Africa was effectively crushed. But it was not just the prospect of democracy in the near future that was suppressed during the 1960s. The creative impetus was also hobbled. While state oppression increased, the 1950s and early 1960s had been a golden era in the arts: with the publication of the popular black-edited magazine *Drum* and Nat Nakasa's literary magazine the *Classic;* and with the London tour of the musical *King Kong* and thriving jazz and visual art scenes, especially in Cape Town and Johannesburg. But as the authoritarian noose of apartheid law tightened around the neck of South African society, South Africa's vibrant culture also was choked off—from its own history and from access to its leading artists. Segregation in theaters meant that musicians and actors could no longer play to mixed audiences, and black performers were often prevented from playing at better-paying venues in the cities. Standards in black schools were also diminished by the imposition of the Bantu Education Act in 1953, with the result that art, literature, and rigorous intellectual training were denied to an entire generation.

During the 1950s, the National Party began implementing grand apartheid, the creation of ten African "homelands," based on a spurious correlation of ethnicity and geography, and inspired by the earlier British colonial policy of native reservations. The homelands, or Bantustans, were meant to become nominally independent so that most black South Africans would no longer legally reside in South Africa—though in practice the majority were expected to attempt to find work there. The homelands were labor reserves whose economies, police,

and government were controlled from Pretoria. The late 1960s and early 1970s were bleak years in South Africa, with the separateness mentality creeping into the hearts and minds even of the remnants of the shattered resistance movement within the country. The most popular form of resistance at the time was the Black Consciousness movement. Black Consciousness was inspired by the poetic beauty of Léopold Sédar Senghor's philosophy of negritude and by the militancy of the Black Power movement in the United States. It tended to operate within the racial terms defined by apartheid, albeit in opposition to the state. The Black Consciousness movement was also notable for its emphasis on poetry, music, and visual culture as means to reeducate the masses about their history and to instill a sense of black self-assurance. By the mid-1970s, Black Consciousness had become popular within black high school and college student unions, and its leading spokesman, Steve Biko, had become a household name. These student groups finally broke the ice of apartheid, when on June 16, 1976, thousands of school-children rallied and took to the streets of Soweto. Police fired upon them, and months of mass protests engulfed the country. The Soweto students had initially meant to protest being forced to study Afrikaans instead of other subjects, but they quickly added an immediate end to apartheid and the release of all political prisoners as their chief demands.

One thing that is remarkable about what happened after 1976 is that the struggle movement seems to have reconstituted itself by feeding off the hype and energy of the spectacular media scandal that the shooting of children in Soweto had caused, both in South Africa and abroad. What had happened in Soweto was in many respects a profoundly visual affair. From then on the art of protest, and protest art—following the previous use of culture within the Black Consciousness movement—was given a central role by the newly awakened liberation movement. As a consequence, an internal struggle developed among those sympathetic to the resistance movement concerning the most efficacious definitions of community, culture, and politics. After 1976 *community* roughly referred to the residents of black townships, *culture* was defined as resistance to apartheid, and *politics* was synonymous with alignment with the liberation movement. The work of aspiring artists was caught in the tangle of these terms.

By the early 1980s the art world had become thoroughly polemical in South Africa. This was especially the case following the call for all "cultural workers" to use their art as a "weapon of struggle," a directive disseminated by activists aligned with the African National Congress, at the Culture and Resistance festival in Botswana in 1982. In 1983 the United Democratic Front (UDF) was formed from a loose alliance of churches, cultural groups, and unions across racial groups, all of which sought an immediate end to apartheid. The UDF was banned in 1988 and its leadership went underground, but the coalition regrouped under the banner of the Mass Democratic Movement. Protest marches, silk-screened

banners and T-shirts, and pointed political critique in theater, song, and gallery art became the status quo in progressive circles. The art scene, as it had been since the early years of apartheid, continued to be one of the few places where people of all races could interact across the color bar.

There was a global dimension as well to the visual culture of South Africa during the final decades of apartheid. Images of police and soldiers mercilessly chasing protesters with dogs, whips, guns, and armored vehicles were broadcast internationally. As with the case of the televisual display of carnage in Vietnam and the impetus it gave to American anticolonial sympathizers a decade earlier, the globalization of images of Soweto became a rallying point for the international antiapartheid movement. Television was perceived by the National Party to simultaneously represent a potential Communist *and* American threat to South African interests. Via satellite, South Africans could access international programming from Bophuthatswana, Swaziland, and even Europe and the United States, but not until 1976 was the South African Broadcasting Corporation (SABC), South Africa's state-run television, in operation. Then, and throughout the 1980s, television broadcasting was controlled as a propaganda tool by the regime. The Soweto uprising had been sparked by the forceful introduction of Afrikaans in black schools, a measure that was itself initiated by the South African government out of its fear of the growing influence of television. It foresaw that the majority of available programming would be English language based, and potentially liberal biased.

During the 1980s, the African National Congress leadership in exile worked largely under the cloak of cultural organizations inside the country. That did not mean that all artists sympathetic to the struggle agreed on the strategies for politicized art making proposed by the leadership in exile. One can trace the sharp debates about the look and nature of "committed" art to a conference at the University of Cape Town in 1979 titled *The State of Art in South Africa.* Conference attendees, including art teachers Cecil Skotnes, Bill Ainslie, and Gavin Younge, called for a boycott of all state-sponsored exhibitions, for all artists to commit their work to social change, and for the education system to be opened to persons of all races. The evolving definition of committed art can also be traced in the pages of *Staffrider,* a nonracial literary magazine first published in Johannesburg in 1978. *Staffrider* featured essays, worker poetry, photojournalism, and realist graphic art before and during the UDF period. Several issues were banned for what the state considered subversive content. The debate on committed art was refined again at the Culture and Resistance festival in 1982, and at the Culture in a New South Africa conference, in Amsterdam in 1987.

The culture of apartheid had further international implications. Among art scholars, South Africa is usually understood in isolation from the later cold war era, even though, especially during the administration of President Ronald Reagan, the National Party took advantage of American fears of a Communist-controlled Africa.

Similar to how Reagan resurrected the "Red Scare" propaganda of America's 1950s, hard-liners in Pretoria revised the anticommunism rhetoric of the early cold war in order to justify their continuation of undemocratic government in South Africa into the 1980s. Antiapartheid activists, for instance, were labeled "Communist terrorists" in South African police parlance, thus falsely equating black liberation with both Russian imperialism and extreme violence.

During the cold war, the whole world was caught in the vise of a reductively binary polemic. Today it is widely acknowledged that the immediate period after World War II was marked by the initiation of a "cold war" (i.e., one without fighting), whose real battles were fought by proxy in the Third World. On the Western art front, and in the wake of abstract expressionism, the 1940s, 1950s, and 1960s were characterized by a growing institutionalization of nonobjective styles of painting within the American academy, and by its promotion abroad by the Department of State as an avatar of the American way. According to Frances Saunders, these official American cold war cultural intrigues had for the most part fizzled out by the end of the 1960s. Their cessation was supposedly signaled when secret agent Thomas Braden's revelations about the CIA's clandestine promotion of American culture abroad were published in the *Saturday Evening Post* in 1967.[2] But the story of cold war art intrigues did not end in 1967. In a strange twist of history, a small number of South African artists associated with a group called "Thupelo," flirted with the practice of American 1950s-style abstract expressionist art during the 1980s. They emphasized the communal and anti–status quo aspects of abstract art, and they gained the moral support of the African National Congress. The earlier America-centered story of the co-optation of art during the early cold war is made ironic by a consideration of this later repetition in South Africa.

South Africa benefited from the disintegration of the larger cold war imperatives on a global scale. South Africa, unlike the United States, was not one of the superpowers vying for global domination, though its internal affairs were perceived abroad to play a distant part in that rivalry. The dramatic end of the Soviet system in Eastern Europe led in 1989 and 1990 to a sudden shift in South Africa's own political landscape. When President de Klerk announced the end of the ban on opposition groups in 1990, he claimed it was only then possible to negotiate because of the end of the specter of communism. The National Party waited until the end of the American–Soviet conflict before its leaders were willing sit down publicly with the opposition in their own country.[3] Their fear had been that "once the blacks got power the Communists would come next," and that Communist threat was now ostensibly diminished. The rationale for negotiations after 1989 was that the power of the black liberation movement to effect sweeping changes after coming to power was correspondingly lessened.

On the social front, it became clear by the 1980s that urban apartheid had been a grand failure. This situation did not curtail cynical, brutal, and ultimately

futile efforts on the part of legislators to push forward their ideas on a micro-managerial scale. But after thirty years of bureaucracy there were as many loop-holes and exceptions as there were apartheid rules. The beginning of the end was signaled by the Govender case in 1982, when the Transvaal Supreme Court ruled that evictions of nonwhite families, living in white-delimited sections of town under the Group Areas Act, could not be carried out unless other accom-modation were provided. Serious housing shortages had reduced Group Areas to a theoretical construct. Subsequently, the influx of "nonwhite" groups into the cities increased dramatically. By 1988 so-called Grey Areas were officially rec-ognized by the Free Settlement Areas Act, with the paradoxical result that grey became another color on the segregated black-and-white map of the city.[4] Grey areas were a de facto repudiation of the farce of de jure Urban Areas divisions, and were often located at the very core of the urban areas themselves. Grey areas, a term taken from the political geography of the 1980s, may also be applied in a metaphorical sense to those cultural phenomena that could never be accurately classified according to apartheid criteria.

In aiming at the complex object of this study, I have written a layered series of narratives. Each chapter addresses a different theme in the history of South African visual culture since midcentury, and is meant to be able to stand alone as well as to create a synergy with the others. Since these thematic histories in-evitably overlap within a common political history and a common visual culture framework, certain landmark events (such as the Sharpeville incident, the Soweto uprising, and the states of emergency in the 1980s) are discussed in several chap-ters. Nevertheless, I have attempted to keep the overall succession of chapters within a roughly forward-moving chronology. I begin, in chapter 1, with a brief review of the crises of tuition, style, and terminology faced by black South African artists from midcentury to the 1990s. Within this historical context I point to the contingency between the solidarity of black artists based on common subject matter and common working conditions, and the larger multiracial art scene that carved out a niche for them. Chapter 1 also sets forth the overriding thesis for the whole study, that is, the concept of the "grey areas," the place outside of apartheid ideas of race where progressive art was often made.

In chapter 2, I look closely at a common theme among a number of South African artists during apartheid: the image of the body in distress, especially its symbolic transformation into an animal state. Chapter 3 examines the leftist ideas about committed art that were promoted at the Culture and Resistance festival that took place in Gaborone, Botswana, in 1982, and their later repercussions within South Africa. Chapter 4 is a meditation upon the ambivalent iconography of the police truck in verbal humor, protest art, and in township children's toys.

The goals (and criticisms) of the Thupelo Art Project, an annual two-week joint studio workshop where the technical aspects of abstract expressionist art

were explored, is the subject of chapter 5. In chapter 6 I discuss the relevance of theories of the politics of the quotidian to art made after Thupelo. Durant Sihlali, an artist, teacher, and key art world figure from the 1950s through the 1990s, is the subject of chapter 7. I examine the artist's biography and several of his best-known works within the context of the political history of urban space in Johannesburg.

Chapter 8 theorizes iconoclastic art from the perspective of a mixed-race group of radical Afrikaans-speaking artists whose work contested official and unofficial forms of apartheid-era censorship. In chapter 9, I consider selected examples from the dark history of portraiture and urban environmental photography in South Africa, as well as from the more ennobling uses of documentary photography that were promoted at the height of the struggle against apartheid. I look back upon this history in order, ultimately, to better evaluate the new questions about imagination, identity, authority, and place posed by two photographers working within the art gallery context, Zwelethu Mthethwa and Santu Mofokeng. This concluding chapter points out contradictions in the development of South African art during the present historical moment, when increased emphasis on self-criticality is coupled with a growing fluency with international art concepts and the lingering backward look of apartheid.

1 | GREY AREAS AND THE
SPACE OF MODERN BLACK ART

Gerard Sekoto's *Yellow Houses. A Street in Sophiatown* (1940) is a modest paint-
ing, one whose small size and innocuous theme belie its importance in the history
of South African art (Figure 1). The story of this painting encapsulates the hard-
ships and the opportunities encountered by black artists in South Africa during
the second half of the twentieth century. It was painted in oil on cardboard and
measures only twenty by thirty inches. Three iron-roofed homes connected by an
undulating wall line a rocky street; two figures walk along carrying packages—
one exits a corner café with his purchases in his hands, the other balances her
burden on her head; and a postman rides his bicycle down the rock-strewn road.
The colors are all primaries: red roofs, bright yellow walls, and blue sky. This
scene was copied from an earlier study in poster paint on wrapping paper that
Sekoto had made on the floor of his cousin's home. It is a romanticized view of
an urban slum.

Sophiatown was founded in 1899 as a white middle-class neighborhood near
the city of Johannesburg, but a sewage plant was built nearby, and by the 1910s
it had become a working-class area and home to a congested and vibrant mix of
cultural types. By the 1930s, when Sekoto lived in Sophiatown, it had become a
mostly black location. Between 1955 and 1960, the apartheid government demol-
ished the neighborhood and relocated its residents to the expanding segregated
township of Soweto.[1] Since that time Sophiatown, the mixed-race slum on the
outskirts of town, has been memorialized as a midcentury crucible for some of

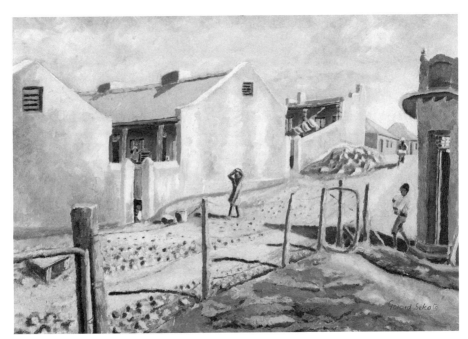

Figure 1. Gerard Sekoto, *Yellow Houses. A Street in Sophiatown,* 1940. Oil on board, 50.8 x 74.5 cm. Courtesy of the Johannesburg Art Gallery and the Gerard Sekoto Foundation.

Johannesburg's most famous (and most notorious) writers, intellectuals, gangsters, artists, and jazz musicians.[2] Sekoto's cousin lived in a house on Gerty Street, and the artist, at home during the day while the family was at work, watched the neighborhood from a window above the street and painted the scenes below.

In 1939 Sekoto had just recently moved to the city from the rural north. He was born into the family of a Lutheran evangelist and teacher in 1913, at the Botshabelo mission station in Middleburg, an area that is today called Mapumalanga. He studied to be a teacher at Grace Dieu, the Anglican Church Diocesan Training College near Pietersburg, and received rudimentary art instruction as an adjunct to teacher training. From 1934 to 1938, he taught at the Khaiso Secondary School in Pietersburg. There he met the artist Ernest Mancoba and the playwright Nimrod Ndebele. Mancoba had already studied at the native college at Fort Hare, and was preparing to depart for Paris. At Khaiso he shared with Sekoto what he had learned about the work, and difficult life, of Vincent van Gogh.[3] Mancoba and Sekoto also visited the traditional villages near Khaiso. As mission-trained Christians, they both viewed the local African culture with fascination, and with a measure of distance. The traditional people in the areas of Middleburg and Khaiso were largely Pedi and Ndebele, both groups noted for the use of hard geometry and contrasting tones in their mural art and beadwork. Sekoto, late in life, recalled the "color and pattern in his childhood environment, amongst the 'non-Christian' black people."[4] This bold application of color, and the "vibrant

play" of pattern seen in Ndebele murals, as South African historian Elza Miles has noted, "became important features in Sekoto's renderings of daily life in Sophiatown and Johannesburg."[5]

Sekoto was quickly brought into the circle of progressive white artists and gallerists in Johannesburg who embraced current trends in European modernism, since his style fit well with the reduction of surface to pattern and the expressive use of color then in fashion.[6] His nephew introduced him to Brother Roger Castle, the art teacher at St. Peter's Secondary School in Rosettenville. There he was given lodging and studio space, and he met Judith Gluckman and Alexis Preller, two young white artists associated with the progressive New Group. Sekoto painted alongside Preller at St. Peter's and learned the rudiments of working in oil in Gluckman's studio. In 1940 he was included in a show of landscapes by twenty-two artists, in 1943 he was invited to exhibit with the New Group for its fifth anniversary show, and in July 1947 he was given a solo show—all at the Gainsborough Galleries in Johannesburg.[7] During 1944 Sekoto spent a year in Cape Town living near District Six, a neighborhood whose cultural flux, racial mix, and later demise was similar to Sophiatown's. There he exhibited alongside the "colored" sculptor Louis Maurice and was (according to some observers) influenced by the expressionist paintings of Maggie Laubser, who had lived in Berlin in the 1920s.[8] Through these experiences, Sekoto gained exposure to the work of white South African artists who followed international trends, and through them to the major styles of European modern art.

Yellow Houses, with its intense use of color, its quickly sketched figures and nervous lines, and its romanticizing attention to the details of everyday life among the working poor, is reminiscent of the work of Van Gogh, and more distantly of the contrastive patterning of traditional murals. The painting also evoked the lives of those living on the edge in South Africa's golden city during the 1930s and 1940s. As a Christian from the rural areas, a newcomer to the city, and a novice in art, Sekoto was in many ways an outsider. His art, he claimed, was a means to "seek himself," to understand by expressively recording the life around him. "The conglomeration of all those races both in the city and Sophiatown," he said, "was a great upheaval and my excitement at being in this new world caused the directions of my thoughts to be very mingled."[9] In Johannesburg and Cape Town, Sekoto sought to make sense of the vitality of life in the city by illustrating the novelty of his environment. At first he approached this newness with the eyes of a visitor, and thus as a theatrical scene: "all these various types of people: women with baskets of shopping, some carrying baggage on their heads or shoulders. Men of various styles of walking and clothing. . . . There were also many children of varied appearance in attire and expression."[10] The characters and scenes Sekoto depicted included street sellers with their donkey carts, residents of men's hostels in their bunks, women shopping in colorfully printed dresses or

washing clothes in courtyards, morning commuters on trains and bicycles, and prisoners on parade. He also sketched portraits of his family and friends at home, and of the private lives of the literate, black Christian petite bourgeoisie—that is, the incipient, cosmopolitan, black middle class in urban South Africa.[11] These were scenes of black life in the city that were unfamiliar to the majority of white South Africans, whose image of the black townships was a place of decadence, overcrowding, and unsanitary conditions—and Sekoto painted them in a positive light, with an angle of vision that was usually at eye level or from the back, but never invasive.

The city of Johannesburg was only fifty years old when Sekoto arrived there, having been built from the ground as a mining town after the Witwatersrand gold rush of 1886. Even though it was termed a European city, at midcentury most of the people of Johannesburg were outsiders, visitors, or recent arrivals. The rich and poor, black and white, English, Afrikaner, Chinese, South Asian, and other groups that commingled there viewed each other, at least initially, with what Roland Barthes might have called the eyes of a tourist. In any city, recent arrivals come initially as strangers. Each new thing and each new type of person encountered are at first viewed as signs of themselves. Novel persons and environments start off as representations with more surface than depth, and the process of making sense of them tends to enfold the strange into the patterns of the familiar, that is, into picturesque types.[12] Although he initially viewed the city through the eyes of a visitor, Sekoto's sense of remove was also filled with curiosity, and he was a keen observer of the surfaces of urban life. The images he selected for depiction were part of his personal exploration of the novelty of urban life. They were also experiments with modernist styles. That said, the white middle-class patrons, critics, collectors, and artists who constituted his main audience in South Africa saw him as a talented but "primitive" Bantu artist who represented the everyday life of blacks in town in a manner they found palatable.[13]

In 1940 the South African Academy included *Yellow Houses* in its prestigious annual exhibition, without placement in the separate "Native Exhibition" category that had been set aside for most previous work by black artists.[14] The painting was subsequently purchased by the Johannesburg Art Gallery and became the first work of art by a modern black artist to be collected by a major art institution in South Africa. Sekoto left for Paris in 1947, the year before the election that brought the Afrikaner nationalist government to power. He never returned to South Africa, and he died in France in 1993. Nevertheless, Sekoto was remembered as the "father" of black modernism in South Africa, and he remained a role model for future generations of black artists.

Yellow Houses and other works by Sekoto from the 1940s are hybrid objects on several levels. They were vehicles for the artist's own self-exploration in the urban life of the modern world. They were a means to share in the middle-

class world and the worldliness of white South Africa. They were a method for representing the experience of black people in the city in a positive light—both for themselves and for Sekoto's white patrons. And they represented the stirrings of a modernist art that would hold the kernel of a crucial alternative to the authoritarianism and the separateness of life under apartheid after 1948. Sekoto's desire for advanced knowledge and training were frustrated in South Africa, because the art schools were not open to black people. That said, Sekoto was afforded a kind of access that was exceptional for a black person of his time. Within the circumscribed social world of progressive artists in South Africa with whom he exhibited, Sekoto shared studio space and learned about modern art a continent away. In the years after he left for Paris, apartheid policy made the segregation instituted during the British colonial period more severe, cutting off most avenues for interaction across the color line. Yet opportunities for exchange among artists continued over the following decades, as a growing number of black artists found their way into the galleries.

From the first stirrings of modernism at midcentury until the 1990s, black South African artists had difficulty gaining access to art historical knowledge, advanced education, art world influence, and exhibition venues. A legacy of informal training combined with paternalistic market pressures with the result that many black artists conformed to a repetitive, sentimental, self-regarding, and limited set of styles collectively, and pejoratively, termed "township art." Paradoxically, the development of black modernist art during the decades before 1994 occurred within a social and intellectual setting that was more multiracial, more multicultural, and more internationally inclined and intellectually curious than most of the rest of South Africa's polarized black and white society. The following pages examine how conceptually, socially, aesthetically, and geographically black modern art in South Africa was a "grey area," a space for interactions of the sort not permitted in the larger society under apartheid.[15] As the state's segregationist program became more onerous after the 1950s, it was the "black art scene" that preserved the promise of a future nonracial South Africa.

Black Modernism

Cultural crossing in formal, pictorial, and experiential terms was central to the work of South African modernist artists at midcentury. Modernism may be characterized at its most basic as a self-conscious break with the past, as an ongoing search for novel forms of expression, and by experimentation with nontraditional media. Modernist art has also been dependent, since the nineteenth century, upon a close circuit of critics and dealers intent on promoting the idea of novelty by foregrounding the artist as an ideal (and marketable) "individual" in the contemporary world. Modernism developed in the context of the global cultural upheaval that

resulted from a century of industrialization and colonialism. Although art scholars are only now beginning to investigate them, there were responses to modernity and modernism everywhere European colonialism impressed its mark. This was especially true in urban centers in Africa, Asia, and the Americas. European artists had revolutionized studio art based on ideas and forms from outside the West, and a similarly outward-reaching gesture took place in art outside Europe during the colonial period. In South Africa, the terms defining the general character of modernism were roughly the same as those in Europe, though the tendency was to respond to modernist principles by means of local historical conditions, as opposed to the presumption of universal relevance assumed by most European artists. There were differences, too, in the approaches of white and black artists. White South African artists looked to local cultures as a means to indigenize their engagement with modernist ideas borrowed from Europe, as well as to validate their own position as a dominant minority in a colonial setting. Black artists who were school educated tended to illustrate the lives of cosmopolitan educated Africans in an urban setting, in sympathetic terms, and in a roughly naturalistic manner, in order to express their right to access to the city, to advanced education, and to modernity at large.

Both Ernest Mancoba and Gerard Sekoto had received a relatively privileged education compared with most black South Africans of their day. They likewise chose to illustrate a modern subject matter that implicitly ground against the grain of the dominant white view of Africans as either tribal country people or urban slum dwellers. John Koenakeefe Mohl, who taught easel painting from the backyard of his home in Sophiatown during the 1940s, spoke for his black peers when he declared that his art would make "the world . . . realize that black people are human beings."[16] For these early black modernists, art was a tool for self-exploration that also interpreted the world of black persons living modern, aspirant lives to people of other races.[17] The media and styles they used were also cross-cultural. Sekoto made his early art within the terms of a roughly mimetic easel painting, and Mancoba's early sculpture was naturalistic. Sekoto's color and Mancoba's line were also derived from looking at African-inflected European modern art, and were meditations on the modernity of black life in South Africa.

Sekoto's *Portrait of a Young Man Reading* (ca. 1946–47) is both a formal study and a poignant document of domestic life in Eastwood, the black township in Pretoria where the artist lived with his family from 1945 until his move to Paris (Figure 2). The man is neatly dressed in slacks and shirtsleeves. One elbow rests in his lap and the other props up his body on a pillow. He is relaxing on a traditional grass sleeping mat and reading an open book placed on the ground before him. The colors are bold white, yellow, and blue, and the composition is built up from a series of angles that cross the rectangular frame of the picture

from left to right. All lines cross the picture plane in sharp angles: the corner of the mat intersects with the left edge of the painting, and the man's elbow and knee are set in opposing triangles that give vitality to his relaxed posture. Although the picture is naturalistic, the application of color and line is reminiscent of the mural art of traditional homesteads. This image of a man engrossed in study is nonthreatening, and its political dimension is left implicit. The painting welcomes the viewer into the heart of a private home as a guest, not as a voyeur. At the time it was painted, it also offered a powerful counterimage to the prevailing view of black life. *Portrait of a Young Man Reading* illustrated with deceptive simplicity the ease with which modern education and vestigial aspects of traditional African culture could and did coexist within black homes in South Africa at midcentury. More important, it showed how natural (and not "foreign") access to a Western-style education could be in the context of black domestic life.

Song of the Pick (ca. 1946–47), based on a watercolor sketch from around 1940, is a more forceful commentary on social inequity (Plate 1). As in *Portrait of a Young Man Reading,* the dynamism of the picture is created through a series of forty-five-degree angles that cross the picture plane from left to right. The

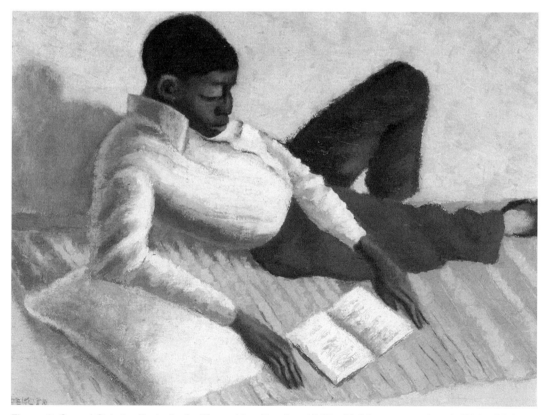

Figure 2. Gerard Sekoto, *Portrait of a Young Man Reading,* 1946–47. Oil on canvas board, 25.4 x 35.2 cm. Courtesy of the Gerard Sekoto Foundation.

image is a line of muscular men who heave pickaxes in unison. The use of color is subtle: the workmen's bodies seem to emerge from earth that is painted pink and dappled with bits of yellow and blue. A white foreman stands to the side smoking his pipe while the men labor away. His suit and hat are painted with the same yellow as the ground he stands on, he is situated almost at the edge of the picture, and the pickaxes look as if they are about to fall upon his head. This gives the impression that the foreman is about to be either pushed out of the picture by the forward movement of the workers, or else he is about to be obliterated by blows and dissolved into the yellow ground on which he stands. Sekoto described his recollection of this image to Barbara Lindop:

> . . . the warden, with his hands in his pockets while smoking his pipe, think-
> ing himself the power, yet being overpowered by the "Song of the Pick" with
> strong rhythm which he can clearly hear so that it diminishes his thin legs
> into nothingness.[18]

This description points both to the aggressive character of the scene and to its musicality. Sekoto was a talented piano player, adept at "marabi" music—a South African form of piano jazz partly derived from American ragtime tunes that was popular at township parties in the 1930s.[19] Marabi music is propulsive, based on repeated rhythmic chords played on the low notes with the left hand, and is similar to the Harlem "stride" style of James P. Johnson. In the painting, the workmen's bodies are arranged in a line like piano keys, and the patchwork colors of their shirts and pants hint at a syncopated beat transposed into hues. It is possible to surmise that this image was a statement about township jazz as a music of rebellion against the European-oriented order of the South African city. Nevertheless this kind of work gang was (and still is) a common sight in South Africa.[20] A decade later, Lionel Rogosin's antiapartheid film, *Come Back Africa* (1959), ended with a similar scene. The protagonist, a labor migrant living in Sophiatown, angrily pounds his fist on a table and recalls all the humiliating moments of his life in Johannesburg, including the rhythmic digging into soil of a work gang like the one painted in *Song of the Pick*. Sekoto's depiction of this common image complexly evoked the vitality of black urban culture, and it was a thinly veiled indictment of black–white labor relations on the eve of apartheid. By imaging the white man as static, presumptuous, and small, and the black workers as full of momentum and muscularity, he may also have been painting an allegory of his own status as a black artist beholden to the whims of the white elite.

Ernest Mancoba's carved wood sculpture *Future Africa* (1934) similarly addressed the dilemma of access for educated Africans under colonialism (Figure 3). It depicts two barefoot young African boys in primary school uniforms.[21] Through this work, made almost two decades before the entrenchment of Afrikaner nationalist power, Mancoba humbly suggested that the only true liberation for black

South Africans would come from *full* access to Western-style education. *Future Africa* was a more direct affront to the colonial education system than Sekoto's *Young Man Reading*. Through the medium of realist figurative sculpture, it was also a subtle demand for a cross-cultural approach to both art and education. Shortly after the completion of this work, Mancoba was forced to suspend his own studies toward a bachelor's degree at the South African Native College at Fort Hare for lack of funds. A year later he decided to leave for Paris.[22]

Sekoto and Mancoba, and the subsequent generations of black artists who followed them, shared a common perspective about the uses and nature of modernist art practice. The colonial view of the "educated natives" was that they had "assimilated to" a European culture that was presumed to be universal. The corollary colonial notion that an "African essence" might be contaminated through the acquisition of *too much* knowledge of Western culture was further hardened

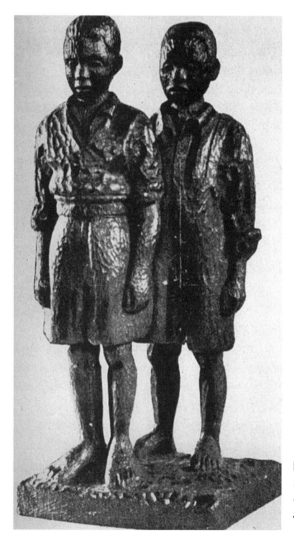

Figure 3. Ernest Mancoba, *Future Africa* (also *The Future of Africa/or Africa to Be*), 1934. Jarrah wood, 61 cm (height).

into law under apartheid. Black artists who sought advanced art training for their own ends were continually frustrated under this contradictory system. And yet black artists in South Africa, and elsewhere on the continent, viewed the techniques of modernism as a skill set that could be acquired in order to build a relevant local culture that was modern, but not necessarily European.

A Modern African Tradition

Art was a contested but shared terrain in aesthetic and social terms in South Africa's cities. Art was also a space for exploring modernity for those living in a more traditional manner in the rural areas. The most notable example is the women's mural art and beadwork of the Ndzundza Ndebele people living north of Pretoria. Ndebele art forms are rooted in the customary celebration of the life cycle. Their imagery reflects the surrounding world in a highly compressed and abstracted form, and it celebrates symbolic relations within the community and to the land. At midcentury Ndebele beadwork and domestic decoration were characterized by hard geometry and contrasting primary colors. They were familiar to those who traveled the roads north of Pretoria. One could view the brightly decorated settlements from the car, or even drive up to take pictures. Because of its easy accessibility, Ndebele art became a highly visible marker of ethnicity in twentieth-century South Africa, and it was central to the character of modernist artists' engagement with indigenous culture.

Elizabeth Schneider has shown that the mural art commonly associated with the Ndebele people has a relatively recent history as a form of ethnic self-identification, and even as tourist art. This history closely coincides with the institution of the ideology of apartheid.[23] The Ndebele are an Nguni language–speaking group, distantly related to the Zulu peoples of present-day Natal, though by at least the seventeenth century they had moved onto the highveld, where they intermarried with Sotho, Tswana, and Pedi peoples. There they were given the name "Matabele," a North Sotho term designating them as strangers, refugees, or invaders, with a foreign culture and language.[24] "Matabele" was Nguni-ized as "Ndebele," and the term became self-descriptive for the people themselves. At midcentury white visitors called the people "Mapoga," a corruption of the name of the most famous head of the Ndzundza Ndebele, Mabhogo.[25] During the late nineteenth century, the Ndzundza of Mabhogo had been allied with the Pedi polity. In 1883 they were defeated in battle by Boer commandos and were forced to work on Afrikaner farms in the Transvaal. A number of the Ndzundza Ndebele family of Msiza were allowed to settle on a white farm at Hartebeesfontein, just north of Pretoria, and this group began to decorate their homes in what would later be referred to as a distinctive Ndebele *ethnic style.*[26]

This notion of an ethnic style merits historicizing, given the fact that the architectural designs supposedly characteristic of the Ndzundza Ndebele were related to those of the Pedi and Tswana with whom they were allied during the nineteenth century. Those designs only began to be interpreted as a unique sign of "ethnic style" during the mid-twentieth century, following years of displacement and disenfranchisement for the Ndebele and following the rise of the ideology of ethnic separatism in South Africa.[27] Peter Delius has even argued that "it seems plausible to suggest that the explanation for both the 'traditionalism' and the artistry of the Ndzundza lies in part in their responses to the particular processes of conquest and dispossession which they experienced."[28] Apartheid evolved from a policy of racial separation into an ideology of ethnic separation, and the Ndebele, with their history of ethnic intermarriage and geographic dispersal, did not fit easily into the official policy of setting up distinct national homelands for South Africa's different ethnic groups.[29] Until 1974, the South African government actually *refused* the Ndebeles' own requests for a national homeland. The establishment of the "homeland" of KwaNdebele ("the place of Ndebele") resulted in the forced resettlement of thousands of people and the creation of an unelected and nepotistic administration controlled by Pretoria. Civil war ensued, and by 1988 the Ndebele were reincorporated within South Africa.[30] Ironically it was a group that was concerned to protect (and establish) its own corporate identity that exposed the contradictions in the ethnocentric policy of the state.[31] In spite of this awkward interface between Ndebele cultural history and state ideology, Ndebele art has been one of the most visible representations of ethnicity in South Africa. For over half a century this has been the case for the government, for tourist agencies, for modernist artists, and even for the Ndebele people themselves.

Ndebele art became almost synonymous at midcentury with "tribal" or "ethnic" art in South Africa. One gauge of the depth of this stereotype is Esmé Berman's encyclopedic book, *Art and Artists of South Africa* (1983), in which the only nonmodernist African arts discussed at any length are prehistoric rock art and Ndebele painting.[32] Berman herself produced a recorded slide lecture in 1976 titled "The Mural Art of the Ndebele Peoples."[33] Berman's emphasis on Ndebele followed a 1960s article by Walter Battiss that had similarly emphasized the "persistence" of "Mapogga art," which he called "transitional" because it incorporated images of Western architecture in its iconography.[34] Even earlier, Isaac Schapera, in the November 1949 issue of *Natural History*, had stated somewhat contradictorily that though the Transvaal Ndebele "have virtually lost their identity," following centuries of contact with Sotho neighbors, missionaries, white farmers, and modern industrial labor, "the people still have enough of their old culture to form a picturesque section of the South African Bantu . . . [and] still rank among the least known inhabitants of the country."[35] On the contents page of the magazine, Schapera editorialized further:

> Those who unconsciously encourage the native to conform to the white
> man's gadget civilization might well think twice before hastening the day
> when such a rich artistic tradition is thrust into the forgotten limbo of
> vanished cultures.

These comments indicate that during the very years that witnessed the invention
of modern Ndebele painting, this "tradition" was already being subjected to a
retroactive nostalgia for "endangered species" and the threat of "contamination"
by Western culture, and to the rhetoric of ethnographic "salvage."[36] It is even more
remarkable that Schapera, whose own earlier research portrayed transculturation
(which moves in *both* directions) as inevitable, if not desirable, shared these senti-
ments.[37] Even if one abhors, as I do, the wholesale disruption of indigenous African
cultures under colonialism, the salvage sentiment is oddly applied to Ndebele mural
art. This Ndebele tradition was a contemporary phenomenon, itself born in re-
sponse to the conditions of settler colonialism in South Africa. What observers
thought they were salvaging, they were in fact helping to create.

The popularity and attractiveness of Ndebele art meant that it became a
kind of generic sign for African ethnicity, both in South Africa and abroad. After
1953 the South African government capitalized on this development.[38] They sup-
plied colorful acrylic paints to the local women and set up tourist villages, with
the aim of buttressing the nascent ideology of apartheid and its separation of
"races" into linguistically, culturally, and geographically distinct units. Since the
early apartheid years, tourist brochures, advertisements, and travel guides have
routinely featured images of Ndebele women's art. Through these forms of mass
media, photographic imagery was historically an adjunct to the homelands sys-
tem in the creation and distribution of ideas of black ethnicity at the service of
white leisure in South Africa. For instance, one German publication from the
1950s included an image of a white tourist in a Sunday dress photographing three
Ndebele women who are also dressed up for the picture.[39] In a similar vein, the
South African Tourist Corporation ran a full-page advertisement in *National
Geographic* and in the large-format pictorial monthly *Holiday* in 1957. The image
included a snapshot of an Ndebele woman stirring a three-legged *poitjie* and a
man in a Hawaiian shirt framing her smiling face in his camera (Figure 4). The
text promised photographic riches to the "armchair explorer" who, "with hardly
any effort at all," could bring home a record of a happy holiday.[40] In an interest-
ing twist of fate, it appears that a copy of Esmé Berman's own taped lecture and
its slide images of the government-supported tourist village at KwaMsiza was the
template for the designs once painted on the rear walls of the National Museum
of African Art in Washington, D.C.[41]

This picture of the modernity of an African "tradition" is further compli-
cated by the fact that already in the 1930s the iconography of the Ndebele murals

Figure 4. SATOUR advertisement in *National Geographic*, October 1957.

themselves was omnivorous, and often contained stylized references to electric light posts, suburban homes, airplanes, automobiles, and commodities. In short, the murals expressed a rhetoric of modernity and displayed knowledge of worlds beyond the confines of the local. It has even been suggested that these types of murals enacted a subtle art of resistance against apartheid.[42] Yet for city-based modernist artists, this contemporary rural art was the primary stereotype (as it was for tourists and apartheid's ideologists) of a culture that could not easily be classified as "modern" nor be mistaken for something European. Fine artists working for the urban galleries looked to rural vernacular art for creative stimulus and to legitimize their practice as "local." Interestingly, among the more traditional Ndebele, a number of entrepreneurial women have themselves sold modified forms of their beadwork and other household items to tourists since the 1930s. Since the 1980s, it has actually been those who have set themselves apart as the keepers of a dying tradition who have been most active in exhibiting mural-derived art, now in a portable scale in acrylic on canvas, at modernist art galleries and museums in South Africa and abroad.[43]

Settler Primitivism

During the late 1930s, at the cusp of when "the Mapoga" were becoming the popular sign of indigenous tradition in South Africa, modernist artists and photographers began to include images of Ndebele women in their work. The photographer Constance Stuart Larrabee (then Constance Stuart) ran a portrait studio in Pretoria in the 1930s and 1940s and is best known today for her "tribal" studies of black South Africans that were included on Edward Steichen's photographic survey, The Family of Man, exhibited in 1955 at the Museum of Modern Art in New York. She photographed the Ndebele, urban scenes, and even Gerard Sekoto preparing for his final solo show before leaving for Paris in 1947 (Figure 5). In an interview in 1994, she recalled her friend Alexis Preller and his "baby Austin" car: "At weekends we would drive out, and he would paint the African people and I would photograph them."[44] During the next three decades, Ndebele art inspired a number of other South African artists, both black and white, including Walter Battiss, Douglas Portway, and Durant Sihlali.[45] Why did these artists choose Ndebele tradition as an inspiration for their modernist art experiments? Perhaps most important, they viewed the Ndebele as "picturesque," in a manner not unlike the anthropologist Isaac Schapera's contemporary appraisal cited earlier. Proximity was also a factor, since a visit to the Ndebele area was just a day trip away for artists from Pretoria or Johannesburg. This geographic nearness, coupled with the outwardly visible signs of Ndebele cultural distinction from middle-class urban life (as well as from urban township life), was arguably what made them seem picturesque. This was especially so for white artists, but it was

Figure 5. Gerard Sekoto, painter, Johannesburg, South Africa, 1947. Photograph by Constance Stuart Larrabee. EEPA 1998-006 (P8), Constance Stuart Larrabee Collection, Eliot Elisofon Photographic Archives, National Museum of African Art, Smithsonian Institution.

also the case for black artists like Sekoto (and later Sihlali) who grew up on the outskirts of traditional culture.

Many of these midcentury modernists who incorporated Ndebele forms in their work had overseas aspirations as much as they had a more or less objectifying view of local cultures. Larrabee, for instance, recalled the camaraderie and ambition of her early colleagues: "We were a group of young, talented people who were going places. Pretoria was not the big city it is today, and so all the young talent . . . got together."[46] Although she was certainly sympathetic toward the poverty of the Ndebele women, and their fragile dependence on male migrant labor, Larrabee also claimed, "I photographed the African people because they were wonderful looking and their culture was so interesting to me. It was just the most wonderful material for my Rolleiflex . . . I just found this beautiful material out in the countryside. You only had to go eight miles to find it."[47] From this

retrospective statement, and from the evidence of the images themselves, it can be deduced that Larrabee's photography treated her African subjects as picturesque material for her modernist formal compositions. These African bodies and painted designs were found objects for her, and, as Brenda Danilowitz has shown, they were objects for a romantic pastoral fantasy about "vanishing tribal culture" in Africa that ultimately enabled white settler society to imagine itself as culturally and technologically distinctive, if not superior.[48] This approach can be seen in the hundreds of Larrabee's Ndebele photographs now held in the archive of the Smithsonian Institution's National Museum of African Art.[49] No names, specific locations, or descriptive details are given for most of these pictures.

In one image, simply captioned "Ndebele 1947" and reproduced in Larrabee's 1984 exhibition catalogue for the Corcoran Gallery, two children are arranged against a wall decorated with abstract "razor blade" motifs and a life-sized reproduction of the Mr. Peanut logo (Figure 6).[50] The center of the composition is empty, the square picture frame is balanced by a dynamic and diagonal pairing of rectilinear forms, and the human figures here carry only as much visual weight as the cartoon logo. If one were to surmise a social interpretation constructed by this scene, here the looming (and somewhat comical) presence of Western commodity culture stands as a threat to the purity of an idyllic African culture. Larrabee certainly did not mean to disparage her subjects. Rather, she intended to isolate what she saw as the beauty of Ndebele culture within a society that treated black people as second-class citizens. All the same, her photographs enacted a formal distance between her and the social world of her sitters. Larrabee's published photographs of the Ndebele further primitivized her subjects by excluding the presence of the adult Ndebele men in Western clothing. These men were sometimes present when she photographed the women and children, and they appear in a number of "outtakes" archived in the Smithsonian collection. In one such image, a man in stylish, urban *tsotsi* (gangster) attire holds a pack of cigarettes in his hands and appears to be counting out money. Perhaps this was the payment given for allowing Larrabee to take photographs that day? The woman to his right is dressed in tattered everyday clothes and gathers dried corn in the dirt. On the wall nearby, a traditional blanket and beadwork hang, ready to be donned if sightseers and artists stop by (Figure 7).

Larrabee was friends with members of the New Group, the loose collective of South African artists formed in 1938, whose founding members included Alexis Preller and Walter Battiss and who exhibited paintings by Sekoto. The aims of the New Group were to promote more current forms of modernist art and to "kick against the junk" of the more reactionary and conservative attitudes toward art that they saw prevailing in South Africa at the time.[51] Most members of the New Group had either studied overseas or actively followed artistic trends in Europe, as had Larrabee.[52] Preller, for instance, had studied at the Westminster

Figure 6. Two Ndebele children, Pretoria, South Africa. Photograph by Constance Stuart Larrabee, 1936–49. EEPA 1998-060675, Constance Stuart Larrabee Collection, Eliot Elisofon Photographic Archives, National Museum of African Art, Smithsonian Institution.

School of Art in London in 1934 and at Le Grande Chaumière, Paris, in 1937. Berman claims that after the outbreak of World War II, "the withdrawal of imported cultural stimulants" led to increased attention to local art.[53] The need to find local referents for a "homegrown" modernism may have increased the desire among these progressive artists—who were also political liberals—to look to African traditions as a source of inspiration with a uniquely local character.

This outlook is apparent in Preller's fascination with the "Mapogga," a recurring theme in his work in the 1940s and 1950s. Preller was perhaps the first South African artist to note the striking look of the Ndebele people, and included studies of the "Mapogga" in his work as early as 1935.[54] As a young artist, he had also exhibited alongside Sekoto and shared technical knowledge with him at St. Peter's. In his *Mapogga I* of 1951, the artist has erased the individuating facial features of the woman, who sits statuesquely and whose form is drawn to

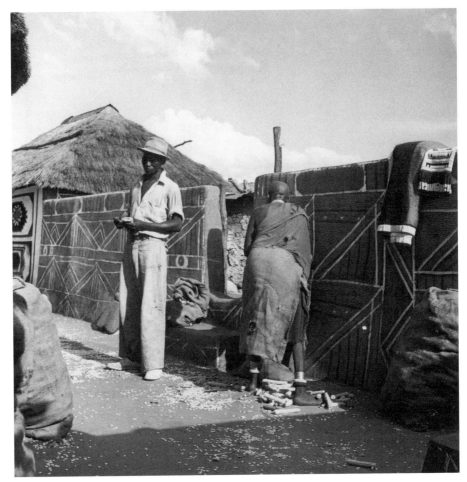

Figure 7. Unpublished "outtake," Ndebele woman and man, Pretoria, South Africa. Photograph by Constance Stuart Larrabee, 1936–49. EEPA 1998-060629, Constance Stuart Larrabee Collection, Eliot Elisofon Photographic Archives, National Museum of African Art, Smithsonian Institution.

look like a giant ear of maize with its outer leaves pulled back (Figure 8).[55] The painting is thus surreal and allegorical. If its symbolic allusions to fecundity, native connections to the agricultural produce of the land, and female genitalia are not immediately clear, Preller even included an ear of corn in the picture, floating in midair at shoulder height to the right of the figure.[56] The image could be considered comical if it were not so problematic. Several elements in this painting merit further scrutiny. Its specific real-world source appears to have been one image from a group of photographs taken by Larrabee that were published in the magazine *Natural History* in 1949, and that accompanied the essay by Schapera cited above (Figure 9).[57] Larrabee's photograph features three women sitting on an earthen bench outside a sparsely decorated wall, and is captioned with the text:

Figure 8. Alexis Preller, *Mapogga 1,* 1951. Oil on canvas, 497 x 604 cm. Courtesy of the Gordon Schachat Collection.

"On Sundays the women of the Ndebele dress in their best and visit each other." Preller isolated the woman on the far left in this image, whose hands are clasped at her knees, and whose toes poke out at the viewer. He copied the horizontal stripes and vertical folds of her blanket, her hair knot, and even the number and placement of beaded rings on her neck, arms, and legs. But he turned her head into an anonymous oval, added tatters to the garment, and has drawn down the woman's cape to reveal two high-set breasts.

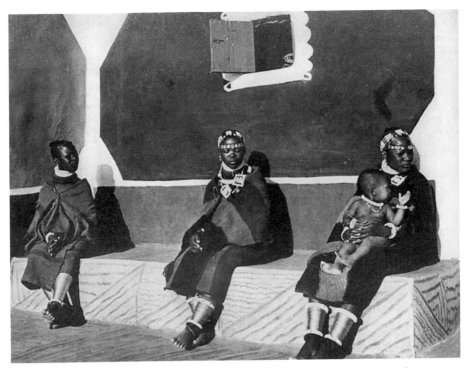

Figure 9. Ndebele women and baby, Pretoria, South Africa. From *Natural History* (November 1949): 414. Photograph by Constance Stuart Larrabee. Courtesy of Constance Stuart Larrabee Collection, Eliot Elisofon Photographic Archives, National Museum of African Art, Smithsonian Institution.

Preller's use of the Ndebele figure in images like this was for possibly voyeuristic consumption, or at most as an item in an iconic inventory whose elements constituted no deep concern with Ndebele culture, but rather with an eccentric personal mythology. This sort of objectification is in evidence in another work from 1952 titled *Collected Images (Orchestration of Themes)*. Here the same "Mapogga" image recurs in one of a set of twenty-one boxes containing miniature reproductions of the artist's earlier paintings, as well as numerous exotic objects collected by Preller during his travels abroad.[58] Esmé Berman summed up Preller's "Mapogga" imagery, claiming he created a personal "imaginative fantasy,"[59] and by "dramatizing their dress and architecture, isolating figures in mysterious surroundings, he generalized on their appearance and created a romantic personal interpretation of the tribe."[60] Preller was in thrall to his own personal mystique of a tribal Africa and held traditional cultures out as distant, living in another age from his own, and ultimately inscrutable. What Berman neglects to point out is that the aesthetic of clean lines, crisp geometry, and isolation and reduction of figure to shape that was so characteristic of Preller's art was also characteristic of the Ndebele art that he had admired in his romantic way.[61]

The gesture toward indigenous traditional art has been a recurring theme among modernist artists in South Africa, and it has clear parallels with the development of modernism elsewhere outside the West. Nicholas Thomas has identified a similar trend among midcentury white avant-garde artists in Australia and New Zealand toward what he calls "settler primitivism." This term evokes the artists' bipolar embrace of both empathy and romanticism. Thomas distinguishes between metropolitan primitivists like Picasso, who made eclectic use of exotic forms without regard for the contexts of their original sites, and settler primitivists in former colonial societies who made specific reference to particular and well-known indigenous traditions in their art. For settler primitivists the exotic other was also local, and their art was intended to emphasize and "affirm a local relationship."[62] Thomas notes that "the deep association between indigenous people and the land provided strong and condensed reference points for a colonial culture that sought both to define itself as native and to create national emblems."[63] Whereas metropolitan artists had appropriated art from other cultures without much regard for context, settler artists were often involved in a two-sided appropriation: of modernist technique from Europe and of indigenous aesthetic forms. Since at the root of this approach was a desire on the part of settler artists to formulate their differential local status vis-à-vis the European modernist metropolis, their subjects were ultimately themselves and not the indigenous cultures referred to as objects for their formal experiments. So, as Thomas notes, "While indigenous claims to the land are being denied or forgotten, elements of their culture are being prominently displayed and affirmed."[64] This kind of local modernist appropriation, whose eyes are dually fixed abroad and at home, also cuts two ways locally in that it both promotes and objectifies its subject, and it pays homage to local tradition while purloining its imagery and aesthetic.[65] Midcentury white South African modernists like Preller and Larrabee, who combined European aesthetics and African images in their art, gestured toward indigenous culture but less often worked toward cultural fusion.[66] These artists, whose politics were liberal and who were generally critical of the policies of the National Party, usually only met the "natives" halfway, and balked at more fully shared forms of cultural integration.

This desire to create a uniquely South African form of modernism with reference to indigenous African cultures would later be a driving concern of the Amadlozi Group, founded in Johannesburg in 1963 by the art dealer Egon Guenther. The name Amadlozi ("spirits of our ancestors" in Zulu) was coined by Cecil Skotnes, who led a biweekly art studio at the Adult Non-European Recreation Centre on Polly Street in Johannesburg, and was a founding member of the group. Sydney Kumalo (a former Skotnes student), Cecily Sash, Giuseppe Cattaneo, and Edoardo Villa also joined Amadlozi. These artists were exhibited together by Guenther, an avid collector of classical African art, who believed that they each were expressing the "essence" of Africa in individual ways. Sash, for instance, painted a heroic frieze

of Rufino Tamayo–like figures titled *Uhuru* ("freedom" in Swahili) (1964), and Villa made a series of metal sculptures inspired by Bakota reliquary figures. By the later 1960s, another former Polly Street student, Ezrom Legae, also showed work under the Amadlozi banner. As a loose collective, the Amadlozi Group produced a synergy, in part the product of sharing ideas about art across racial boundaries. Following the precedent of the New Group, they exhibited work along nonracial lines, and the intercultural exchange among members of the Amadlozi Group was marked by a great degree of fluidity. This quality, and the public example set by the group, had as much influence on the direction of art in South Africa as did the informal types of exchanges that went on at recreation centers like Polly Street.[67] Within this small group, each looked to the other for ideas and affirmation. For instance, whereas Skotnes's students at Polly Street learned about European modernists like Picasso and Moore, and worked in traditionally Western media like watercolor, pen and ink, and bronze, his own art tended to explore more traditional African spiritual and historical themes as well as the more "African" (but also medieval or expressionist) medium of cutting wood (Figure 10). Skotnes and Kumalo even collaborated directly on a number of projects, including the decoration of the ceiling of St. Peter Claver Church in Kroonstad (now Seeisoville) in 1957. The ceiling paintings interpreted Christian symbols and mural motifs seen in Johannesburg's Western Native Townships with a modernist sensibility.[68]

Artists like Larrabee, Preller, and Skotnes were members of a European settler society in Africa. As such they had their own feelings of internal exile that they attempted to resolve though their art, but in ways profoundly different in intention from black artists like Sekoto, Kumalo, and Legae. This was so, even if many of the references to indigenous art in their works seem on first sight to be formally identical. It is not unusual in the history of modern art for urban artists to search for some (perceived to be) primitive source material to rejuvenate contemporary cosmopolitan culture. This was true for the orientalist painters, for Gauguin, for the fauves, for the cubists, and for Jackson Pollock, Mark Rothko, and other early abstract expressionists. A complete list of this type might even be synonymous with the major avant-garde trends since the middle of the nineteenth century. But when the sources were actually part of the local culture, in the context of settler colonialism, the stakes for cross-cultural inspiration or exchange were that much more profound, and the potential for paternalistic attitudes on the part of white artists was always present.

Tuition, Repetition, and Emulation: "Township Art"

Throughout South African history, art education has not been generally available to black students. As late as 1994, the year of South Africa's first democratic election, only a handful of the thousands of black-only primary and secondary

Figure 10. Cecil Skotnes, *Mhlangane Stabs Shaka*, 1973. 50 x 33 cm. Woodcut number two from a series of forty-three to accompany poems by Stephen Gray titled *The Assassination of Shaka by Mhlangane Dingane and Mbopa on 22 September 1828 at Dukuza by Which Act the Zulu Nation First Lost Its Empire.* Courtesy of Cecil Skotnes.

volunteers, including the former students Sydney Kumalo and Ezrom Legae. A number of the leading black artists during the 1970s and 1980s in South Africa had attended classes at Polly Street, including Ephraim Ngatane, Durant Sihlali, Louis Maqhubela, and Patrick Mautloa.

Even in white schools, prior to the 1980s, most advanced art instruction was restricted in its emphasis to drawing from life, oil painting, landscape, and still-life studies. According to Skotnes, though the facilities were certainly better at the white universities, the instructors were mostly conservative in what they considered "art" and taught within the European tradition of naturalism. When Skotnes was a student at the University of the Witwatersrand in the 1940s, Pablo Picasso's cubist work (ca. 1908–14) was still considered radical, and even "not art," by most of his professors.[72] Partly in reaction to this experience, the way Skotnes ran the fine art section at Polly Street was both more liberal and less intensive than what was being offered to most white art students in South Africa at the time. Furthermore, Polly Street was a night school and a recreation center offering a range of functions, from music and physical education to art, and Skotnes's duties as director were correspondingly diffuse. For this reason, too, the art studio at Polly Street had more of a workshop atmosphere than the feel of a structured course of study at university. Skotnes was at first curious to see what styles the students would develop on their own rather than being intent upon impressing a Western academic perspective on their art. He was concerned that he might be interfering with the "natural" African creativity of his students. This was a view shared by the organizers of other art training centers in Africa at the time, including Frank McEwan at the Salisbury Workshop School in Rhodesia, Pierre Romain-Desfossés at the Atelier d'Art in Elisabethville in the Congo, Ulli Beier at Oshogbo in Nigeria, Margaret Trowell at Makerere University in Uganda, and Papa Ibra Tall at the École des Arts in Senegal. All of these founders of modernist art schools in Africa believed that technical advice, if given at all, should aim to elucidate the "innate" cultural memory of modern African artists, and not to "contaminate" them through too much exposure to "European" ideas about art.[73] The idea of creativity, as something natural that an academic approach could spoil, was also common among twentieth-century European and American avant-garde artists such as Gustave Moreau, Jackson Pollock, and Jean Dubuffet. But black artists in South Africa were hungry for education, and any perceived withholding of tuition by white teachers—who had themselves received the benefits of academic training—seemed an unacceptable double standard.[74] Despite (or perhaps because of) such objections, Skotnes introduced a number of students at Polly Street to international art in a range of styles, from classical African sculpture to European modernism (especially of the sort derived from African art), depending on the inclination of individual students. In retrospect, Skotnes did provide the rudiments of a formal art education to

regular attendees of the biweekly sessions at Polly Street—albeit of a staggered and compressed sort.[75]

Steven Sack has observed that there were primarily two types of work made by most of the artists associated with Polly Street.[76] On the one hand, there was a tendency toward naturalism in painting (e.g., Sihlali) and on the other, a tendency toward cubist-like reduction of the figure in sculpture (e.g., Kumalo) (Figures 11 and 12).[77] Elizabeth Rankin has argued that it was the pressure of the market more than the method of instruction under Skotnes that encouraged black artists to work within this stylistic dyad.[78] Sack has written, further, that some artists from Polly Street, most notably Ephraim Ngatane, achieved such quick market success with their colorful depictions of township scenes that they began turning their liberal interest in art into more of a business venture.[79] Black artists were expected by their white patrons to depict their own people and customs within a narrow iconographic range: either typical scenes of "township life" or of "exotic Africa." Taken as a whole this art came to be termed, rather deprecatingly, "township art." By the 1970s, "township artist" had become even more of a catchall term and was used simply to mean "black artist," with the expectation that what black artists did was "paint the black townships." Critics used the term reductively to gloss a whole category of vital art practice in South Africa by conflating form, content, and the identity of the maker. According to South African

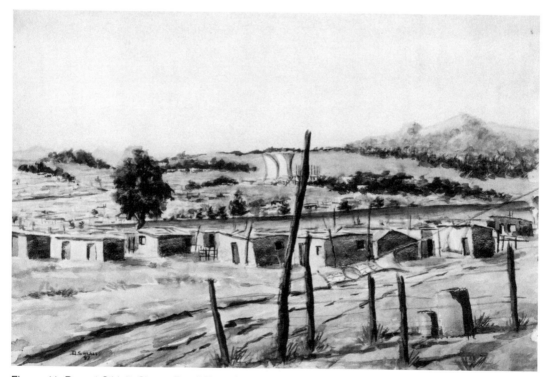

Figure 11. Durant Sihlali, *Slums, Zondi Township,* 1957. Watercolor, 42 x 58.6 cm.

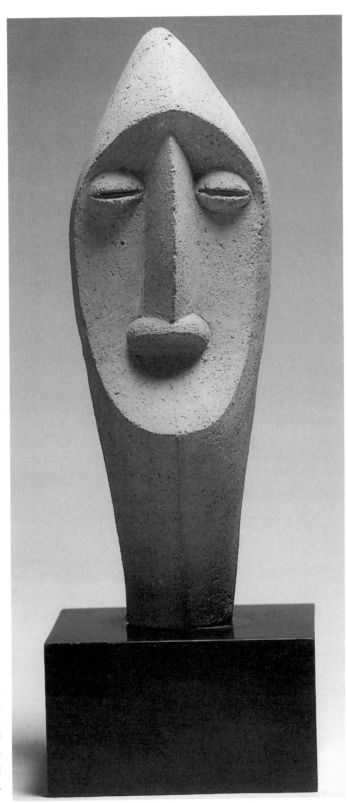

Figure 12. Sydney Kumalo, *Mask,* 1960. Brick clay, 38.5 cm (height). Courtesy of the estate of the late Sydney Kumalo and the Goodman Gallery.

artist and curator David Koloane, if you did not conform to gallery demands, you could not sell your work:

> If you didn't do this kind of thing [township art] it was harder. In 1977 and 1978 I started experimenting with collage, and I took some of these pieces to Gallery 21. The first thing the owner said was that I didn't do the work . . . because this is so "un-African." He said for that reason he didn't feel comfortable buying it.[80]

"African" work for this gallerist meant township art: either cubistic distortions of the figure or naturalistic renditions of black life. Here the standard for what constituted Africanness was itself European-derived. It was wooden sculpture, of a type made in West or Central Africa but rarely made in South Africa, that ranged in height between one and several feet, dated to the period of European colonization, had been selected according to European tastes, and was displayed in European museums. Or, it was the work of the canonical modernist artists, especially Picasso, Constantin Brancusi, the German expressionists, or postcubist artists like Henry Moore, Rufino Tamayo, and Lynn Chadwick. All of these European artists claimed creative inspiration from the canonical examples of African sculpture displayed in museums. Otherwise, "African" meant a two-dimensional, self-referential, figurative art after the styles of the European realists, impressionists, or expressionists. Partly because of the demands of gallery owners, this limited set of iconographic genres and restricted range of stylistic modes continued to be reproduced by most black South African artists into the 1980s and beyond. Even Sekoto, who continued to exhibit back home by sending paintings from Paris, was unable to show his images *of* Paris in the South African galleries—or, more remarkably, even those made during his trip to Senegal in 1966.[81]

The repetition of iconography and style was also due to an internal dynamic among black artists themselves, which, though interwoven with the history of patronage, is not adequately explained by sole reference to the market. This internal factor was born of black artists' history of restricted access to higher education and from the consequent lack of diversity in known antecedents for their art practice. Koloane claims that the development of style and iconography among black artists demands a more historically contextualized approach that considers these relations between artists, as well as market factors:

> One thing you have to realize is that we've never had role models in the visual arts in this country. We were not even allowed into art museums, or theatres, or cinemas because of the Separate Amenities Act. Most of the artists who are practicing now, [and] when the centres like Funda, Rorke's Drift, and all the others were started—their only role models were the Polly Street artists, the Gerard Sekotos, the George Pembas, and obviously their environment which was different from the white environment. You couldn't

Black artists did not portray ANC leader Nelson Mandela speaking defiantly at the 1963 Rivonia Trial. This was perhaps because it was considered treasonous to reproduce Mandela's face. Nor did they make a genre picture of the shooting of unarmed protesters at either Sharpeville in 1960 or Soweto in 1976, though protest posters did depict these scenes. Protest images did not become common until the early 1980s.

There were exceptions. Several Rorke's Drift students made linocuts and etchings that contained coded references to political prisoners, and even surreptitious portraits of Mandela and of Steve Biko. Mandela's face can be seen in etchings such as *In Prison* (1969) by Cyprian Shilakoe (Figure 13), and again in *Robbed Man* (1974) by Vuminkosi Zulu. These two prints were borrowed directly from the school collection at Rorke's Drift for inclusion in an exhibition titled Black/South Africa/Contemporary Graphics and Tapestries at the Brooklyn Public Library in 1976. Unfortunately for the American audience, the artists' political intentions would likely have gone unnoticed, since the accompanying cata-

Figure 13. Cyprian Shilakoe, *In Prison,* 1969. Etching, 34.3 x 31.8 cm.

logue mentioned neither the word "apartheid" nor the name of Nelson Mandela anywhere between its covers.[91] Philippa Hobbs and Elizabeth Rankin have recently argued that the accepted view of Rorke's Drift as a missionary school that solely promoted ecclesiastical art is mistaken.[92] Their research showed that political discussions were in fact common among teachers and students; that the school's founder, Peder Gowenius, was deported from South Africa in 1970 for being outspoken against apartheid; and that a number of student works contained antiapartheid references. This history is less well known, they surmise, since the more politically contentious images made by Rorke's Drift students were suppressed by South African art dealers. Their assertions are borne out, too, by the evidence of the Brooklyn show, where curators obscured potentially antiapartheid messages of the exhibited works. Along these lines, Louis Maqhubela recalled that his mixed-media work *Peter's Denial* (1966) was a coded political statement, and that it was common for South African artists to make similarly (and necessarily) indirect antiapartheid comments in their work during the 1960s and 1970s.[93]

It seems reasonable to conclude that township art, or at least the way it was shown in the galleries and discussed in print, went hand in hand with apartheid. According to South African art critic Ivor Powell, this art reproduced "the basic assumptions that whites wanted to nurture around their compatriots. Thus the primitivisation of the human figure; thus the exaggeratedly African look as an immediate token of difference; thus the absence of technology and progress; thus the emphasis on music and dancing as rendering blacks as creatures of feeling rather than thought; thus the overwhelming picture of the township dweller as being helpless, in need of guidance of whites."[94] In contrast to this dire view, David Koloane has urged that viewers consider a wider context when viewing even the more commercial works of so-called township art:

> You know, we had to live in these crowded surroundings—whereas one
> white person lives in a yard big enough to accommodate a whole commu-
> nity. It was a way of emphasizing the apartheid legislation. The mere fact
> that there are shacks [and] there are townships is evidence of this fact. And
> I don't think, for a young artist who has never had any formal education,
> that he's going to do something different. He is going to do what is around
> him. He is going to deal with his space. Any space in the township is political
> space. It deals with confinement. It deals with restrictions. It deals with a
> whole lot of taboos.[95]

For Koloane the repetition of genre scenes of the townships ought to be reframed as so many covert acts of agency, with an undercurrent running counter to market demands for a quaint art of self-pity. For him, even the more hackneyed forms of black art ought to be considered a manifestation of solidarity with the common cause of black South Africans, as well as an illustration of inhumane

the neighborhoods like Jeppe, Mayfair, Newtown, Braamfontein, Doornfontein, Crown Mines, Troyeville, Hillbrow, and Yeoville in Johannesburg, and District Six and Woodstock in Cape Town. All had been settled by working-class people of all races, and were bohemias for artists, students, and revolutionaries.

Many of South Africa's black artists felt freer to live, work, or socialize in these places. Sekoto, for instance, had lived in the cosmopolitan slums of Sophiatown in Johannesburg and in District Six in Cape Town. In these places he experienced the difficult pleasures of interracial interaction within the frame of art, at a time when such exchanges were still quite rare in the rest of South African society. Polly Street, Dorkay House, the Market Theatre, FUBA Academy, the Alex Art Centre, the Community Arts Project in Cape Town, and other schools and venues where black artists trained or performed were all located in or near the unsightly edges of "white" cities, that is, in the "grey areas." David Koloane's "the Gallery," a black-run commercial showcase for black artists in the late 1970s, was located in Jeppe, just east of downtown Johannesburg—a location chosen so as to keep relatively out of sight from the authorities. During the 1980s, the Market Theatre and Gallant House in Newtown hosted art openings, leftist theater performances, and musical events that presented similarly precious opportunities for the mingling of bodies and ideas despite the official racial divide. The Market Photography Workshop, also located in the Market Theatre complex in Newtown—and on the "grey" western edge of downtown Johannesburg—was a small oasis in a landscape of exclusion. According to Photography Workshop founder David Goldblatt,

> If the primary thrust of such a facility was to be towards young black Africans it had, at the same time, to be open to everyone, irrespective of race. In this there was a principle but also the hope that in throwing people together who would otherwise have no experience of each other, the Workshop might be a small counter to the ethnic surgery that had so successfully separated South Africans under apartheid.[102]

During the 1970s and 1980s, overtly political protest art was also made in grey areas, for instance, under Steven Sack, who ran an underground poster workshop at Shaft 16 in the Crown Mines settlement. Sack also served as the first director of the African Institute of Art, a tertiary training program in Deipkloof, at the edge of Soweto. Most of the posters, T-shirts, and other types of "people's art" made during the 1980s were produced under racially interactive social conditions. The alternative art press also played a part. Nat Nakasa and Barney Simon's literary magazine, the *Classic,* was, from 1963 to 1968, the place to find leading-edge writing and art by persons of all races. During the 1970s and '80s, that role was taken up by the nonracial *Staffrider* magazine, which had a more populist-progressive

political inclination. During the 1980s, other alternative journals such as *Speak, Sesame,* and *Art* consistently published art and debates across the color line.

In retrospect, much of the formally interesting and historically important art in South Africa since the 1930s has been produced in these edgy, grey zones. The term "grey areas" may also be loosely applied to the social lives of black artists in South Africa. The term would then be descriptive of artist collectives like the New Group in the 1930s, the Amadlozi Group in the 1960s, and Afrapix and Skuzo in the 1980s. Mixed exhibition openings at galleries like Gainsborough, Adler Fielding, Lidchi, Gallery 101, and Goodman; as well as the studio experiences shared between individual artists—these were also grey areas in contradistinction to the rest of South African society. This aspect of the social world of the black art scene was noted early on (and perhaps overoptimistically) by an anonymous *New York Times* reporter in a 1965 review article titled "Art Under Apartheid":

> There is a curious paradox about race-haunted South Africa. Under the iron-clad *apartheid* laws the ring of racial separation is complete—except for one link. This link is art: there is no bar whatever to the free mixing of blacks and whites at art exhibitions. Africans can attend opening night shows patronized by the top levels of society in Johannesburg, Cape Town, and Pretoria, the three leading art centers. And they do. The artists among them are free to exhibit their paintings and sculptures on exactly the same terms as the whites. And they do . . . the best known, most admired, and most sought-after figurative sculptor is [in fact] a Negro—Sydney Kumalo.[103]

Social events and parties involving artists, writers, and musicians were precious venues for interracial dialogue, especially after the implementation of Separate Amenities. In his memoir *Down Second Avenue,* the writer Ezekiel Mphahlele recalled these occasions with relish—as rare moments to meet as equals across the color bar:

> Sylvester and Jenny threw a party for me at their suburban home [in 1957]. They invited a few European friends and I invited both European and non-white friends. We were unconsciously violating the so-called traditional way of life in South Africa. We ate, drank, and danced furiously and at any time during that night police might have come in and arrested us, the non-whites for "trespassing" or for not having night special passes or for drinking so much as a tumbler of beer . . . A week later we had a party in our Orlando [Soweto] house . . . this time it was for Sylvester, Jenny and other friends to violate the traditional way of life in South Africa.[104]

Years later, Paul Stopforth recalled the "beat" (i.e., "beatnik") parties held during the 1960s and 1970s in Braamfontein, near the University of the Witwatersrand

campus. He specifically remembered Ezrom Legae and Ben Arnold as regulars on that party scene. Black artists hung out with white students from the university, and they sometimes slept over when it was unsafe to travel to the "location" late at night because of the danger of encountering the police or *tsotsis*.[105] Students and artists held these parties in the decrepit former mansions of the "Rand lords," the wealthy robber barons of turn-of-the-century Johannesburg. One favorite spot was "the Pad," a huge house that contained a ballroom, where the young Barney Simon would also stage plays. The Pad was a precursor to the Market Theatre (run by Simon) and to Gallant House (run by Robert Weinek and Wayne Barker). At the time, and at these get-togethers, claims Stopforth, "We were radical in a social sense, if not a political one."[106] This kind of flaunting of the color bar was a kind of bohemia for white students, but it was more like living dangerously for black artists. Nat Nakasa famously described sleeping on his desk at the *Rand Daily Mail,* where he was a journalist during the 1960s—or staying with white friends in town if he was out late. His (legal) alternative was to live in a black township fifteen miles away, or to live in a men-only labor hostel. He also recalled the pleasure of those rare opportunities for racial mixing in the art, academic, and music scene:

> There was a general eagerness, often pretentious, to rush into each other's arms. But those who transcended the superficiality of this back-slapping brotherhood managed to establish warm, unaffected relationships.
>
> It was students like these who descended on Uncle Joe's restaurant in Fordsburg, the predominantly Indian quarter at the west end of town. They came to eat Indian curry and listen to jazz in what was the only restaurant that allowed jam sessions before mixed audiences.[107]

Even as the larger society that surrounded and included them was bifurcated along racial lines, the multiracial art scene was the place to hang out if you were hip at all during the 1960s, 1970s, and 1980s. The art scene was a way to bridge the otherwise tense social gap between the races, as a way for men and women who were legally set apart to hook up—socially, even sexually. Part of the pleasure of that revolutionary period had to do with pushing the edge of the law, just to stay human.[108] These instances of close fraternization invigorated the arts in South Africa. Cecil Skotnes even credited them with inspiring his own art practice: "I began my professional career seriously in 1951 when I was privileged to work with my peers across the social and political barriers that beset our land. The effects of that liaison were to play a major role in my creative vision of our land."[109] Louis Maqhubela had also worked at Polly Street and frequently discussed art with Bill Ainslie. He was a close colleague of David Koloane and Durant Sihlali. Maqhubela similarly recalled how the art world was not the same as the rest of the country:

"[R]ace conflict is one issue that was the least prominent amongst artists I used to mix with . . . even way back in the sixties, artists were the only community that could be on first name terms across the color line."[110]

Steven Sack has further characterized these interracial liaisons in the South African art scene of the 1960s and 1970s as forward looking: "All of these artists, those who sought to entertain and those who sought to declaim, lived and worked outside of the laws that enforced petty and grand apartheid. Under these trying conditions, black artists developed relationships with white artists such as Ezrom Legae, Sydney Kumalo, Cecil Skotnes, and Bill Ainslie, and began to explore the boundaries of the common South African experience."[111] Each of these testimonials give prominence to something rarely highlighted by historians of South African art: that there were debates and discussions on more or less equal terms between black and white, and that these were still possible in the art world even after the draconian days of apartheid began in the 1950s. "Cultural types became the bearers," claimed Paul Stopforth, "of the tradition of free thought and cultural mixing that had been cut off at the throat—so that these things could be continued, and carried through despite the political situation."[112]

Finally, as I have shown throughout this chapter, the styles and forms of South African art (whether "settler modernist" or "black modernist") were often explorations of the grey areas of cultural hybridity. As if to underscore this point, Ezekiel Mphahlele, in a forceful denunciation of Senghor's negritude at the University of Dakar in 1963, even went so far as to argue that such formal experimentation was a form of cultural exploration essential to the vitality of all African peoples in the modern era: "This synthesis of Europe and Africa does not necessarily reject the Negro-ness of the African," he declared, adding, "If African culture is worth anything at all, it should not require myths to prop it up."[113] This imaginative synthesis, he argued in an earlier essay, had political implications too: "[T]he artist never waits for that political kingdom to come: he goes on creating. Our music, dancing, writing, and other arts reveal the cultural cross-impacts that have so much influenced our lives over the last 300 years . . . It is exciting, if often excruciating, to be the meeting point of different cultural streams."[114]

As a space for communication, art and the social world around it did not always nor completely bridge the gaps of cultural knowledge or political and economic power between "black" and "white" and "colored" and "Asian" in South Africa. The closeness of art alongside the painful distance Alan Paton described between his Simelane and van Rensberg continues to be a relevant parable for the South African art scene. We should be cautious, then, before stating too euphorically that grey areas inverted all of the abuses and colonized mind-sets of apartheid. It is more accurate to say that art making, and the social world of the arts—especially "black art," that is, the "multiracial art scene"—proposed

the parameters of a postapartheid world, in advance. It was within this often very exciting mixed context, despite and across stylistic, racial, and geographic boundaries, that much of the modernist art by black artists was produced, including that which has so inaccurately and so often been called simply township art. A history that sees art as central to the struggle for representation in South Africa could begin here.

2 | BECOMING ANIMAL
The Tortured Body during Apartheid

South African artists have long used the image of the human body in distress as a sign of the inhumane conditions in their society. The 1960s was the decade of entrenchment of apartheid, with the imprisonment and exile of the opposition, and the state's increasing willingness to terrorize its own citizens. In the black communities, mutilated, broken, or otherwise abused bodies became a common sight after 1976, when South Africa was torn apart by the violent actions of the police and the antiapartheid insurgency. In art of the period, the human figure was often put through animal transformations that indicated how this everyday brutality of apartheid was internalized and how it might be exorcised. Through the graphic distortion of the body and its metamorphosis into a beast, artists posed trenchant questions about the relation of corporeal experience to ideas about animality, community, and the sacred. They implicitly challenged Manichaean distinctions between the physical and the spiritual and "us" and "them" that permeated South African society. Their figural propositions sought, alternately, to make sense of the present chaos or to give form to the coming revolution.

Prelude: Black Consciousness

In South Africa, artistic depictions of human beings reverting to forms of animalism had their roots in an indigenous sacred worldview that was applied to the culture of violence spawned by apartheid. They were also heirs to a tradition among

black modernist artists who evoked the burden of living in a divided society, by imagining the human figure in abstracted or nonhuman form. For these artists, postcubist forms of abstraction were formalist experiments, but they also served an expressive purpose. Some of the earliest examples of this trend date to the 1950s and 1960s and derived from the exploration of postcubist and canonical African sculptural forms among artists associated with the Adult Non-European Recreation Centre on Polly Street, and with Egon Guenther's gallery and his Amadlozi Group. Classical African art was not widely known in South Africa in the 1950s. Cecil Skotnes, who was the director at Polly Street and showed with Amadlozi, learned about it only when Guenther showed him the work of two German artists who had been influenced by African sculpture: Rudolf Scharpf and Willie Baumeister.[1] With Guenther's support, Skotnes and Sydney Kumalo (then a student at Polly Street) each began to distill formal ideas from African sculpture through the example of European late modernists like Picasso, Brancusi, Giacometti, Moore, and Marini. Skotnes adopted expressionist-type wood engraving as his primary medium and historic or mythological subjects from Africa as his main subject matter. Kumalo was known for his figurative sculpture, first in brick clay, then in plaster and bronze, and characterized by a general abstraction of natural features. He worked in various sculptural styles, but mostly applied a classic modernist sensibility for the reduction of the body to an essential geometry, the mirroring of fluid shapes, the distortion of limbs, and the thickening of torsos. Many of these elements can be seen in his *Killed Horse* (1962), a small bronze sculpture of a dead animal lying on its back, with its legs stiffened and its belly bloated with decay. This image was a possible metaphor for the dissipation and decay of life in the townships, where discarded animals could be seen rotting on the side of the road. In *Seated Figure* (1965), a muscular animal of indeterminate species wears a human though masklike visage (Figure 14). The creature's body faces away, but it is depicted swinging around aggressively to stare at the viewer. Its thick body is a storehouse of unreleased energy. South African art historian Elizabeth Rankin calls such works "animist," in keeping with the artist's "African spiritual heritage." She also notes that "most of Kumalo's studies of animals are images of predatory power, often invested with human features."[2]

The commercial success they achieved, and Kumalo's and Skotnes's mentoring of later students at Polly Street, inspired a number of younger black artists associated with the center to explore similar dimensions of Africanism through modernism in their own work.[3] Ezrom Legae had attended classes at Polly Street from 1962 and eventually taught at the center. He also exhibited at the Egon Guenther Gallery and became a member of the Amadlozi Group in 1969. His art from the 1960s and 1970s can be divided into two main styles: naturalistic pen and pencil drawings of clustered symbolic forms, and totemic bronze sculptures composed of

Figure 14. Sydney Kumalo, *Seated Figure*, 1965. Charcoal, 77 x 57 cm. Collection of Bruce Campbell-Smith. Courtesy of the estate of the late Sydney Kumalo and the Goodman Gallery.

elemental stacked shapes. The latter appear to have been modeled after the heroic sculptural forms in the art of Brancusi, as well as after the complex geometry of much traditional African art.[4] An example of this type is *Head with Vertebrae* (1966), with its elongated planar face and column of lozenge shapes forming an exposed spine behind (Figure 15). This early work by Legae resembles the shoots of young vegetables when they first emerge from the earth. The opened spine also brings the feel of the butcher shop to the work. Legae's imagery could be even more graphic in its disturbing suggestion of human–animal union, for instance, his charcoal drawings from the 1970s that imagined acts of violent copulation with goats and horses (Figure 16). As we will see, these themes of bodily abuse and re-generation in a disturbed society—as worked through the bestial metaphor—were complicated further in Legae's graphic artworks after 1977.[5]

During the 1960s, Mslaba Zwelidumile Mxgasi Feni, popularly known as "Dumile," extended the expressive distortion of the human form to its imaginative limit.[6] Dumile was orphaned at age seventeen and was largely self-taught, but he also had close working relationships with a number of Polly Street artists, including Kumalo and Legae. When he and Ephraim Ngatane were both recovering from tuberculosis at Baragwanath Sanatorium in 1963, the two made murals together at the hospital. He was especially close with Bill Ainslie, founder of the Johannesburg Art Foundation, sharing studio space and often living at the Ainslie home. After his introduction to Ngatane and Ainslie, he was further "discovered" when he visited Gallery 101 in Johannesburg and met Mme. Haenggi, the proprietor of the gallery and a major patron of black artists. Although he had not exhibited before 1965, in three short years he became South Africa's best-known art star. In 1968, harassed by the police and faced with an official order to leave Johannesburg and "return" to a "native homeland" in the Cape, Dumile went into exile.[7]

In his ink and charcoal drawings, Dumile, like Legae, was a keen draftsman with a sculptor's sensibility for the stark isolation of figures within an empty ground. His drawings displayed a level of anguish and acute social commentary rare among other black artists in the 1960s. He was called "the Goya of the townships" by the art press for his tendency to caricature and to brood upon human folly, and his hallucinogenic visual parables were also compared to those of Hieronymus Bosch.[8] Dumile's graphic work was an art of psychological torment that sometimes bordered on the adolescent. Often his human subjects had "animal proxies" that were stretched and torn beyond normal recognition.[9] This may be seen, for instance, in *Man with a Lamb* (1965), a large charcoal drawing of a sheep being carried off for slaughter (Figure 17). The bodies of the animal and its abductor are so intertwined in this drawing that it is difficult to tell the one from the other. The man seems the more bestial and the animal the more pitiably human in this image. The man is covered by shadows, his face has turned into a

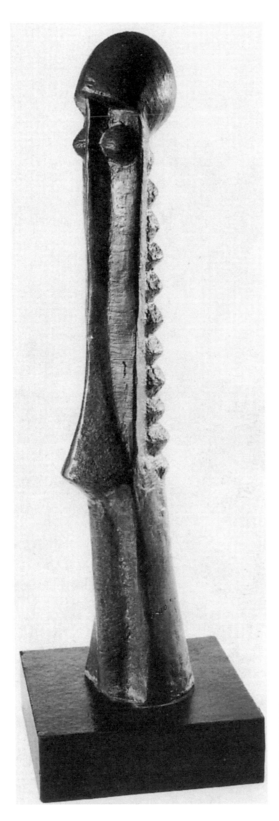

Figure 15. Ezrom Legae, *Head with Vertebrae,* 1966. Bronze, 44.3 x 8.9 x 8.6 cm. Courtesy of the University of the Witwatersrand Art Galleries.

Figure 16 *(above)*. Ezrom Legae, *Copulation,* 1970. Charcoal, 53 x 42 cm. Courtesy of Gavin Watkins.

Figure 17 *(right)*. Dumile, *Man with Lamb,* 1965. Charcoal and wash, 72 x 52 cm. Courtesy of the Dumile Feni estate.

muzzle, and he appears to be running with his (possibly stolen) prize. The lamb writhes in an effort to free itself, its eye pleading with the viewer. This could be a metaphor for a rape, for stolen youth, or for the codependency of those who were "Baases" and those who served them under apartheid. In an insightful reading of this drawing, Ivor Powell noted that "it is as though the two separate entities have become one in the brutality of their encounter, and this effect is also played out on the psychological level."[10] Dumile's image of human–animal metamorphosis evoked a truth that could only be seen in the mind: the merging, or trading places, of victims and their abusers. And, Dumile's bestial figures demonstrated an understanding of a fundamental condition of colonized people, that is, their own status as "animals," as instrumentalized beasts of burden and as fungible *objects* for labor (and for abuse) in the economy of the colonial "masters." Like Legae and Kumalo, Dumile sought to make sense of this debased condition and to contest it through art.

During the 1950s and 1960s, while the rest of Africa was gaining independence from European colonialism and the civil rights movement was gaining ground in the United States, South Africa was subject to the further entrenchment of apartheid laws. During the first decade of National Party rule, successive legislative acts classified the population according to race, forbade interracial sexual relations, mandated separate facilities for citizens according to color (including music halls and exhibition spaces), created a separate and inferior "Bantu Education" system for black students, forced all nonwhite adults to carry a *dompas* registration book that itemized their employment history and their movements, and made opposition politics punishable as "Communist" treason. Mixed-race Sophiatown was declared a "whites only" area, bulldozed, and its black residents moved to Soweto. In response, Father Trevor Huddleston, a leading philanthropic figure in Sophiatown and a patron of black artists, initiated the Cultural Boycott against South Africa that would later be adopted, in 1969, as United Nations Resolution 2396. A number of opposition groups met at the Congress of the People in Kliptown, Soweto, in 1955, and signed the Freedom Charter, a blueprint for democracy and eradication of poverty according to nonracial principles. The groundswell in public dissatisfaction with apartheid culminated on March 21, 1960, when a crowd organized by the Pan Africanist Congress (PAC) gathered in Sharpeville to protest the *dompas*. The police shot into the crowd; 67 people were killed and 186 were wounded as they fled. Fearing an insurgency, the state banned the African National Congress and the Pan Africanist Congress, and opposition leaders escaped into exile, were arrested, or were forced underground. The following year, South Africa unilaterally left the British Commonwealth and declared itself an independent republic. With all avenues for legitimate protest cut off, the African National Congress adopted the tactic of sabotage and armed struggle, forming Umkhonto we Sizwe (Spear of the Nation) in 1961. By 1963

Nelson Mandela, Walter Sisulu, and other African National Congress leaders had been captured and sentenced to life in prison.

All of these events were in the immediate background, and popular resistance had been beaten down significantly, when Dumile entered the South African art scene in 1965. At the time, most other black artists were repeating well-worn themes of self-pity and aestheticization of poverty for the consumption of a predominantly white middle-class audience. It was the height of the period of popularity for the euphemistically termed "township art." Dumile's bizarre figures confronted the effects of authoritarian abuses of power in a novel way, and his outspoken critique of racialism made him stand out from his contemporaries. Regarding the use of animal and especially cattle imagery in Dumile's art, Ivor Powell has identified these motifs as "essentially redemptive." He suggests that Dumile's animals are nostalgic signs of a precolonial African life and that they also evoke an animistic consciousness of "a natural world populated by animal familiars."[11] In such a worldview, the disruption of relations between human beings and animals results in a life out of balance, and in an identity placed in question.

Dumile's most ambitious work from this period was *African Guernica* (1967), an oversized drawing in charcoal on newsprint that depicted a garden of earthly delights gone wrong.[12] The scene is a menagerie of humans and animals engaging in weird acts. A priest points an accusatory finger. His head is situated below the anus of a cow. The cow suckles an infant while also crushing its genitals with a hoof. Two naked figures stand and sit on cattle. One man has three legs. Another man jumps in fear into a woman's arms, and cats and ducks peck away at the ground. Perhaps it is the preacher's apocalyptic sermon that has described the world in this way? The title gives us some clue as to the meaning of the piece. It refers to Pablo Picasso's painting *Guernica* (1937), the artist's famous statement against the aerial bombing of civilians during the Spanish civil war. Dumile's drawing style is completely different from Picasso's, but the depiction of animals running amok and humans scattering in fear, as well as the newsprint base on which the drawing was made, are similar to the original *Guernica*. This work is otherwise difficult to characterize, aside from noting its generally hallucinogenic aspect. Any definitive interpretation is potentially undermined by the fact that even the title may have been suggested by Dumile's dealer, Mme. Haenggi, and not given originally by the artist himself.[13] It can at least be said that the animals have gone on a rampage in this image, and Dumile has left us a nightmare portrait of a world whose order has been turned upside down. I would venture further that the scene in *African Guernica* is reminiscent of the Beatles' song "A Day in the Life" from the same year (1967), an early example of experimental pop music and an anthem of the psychedelic era. In the song, the events in the morning newspaper open out into a cacophonous evocation of sex and violence and

social chaos, while sonic deconstruction builds to a crescendo in the background. A similar concept of the newspaper that opens to reveal a hidden, sinister, and chaotic interior beyond the surface description of the events of the day seems to be displayed in Dumile's charcoal drawing. There is also an inherently experimental approach to visual media in the work, for instance, the artist's use of the *negative* space of the drawing to form ghostly figures that emerge only where the charcoal has not touched the paper.

Dumile's art, and to some extent the earlier Africanist work of Legae and Kumalo, was a crucial precursor to the Black Consciousness (BC) movement.[14] Black Consciousness was a philosophy promoted by radical intellectuals on black university campuses during the late 1960s and early 1970s and elaborated by numerous cultural organizations in South Africa.[15] Black Consciousness evolved from the activism of the South African Students' Organization (SASO), whose cofounder and charismatic spokesman was Stephen Bantu (Steve) Biko, a medical student in Durban. SASO was a separatist organization open only to "nonwhite" members whether (using apartheid definitions of racial distinction) Asian, Indian, African, or "Colored" (i.e., mixed race), and it was opposed to apartheid. Biko and other youth leaders felt that mixed-race organizations too often sidelined black voices, and that black activists needed space to examine their own situation first, before joining a nonracial unity movement.[16] According to Shannen Hill, who has studied the visual culture of the Black Consciousness movement, the central aim of the BC philosophy was "to renew a sense of self-worth within black South Africans in order to combat the racism that permeated their lives. It inspired pride in one's heritage, community, and self," with the ultimate goal of forcing political and economic change.[17]

Black Consciousness was primarily a philosophy of struggle against defeatism and psychological oppression within the black community, and it aimed to counter emotional negativity with hope, pride, and self-determination.[18] It was inspired in part by the Black Power movement in the United States and by American writers like Stokely Carmichael (who coined the term), Malcolm X, Eldridge Cleaver, and Amiri Baraka.[19] Black Consciousness leaders read and discussed the works of Francophone negritude writers, and the philosophers of Afrocentrism such as Léopold Senghor and Cheikh Anta Diop, and they debated the political writings of African nationalists and revolutionaries like Julius Nyerere, Kwame Nkrumah, and Frantz Fanon.[20] It is likely, too, that they were aware of the negritude-inspired surrealist painting of Skunder Boghossian, an Ethiopian artist then living in Paris, since he was included in an anthology of Francophone art and writing published in South Africa in the *Classic* in 1966.[21]

Black Consciousness artists valorized the kinds of emotional complexity and technical experimentation seen in the art of Dumile, as well as the Africa-centered humanist themes of Kumalo and Legae. They repudiated the themes of self-pity and prettified life in shack lands as products of colonized minds, and they

disdained those who sought to mimic the success, and to further commercial-ize through sentimentalism, the more trenchant imagery of Dumile's or Sekoto's art. Also, as the euphoria of post–World War II youth culture went global in the 1960s, beatnik and hippie aesthetics spread to South Africa. One result was that BC artists participated in the international art trends that sought to break down barriers between the arts toward a more inclusive nexus of politics, per-formance, music, visual art, and poetry.[22] The essential combination of elements characteristic of BC art is exemplified with lyric clarity in the opening pages of *Yakhal'inkomo* (1972), the first book of poems by Mongane "Wally" Serote:[23]

> Yakhal'inkomo—the cry of cattle at the slaughter house.
>
> Dumile, the sculptor, told me that once in the country he saw a cow being killed. In the kraal cattle were looking on. They were crying for their like, dying at the hands of human beings. Yakhal'inkomo. Dumile held the left side of his chest and said that is where the cry of the cattle hit him . . . Yakhal'inkomo. The cattle raged and fought, they became a terror to them-selves; the twisted poles of the kraal rattled and shook. The cattle saw blood flow into the ground.
>
> I once saw Mankonku Ngozi blowing his saxophone. Yakhal'inkomo. His face was inflated like a balloon, it was wet with sweat, his eyes huge and red. He grew tall, shrank, coiled into himself, uncoiled and the cry came out of his horn.
>
> That is the meaning of Yakhal'inkomo.[24]

Serote was a leading literary figure and political activist in the Black Con-sciousness movement. For him, as it was for Dumile, the emotional cry of black music, poetry, and art contained not only a linked set of signifiers of racial tribu-lation but also the seeds of liberation. This is a concept that has been applied to African American jazz and blues by several generations of black culture theorists, from W. E. B. Du Bois to Paul Gilroy. It is also stated quite forcefully, and bleakly, in Edward O. Bland's polemical 1959 film *The Cry of Jazz*.[25] In Bland's film, the narrator intones that jazz is the condition of the "Negro," since it evokes his sense of a "futureless future," a stagnant and constrained present torn, through slavery, from history. For Bland, black people are forced to find freedom in improvisation, within the confines of a repeated theme. For Serote, and for other artists associ-ated with Black Consciousness, the idea was, rather, to find ways to escape the confines of the status quo through technical experimentation and a rejection of imagery of black degradation.

Thamsanqa Mnyele was the cover artist for Serote's *Yakhal'inkomo*. His drawing is a curvaceous figure in profile, composed of stretched-out limbs and lobelike belly, breast, and head (Figure 18). It appears to be a pregnant woman with a child on her back, with her head cast down, and surrounded by shadow. Both the woman and the child are drawn as fetuses, in a manner reminiscent of

Figure 18. Harry (Thamsanqa) Mnyele, cover detail from Mongane Wally Serote, *Yakhal'inkomo* (Renoster, 1972). Courtesy of Rhona Segale.

Ezrom Legae's sculptures of elementary organisms. Perhaps Mnyele's image was a sign that even the mothers of the future revolution had not yet been fully formed. According to Diana Wylie, "Artists within the Black Consciousness Movement often adopted the symbolism of birth and motherhood to express the pregnant mood of the 1970s."[26] Like the book cover, several poems in Serote's collection address themes of birth and regeneration, the precarious situation of black women in South Africa, and the symbolism of Africa or home as mother (see chapter 6).

Another notable exponent of the BC aesthetic was Fikile Magadlela, a mostly self-taught artist who studied briefly with Bill Ainslie and Ezrom Legae, and exhibited with Mnyele.[27] Fikile's work, mostly graphite on paper, was steeped in arcane symbolism. Visually it was related to the kind of commercial illustration in an Afrocentric mode merged with science fiction that was internationally popular in the 1960s and 1970s. This style of art was broadly characterized by the use of highly fluid line and experimental surface techniques. These techniques were placed in the service of a kind of New Age, nature-as-God spiritual content, often shrouded with revolutionary overtones of an imminent black uprising.

Human figures were merged with the grandeur of natural forms in the landscape. One well-known image in this vein was Edward Soyka's cover illustration for the 1975 "Philadelphia soul" record album by Harold Melvin and the Blue Notes, *Wake Up Everybody*. Soyka's album art pictured a great stone giant with an "Afro" hairstyle, a flower emerging from a crack in his forehead, and his massive body rising from a valley in a landscape of forested mountains. The lyrics to the title song on this album, made famous by Teddy Pendergrass, were equally affirmative and liberationist: "The world won't get no better . . . You got to change it, you and me."[28]

American Black Power themes appealed to the "non-European" youth in South Africa during the 1970s, despite apartheid divisions between "Asian," "Black," and "Colored." Black Power art and euphoric revolutionary pop songs were understood to be operating on the same terrain among South Africa's youth, especially in the urban areas during the years immediately preceding and following the Soweto uprising of 1976. In Fikile's *Remind Me Not* (1978), as on the Soyka album cover, faces emerge from stones in a surreal landscape.[29] In the foreground, a man kneels in plaintive meditation. Behind him on one side a broken chain lies on the earth and a tulip grows on the other. Drawn two years after the Soweto uprising, this image appears to offer a silent prayer that the moment of the painful birth of freedom and the memory of captivity might pass, and that it be replaced with a more solidly formed humanity. Here the man is fully formed though still naked. In *Observer*, published in *Staffrider* in 1980, a face with closed eyes appears to take the form of Mozambique, then an independent Marxist nation on South Africa's eastern border. The face hovers in a solar nimbus, above a "feminine" landscape opening below (Figure 19). This symbolism of germination and birth seen in the early art of Legae, Mnyele, and Fikile was transformed, after 1976, into an art of contemplation and revolution.

Sacrifice

June 16, 1976. Students in Soweto marched, waving placards and singing songs, to protest the imposition of Afrikaans in black schools. The police shot tear gas into the crowd and the schoolchildren threw stones. Then, without warning, gunshots were fired at the children and the scene erupted into chaos. Over the next twenty-four hours the students, incited to fury, attacked the most hated symbols of the state in the township. They ransacked government-run beer halls and liquor stores, destroyed public buses, and burned down community centers and government offices. Hundreds of children were killed in the unrest as it spread to other black townships across South Africa. In the coming months, thousands were detained and tortured by the police. On June 16, the first day of the violence, photographer Masana Sam Nzima took a picture that appeared on the front page of the black-run newspaper the *World* (Figure 20). Two children run toward

Figure 19. Fikile Magadlela, *Observer*, from *Staffrider* (June 1980): 24.

Students clench their fists in the "Black Power" salute as they march through Soweto streets.

4 DEAD, 11 HURT AS KIDS RIOT

Whites ordered out

ALL White officials of the West Rand Administration Board and White visitors to Soweto have been ordered out of the area for the day.

This was said in a radio message to all offices this morning after police warned that they would not be able to protect Whites in the area.

The White staff of the Jabulani State School, left the premises in a hurry during examinations after a similar warning.

The teachers were warned after a White school inspector had been assaulted near Morris Isaacson High School on his way to the Jabulani school. The rear windscreen of his car was smashed.

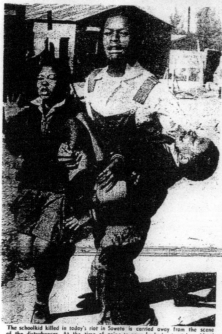

The schoolkid killed in today's riot in Soweto is carried away from the scene of the disturbances. At the time of going to press he had not yet been identified. (More pictures on Page 4).

Police clash with protest marchers

AT LEAST four people are reported dead and 14 injured in Soweto today when police clashed with some 10 000 schoolkids who marched through the streets of the townships, protesting against being taught certain subjects in schools through the medium of Afrikaans.

One of the dead is a student and an other an old man who died from a stray bullet.

A policeman was also reported to be dead and a White motorist, who was stabbed to death. His car was stoned and set alight.

Among the injured were a student who was shot in the leg and another, with a bullet wound in his back.

Police and schoolkids clashed near the Belle Higher Primary School, Orlando West.

A White motorist passing was stoned, stabbed to death and his car set alight. Another White man's car was also set alight. He escaped with head injuries.

In Phefeni a police car was stoned and set alight but the Black police driver escaped uninjured.

About 300 police fired hundreds of rounds into the air as they tried to quell the riot as kids hurled stones at the police.

At the time the police opened fire more than one thousand more pupils from Naledi on the west of Soweto were still marching to join the rioting pupils.

Smashed

Many of the 50 police cars which raced to the scene of the riot had their windscreens smashed by the rampaging students.

More than 10 000 students from a number of Soweto schools staged a march this morning through the township, protesting against the teaching of certain subjects in schools through the medium of Afrikaans.

The march follows the strike by students in ju-

To Back Page ➤

Foreman blasts Frazier — Page 3

Figure 20. Cover of the *World*, June 16, 1976. Photograph by Masana Sam Nzima.

Nzima's camera. The limp body of Hector Pieterson, age thirteen, is carried in the arms of Mbuyisa Makhubu, whose face reflects the weight and the horror of his burden. The dying boy's sister, Antoinette, runs alongside, holding her hands in a gesture of grief. Nzima shot six images of these children running. In the final one, Makhubu places Hector in the backseat of the photographer's VW Beetle. The group then drove to the local clinic, where Hector was pronounced dead on arrival. Nzima hid the film in a canister in his sock.

These are the last pictures Sam Nzima published as a journalist. Hearing that the police were looking for him, he fled Johannesburg for rural Gazankulu. There he was placed under house arrest and constant surveillance, and was banned from taking any further photographs. After 1976 the police were given increased powers for detention, and for banning any persons, organizations, and publications broadly perceived to pose a threat to the state. Editors and reporters at a number of newspapers were detained or "disappeared." Police arrested Nzima's editor at the *World*, Tselito Percy Peter Qoboza, for openly condemning the use of excessive force, and the newspaper was banned from publication. Makhubu was also harassed by the police and accused of "posing" for the pictures with the body of Hector Pieterson. He escaped the country and went into hiding in Botswana. The last his family heard of him was in 1978, when he wrote to them from Nigeria complaining of illness from malaria. Thousands of other children from the "Class of '76" also fled the country, joined up with the African National Congress in exile, and sought higher education or military training in support of the struggle. In the aftermath of Soweto, the repressive measures used by the state became crueler, but a new generation of mass resistance was also born.

As these events unfolded, Nzima's photograph of the death of Hector Pieterson was broadcast around the world. This iconic image of an innocent child savagely killed helped shock the global public into an awareness of the bloody repression that was being committed in the name of racial segregation. The image also struck a chord because of its resemblance to a pietà, the representation of Christ's mother mourning over his dead body. Within South Africa, too, Nzima's photograph became an icon of the first martyr for the newly awakened struggle to end apartheid, and it became a memory image through which the events of June 16 could be recalled.[30] Nzima's picture of brutality at the hands of the state was further symbolic of a bloodletting, a ritual sacrifice that would unite the black community.

On August 18, 1977, Steve Biko, the Black Consciousness leader who had inspired the "Class of '76," was arrested in the Eastern Cape. He was taken to Port Elizabeth, brutally beaten in police custody, and left naked and handcuffed in a cell. During interrogation Biko received a severe blow to the head, causing brain damage and eventual loss of consciousness. He was then driven twelve hours to Pretoria Central Prison, still naked and chained, in the back of a police

vehicle. He died on the floor of a cell in Pretoria. His death was first pronounced the result of a hunger strike, and later as the result of injuries sustained when he "attacked" his interrogators. Autopsy reports showed that Biko died from traumatic brain injury.

Ezrom Kgobokanyo Sebata Legae was so distressed by the Biko affair that in 1977 he began a series of pencil and ink drawings that dissected and made zoomorphic the tragedy of torture, murder, and confinement to which Biko and thousands of other South Africans were being subjected. His drawings were not heroic images of the struggle. Rather they encoded the pathetic tragedy that befell hundreds of black schoolchildren, in the figure of fragile domestic fowl, and were titled the *Chicken* series. One image was a roughed-up, impaled chicken, hanging off-center amid swirling clouds made of heavily overscratched pencil marks.[31] Legae set up a gothic mood in this drawing, one that invoked the passion of Christian martyrdom.[32] But the image was also absurd. Why would anyone crucify a chicken?

To fully understand Legae's image, it is important to consider the meaning of the killing of domesticated animals in the context of an African traditionalist sacred worldview.[33] This is a worldview broadly shared across ethnic groups in the rural areas of South Africa, as well as by those, like Legae, who grew up in cosmopolitan urban centers like Johannesburg. Through the act of sacrifice, the lifeblood of an animal is spilled into the earth, where it nourishes the ancestors dwelling in the soil. The carcass is shared out among participants in the sacrificial event, who then also share in the released potency of the animal. Animal sacrifice binds and energizes a living community by strengthening the bond between the community of the living and the community of the deceased. Cattle are the most important sacrificial animals among the traditionally pastoral indigenous people of South Africa. They occupy a pivotal location in the indigenous political economies as the most valuable material marker of social relations, and as the carrier of symbolic relations linking the bodies of men and women to the agricultural cycle, the world of animals, and the land. A chicken is perhaps the most common, lowly form of animal sacrifice that may be offered on sacred occasions, but the potency released through its ritual killing is not entirely negligible. In the cities, the symbolic economy of cattle is less important and the traditionalist worldviews of several African, European, and Asian groups tend to come under collective compression, simplification, and recombination. In the cities, goats and chickens are more likely to be the common form of sacrificial animal. The killed chicken in Legae's drawing was a reference to this practice and this cosmology, as well as a coded representation of the murder of Steve Biko. By extension, it also referred to the gunned-down bodies of the children of June 16, whose march into the streets of Soweto had been inspired by Biko's call for black self-confidence and resistance against racial oppression.

Becoming

It was foolish to sacrifice the lives of children when apartheid was in crisis. Ultimately the state's heavy-handed response to the demands of its weakest members was an act of cowardice. Recoding them as sacrificial animals, Legae recast the children of Soweto both as innocent victims and as an inextinguishable threat. In 1984 he stated: "You see, I used the chicken as a symbol of the black people of this country, because the chicken is a domestic bird. Now, one can maim a chicken by pulling out its feathers; one can crucify him, and even kill him. But beware . . . there will always be another chicken."[34] This point of view was elaborated by the artist in an interview with Mary Nooter-Roberts: "Chickens and goats are the ultimate sacrificial animals of Africa, and yet they represent resistance and eternal life, because no matter how many are tortured, killed, or sacrificed, there will always be others."[35] As seen from Legae's perspective on traditionalist practice, it can be inferred that the spilled blood of countless small sacrifices—of children or of birds—only empowered more popular resistance. The state had intended to stamp out all dissent by using excessive force. Instead, its actions further emboldened the antiapartheid movement.

In another image from the *Chicken* series, a figure's fallen, possibly buried, body is complemented in the lower register by an image of an awkward-looking chicken emerging from its egg. In this drawing, Legae's metaphor of the human sacrifice as bird, and of individual death and popular rebirth, is stated outright. Here, too, we may begin to see the deeper intent of Legae's strung-up birds. The reincarnation theme, drawn from both Christian and indigenous iconographic sources, called attention both to the moral weakness of the oppressive state and to the resilience of the children's protest movement. Resurrection was transfigured as insurrection. This was achieved by depicting an ornithic transformation of the human body as a *memento mori*. Legae's chickens are multiple and pedestrian, and their heroism lies partly in their commonness.

There is a further degree of animalism at work in Legae's art that is evident in his *Jail* series (1981). Its theme is the political prisoner, and again, the point of departure was the death in detention of Steve Biko. The murdered activist's face even appears in some of the images. In one drawing from the *Jail* series, a naked, muscular figure faces a barred prison window.[36] Its spine is exposed, its head is a mere skull, and its flesh is bruised. The left side of the figure is a large bird's wing that is clipped and folded over the shoulder. The sharp, hook-ended beak of a raptor, a bird of prey, projects from the side of the head. Pictures like this were coded indictments of the tortures inflicted upon real human beings, which Legae felt were too terrible to illustrate literally.[37] But their animal aspect did not merely stand in as a symbolic or metaphoric image of the broken and confined human body. It also illustrated the invisible animal potential of human beings. Just as in a traditional sacred setting the potency of animals may be shared with people though commu-

nal sacrifice, so may the spiritual and even physical characteristics of animals be harnessed by persons. This is especially so for those who are spiritually powerful, such as traditional leaders and healers. For instance, the Swazi royal praise name *Ngwenyama* (Black Lion) is not just a symbolic compliment. It describes the actual prowess of the king. (The protesting children of '76, too, were popularly known as the "young lions.") Other examples may be found in the oldest art traditions in South Africa. Rock paintings dating back several thousand years commonly depicted men with the body parts of elands and other animals. David Lewis-Williams has linked this imagery to shamanistic trance states and the animal characteristics and faculties taken on by traditional San healers while in altered states of consciousness.[38] For Legae, too, the "victims" he portrayed in their pathetic state were no longer merely human. Their bodies were transforming and taking on the physical and psychic potential of animals. To borrow a term from Gilles Deleuze and Félix Guattari, they were "becoming-animal" in a psychic and physical sense, rather than being merely symbolized by animals in the iconographic sense.[39]

"The becoming-animal of the human being is real, even if the animal the human being becomes is not," wrote Deleuze and Guattari, since "becoming" is a process that is neither wholly mimetic nor fixed nor purely imaginative.[40] Becomings-animal are hybrids and are thus sterile. They must begin again at every iteration, and they proliferate through contagion (as do violence and revolution).[41] Once a human becoming-animal can no longer be distinguished "from those other becomings that run through us" (when one loses oneself in the other), the individual is several, a pack or swarm, a multiplicity. The enemy, or the other, dissolves along with the idea of a distinct self and is metamorphosed into an aggressive monstrosity or an infectious community. Deleuze and Guattari were seriously joking when they claimed, "It is in war, famine, and epidemic that werewolves and vampires proliferate."[42]

Likewise, in Legae's drawing the confined human figure is taking on the attributes of an aggressive bird of prey—a kind of hybrid monster of the sort produced in times of civil war and barbarism. It is becoming a hawk or vulture, waiting restlessly for a break in captivity. Given the opportunity, this man-becoming-bird may haul off its victim, its tormentor. Or, as Legae explained, "If you remember in all these drawings with the symbolism of the domestic fowl, the spirit of Biko hovered and emerged even in the shadows, sometimes behind bars and sometimes free. And then watch out because the chicken suddenly became a vulture and the aggressor."[43]

Bestial

The decade after the rebirth of popular insurrection in 1976 witnessed a subtle shift from the rhetoric of "Black Power" to an emphasis on the more racially neutral terminology of "People's Power." Black Consciousness had helped give

birth to the organized revolt of the late 1970s, but the spirit of nonracialism resurfaced in the rhetoric and tactics of the struggle after Soweto. As the black unions within South Africa and the African National Congress leadership in exile mostly took over the organization of resistance, white intellectuals and activists also contributed to the struggle within the nonracial principles of the Freedom Charter.[44] The ongoing detention, torture, and assassination of children, journalists, and antiapartheid activists prompted a number of white artists to create powerful works of protest. The atrocities of the mid-1970s moved a white artist, Paul Stopforth (who had known Steve Biko in Natal during the early 1970s), to produce an installation titled *Torture and Deaths in Detention* (Figure 21).[45] This work was exhibited in the gallery at the Market Theatre in 1977, just as the horrific details of Biko's murder began to appear in the press.[46]

The Market Theatre was a space for experimental and activist theater founded in 1976 in Newtown. It was situated in a building that was once the site of the Johannesburg Indian Fruit Market. The Market Theatre was one of the few places during the 1970s and 1980s where artists, actors, directors, and audiences from all communities could mix and debate freely and openly. Stopforth, Michael Goldberg, and Wolf Weinek opened the art gallery at the market in 1977 to provide a venue for the kinds of contemporary art that would not likely be viable in commercial galleries. The Market Gallery, operating on nonracial principles, exhibited "leading-edge" art that was in touch with progressive politics and art trends abroad, and it featured work that contained acute social commentary on events in South Africa.

Stopforth's *Torture and Deaths in Detention* followed the style of American sculptor George Segal, whose life-sized figures of common people in white plaster were engaged in everyday activities. Six male figures were arranged around the market building, each in a different position of distress, each naked. Their postures were based on reports of treatment of detainees that Stopforth had found in the South African press. The implication was that Segal's everyday-type people were being tortured, in secret, by the South African state. One figure was placed on top of the market building, which is several stories high, as if it were being thrown down—a reference to the "accidental" deaths of detainees by falling from windows that had occurred only blocks away at the notorious John Vorster Square police station. Another was mounted as if perpetually falling down the stairs at the gallery. Yet another was seated hooded on a chair, in reference to the interrogation technique of placing a wet bag over the head to suffocate a detainee. One was tied to a bar, another lay prostrate on the floor, and a third stood spread-eagle against a wall. Police security actions were rarely reported in the press. So these brutal acts, though common, were rarely seen—unless you were there in the jail cell, you had scanned the newspapers for clues (as Stopforth had), or you visited the Market Gallery. After 1976 art became one crucial way to spread information about the

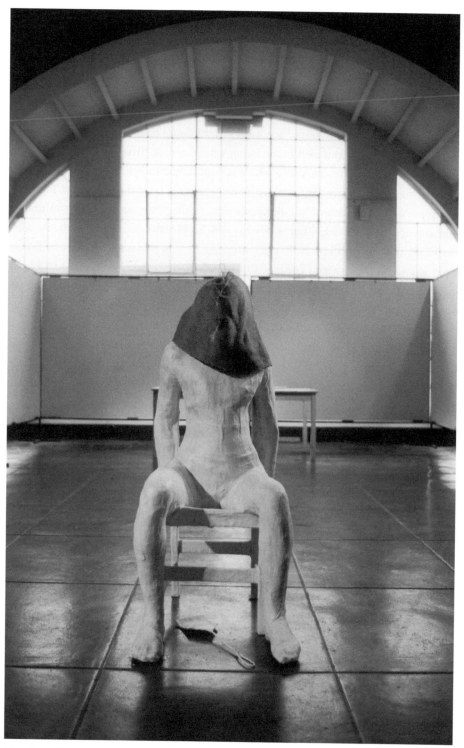

Figure 21. Paul Stopforth, detail from *Figures (Torture and Deaths in Detention)*, 1977. Life-size plaster of paris and wax figure. Photograph by Ivor Markman. Courtesy of Paul Stopforth.

punitive side of apartheid. *Torture and Deaths in Detention* hinted, further, that anyone could be vulnerable to bodily violation by the state. The figures carried no visible signs of race, since their only color was the white of the plaster from which they had been cast.

In an untitled work made in 1980, Stopforth compiled an inventory of wounds based on photographs of Biko's body from the coroner's inquest.[47] This work consisted of a series of drawings made with graphite and floor wax. In one image, a swollen arm was laid out as if in a butcher's display case. Bruised legs and feet are isolated in another. The group as a whole is impersonal and clinical. The body parts displayed are exactingly rendered as if they were zoological specimens. Through this rendering they become small monuments to the "banality of evil" within the bureaucracy of apartheid.[48] The following year Stopforth continued this theme with his *Elegy* (for Steve Biko) (1981) (Figure 22). In this mixed-media work, Biko's body is laid out on a metal coroner's tray. It floats in a field of red as if its blood has drained out and has stained the surrounding rectangle. The work's angular geometry is reminiscent of a Russian constructivist painting. It also clearly references the theme of the solitary dead Christ that runs through the history of art. Christ's humanity is indexed in the history of painting through the evidence of suffering left in the puncture marks and bruises on His body. These scars are also evidence of the cruelty (and animal inhumanity) of Christ's tormentors. Stopforth's *Elegy* is

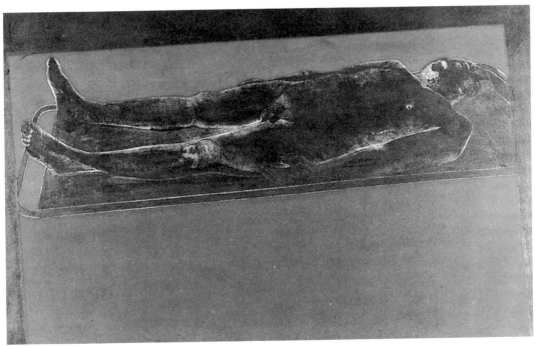

Figure 22. Paul Stopforth, *Elegy,* 1981. Mixed media on paper on wood panel, 152.4 x 243.8 cm. Courtesy of Paul Stopforth.

further reminiscent of an iconic mass media image from the history of Communist revolution in the Americas: the well-known photographs of Ernesto "Che" Guevara shot dead in Bolivia in 1967, with an officer pointing to the bullet holes in his chest. Finally, it is linked in both subject matter and execution to the early 1980s red-field paintings by Leon Golub, such as his *Mercenaries* and *Interrogation* series.[49]

Is this work an "elegy"? I would argue, following Andries Oliphant, that Stopforth created a monument against brutality and injustice more than a lamentation for Biko's heroic deeds or his unjust death—and further, that the monument itself was clinical, even brutal.[50] Biko's corpse is depersonalized in the work. His injured body is set out like raw meat on a butcher's table. The work is perhaps more antimonument than monument, since the body of the hero lies immobile and mute, and powerless to resist the viewer's gaze. Stopforth's image of Biko's body has all of the life drained from it, leaving only, in death, the animal side of the man. A martyr, perhaps, but the human side of the victim is absent. In its place is the instrumental display of a beaten corpse, an image that was clearly made to arouse indignation. *Elegy* is a powerful statement about the kinds of subterranean barbarism that were committed in the name of apartheid, about the heroism of those who dared to resist, and about the vulnerability of all South Africans to statutory repression and physical violation.

Us and Them

In a discussion of their film *Frantz Fanon: Black Skin White Mask* (1996), Isaac Julien and Mark Nash point out that for Fanon, "in the instance of torture . . . he or she who is being tortured scores a moral and ethical victory through their bodies' resistance and submission . . . both demonstrating the limits of that power and the possibility of its overcoming."[51] They cite the anticolonial author on this point: "You must therefore weigh as heavily as you can upon the body of your torturer in order that his soul, lost in some byway, may finally find once more its universal dimension . . . And then there is that overwhelming silence—but of course the body cries out—that silence that overwhelms the torturer."[52] The radical suggestion here is that the oppressors and the oppressed form an interdependent dyadic system wherein the anticolonial struggle is a violent juxtaposition of bodies and the moral integrity of both is called into question.[53] During 1985 a state of emergency was declared in South Africa in response to renewed outbreaks of violent resistance, and was renewed yearly until 1990. The police were again given wide-ranging powers for the forceful suppression of popular protest, including the detention and interrogation of suspects without trial. Over thirty thousand people were detained between 1986 and 1987. During this period, Jane Alexander produced a sculptural group, *The Butcher Boys* (1985–86), that gave plastic form to Fanon's (and Julien's) relational theory of torture (Figure 23).

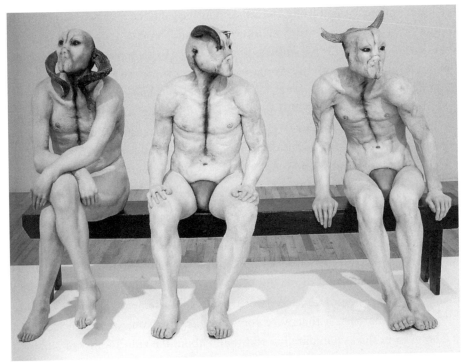

Figure 23. Jane Alexander, *The Butcher Boys,* 1985–86. Plaster, bone, horn, oil paint, wooden bench. 128.5 x 213.5 x 88.5 cm. Photograph by Eileen Costa. Courtesy of Iziko Museums of Cape Town and Jane Alexander.

Jane Alexander had studied under Paul Stopforth at the University of the Witwatersrand, and received her BA in fine art in 1982. For her degree she created a body of grotesque sculptural pieces made of bones, plaster, and wax that were displayed hanging from hooks in a wooden frame.[54] She continued her studies toward a master of arts, with a dissertation titled "Aspects of Violence and Disquietude in Twentieth-Century Three-Dimensional Human Figuration," that included a discussion of social commentary in the visceral sculpture of Mark Prent and Edward Kienholz.[55] *The Butcher Boys* installation was part of these MA studies and was exhibited at the Market Gallery in 1986. The work was clearly influenced by the artist's research on Prent and Kienholz, and it bears some resemblance to the work of George Segal, especially his *Three People on Four Benches* (1979), and to Stopforth's *Torture and Deaths in Detention.* But Alexander's sculpture is weirder than these precedents. She constructed her quasi-human figures in a manner reminiscent of Legae's "Biko" series, except in three dimensions and using actual animal bones.

The Butcher Boys are three half-human creatures sitting in a row on a simple bench. It looks as if they are waiting for something. It also looks as if they are sick. Their chests are slit from the throat to the navel. Has something been

inserted? Have their hearts and other organs been removed? Their spinal cords seem to have been subjected to some cruel surgery. Broken horns protrude from their skulls. Their mouths are fused, sealing off the human faculty of speech; their ears have been torn from the sides of their heads; and their black eyes stare blankly. Their sex is fused; they are sterile like mules. Only their posture gives a clue about the different "personalities" of the "boys." One leans back anxiously, another leans in aggressively, and the third sits cross-legged, looking bored by the whole business. This last one is the most frightful, since it personifies the kind of complacency that condones the most inhumane acts.

The Butcher Boys are the three graces of apartheid. Alexander's zoomorphic transformation of the human body was meant to evoke the psychological inscription of daily cruelties and hypocrisies inflicted, and self-inflicted, upon the people of South Africa. Even more strangely—and here the work is closer to Dumile than Legae—The Butcher Boys illustrated the sinister, inhuman, and amoral nature of apartheid society as a whole. The sculptural group was Alexander's appeal to sanity in a society gone sick under forty years of a hyper-rational authoritarian regime. Fanon's dyadic schema for the psychology of colonialism is apposite here, since The Butcher Boys personify the abominable hybrid issue from a bestial union of the torturers and the tortured, the oppressors and the oppressed. These opposites are merged into a single body, and as such represent the unexpected outcome of the apartheid experiment in social engineering. The Butcher Boys are the "body of the state" personified; they depict the entire society as a monstrosity.

If you visit The Butcher Boys where they now live, in the main room of the South African National Gallery in Cape Town, they seem to come to life with atavistic potency. In my experience, they are repulsive to look at but you cannot keep your eyes off them. They instill a kind of animalistic reversion in the viewer that catches speech in the throat and transfixes you to the spot with adrenaline-induced fear. To gaze upon the figures is to understand the slowed-down, glazed expression on the faces of onlookers after the scene of some gruesome crime or accident. The group is horrifically menacing, but their wounded look is also seductive. As with the hybrid creatures in H. G. Wells's anticolonial novel, The Island of Dr. Moreau (1896), these vivisectioned and sutured beast-men never end up becoming wholly human.[56] They also hint at the barbaric animal nature hidden within all civilized men and women. Using words that echoed Fanon's, Jane Alexander described her mid-1980s work as an investigation of "the degradation, anxiety, and vulnerability of the aggressor, or the capacity of the victim to transcend deprivation and damage."[57] As with Legae's drawings, the work contains an implicit accusation that unspeakable atrocities were committed. The subtler point made by both artists was that the state, and those who condoned it, were cowardly at the core. Speaking broadly about the nature of torture, Elaine

Scarry has claimed that it is "precisely because the reality of that power [that has ordered torture] is so highly contestable, the regime so unstable, that torture is being used."[58] It was the revelation that the apartheid state itself was a perverse and fragile thing—not the rational and protective entity that it publicly claimed to be—that was at the heart of Legae's and Alexander's art.[59] What they each attempted to unveil was the very real crisis of meaning and sense behind the popular pretense of "law and order" during the states of emergency.

Along similar lines, Michael Taussig has referred to the difficulty of overturning what he calls the "public secret." The public secret is "that which is generally known but cannot be articulated," because of the danger its public acknowledgment poses either to the legitimacy of the state or to personal ideas of wholeness integral to conceptions of the self.[60] Power operates, in this view, not just as access to knowledge but as an active knowing of "what not to know" in order to not get into trouble—with the state or with yourself.[61] It is so difficult today, especially from an outsider's perspective, to believe that so many South Africans were simply not aware of the cruelties enacted "for their protection." In retrospect it seems that, especially in the white community, they only "knew" what they needed to know in order to get by. Alexander's *Butcher Boys* confronted this public secret that underpinned apartheid head-on by "giving evidence" of the sort that could not readily be admitted in public (or by the white public, to itself).

If they could speak, the weird creatures called *The Butcher Boys* might ask tougher questions about the South African experience, beyond the simple formula "What did the government do wrong?" They might ask, for instance, how were the acts of terrorism and the lynching of accused informants by partisans within the struggle similar to the savagery of the apartheid state? The problem is that they cannot ask such questions. Their cries have been silenced, not by the torturer's glove, but by the artist's own plastering hand. They were made to be mute. Where Legae's animal transformation of things "too horrible" to describe opened the possibility of social regeneration, Alexander exposed the fuller disease of the system in a way that made it harder to avert the eyes from the horror on all sides. Perhaps aware of this disruptive, but also distracting element, she commented that "the public is drawn to violence. It . . . perhaps creates a sense of worth. People are fascinated by car accidents, for instance . . . I discovered that the more horrific my work, the more readily people looked at it."[62] The public's appetite for the spectacle of violence can be overpowering, and it holds the potential to co-opt the "unveiling" aspect of *The Butcher Boys*. Or is it that "The Boys" themselves tease out the feral potential in our collective human nature and encourage a becoming-animal by appealing to the basest instincts of their audience? In approaching this difficult and important work, we must remain on guard. It is too easy to be seduced by the horrific aspect of *The Butcher Boys,* and to lose our ability to witness our own predicament in its muffled cry.

Suture and Rupture

Animalism of a different sort can be seen in the art of Mmakgabo Mmapula Helen Sebidi.[63] Sebidi was born in 1943 and grew up in rural Marapyane, a Tswana-speaking area in the northern Transvaal that was incorporated into the Bophuthatswana "homeland" in 1977. There she learned mural painting and the pyroengraving of calabashes from her grandmother. At age sixteen she moved to Johannesburg to support her family and found employment as a domestic servant. Sebidi first learned about easel painting from her employer, a German expatriate who was also an amateur artist. Seeking further instruction, she attended evening drawing classes led by Ezrom Legae at Dorkay House in downtown Johannesburg, and later learned the fundamentals of working in color with oil paints from John Koenakeefe Mohl, who had been a friend and mentor to Gerard Sekoto in the 1940s. During the early 1970s, Sebidi returned to Marapyane to care for her aging grandmother and to raise a child from an accidental pregnancy. In 1977, again faced with the need to support her family, she began traveling to Johannesburg once a month to sell engraved calabashes and paintings of rural scenes at the outdoor market called Artists under the Sun.[64] Following the death of her grandmother in 1984, Sebidi moved back to Johannesburg. She was motivated by a desire to supplement her firm grounding in traditional culture with more cosmopolitan experiences in town, and to improve her art by establishing "stronger communications" with white artists in their studios. Bill Ainslie invited her to take classes at the Johannesburg Art Foundation and to participate in an annual workshop named Thupelo, where she experimented with collage and abstract painting techniques. At age forty-three, Mmakgabo Sebidi was finally able to attend art school, something she had dreamed of for twenty-five years. At the Art Foundation she was also surrounded by heated political discussions for the first time. These experiences radically changed the look of her art.

During the 1970s, despite the poverty and other hardships of life in the homelands, Sebidi's paintings had illustrated black rural life as idyllic. Her collage-based work, after 1987, though still steeped in a romantic mythology of traditional life, addressed issues of overcrowding, violence, and cultural confusion in South Africa's cities. The "allover" look of these later pieces is reminiscent of the work of so-called self-taught "outsider artists" elsewhere, except that Sebidi adopted this technique only *after* receiving advanced training at the Johannesburg Art Foundation. Her earlier work was more in line with the paintings of John Koenakeefe Mohl, her first teacher, and was characterized by a more naturalistic drawing style and the use of perspective.[65] After 1987 Sebidi's finished work literally tore up and rearranged these earlier scenes. Her pictures from the late 1980s are jumbles of bodies and body parts (some appear to be butchered or flayed) that signal the chaos of the city and the disruption of black family life under apartheid. In her view, "People in the cities do not have a better life than those in the village.

They are lost; they don't know themselves . . . In the village, people weren't greedy. They helped each other in order to live."[66]

The tears and cuts of Sebidi's collages literally tear and cut her figures apart, and evoke a life of ruptured identity and broken homes. "The people in my paintings," she said, "cannot enjoy what they have when other people are suffering."[67] She used a Picasso-like split face technique to evoke psychological distress and the loss of what she saw as distinct cultural values of the African people when they are seduced by the decadence of urban life. These are congested images. Their many fragments of color fill the frame like shards of colored glass. Bombs, knives, pot smokers, and bible readers all wrestle for position. Often there is a female figure at the center, set apart as an island of comfort (or despair) within the tumult that surrounds her.

The role of black women is central to Sebidi's art. Black women in South Africa are persons who have been multiply burdened. They are "bearers of tradition" in the popular mind-set, and bearers of the next generation of children. They have been subject to misogyny in their own homes. They have been exchanged for cattle in the traditional pastoralist wedding gift called *lobola*, they have been primary breadwinners for their families in the "homelands" and in town, and they have been abused when working as domestic servants for white employers. In all these dimensions, they have been one of the more critical elements underpinning the South African economy and one of the most underrated. These historic "roles" have also given black women particular insights into the problems facing South African society. Sebidi's work focuses on them in order to propose solutions.

It is a dog-eat-dog world in the *horror vacui* of Sebidi's canvases and pastels from the late 1980s. Strangely smiling heads of sacrificial beasts even haunt their corners and shadows. Sebidi used animal images in at least three ways. They were signs of men's traditional wealth in cattle in pastoral societies and symbols of materialism in the modern world. They were representations of the objects of sacrifice that bind communities and placate the ancestors. They were also visualizations of personal totems or spirit doubles that influence the fate of the living. Sue Williamson states it concisely: "The animals in Sebidi's work are used as symbols of certain aspects of human nature or metaphorically."[68] Cattle and sheep were often depicted being grasped by the head and nostrils, sometimes grasped by the tongue and held down for slaughter. Sebidi has commented on these scenes: "In our culture, we don't say a thing straight out—if you are having a hard life, we won't call your life bad . . . we will say, 'You are fighting with an animal, and if you catch his tongue then you will come right.'"[69] By this she means: you master the beast that troubles you, since only one who is in complete control of an animal can "catch its tongue," that is, put it to death to placate the spirits.

Sebidi's animal symbolism can be seen in her large pastel and collage titled *Where Is My Home? The Mischief of the Township* (1988) (Figure 24). The artist

Figure 24. Mmagkabo Mmapula Helen Sebidi, *Where Is My Home? The Mischief of the Township*, 1988. Pastel and paper collage, 200 x 147 cm. Courtesy of Mmagkabo Mmapula Helen Sebidi.

has claimed that this work evokes the dilemma faced by her and thousands of other people who fled the misery of the apartheid homelands, only to feel like unwelcome, fearful, outsiders in the city.[70] The image contains a writhing field of bloodied and scored limbs, a woman's leg in a high-heeled shoe, a man shoving other men down, and what appears to be a giant phallus entering the frame from the left. A man pours African beer from a pottery vessel at top left. Lambs are held for sacrifice at the top and right. At the center is a woman who is naked form the waist up. She appears threatened by the scene that swirls around her, but is also a symbol of stasis within chaos. Her face is split into four parts, Sebidi's sign for acute distress. One of the woman's hands grasps her head in an ambiguous gesture that may indicate grief, being comforted, or being held down for slaughter. The gesture is mirrored in the figure of an animal directly above it that is grasped by the back of the head. The woman's other hand appears to be a fist raised in a Black Power salute. Alternatively it is sign of sorrow, pressed against the woman's cheek.

This is a scene of rape and robbery in the black townships—of terror, dissolution, and greed. Sebidi's collage implicated the people who lived in the townships in this violence, as much as the political system that helped create it. It was an admonishment. In Sebidi's view, this is what you get when people are alienated from their roots in the soil. Through images like this one, the artist proposed her own solution to the supposed incompatibility of rural and urban, and traditional and modern life in South Africa. She suggested a marriage of the two that was grounded primarily in ancestral culture, which for her was symbolically sited in the South African countryside. With this foundation, one would then be able to "move forward in town" (as Sebidi herself did) and to reconnect the organic links that exist between the two zones but were not acknowledged under apartheid.

Since she herself grew up in a rural area steeped in traditional culture, Sebidi's persona as a modern artist was also as one who bridges the knowledge of traditional and modernist sensibilities. Her peers may have referred to rural life and art in their work, but their firsthand experience of the rural areas usually had less depth than Sebidi's. One might even venture that there was an aspect of intentional masquerade in her persona. For instance, the photograph of Sebidi included in Sue Williamson's essay on the artist, in her book *Resistance Art in South Africa,* is actually the artist dressed up in Ndebele attire, in front of an Ndebele house, posing with two children.[71] According to Annette Loubser, who was studying mural art during the late 1980s, the photograph was taken during a visit she and Sebidi made to Esther Mahlangu's house.[72] Sebidi's heritage is Tswana, not Ndebele, even though she would insist that "we are all 'Africans.'" Apparently she was so taken with Mahlangu that she asked to try on an Ndebele outfit, and the picture taken on that occasion was the one given to Williamson for her book.

The traditional and the contemporary were conceptually and geographically relinked in Sebidi's art and public persona. And the metaphysical resuturing of

the animal world to the lives of men and women was central to her complex neo-traditional vision: one must "catch the tongue" of the animal within, and sacrifice that beast for a feast in honor of the ancestors. Sebidi, using a curious rhetorical mixture of Christian, evolutionist, and African themes, believed that since animals preceded humans in history they should serve as spiritual guides to civilized men and women: "In the Garden of God animals were there first—the animals taught the people [how to survive]."[73] Sebidi claimed that her art has always shown her "the way to go" in life, and through it, perhaps, she could offer others guidance as well. Ultimately the practice of art, and the place of the animal image in art, was a means (as she would say it) "to wipe away the tears."

Opening

Each of the artists discussed in this chapter insisted in his or her own way on some kind of violently imagined conjunction, rather than division, between human beings or between human being and beast. Italian philosopher Giorgio Agamben's meditation on historical conceptions of man and animal has some relevance here, especially his claim that (following Alexandre Kojève) the idea of "man" exists historically in the tension of a negation "by mastering and, eventually, destroying his own animality."[74] This sounds close to Sebidi's idea of "catching the tongue" of an animal spirit that is making life difficult. In order to move beyond this sort of conflict, Agamben suggests "risk[ing] ourselves in this emptiness" that separates man and animal.[75] Getting in touch with animality may be a key to a fuller sort of humanness, if indeed a posthumanism. On this point, too, the Continental philosopher and the antiapartheid artist would seem to agree.

Societies like South Africa's that are at war with themselves tend to transform the human into a beast or a pack animal. The beasts of war can assume many forms. They may be sinister types, such as those made manifest in the apartheid war machine, or in the internecine violence between revolutionary groups. They may be of the insurgent revolutionary type, such as the "young lions" of the struggle. One step removed, and the entire society may be seen as a monstrosity, like Jane Alexander's *Butcher Boys*. During the late 1970s and 1980s, the escalation of violence in South Africa moved artists to confront these animal aspects of humanity. The slaughter of men that reduced them to animals was symbolically recoded as an indictment of the apartheid police state by white artists such as Stopforth and Alexander. These white artists' everyday lives were in fact removed from the worst violence of the struggle. For them, as sensitive outside observers, it was the bloody conflict between men that revealed the animal side of human beings. Artists who knew the dangers of living in the black townships firsthand were more likely to view the brutality of the events around them in terms of animal sacrifice or the ancestral protective roles of animals. For artists like Legae

and Sebidi, the image of animal sacrifice was more than an indictment of human cruelty, it was also a sign of "the way forward" and a means to the dissolution of the dichotomous terms of apartheid. They viewed barbarism as a sign of human neglect of the rightful relations within the natural world. And yet sacrifice, or martyrdom (Stopforth and Legae might agree on this point), *creates community.* Although horrific, the spectacle of pain and the release of individual life, if ritualized, may be a force for social unity. As the body of the victim is taken apart, society may itself cohere around the spectacle and move into the realm of the wolf pack—the becoming-animal that Deleuze and Guattari described. Christian and African narratives of regeneration and rebirth find a curious common ground in this perspective.

3 | CULTURE AND RESISTANCE
Activist Art and the Rhetoric of Commitment

In 1974 Thamsanqa "Thami" Mnyele, an artist committed to Black Consciousness principles, made *Remember me/i am going/Time calls me,* a crayon and Conté drawing of a man seen from the back whose form decomposes into hundreds of tiny circular marks (Plate 2). A blood-red slash passes through the figure, and the background is a field of black smudges. The piece evokes a fading memory of the many men and women who had disappeared into police custody for speaking out against apartheid. It is reminiscent, too, of the tortured images of Dumile Feni and the surreal drawings of Ezrom Legae and Fikile Magadlela. Its style shares the atmosphere of mysticism and the interest in technical experimentation common among artists in the Black Consciousness movement.

Mnyele worked closely with Fikile, and he was part of the social scene that interacted around Bill Ainslie's studio and workshop in Johannesburg. *Remember me* was a prophetic work. Within a year, Mnyele was further radicalized when he was interrogated by the police about his activities in support of Steve Biko's South African Students' Organization, and for his participation in Mihloti Black Theatre. Mihloti was a Black Consciousness–oriented troupe, founded in 1971 by Molefe Pheto and a dozen other young men. It produced music, poetry, and theater events and performed speeches by black activists at schools, churches, and political rallies.[1] Wally Serote and Thami Mnyele joined Mihloti, and their experiences with the collective later informed their collaborative work and their interest in integrating performance and visual art after they went into exile. During

1973 Mnyele attended the fine art school at Rorke's Drift in Natal, but his formal art studies were cut short. In one published account, he was forced as the primary breadwinner to return to Alexandra Township so that his family could claim legal residence in Johannesburg under apartheid law.[2] According to Diana Wylie, who has researched the artist's life, he left Rorke's Drift because he was unhappy with the instruction at the school, and because his health was poor.[3] Back in Johannesburg, he took a job as an illustrator for the South African Committee for Higher Education (SACHED), an organization that promoted adult literacy and was generally supportive of the struggle against apartheid. In September 1977, Mnyele, along with Fikile and Ben Arnold (a Polly Street alumnus), staged an exhibition titled A New Day at the YMCA in Dube, Soweto.[4] Their intention was to take their art directly to the people of the townships at a moment of political crisis, and to put to rest once and for all any remnants of the commercialized township art aesthetic. Attendance was in the thousands.

After 1976 Mnyele began to move away from the racially exclusive ideology of Black Consciousness, and in 1978 he visited exiles living in Botswana and joined the ANC. In 1979 he went into exile in Gaborone, Botswana. There he joined Serote and other exiles who debated and promoted the concept of the "cultural worker" that would have tremendous influence within South Africa during the 1980s. These exiles and artists formed the Medu Art Ensemble. Medu was originally founded in 1977 by artists who had fled the South African townships, including Molefe Pheto of Black Mihloti. Initially membership was only open to "black" artists, and the group was heavily into Black Consciousness. By 1979, when Serote and Mnyele had assumed leadership positions in the collective, it had become more aligned with the nonracialist principles of the ANC, and after 1980 white members were allowed.[5]

Mnyele headed the graphic art unit and later became chairman of the ensemble. From this period on, his art took a radical turn, away from the more emotionally expressive style of his Black Consciousness work and toward a style closer to what could broadly be described as social realism. The look of Mnyele's later "realism" was clearly influenced by Soviet socialist art as well as the revolutionary art of Mozambique and Cuba. He came to espouse the view that since the subtleties of fine art were too often lost on the masses, what was needed in a time of popular resistance was an art that spoke directly to the people in a visual language they could understand. In this, he embraced the perspective of the Guinean revolutionary Sékou Touré, who wrote: "To take part in the African revolution, it is not enough to write revolutionary songs; you must fashion the revolution with the people. And if you fashion it with the people, the songs will come by themselves and of themselves."[6] Mnyele argued for popular relevance, for rejection of thematic mystification and excessive figural distortion, and for direct political commitment in the art of his South African peers, stating: "The

task of a vital South African art practice demands of us to confront the reality of [the South African regime's] 'Total Strategy' with a response that holds artistic, social and political meaning."[7]

Mnyele's art cannot be simply categorized as "Soviet realist." For while Mnyele cultivated a poster-oriented style during the 1980s that was clearly social realist in the tradition of the Popular Front in Europe and America during the 1930s, his art also contained a subtly chaotic aspect, an expressionist's touch, and even a hint of postmodern pastiche. The influence of Black Consciousness art could still be seen in his use of montage elements to construct scenes, and the way that, as one Medu colleague described it, "landforms and earth dissolve into swirling haze of spots and smudges to form a massive dark chaotic cloud."[8] Despite this abstraction at the edges, Mnyele's images from the 1980s focused on the culture of the struggle, which, in the spirit of African revolutionary theorist Frantz Fanon, he considered the most important culture of South Africa. His approach can be seen in a foldout graphic that was included in the Medu newsletter in 1983 (Figure 25). Figures emerge and dissolve into scrambled lines that define them and abstractly delineate the background. This untitled ink and mixed-media work is a quadruple montage of images from photographic sources: protesting children cheer with fists pumping in the air (from Peter Magubane's documentation of June 16); jazz musician Kippie Moeketsi looks forlornly at his horn (from a photo published in *Staffrider* magazine); miners labor over hoses and heavy equipment; and guerrilla fighters fire machine guns somewhere "over the border." These are the protest artist's symbolic stock in trade, images meant to carry the widest populist appeal: revolutionary "fists and flags," the "outsider" musician as spokesman for the souls of the downtrodden, proletarian industrial workers, and armed anticolonial revolutionaries. A similar series of illustrations was included in Wally Serote's book of poems *The Night Keeps Winking* (1982):

Figure 25. Thamsanqa Mnyele, ink drawing published as a foldout section of *MEDU Art Ensemble Newsletter* 5, 2 (1983). Courtesy of the South African History Archive (SAHA) and Rhona Segale.

a woman clutches an infant and looks nervously out a window; a returning hero of the revolution with a Kalashnikov rifle slung over his shoulder gently takes the hand of a small boy; and schoolchildren raise their fists to the sky and shout joyously, but the look in their eyes darkens.

According to Judy Seidman, an American who worked with Medu, Mnyele was concerned in these works with that moment at which the euphoria of the people turns into anger and evolves into a focused form of protest.[9] One can also note in Mnyele's portrayal of the psychological vicissitudes of scenes and people in the "culture of resistance," an extension and development of the depiction of township events seen in the work of earlier black artists. But Mnyele's scenes lack the kinds of detachment or even sugarcoating found in much of the work by black artists from the 1950s and 1960s. His images further concretized the urgency of remembering and reimagining recurrent events in the experience of South African black communities. His drawing captured, selected, invented, and foregrounded selected images aimed at promoting the struggle. They directed what David Koloane might call the social memory function of township art to an un-mistakably revolutionary end.[10] In this chapter, I explore the ideas about art and commitment debated by Mnyele and his colleagues in the Medu Art Ensemble that thoroughly radicalized the politics of culture in South Africa during the 1980s.

The Medu Art Ensemble versus the Total Strategy

In the wake of the 1976 Soweto student uprising, and the subsequent rise to na-tional power of former minister of defense P. W. Botha as prime minister after 1979, the South African government devised what it called the "total strategy." This was a counterinsurgency plan designed to push back the rise of Black Power, using military, psychological, political, and economic means. The Botha govern-ment's strategy was meant to combat what it perceived was a Communist-backed total onslaught on a mixed terrain. This idea was based on the exaggerated fear that South Africa was a central concern of the Russians and the Americans in their cold war conflicts and proxy wars in Africa. According to South African historian Gavin Cawthra, the total strategy included aspects of both reform and repression, in line with American political scientist Samuel Huntington's theory on how to rout a popular revolution.[11] A slow and partial repeal of petty apartheid laws was enacted, black trade unions were tolerated, and a new tricameral parliament was created that offered limited national representation for "Colored" and "Indian" popula-tions, but not for black South Africans. These partial efforts at reform resulted, in 1983, in a revitalization of the popular insurgency that had begun in 1976 but had lost much of its momentum by the end of the decade. The resurgence of protest ac-tions and political violence in the early 1980s was followed by police crackdowns, increased censorship, and the declaration of a state of emergency in 1985 that was

renewed each year until the end of the decade. Also in 1983, the United Democratic Front (UDF), an alliance of progressive and grassroots organizations, was formed to counter the state's repressive tactics, to resist sham political reforms, and to demand total eradication of the apartheid system. UDF affiliates broadly supported the aims of nonracialism and democracy outlined in the Freedom Charter, and their activities were loosely coordinated with those of the African National Congress leadership in exile. As part of the lead-up to the creation of the United Democratic Front, the Medu Art Ensemble organized an art festival in 1982 to promote a culture of "commitment" toward a future democratic South Africa.

By 1982 the Medu Art Ensemble had evolved into a multiracial collective of visual artists, writers, and performers living in Gaborone, Botswana. Contributors to Medu publications and projects included Serote, Mnyele, Mike Hamlyn, Albio and Theresa Gonzales, Patrick Fitzgerald, Gordon Metz, Judy Seidman, James Matthews, Lentswe Mokgatle, Tim Williams, Bachana Mokoena, Marius Schoon, Mafika Gwala, Kenyan writer Ngũgĩ wa Thiong'o, Keorapetse and Baleka Kgositsile, Mandla Langa, Miles Pelo, Heinz Klug, Muff Anderson, James van Wyk, Mike Kahn, Jonas Gwangwa, Dennis Mpale, Tony Cedras, Steve Dyer, Hugh Masekela, and many others.[12] Most were South African exiles, but the membership included Europeans and Americans as well as some Batswana. Medu members shared a common determination to fight apartheid using the tools of culture. They established links with progressive cultural organizations and magazines within South Africa, such as the Junction Avenue Theatre Company and *Staffrider* magazine in Johannesburg, and the Community Arts Project in Cape Town.[13]

Mnyele, Serote, and their Medu Art Ensemble comrades argued for a "people's culture." For them a true culture of the people would be one that was not exclusive to the elite world of art galleries, but was seen in the streets, on T-shirts and posters, and was voiced in political songs and poems performed at political rallies. Medu was a think tank for cultural revolution. Its mission was to debate and develop ways to use art that would give voice and vision to the growing popular struggle back home. Medu produced posters and a newsletter that were smuggled across the border for later reproduction and dissemination inside South Africa by UDF-affiliated organizations. Their *MEDU Art Ensemble Newsletter* argued that South African art needed to be relevant to the antiapartheid struggle if it was to be relevant at all. This was also the message of the Culture and Resistance festival hosted by Medu.

Culture and Resistance

During July 1982, several hundred South African visual artists, writers, musicians, and actors, many of them living in exile in Europe and America, attended the Medu-organized Culture and Resistance festival in Gaborone (Figure 26). They

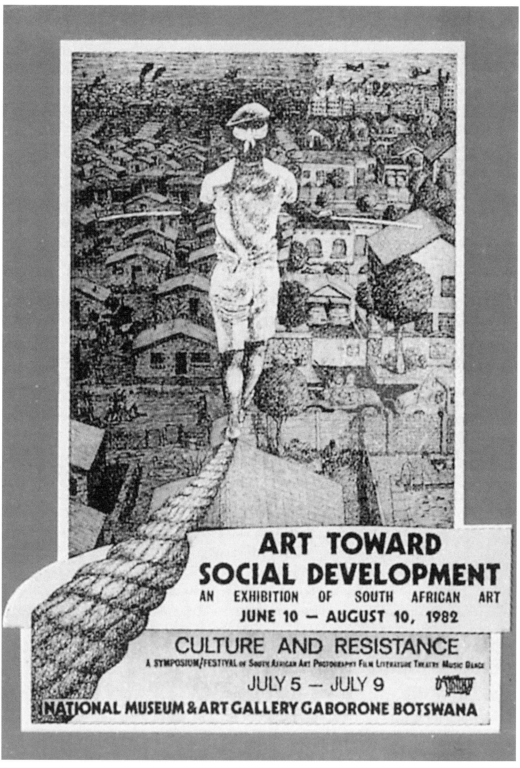

Figure 26. Figure by Thamsanqa Mnyele and landscape by Gordon Metz, poster for Culture and Resistance festival, Gaborone, Botswana, 1982. Courtesy of the South African History Archive (SAHA).

converged on Gaborone for a week of talks, art exhibitions, and performances. Many had never met before, though they may have previously known each other's work. Others were able to see old friends from across the country or from exile. For many of the festival's attendees, especially for black South Africans living under apartheid pass laws and urban areas restrictions, the opportunity to connect socially with other colleagues on this scale was a rare occasion. By most accounts it was an exhilarating week filled with intense discussion about how to steer the trajectory of culture in South Africa in a progressive direction. Each day there were papers on fine arts, film, photography, music, dance, writing, and theater. An accompanying exhibition titled Art towards Social Development was held at the Botswana National Gallery and Museum.[14]

The stated purpose of the Culture and Resistance festival was to examine and propose suggestions for the role of art in the pursuit of a future democratic South Africa. "Political struggle is an unavoidable part of life in South Africa, and it must therefore infuse our art and culture," and "art is a weapon of the struggle" were the slogans proclaimed by Medu at the conference section of the festival.[15] Speakers debated the relevance of the arts to the intensification of the struggle after 1976. In preparation for the launch of the UDF movement the following year, and twelve years before the first democratic elections would be held in South Africa, ideas about what culture could look like in a *future* South Africa were discussed at Gaborone. Strategies for resisting the status quo were also debated. The keynote speaker was the writer Keorapetse Kgositsile, and his passionately partisan speech set the politicized tone for the rest of the festival. Kgositsile underscored the importance of the gathering using socialist rhetoric, and he emphasized the central role of the African National Congress at the head of the revolution:

> A few years ago a fellow South African writer asked me to explain to him how people like [Alex] la Guma and I could be in the Movement but still manage to write poems and novels. And I replied, with a bit of acid on my tongue, that I had always wondered how a South African writer could be outside the Movement but hope to write anything of value or significance . . . I hope that in discussing "Culture and Resistance in South Africa," I will make a contribution towards clarifying a few things about what time this is in our life; what tasks are facing us; what writers and other artists worth their salt are doing in living up to their responsibilities . . . In declaring 1982 the Year of Unity in Action, the year in which to move forward to a democratic South Africa, we must act in unity and unite, in action. Comrade O. R. Tambo, President of the ANC, points out that: "The comradeship that we have formed in the trenches of freedom, transcending the barriers that the enemy sought to create, is a guarantee and a precondition of our victory. But we still need to build on this achievement. All of us—workers, peasants, students, priests, chiefs, traders, teachers, civil servants, poets, writers, men, women and youth, black and white—must take our common destiny in our own hands."[16]

Following a brief history of struggle-oriented poetry, Kgositsile concluded his talk with an art-inflected echo of Marx's definition of the social species life of humankind from *The Communist Manifesto*: "[T]here is no such creature as a revolutionary soloist. We are all involved. The artist is both participant and explorer in life. Outside of social life there is no culture, there is no art; and that is one of the major differences between man and beast."[17] With these words, Kgositsile urged collectivity as a core value in the arts, a form of practice that would bring into being new communities for a new South Africa. Visual art, though not mentioned directly by Kgositsile (or by ANC leader Oliver Tambo), would nevertheless become one of the most potent vehicles for this revolutionary idea of community, and the social world of artist groups like Medu was a harbinger of a nonracial political future in South Africa. Although the existence of such "grey areas" in art preceded the Medu Art Ensemble by many years, the festival Medu organized in 1982 should be recognized as one of the most important flash points in the history of South African art. During the early 1980s, the social life of art became an even more crucial site for the struggle against apartheid.

At the Culture and Resistance festival, the title "cultural worker" was suggested as an alternative to what the organizers considered to be the more elitist term, "artist."[18] The role of the cultural worker was elevated to a position of critical importance in the democracy movement, and at the same time artists were brought to a position of equivalence with other workers in the struggle. The enemy, according to the Medu Publications and Research Unit collective statement for 1982, was the "trap of individualism." "Clearly, the central issue here is that artists must learn to break out of the bourgeois trap of individualism, and must discipline themselves to place their talents and their perceptions at the disposal of their communities," they wrote, adding, "Any tendency towards elitism among cultural workers must be countered vigorously, not only by other cultural workers, but also by the community at large."[19] At the festival, in keeping with this general view, jazz pianist Abdullah Ibrahim (a.k.a. Dollar Brand) "correct[ed] anyone who call[ed] him a musician or pianist. He define[d] himself as 'the messenger boy' and recall[ed] a saying of his that has become famous: 'I regard myself as a worker . . . my function is no less or more important than a street sweeper's or a doctor's.'"[20] Almost everyone at Gaborone in 1982 agreed that artists were "workers." This terminological shift from the individual to the collective, and from artist to worker, had the added benefit of temporarily making the race of the maker less relevant to the act of creation—or of interpretation. No longer were there (white) "artists" and (black) "township artists." From now on, they were all "cultural workers."

General agreement over the terminology for artists did not necessarily parlay into unanimity about the proper aesthetic direction for art in a rebellious present, or in a future South Africa. The conference papers, and the debates that

ensued during the months and years to follow, contained dramatically differing views about the methods and aims for using "art as a weapon of the struggle." According to the artist Lionel Davis, participants at Gaborone amicably discussed a range of options for the role of art in the struggle, but afterward the debate became more polarized.[21]

Revolutionary Roots

Thami Mnyele was prescriptive in his pronouncements about the role of the cultural worker. In a retrospective statement commenting on the Culture and Resistance festival, he wrote:

> With developments at home today, the country is obviously in grave need of a new caliber of cultural worker, notably in the visual arts and song. The kind we have now has yielded too willingly to the dictates of negation. We must now create this new man and woman whose visuals and songs will be informed by the most pressing needs and demands of their time, place and circumstances: they ought to be articulate but simple so as to be accountable to their work and with clear political insight, a skilled hand and firm revolutionary sentiment.[22]

An "accountable" art, wrote Mnyele, was one that would rise organically from the oppressed communities in South Africa and would clearly reflect their interests. What disturbed him most was what he called the art of "negation." For Mnyele this meant an easily marketable art of self-pity—in short, "township art." He believed this sort of art was especially inadequate for the coming historical moment. His notion of a committed, community-based, and community-centered art was derived in part from his conception of a "functional traditional art" that he believed still had some resonance in South Africa:

> [T]hat principle which governs traditional art is valid today; i.e. that art must have a function: a walking song, the sculpture that serves as a chair, the majestically decorated houses of the siNdebele-speaking communities. The subject matter is drawn from the actual activities of the people in their living surroundings, the source and supreme function of art. We may go further and say that the actual act of creating the visual imagery is informed by the community and nourished by it, consciously or unconsciously, and that it is the community, which will or must act as audience.[23]

Mnyele believed that most black artists neglected to work with "the people" as both their source and audience. Township art's imagery depicted the black communities, but its audience was the white middle-class and its message was therefore confused. Mnyele's alternative model for an activist art practice was a generic invocation of traditional African art. He argued that since the colonial

period a rupture had occurred in the structure of everyday life for black South Africans. In his view, the older communal way of life had been emasculated by the labor, land, and ethnicity policies of the British and the National Party. Only a vestigial form of the old ways remained. Still, Mnyele believed that those who hoped to resist the current oppressive order could find inspiration through a return to the *spirit* of the communal social responsibilities of old, by using cultural work to emphasize the conditions and aspirations of the people of South Africa. For Mnyele this new "community art" would be characterized by the sort of mutual nourishment of the people and their art that he understood had once existed within traditional African cultures:

> [T]here are just the beginnings of a new approach to art growing at home. As the grassroots organizations gain in strength, some artists are finding a new home for themselves and their work . . . Community Arts Project, the Johannesburg Silkscreen Workshop, etc. We are beginning to see banners, posters, and graphics in the trade unions, civics, women's organizations, the UDF. These graphics are the birth of a new culture, conceived in the hopes and aspirations of the community, nourished by the people's organization.[24]

The new community Mnyele referred to was primarily the historical community of those who lived in common, under conditions of surveillance and squalor in the black South African townships. But that is not the whole picture. For the ideal community referred to by Mnyele was really that group that had been radically conscientized and had *created community* by taking to the streets in unison. Broadly speaking, this was a community that included those white South Africans and foreign nationals who had chosen to join the struggle against apartheid. This community would not be defined according to apartheid's strict ethnic geography, but rather through the practice of collective resistance and the principles of the historic Freedom Charter.

Mnyele's definition of community was both socialist and modernist. It echoed Marx and Engels's suggestion, in *The Communist Manifesto,* that the communal social order of the precapitalist past could be an inspiration for the radical revolutionary aims of the modern working class. It also rekindled the classic avant-garde strategy of remaking the aesthetic and the political in the same crucible. Against the tribalism of apartheid, Mnyele proposed a historic break from the way in which indigenous communities had been brought into being in South Africa. At the same time he retained a romantic conception of a premodern African social world as a suitable, if partial, metaphor for a future postapartheid society.[25] A forward march, and a return. In this he followed Frantz Fanon, who wrote, "The colonized man who writes for his people ought to use the past with the intention of opening the future, as an invitation to action and a basis for hope."[26] Mnyele and his Medu comrades referred to traditional African culture

in a paradoxical fashion, since it must be destroyed in order to be transformed into a model for an imminent culture of resistance. Also, following Fanon, they believed that the character of the revolutionary struggle itself, and not traditional society per se, would give definition to the culture of the new South Africa.[27] The Kenyan novelist and anticolonial activist Ngũgĩ wa Thiong'o made a related but more universal formulation in the context of literature when he wrote that "the real language of humankind [is] the language of struggle. It is the universal language underlying all speech and words of our history. Struggle. Struggle makes history. Struggle makes us. In struggle is our history, our language, and our being."[28] A new community was to be brought into being through revolutionary self-awareness, in opposition to the ideology of apartheid. Making community in this way would thus be considered an act of culture in resistance. Medu cofounder Wally Serote was perhaps more pessimistic than Mnyele (as were Ngũgĩ and Fanon) about the vitality of traditional African cultures in the present age:

> A people's culture is the expression of their awareness of their conditions
> of existence: our culture is a culture of resistance. The imperialists took our
> land and handed us the bible. In so doing, they destroyed the foundations
> of pre-colonial culture. In its place they gave us a misery of tin and mud huts,
> poll-tax, malnutrition and disease, migrant labour and the mines . . . And
> this very misery became a common bond between our people, a common
> ground from which has grown a new awareness: an awareness of the need
> to resist.[29]

The correlation between the activist community and indigenous tradition was a recurring metaphor in the progressive discourse of the South African art world of the 1980s, in a way similar to the popularity of indigenous "primitivism" among the South African avant-garde at midcentury. The correlation was mostly rhetorical, since there was really very little in common between the Southern African traditional arts meant for decoration, ritual, or the marking of changes in social status, and the protest art styles favored by Medu. That said, the very real disjuncture between community art and traditional art did not deter those African communities that held on more closely to their roots in the land, the family, and an older sacred worldview from militating against apartheid. In fact, some rural women artists working within older art-making traditions (such as the Ndebele, discussed in chapter 1) also produced an art of resistance. Their art was different in outlook and in style from the type of "cultural work" endorsed by Medu, except when defined at its broadest, as "people's culture."

One measure of the depth of the Medu Art Ensemble's engagement with contemporary forms of traditional African culture was the name of the group itself. According to Judy Seidman, the name was chosen by Serote, who was looking for an African-sounding word to evoke the spirit of the group in Botswana. Serote

chose a Sepedi/Northern Sotho word familiar to him from South Africa: *medu,* meaning "roots." The problem was that *medu* had no meaning in Setswana and was thus unintelligible to most of the local people in Botswana. Medu eventually became "MEDU" on a number of the group's publications. "MEDU" had the benefit of looking like a bureaucratic acronym, possibly for "media education unit." In that way, it fit within the roster of initials and acronyms for other organizations of the progressive movement that became nicknames, such as ANC, COSATU (Congress of South African Trade Unions), PAC, UDF, SACHED (South African Committee for Higher Education), CWC (Cultural Workers Congress), and COSAW (Congress of South African Writers). Any book on South African politics or art during the 1980s contains a page or two of these terms in the front. When it came to indigenous art, the "roots" of MEDU were more revolutionary and theoretical than they were "traditional."

Choose Your Weapon

Medu created pamphlets and posters for distribution inside South Africa.[30] The group's aim was to disseminate concrete examples of the kinds of art and collective practice it felt were appropriate for the intensification of the struggle. In addition to promoting a collectivist method for art production, Medu and the network of UDF-affiliate organizations in South Africa embraced the idea that committed visual art should be simple, direct, and unambiguously critical of the regime. Mnyele was adamant about the "correct" interpretation of the issue of aesthetics:

> Forward with the creation of a new caliber of cultural worker! This was the call made at the gathering on Art Towards Social Development and Culture and Resistance in Botswana in 1982 . . . Our people have taken to the streets in the greatest possible expression of hope and anger, of conscious understanding and unflinching commitment. This calls for what all progressive art should be—realist, incisive, and honest.[31]

At the Culture and Resistance festival, the slogan "Art is a weapon of the struggle" was not questioned. But attendees did debate the means and the look of the "weapon." Some at the festival were uncomfortable with what they felt was the doctrinaire tone of the event. For instance, P. J. Lourens left with "mixed feelings about the meetings." As he saw it, "there was a lot of revolutionary zeal; but the implications of the blatant pressure to conform, the Marxist preachings and the attempts to politicize artists and writers were not spelt out clearly and honestly."[32] Pianist Abdullah Ibrahim (Dollar Brand), speaking to a reporter, voiced the sentiments of others at the conference and was not specific about the exact kind of art that should be expected of cultural workers. In his view, some leeway for personal creative choice should be allowed among those committed to

the struggle. Ibrahim instead emphasized the importance of what he termed the "jihad," "the struggle" within:

> "The human spirit recognizes the quality that is injected through music," he said . . . [Ibrahim] suggested that this contributes to the jihad that is waged with the self. It is necessary for each individual to re-orientate himself before society as a whole can be transformed. "After all," he maintained, "it's no good shooting if you shoot in the wrong direction."[33]

In these words, Ibrahim rephrased Antonio Gramsci's concept of the contest of hegemony, in which the ruled must resist the ruling ideas of the ruling class. He also seemed to concur with Ngũgĩ wa Thiong'o, who applied Gramsci's theory to the anticolonial struggle in Africa through his own formula of "decolonizing our minds." Compare Ngũgĩ wa Thiongo's description of the "cultural bomb" that must be resisted by the colonized:

> The oppressed and the exploited of the earth maintain their defiance: liberty from theft. But the biggest weapon wielded and actually daily unleashed by imperialism against that collective defiance is the cultural bomb. The effect of the cultural bomb is to annihilate a people's belief in their names, in their languages, in their environment, in their heritage of struggle, in their unity, in their capacities and ultimately in themselves. It makes them see their past as one wasteland of nonachievement and it makes them want to distance themselves from that wasteland . . . indeed this refrain sums up the new creed of the neo-colonial bourgeoisie in many "independent" African states.[34]

Abdullah Ibrahim enfolded this idea into the Muslim tenet of personal jihad. His remarks also resonated with the fundamental Black Consciousness goal of unlearning the ingrained psychology of apartheid by resisting despair and negativity, while eliminating the racially separatist perspective. Finally, Ibrahim's comment is notable in that he favored a more abstract approach to committed art than the kinds of social realism (even given its "abstraction at the edges") promoted by the Medu group. Perhaps this was because as a jazz musician, his own medium of expression was inherently more abstract than visual art or literature.[35]

In addition to informal debates among attendees, a number of critical debates on ANC (and Medu) arts policy were aired at the festival conference. These were stated most clearly in the papers read by artist in exile Gavin Jantjes and by novelist Nadine Gordimer. Jantjes's paper was on visual art. It began by taking umbrage with European expectations about the authenticity of African art: the demand that it always be timeless, anonymous, and "tribal" in order to be truly African. He then chided his fellow contemporary African artists about what he considered their timidity when it came to exploring novel stylistic terrain. In response to his own rhetorical question, "How is it possible to be creative in the

oppressive South African situation?" Jantjes stated, "We have survived because of our parents creativity and their parent's creativity . . . Creativity is our domain. It is action towards and for a fuller humanity." He argued further that in South Africa's current time of crisis art ought not be caught up in arguments about "art for art's sake" but should instead be "in the service of man," just as traditional African art was. He concluded, in agreement with Mnyele, "If there is something to bring out of Africa's cultural traditions into the contemporary world then it is the social aspect of that praxis."[36]

Nadine Gordimer's paper on literature was titled "Relevance and Commitment: Apprentices of Freedom." In it she argued for an even wider definition of culture. For her, "relevance has to do with outside events; while commitment comes from within."[37] Black artists, according to Gordimer, find relevance by facing their own reality, that is, the reality of exploitation and the necessity of struggle. But this kind of relevance alone is not a measure of a successful art, even in time of struggle. Gordimer warned:

> There is a kit of reliable emotive phrases for black writers, a ready-made if unwritten index of subjects . . . If these dictates are followed faithfully, the result is a form of literature called agitprop—literally a contraction of "agitation" and "propaganda". Agitprop (as always, wherever it has been imposed) ends up binding the writer with the means by which it aims to free the minds of the people; it licenses a phony sub-art. It is at this point that commitment takes over, within, from the outer dictates of relevance, and the black writer has to assert the right to reject agitprop and search out his own demotic artistic vocabulary with which to breathe new life and courage into his people.[38]

Gordimer argued further that white artists needed to struggle with "white values," and black artists needed to search for the vernacular, the "demotic." This distinction brings to mind the discredited phrase "separate but equal," and so Gordimer's paper, though forward-looking, did not escape the hold of a racially bifurcated mentality. Considering their disavowals of the contemporaneity of African tradition, and their romantic misconstrual of indigenous cultures as monolithic and holistic, neither Mnyele, Jantjes, nor Serote was able to fully escape the traps of the "colonized mind" either. That said, the Culture and Resistance festival was only a beginning. The conference attendees came to Gaborone to create alternatives to the historically racialized culture they were born into. In Gordimer's view, realism by rote would not be enough to accomplish this end. She expressed the mood of others, like Ibrahim, who felt that *greater* aesthetic openness was what was needed if the goal was to move beyond authoritarianism and apartheid. She noted that artists transform the world by inclination, where others do so as a political act. Openness in the arts would therefore be crucial if the artist was to be

"the prophet of the resolution of divided cultures."[39] The Culture and Resistance festival was a platform and a model for this kind of future imagining. Despite (or because of) the differences of opinion aired at Gaborone, the Johannesburg activist, theater director, and writer Malcolm Purkey would ultimately praise the festival as a "triumph of non-racialism."[40] The festival was in this way a precursor to the mixed alliance of the United Democratic Front movement of the mid-1980s.

Beyond Gaborone

One of the participants at the Culture and Resistance festival in 1982 was Lionel Davis. He had come by bus all the way from Cape Town with a group of students and teachers from the Community Arts Project (CAP). Davis had been a political prisoner on Robben Island from 1964 to 1971. Thereafter he was a banned person and lived under house arrest until 1976. He studied art informally at CAP, and in 1981 he completed a two-year art course at Rorke's Drift. Davis returned to CAP following the Gaborone festival and in 1983 helped organize the Media Unit, an outfit that, like Medu, printed posters for UDF-related activities. He later recalled the excitement the Culture and Resistance festival had generated in South Africa:

> I think a lot of the people who went to the Botswana conference came back filled with enthusiasm to want to start cultural happenings, you know, simply because then it was felt that there was a need for disadvantaged people in the country, to empower them . . .
> I think the festival in Gaborone was the first time ever that artists across the spectrum, exiled artists, and artists in South Africa could get together and talk about the future of art in South Africa. And also to, in depth, talk about a way forward . . . it put a lot of heart and life into activists, especially cultural activists, to start working with the marginalized communities. So that when the people came back they came back with this definite feel that something was happening.[41]

For Lionel Davis and for the other artists who attended the festival, culture became a vehicle for putting life back into the political struggle. It was not simply a case of the ideology of the political struggle being injected into art and culture after Gaborone. The use of art during the UDF period was much more complex than this. For instance, as political groups were banned under successive states of emergency, cultural groups such as churches and arts organizations became conduits for laundering antiapartheid money into the country from overseas donors.[42] Cultural events also became a platform and a cover, as Davis and others informed me, for other more directly political actions. According to Davis, during the 1980s, art objects—and the art scene itself—became political rallying points

Figure 28. "Asiyi eKhayelitsha" (We won't go to Khayelitsha), 1986. Poster produced at Community Arts Project, Cape Town, for a campaign against forced removals. The demand at the bottom is from the Freedom Charter. Courtesy of the South African History Archive (SAHA).

[T]his is suddenly a new South Africa. We are amazed at our own efficiency, at the competence of those hundreds of organizations we already have when they work together . . . Even, the delicate act of meeting people at the airport by walking past the police contingent holding signs reading AVIS, then revers- ing them so the police behind still read AVIS while the incoming passengers see UDF. A new South Africa; this one of ours. Our non-racial, democratic, just society in the making . . . We are creating our history. We are painting our images. We are discovering our new reality . . . And we will have other new photos, and the new words and programme we found at this rally will be our point of reference in the future:—we want all our rights, we want them here, we want them now! . . . We went off to the Cape Town night singing, singing our new freedom songs back to Jo'Burg and Durban and Mdantsane and Bloem. Victoria West blossomed t-shirts and UDF stickers; people stopping in cafes had this expression which said: watch us, this thing we carry is infec- tious, it may just finish off this country that is already so very sick.[45]

"Linda's" letter is an important document, because it so clearly describes how the look and temperament of the "people's culture" were already fully formed at the time of the launching of the UDF movement in 1983. Grassroots activism and the art forms related to it only grew in scale as the 1980s progressed. Lawyers, graphic art, protest songs, mass gatherings, and other "cultural weapons" had been tactically used at earlier moments in the struggle, from the 1950s to Soweto. During the 1980s, they were all brought into play in a highly coordinated fashion within the UDF.

What "Linda" reported from Cape Town also exemplified a growing dif- ference between those living in exile and those in South Africa. The exiles in Gaborone were more familiar with the progress of guerrilla battles for indepen- dence in the "frontline" states of Zimbabwe, Mozambique, Namibia, and Angola. Medu remained committed to the militant overthrow of the South African govern- ment, and Mnyele himself received guerrilla training at an ANC base in Angola shortly after the Gaborone conference.[46] Many of those who remained in the country instead saw the future of the revolution in mass action and in the types of coordinated resistance mentioned in Linda's letter. These contrasting perspec- tives were strikingly displayed in Medu's newsletter, by the placement of the letter from Linda next to the foldout poster by Mnyele described at the beginning of this chapter. The poster is a masterfully drawn series of images that established a teleol- ogy, from protesting children to guerrilla war. Yet it is almost the opposite of the studied playfulness of lived struggle at the UDF rally in Cape Town as witnessed by Linda. The poster, by comparison, is almost utopian in its distanced, ideologi- cally driven view of the militancy of the struggle.

These differences in outlook should not be overemphasized, since especially before the systematic repression that followed the state of emergency in 1985, there was a regular movement of ideas and people between South Africa and Gaborone.

Thami Mnyele, as we have seen, used images from *Staffrider* to construct his images in exile. There were also those like the artist and poet Dikobe waMogale Martins, who was based in Pietermaritzburg and was jailed from 1983 to 1990 for Umkhonto we Sizwe sabatoge activities. Martins published work in *Staffrider,* he was a key organizer and speaker at the Culture and Resistance festival, and was an inspirational figure for artists both at home and in exile. But not all "cultural workers" within South Africa were as inclined to overt militancy as Martins, and those who were had to keep a low profile after 1985.[47] The picture is further complicated by the fact that "Linda" was Medu member Judy Seidman, who was able to travel to Cape Town because she had a U.S. passport.

Despite the parallel sympathies and exchanges across the border, there was always the danger that a "committed art" might fail to rise above more over-determined forms of agitprop. This was debated within the Art Ensemble, and ANC lawyer Albie Sachs warned about the prospect in an open letter to the Medu newsletter:

> The trouble with most of our graphic work, I feel, is that it tries to say everything in one picture. Instead of taking its time—choosing just one beautiful, clean image every time—it's crowded; and the more people who work the more "over-determined" the picture becomes, falling back on romanticism or cliché to give it coherence . . . The enemy is still camping in our heads—as Samora [Michel] says. We spend all our time shouting at him or trying to negate his images, his consciousness (often with a spurious consciousness based on a mystification of the past, on spurious symbols). We don't feel liberation in our bones . . . we haven't liberated beauty in our-selves, we haven't felt our true strength.[48]

Sachs's letter goes on to state that those who are living in exile have the greater chance of going "all the way," of creating "liberated zones inside ourselves." This may have been true in Mozambique, where Sachs was then living in exile, but it only partially described the Medu group living in Botswana. True, the Medu Art Ensemble was itself a "liberated zone" and a model for other like-minded groups in South Africa. But the style and contents of art disseminated by Medu often reproduced the clichés of revolution that Sachs (and Ibrahim and Gordimer) warned about. Medu was involved in planning the revolution from over the border, and was thus removed from the day-to-day struggle within South Africa. Consequently, the group's art could sometimes appear to be shouting (or shooting) at the enemy, instead of participating in what Ibrahim had called "the *jihad* that is waged with the self." And yet, despite their geographic, and sometimes even ideological or stylistic distance from the art scene back home, the Medu Art Ensemble was idealized in South Africa, and its communiqués were tremendously inspirational for progressive artists there.

Toward a People's Culture

There were important precedents to the work of Medu and its promotion of the "committed art" ethic in South Africa. In 1979 the "State of Art in South Africa" conference was held at the University of Cape Town. Although most black artists boycotted the event for its outward appearance of being a "white" gathering at an elitist institution, several key participants argued for a positive role for art in the struggle to end apartheid.[49] Informal education venues operating under nonracial principles opened at the Johannesburg Art Foundation and the Open School in Johannesburg, at the Community Arts Project in Cape Town, and at the Community Arts Workshop in Durban. Beginning in the 1970s, leading artists in South Africa boycotted major national exhibitions, such as Art—South Africa— Today and the Republic festival, on the grounds that state-sponsored events only served the propagandistic ends of the National Party. During the 1980s, spurred on in part by the success of the Culture and Resistance festival, progressive alternatives to these state-run shows emerged. These were closely monitored by the security branch and were sometimes forced to close by the police. This was the case for the arts festival titled Towards a People's Culture, scheduled to take place in Cape Town in December 1987. The state censored the festival, but not before a triumphant opening night. In a report reminiscent of Linda's letter about cleverly subversive AVIS signs at the Cape Town launch of the UDF, artist and activist Gavin Younge wrote to the *Weekly Mail* about the event. Younge's account revealed the game of bob-and-weave that was played with the censors and the state and that was characteristic of the activist art scene of the 1980s:

> According to Major-General AC Swart, the arts festival, "Towards a People's Culture", is part of the revolutionary onslaught against South Africa and he has banned all aspects of it. However, the security police failed to notice that the advertised opening of the festival's art exhibition fell on the evening of Dec 11. Since the banning order only took effect from Dec 12, I am now able to report on the shortest exhibition in South Africa's history . . . The arts festival was partisan. It was oriented towards promoting "people's culture", whereas the government is dedicated to protecting separate "national" cultures.
>
> . . . In the case of the arts festival, the government has conceded an important political point. The struggle for a genuinely South African culture is dangerous to a political party which is founded on the principles of racial, religious and social separation.[50]

Younge's letter claimed further that the art shown on the first and only night of Towards a People's Culture was not really that revolutionary. A preview of the exhibition by Ivor Powell and Charlotte Bauer confirmed that even though invitations for the festival had been headed "Dear Comrade" and signed "Yours in the

William Kentridge, Nadine Gordimer, Abdullah Ibrahim, David Koloane, and others eventually viewed the consciousness-raising aspect of people's culture as a process internal to the artist's own development, as much as it was the creation of a sense of community against the grain of apartheid. They were concerned that the more strident forms of people's art, as predicted by Albie Sachs, might not actually relate to "the people's" more fundamental need to create zones of freedom within.

Culture and Resistance in Retrospect

In an unsigned review of the Art Towards Social Development exhibition that accompanied the Culture and Resistance festival, the Medu group gave its own perspective on what had taken place at Gaborone. The review began by recognizing, in general terms, the need for stylistic diversity among progressive artists:

> The exhibition "Art Towards Social Development", held in Gaborone Botswana in June–August 1982, must be viewed as a seminal point in the growth of South African art. For the first time graphic artists from throughout South Africa came together within the context of the struggle against the repressive South African regime . . . One of the obvious implications . . . must be that no one style holds a clear monopoly on progressive art.[57]

The Medu review also complained that too much of the work remained within the elite art gallery and art school framework. Not enough of the work, claimed the writer, "actively calls for change": "There was surprisingly little art on community organization, on strikes, on mass resistance, on armed struggle. These are also realities that can be reflected; and by building an imagery, a consciousness of such resistance, of people's power, our graphic workers might directly contribute to this process of change." The writer concluded that "such art is not likely to thrive in the gallery-oriented structures of the existing art world."[58]

What kind of art, then, would build "people's power" but exist outside the gallery art system? The answer could be found quite near at hand, as the reviewer stated somewhat immodestly: "The one real break with this tradition in the exhibition was in our own Medu posters."[59] The author also complained that there was not a historical dimension to the show, that older-generation South African artists like "Gerald Sekota" [sic] and Dumile could not inspire the younger generation, leaving each young artist to "frantically fill from whatever imported trend might appeal to him personally."[60] The result, it was claimed, was a sense of historical isolation for contemporary visual artists—something clearly different from the feeling of continuity evoked by musicians like Hugh Masekela and

Abdullah Ibrahim who performed at the festival. The review concluded that the event impressed upon all attendees the need for a new sense of community among artists, and for a more direct relation between the people, their struggle, and art. A new type of art was urgently needed that would invent a future democratic South Africa:

> In all, we feel Art Towards Social Development was a beginning in the right direction . . . But we have also exposed the long way we have to go—in creating an alternative to the "western" definition of art which we have been so steeped in. We have to get out of this tradition in our work, directly relating our work to our people, to our struggle; by defining our position, our purpose; by creating our own artistic institutions. Art Towards Social Development was, indeed, a beginning.[61]

Was committed art solely about projective consciousness-raising, about telling "the people" how they ought to think differently than they already did? If so, how does that connect with the Medu Art Ensemble's concept of working "for and with" the people, according to their needs? The extent to which the revolutionary idea of culture propounded by Medu was meant to envision a future nonracial South Africa cannot be overstated. The Gaborone festival in 1982 was an apogee moment for the "grey areas" that had been preserved in the South African art world up to that time. The stakes for the struggle and for art were at a peak. After 1976 art became more politicized, and different voices within the South African art scene were divided over the most effective way to enact the newly polemic agenda for culture, even while almost all agreed on the desired end to apartheid. The community of cultural workers who met at Gaborone was black, white, male, female, and international—from southern Africa, the Americas, and Europe. It included exiles, activists, and students from South African art schools. This group was a microcosm of, and a model for, a future South African conception of society. In the interim this community of artists was in a kind of holding pattern, a grey area. After Gaborone, an increasing number of incidental and purposeful collectives made up hybrid and ambivalent spaces where artists could discuss and develop a concept of society more relevant than race. In the end, for Medu, the most critical aspect of the Culture and Resistance Festival was the sense of community and the open debate among artists that it encouraged. It was a hopeful beginning, a view beyond the aesthetic isolation and the social alienation that had evolved over three decades of apartheid. In retrospect, the Medu Art Ensemble itself also presaged the working methods of the UDF committees, which, according to South African activist and historian Keith Gottschalk, "were often commanding in style as to transmitting new tactics and campaigns, [but] . . . were still participatory and debating in tradition."[62]

problem of policing black "locations" in South Africa by speaking of insulting names. I describe the building-up of the apartheid arms industry and the development of the urban assault vehicle as a form of state terror. I discuss protest songs. And I conclude with a long meditation on the war machine reimagined as child's play, and later as a commodity on the international art market. This history of images reaches up to our present, and so this chapter is, in its way, an exercise in the study of historic images that continue to be modified and reinterpreted over time—that is, the processual aspect of art history and visual culture.

Studies of violence often focus on its reproductive capacity to beget further violence through imitation.[1] This chapter is concerned with different but related questions about mimicry and the imagination: How can widespread brutality be "handled" through mockery, anxious mimicry, humor, and play? And, specifically, how was the pervasive violence of apartheid coded, resisted, recalled, and even turned into a commodity through its images? In short, are there other kinds of "copies" that can result from violence besides the literal imitation of cruel acts? If so, what can the study of these other copies (that is, of the productive life of images) tell us about affect and human experience under conditions of social, psychological, and physical duress? I explore these fundamental questions below, by following depictions of the "Mello-Yello," the notorious canary-colored South African police truck, and its khaki armored car cousins the "Buffel" and the "Hippo" on their zigzag routes through recent history. Stories shared by two artists who grew up in Soweto during the states of emergency moved me to write this chapter. Miriam Mathabane's autobiographical description of the terror-filled days of her youth in Johannesburg's Alexandra Township further inspired my reflections. At several poignant moments in her story she recalls with painful detail the game of violence shared by South Africa's black children during the 1980s. One passage in particular speaks directly to the relations between play, art, and trauma that are the central concern of this chapter:

> My heart is beating wildly. All I'm thinking of is the tear gas, the *sjamboks* (rawhide whips), the truncheons, and the bullets. Our leaders demand the release of all political activists. The police tell us to go home. The crowd starts taunting the police. A helicopter is hovering above us . . . They simply stand there, shotguns raised, watching us as we dance the toyi-toyi and chant:
>
> > Oliver Tambo, speak with Botha
> > to release Mandela.
> > Mandela, remain strong.
> > The day of your freedom will come.
>
> . . . The police have their Hippos, tear gas, and bullets—we have our numbers, our revolutionary songs, and our rage.[2]

In what follows, I look beyond the "numbers" and the "rage" that Miriam Mathabane described, in order to consider how the armored cars, the tear gas, and the bullets of late apartheid were mediated through oral and visual culture.

Terror's Shield

One of the more remarkable responses to routine violence and criminalization by the state is to face it with itself, to throw up a mirror with mockery and mimicry. The following passage from the biography of the activist Moses Kotane gives a good sense of how the actions of the police in relationship to the black residents of South Africa were characterized more by surveillance and influx control than by crime prevention or a keeping of the peace:

> On May 4, 1956, six uniformed police, two white and four African, visited the home of Moses Kotane at 8 a.m. and arrested him on a charge of being in Alexandra Township without a permit. When the police arrived at his house they said they had come "on behalf of the Government" and asked to see his papers. After examining Kotane's tax receipt, they asked him to explain how he earned his living. Finally they asked to see his permit to live in the township. When he failed to produce one, they said they were arrest-ing him on a charge under the Urban Areas Act and "ordered" him into the "kwela-kwela" (police truck) drawn up outside the house. . . . Kotane lost his appeal, but remained at his home in Alexandra. Accordingly, one night in September 1956, 19 police in a "kwela-kwela" came to arrest him again. Kotane was ill in bed on this occasion, but the police told him to "get up" and "come" and he was then ordered into the police van full to the brim with men arrested in one of the township's periodic raids for passes and permits. The authorities had obviously decided he was to be harassed out of the area if they could manage it.[3]

After the establishment of National Party rule in 1948, and the gradual imposition of apartheid during the 1950s, the enforcement of increasingly re-strictive urban areas pass laws designed to control the labor and the mobility of black South Africans progressively dominated the activities of the police. Moses Kotane's experience of being rounded up by the police for supposed contraven-tion of the Native Urban Areas Act was the same as that of thousands of other South Africans from the 1950s to the early 1990s. Paddy wagons were regularly sent into the segregated black urban areas to haul those persons suspected of not carrying proper passes off to jail. In a darkly humorous response to this stripping away of personal dignity, the popular name given the box-shaped police lorry was *kwela-kwela*. The imperative verb *Kwela!* means "climb up" or "ride" in Zulu. The term was formerly used to refer to riding a horse or wagon. The new name

same units were brought into South Africa's black urban areas with their heavy equipment in 1976.

One of the nasty details of South Africa's cold war–era conflicts "on the border" was the extensive use of land mine warfare, resulting in a military need for specially armored troop carriers.[14] In 1963 the United Nations declared a voluntary arms embargo against South Africa.[15] Thereafter, spare parts for imported armored trucks like the Saracen could not be easily obtained, and the state had to find ways to develop its own military equipment without dependence on overseas markets. As a result, ARMSCOR, South Africa's parastatal arms development company, became well known in international arms-dealing circles for a number of its "field tested" mine-protected vehicles. During 1974 the Hippo Mark I R-series truck was produced by the South African Research Defense Unit for the South African Police COIN units fighting in neighboring Rhodesia.[16] It was the first mine-protected personnel transport vehicle to be employed on a large scale. Several hundred Hippos were produced before they were superseded by the "Buffel" in 1978 and the "Casspir" during the 1980s.[17]

P. W. Botha was minister of defense from 1966 to 1979, and in that capacity he presided over the covert invasion of Angola as well as the use of troops in South Africa's own black townships. As head of state from 1979 to 1989, he introduced draconian states of emergency to the rest of the country. One record of the martial self-image of the tenure of P. W. Botha was the propaganda magazine distributed abroad by the South African Information Service: *South African Panorama*. *Panorama* carried half a dozen feature articles boasting of the country's military and police strength between 1982 and 1989.[18] In one striking example, President Botha's introductory remarks for the issue commemorating twenty-five years of the republic consisted entirely of paranoia, doublespeak, and euphemism: "The RSA is a bastion against communist enslavement . . . [committed to] protect minorities from domination," he claimed.[19] The rest of the issue was filled out by photo-essays describing South African security, the nation's "formidable military power," and the South African police and prison services, all of which were enlisted to protect the *white* minority from "domination." These photo-essays highlighted the global independence of South Africa's armed forces and the homegrown character of its arms industry. One article, titled "South Africa's Shield," extolled the history of ARMSCOR.[20] It claimed that ARMSCOR's vehicles outclassed those captured from the Russians and East Germans in Angola because they were made for African and not European battle conditions. It also contained a picture of a Buffel APC with a caption labeling it a "formidable weapon." Another picture shows black laborers in an ARMSCOR factory making munitions for South Africa's "border wars"—which, as we have seen, may have actually included their own neighborhoods.

In addition to *South African Panorama*, a number of large-format military memorabilia–type coffee-table books were published during the 1980s, with titles like *Taming the Landmine, South African War Machine,* and *Africa's Super Power.* These were dedicated to proclaiming the virtues of South Africa's mushrooming war machine. The security picture for South Africa, as portrayed in propaganda like *Panorama* and the coffee-table books, was dependent upon the strength of its "shield," defined as the parastatal arms industry. And this South African arms industry was epitomized by (and boasted) one of its most unique products: the homemade mine-protected APC.

The bodies of all of these APC trucks sit far above the ground, because their narrow V-shape hulls are made to deflect mine blasts. This design lends them a high-waisted, bulky gait. Land mines were not really a problem in South Africa's urban areas, and so the tall hulking forms of the personnel carriers stood out in residential neighborhoods, noticeably out of place in terms of both form and function. When they first appeared in Soweto in 1976, the South African press called the Hippos "anti-riot vehicles," even though they were expressly built for anti-mine protection in the bush war outside the country.[21] In town these vehicles were bizarre looking and imposing, and their appearance on a city street corner was an upsetting sight, especially for young children. According to reports, the first sight of armored personnel carriers in Soweto was terrifying. After 1976 armored vehicles were ubiquitous in the black townships, and the presence of these agents of surveillance and harassment became a regular, but never welcome, feature of daily life. The police believed they were sent into the townships to put down unrest, but they were viewed by residents as disturbers of the peace.[22] Marshall Lee wrote that the principals of four hundred schools met in July 1976 to demand "removal of police 'hippo' vehicles from the vicinity of schools because they were frightening off children who wished to return."[23] In a remarkable set of photographs alongside Lee's text, Peter Magubane captured the dramatic change in atmosphere that accompanied the sudden frightening presence of Hippo trucks in the midst of a protest march. Three frames of a double-page spread show the euphoria of Soweto's children, but in the top right frame two Hippo APCs lumber up the road, and the gathering crowd seems skittish, on alert for sudden violence (Figure 29).[24]

These machines became a sign of the occupation itself. The January 1977 issue of the black pictorial magazine *Drum*, for instance, declared 1976 "The Year of the Hippo." The children of the 1980s would later hear stories of the menacing Hippos of '76 from their older brothers and sisters, and so a mythology was built up around these vehicles. When new types of mine-protected personnel carriers were introduced during the 1980s, these were sometimes popularly called "Hippos" too, regardless of whether the model names of the newer machines were different. Activist photojournalists, such as those affiliated with the antiapartheid collective Afrapix, contributed to the conflation of terms even while

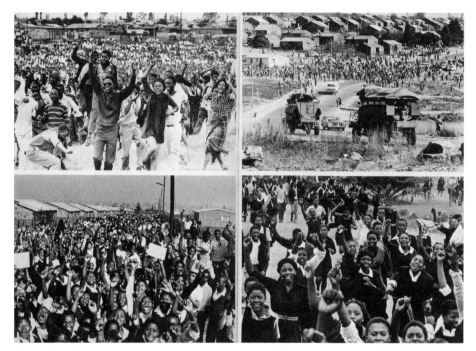

Figure 29. Photographs taken by Peter Magubane, 1976. From *Soweto*, pages 148 and 149. Courtesy of Dr. Peter Magubane.

intent on publicizing the facts of the occupation of the black townships.[25] One iconic example is Paul Weinberg's image of a lone woman shaking her fists at two trucks full of soldiers. Weinberg's composition cleverly contrasts the fragility of the human body (and the bravery of a solitary act of defiance) with the steel-plated menace of the avatars of the police state. The seeming futility of the woman's gesture, a sign of the structural violence of her predicament, is underlined when one notices that the servicemen mostly ignore her. This photo was widely reproduced and was included in the Afrapix anthology, *Beyond the Barricades*.[26] Its caption inaccurately described the trucks as "hippos," when they were actually army Buffels. (The former were bus-sized canvas-covered vehicles, while the latter were smaller and remained open on top like big bathtubs.) This compression of a number of vehicle types into the singular term "hippo" created a novel iconic image that could deliver, at a minimum, an intentionally straightforward political message: "The state is occupying its black townships and using excessive force."

The striking image of these outsized police trucks made its way into photo-journalism, popular protest posters, and T-shirts. It evolved into a simple code, a telegraphic sign for the military-style occupation of South Africa by its own army and police that the government denied.[27] This use of the direct statement can be seen in the stark imagery of David Hlongwane's linoleum cut print titled *Khayelitsha*, after the shack-filled resettlement area near Cape Town that thousands were forc-

ibly removed to from informal settlements during the 1980s (Figure 30). In this print, Khayelitsha Township is indicted visually as consisting of nothing but flimsy shacks, invasive police Casspirs, and a sandy wind-swept plain. A similar use of the image of the APC appeared on a 1984 poster for the End Conscription Campaign, a movement founded by white youth to resist mandatory army service (Figure 31). In between the title, "Troops out of the Townships," and the subtitle, "No Apartheid War," a woman raises her hand in despair and an army Buffel looms behind her. The viewer is left to imagine the destruction of homes and of normal life that the silhouette of the stalking armored vehicle implies.

The media, popular manifestations in the streets, and visual art were all critical elements of the struggle, since apartheid was a politics of visibility as much as it was a politics of space. In the words of Lacanian film theorist Kaja Silverman, "It is at the site of the cultural representations through which we see and are seen that the political struggle should be waged."[28] One of the few strategies available to those involved with the antiapartheid movement within South Africa was the translation of the opposition's views into artistic media, since open dissent was largely censored.[29] The artist David Koloane has pointed to the critical importance of artistic expression in opposition to the legal, as well as the spatial, logic of apartheid:

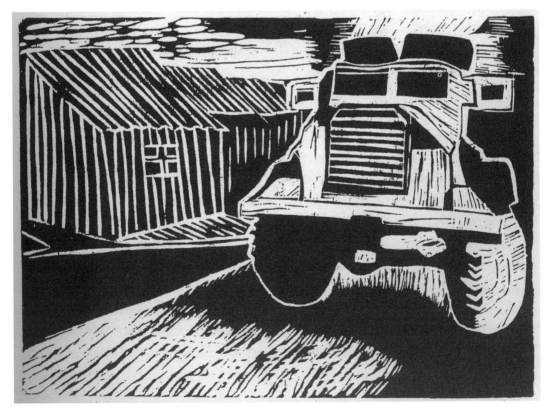

Figure 30. David Hlongwane, *Khayelitsha,* 1985. Linoleum cut print, 20 x 24 cm. Courtesy of David Hlongwane.

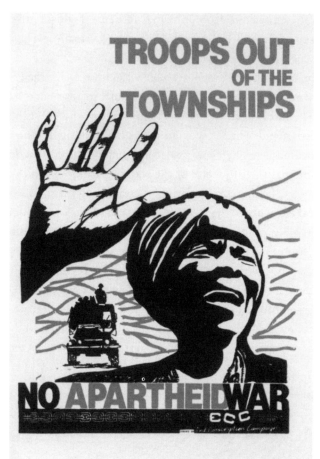

Figure 31. "Troops Out of the Townships," poster for the End Conscription Campaign, 1984. Courtesy of the South African History Archive (SAHA).

"Apartheid was a politics of space more than anything . . . much of the apartheid legislation was denying people the right to move. It's all about space, restricting space . . . Claiming art is also reclaiming space."[30] For these reasons, during the last decades of apartheid alternative media, poster campaigns, and art exhibitions were organized to get the word out on the streets. They spread the word about the brutality of government crackdowns, about which companies to boycott, and about successful acts of sabotage that were officially censored by the government.

Here Comes Mello-Yello

Armored trucks hover over every page of Miriam Mathabane's autobiography, just as they haunted the street corners of her native Alexandra Township. Halfway through, her narrative tells of the terrifying vehicle called "Mello-Yello":

> Suddenly out of the corner of my eye I notice a Mello-Yello armored truck racing down the street. My instinct is to run, but I instantly abandon that idea—I can't outrun the police. Since I'm carrying two liters of Coke, if

they stop me and ask me what I'm doing on the street, I'll simply say I've just been to the store to buy Coke.

The Mello-Yello comes to a screeching halt right next to me. Without warning, three black policemen leap off the truck and start whipping me with their sjamboks. For several seconds my feet fail me. Snapping out of shock, I scream at the sharp sting of the thick plastic whips flailing my back, buttocks, and legs.

I drop the Coke bottles and run toward the nearest yard. "Yo! Yo! Yo!" I scream at the top of my lungs. "I'm not a Comrade. I'm not a Comrade." . . . It is not until I reach home that I realize how badly I've been whipped. The sjamboks have raised huge welts behind my legs and across my back. Some of the welts are bleeding and it's torture to remove the blouse, which is embedded in some of the gashes.

Mama is away at work . . .[31]

When I met Selope Maaga in 1994 he was an artist living in Mapetla, Soweto. Like Miriam Mathabane, he was in high school ten years earlier. According to Maaga, during the state of emergency in 1985, police vehicles that terrorized the children were given the nickname "Mello-Yello."[32] A local subsidiary of the Coca-Cola Company (whose trucks were favored targets for hijacking by comrades in need of cash and cold drinks) had recently introduced a new soft drink to the township market. This highly caffeinated, brominated, greenish yellow beverage in a bright yellow can was called "Mello Yello." It is a taste clone of PepsiCo's Mountain Dew. The brand name describes the soda pop's color, with a nod to Donovan Leitch's bawdy strip-tease romp, the 1967 free love song with a similar name.[33]

Mellow Yellow. South African police trucks were painted yellow, too, with a band of light blue across the middle. In a morbidly jokey twist, the trucks that used to speed into the township and collect the youth for detention were named after the soda can.[34] There was a song very different from Donovan's, one that the young comrades had invented at the nexus of mass-marketed soda pop and excessive police action. The verses changed depending on the occasion:

Nayi iMello-Yello (ma)
se si se ngozini (mo we ma)
[Here comes Mello-Yello
We are now in danger]

Nayi iMello-Yello (ma)
mama mus' ukukhala (mo we ma)
ngoba kuzo lunga ma
[Here comes Mello-Yello
Mother, don't cry
because it will be all right]

Nanku uBotha
se si se ngozini
[Here comes Botha
we are now in danger]

Mama suli nyembezi (we ma)
ngoba sizo nqoba ma
[Mother, wipe away the tears
because we shall overcome]

Mama sengiboshiwe
mama duduzeka (we ma) . . .
[Mother, I've been arrested
Mother, be comforted . . .][35]

This song was one that the kids used to break into when sitting around killing time because they were boycotting school. On occasion, Maaga claimed, it was shouted out in spontaneous referral to the soft drink that was held in their hands (an assertion that others denied to me). Otherwise when they were drinking together, someone would start up the song and the rest would carry it along laughing, as politicians or persons they knew were included in the lyric. Parts of this tune were cried out during moments of danger. After sighting the lumbering yellow paddy wagon from the corner, "Nayi iMello-Yello" would be sung out, and the people collected in the street would scatter. Alternatively it was sung as a taunt when the Mello-Yello vehicles were in sight during marches and rallies.

The use of "freedom songs" like these, along with the high-energy martial dance called the *toyi-toyi,* probably originated during the revolution in Zimbabwe, where they were heard by African National Congress soldiers training alongside Zimbabwean cadres. They became a distinctive part of the culture of the youth in South Africa during the 1980s.[36] The form of these songs intersected with a long local history. They adapted and modified traditional call-and-response tunes sung to build camaraderie and courage during ritual occasions. The older forms were sung at weddings and circumcision camps, while doing hard labor, or when preparing for war. According to Jessica Sherman, these songs "lift one's spirits, give courage for the tasks ahead as well as provide entertainment. They release the tension of a situation without causing chaos. They produce unity amongst a group of people." Additionally, they provided a simple form of political education, teaching the names and dates of important events and persons in the struggle.[37]

The singing of freedom songs and the repetitious mocking and running from the police were part of one big brutal game for the township youth, a radically dangerous game, marked by tragedy, but not without its pleasures. It would be a mistake to exaggerate this point. Some children from this generation in South Africa never returned from detention. Many were beaten savagely, electrocuted,

tortured. The Mello-Yellos, nylons, and *kwela-kwelas*—the armored cars that the police called Hippos, Casspirs, and Buffels—were no joyride. They were the carriers of the brutal abuse of state authority under apartheid. The only funny thing about the Mello-Yello was the name.

Toying with Violence

When the Lawyers Committee for Human Rights published its 1986 report on the treacherous daily living conditions of children in South Africa's black neighborhoods, it noted, among other tragically absurd details of township life, that on several occasions entire schools had been arrested. Schools, they said, had "become battle grounds as the security forces have attempted to put an end to the widespread school boycotts. Many pupils, including those not participating in the boycotts, have been arrested, injured and even killed in these attacks."[38] The situation summarized by the Lawyers Committee was dire:

> Play areas in the townships are practically non-existent and children often play in the streets, making them vulnerable targets for random arrest, assault and the crossfire of bullets and shot. Young children who, out of natural curiosity, have been drawn to watch burning barricades or other incidents of unrest, have been pursued by the police or soldiers, assaulted and sometimes arrested and accused of being perpetrators of the incident . . . In many townships armed police and army units conduct frequent patrols on foot and in the heavy armored vehicles known as "casspirs" and "hippos."[39]

Children, daily violence, the streets as playground, armed vehicles lurking about residential neighborhoods—this is the significant cluster of phenomena that the Lawyers Committee report claimed made up daily township life. One visually striking aspect of the states of emergency period of the 1980s, and into the early 1990s, was that the spirit of township life turned dark whenever "ugly brown vehicles" regularly patrolled the streets and menaced residents. These were the police and army APCs painted "bush khaki" for the war on the border, which were increasingly doing time putting down unrest in-country after 1976. The bullying presence of armored trucks, daily roadblocks, and random tear gas attacks on houses left township children obsessed with the art of war, with uniforms and Hippos and guns. In response, militant youths barricaded roads with rocks and debris, dug trenches to ambush Buffels, and pulled the reinforcement wire from burned tires to string across roads and "clothesline" cops on motorbikes.[40] Cartoons printed on underground leaflets gave instructions on how to sabotage police trucks. People fashioned crude gasoline bombs and other missiles to hurl at Casspir and Buffel APCs. What happened in South Africa in some respects resembled what happened when Palestinian children became famous for

their resistance against impossible odds by throwing stones at Israeli tanks during the first intifada. The child comrades of South Africa committed similar acts of provocation and resistance against armored cars that for them, too, were representatives of the war machine of a regime they opposed. And similarly, the other kids on the block considered these acts heroic. They were a means to distinguish oneself from the crowd by brazenly committing acts of which the rest of the crowd mostly dreamed.[41]

According to a number of eyewitness and participant reports, the act of taunting the police had become a kind of dangerous game already at the moment of the initial street protest against the Bantu Education system by schoolchildren in Soweto on June 16, 1976. The description of events that day by Jon-Jon Mkhonza, one of the Soweto march leaders, clearly related a tense element of play in the face of danger:

> Students were scattered, running up and down . . . coming back, running . . . coming back. It was some kind of game because they were running away, coming back, taking stones, throwing them at the police . . . It was chaos. Whenever the police shot teargas, we jumped the wall to the churchyard and then came back and started discussing again.[42]

Miriam Mathabane has also told of daily confrontations between young comrades and armed forces in Johannesburg's Alexandra Township when she was a child during the 1980s. The incidents she recalls are many, and they are repetitive. She describes one such routine occasion during February 1986, following a mass funeral that was fired upon by APCs filled with soldiers:

> Throughout the long day there are repeated clashes between the soldiers and the Comrades, who fight bullets and tear gas with stones, bricks, and petrol bombs. . . . We dig ditches across the road called "tank traps" and erect barricades of burning cars to stop the armored trucks.[43]

In one subversive pamphlet distributed by insurgents during the late 1980s, the kind of "tank trap" Mathabane spoke of was demonstrated with great visual economy (Figure 32). The use of a cartoon strip aesthetic—stark visuals with spare captioning text—was meant to appeal to younger comrades and to illiterate members of the community. This particular leaflet was intended to train township residents in basic methods of sabotage. On the page "ONE FIST," is printed at the top right of one of four vertical frames. "ONE FIST" is a Black Power salute in words, perhaps the name of an imaginary revolutionary hero, and perhaps a metaphor for the power of the human hand against the inhuman machines of apartheid. In the following frames, "by day" workers dig a trench for a potbellied white overseer. "By night" they use their tools to dig a hole in the township street and disguise it with boards—after the manner of a trap for large game used in

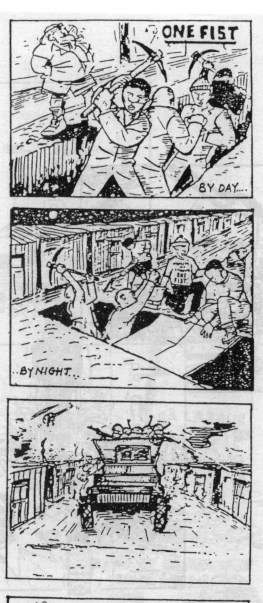

Figure 32. "One Fist," 1980s. Cartoon instructing comrades on how to dig a "tank trap." Artist unknown. Courtesy of the South African History Archive (SAHA).

earlier centuries by hunters in southern Africa. Next, the armored vehicle arrives, and soldiers hidden in back fire rounds into corrugated tin houses. Then, as the arms of onlookers rise into Black Power salutes, the APC crashes into the camouflaged hole in the road, sending apartheid's soldiers, guns, and matériel flying in all directions.

Mathabane's account of her childhood in Alexandra Township, while reiterating stories of horrors witnessed, also contains a sense of taunting and play similar to that seen in Jon-Jon Mkhonza's description of the Soweto uprising. Both evoke, too, the children's world setting of the struggle, as seen in comic books training kids for sabotage. One is struck in these images and accounts by their redundancy. For township children the nature of violence was recurrent, and built upon itself in a manner that did not allow for a dulling of the senses in the way that, say, watching gory scenes on television or reading about Soweto in the Sunday paper might inure one to the sight of trauma. Clearly, too, the violent unrest across South Africa after 1976 was a gamelike performance whose primary actors were very often children. Many comrades were teenagers or younger, and many other children were innocent victims caught in the crossfire. From this perspective, the uprisings were a kind of child's play—a game of chase gone seriously awry—and the random violence let loose after confrontations with police was the unleashed wrath of children, frustrated at their childhood games and provoked to fury. This scenario of the occupied townships was evoked in a remarkable sculpture by Billy Mandindi titled *Fire Games* (1985).[44] It depicts the township landscape as a small game board, with guard towers and police trucks in the corners. Miniature coffins, a factory or prison, and the words "jail," "bank," "hell," "pass," and "go" fill the spaces in between.

For South Africa's children growing up during the 1970s and 1980s, their understanding of the images of violence around them was more multivalent than a simply heroic view of righteous comrades in the revolutionary struggle might allow. As we examine this police vehicle, this violence, and its sign, we should also not fail to recognize that most in the post-Soweto generation were not student leaders or comrades, nor the likes of a Jon-Jon Mkhonza. They were average children caught up in the daily conflagration in the segregated black part of Johannesburg during South Africa's 1970s, 1980s, and early 1990s. Many, like Miriam Mathabane, were only reluctant comrades. That did not mean they were for the racist system, nor that they did not in general support those who made resistance their full-time occupation. All the same, they were schoolchildren caught up in a revolutionary moment. Mathabane was only one of the many children caught up in, indeed often excited by, dramatic confrontations with the heavy hands, the whips, the guns, and armored trucks of the law during the states of emergency. These children were objects of surveillance for the police, but they in turn were watching and sizing up the police.

Young Agrippa Nhlapo was not a comrade as a child, but he was not pro-apartheid. As a schoolkid in Soweto he felt caught in the middle of events of the 1970s and 1980s. He eagerly attended art workshops at the Open School, a multiracial and progressive cultural education program that offered alternative education to the youth of the "lost generation." His words as a twelve-year-old were included in a 1986 anthology of children's drawings and writing from the Open School titled *Two Dogs and Freedom*. Agrippa wrote in his child's awkward longhand:

> My mother say she do not want this things Boycotting or fighting with other people. she says we must share the same thing like to be in one [nation].
> . . . i must not do this i must stay at home.[45]

The *Two Dogs and Freedom* anthology contains page after page of images of everyday life in the eyes of township children. Images of soldiers lobbing tear gas, children lobbing stones, and awkward cartoons of police trucks predominate. These signifiers of the struggle appear again in the poignant words of another student, Thulisile (thirteen years old):

> Our students are not going to school because teaching and learning is difficult. There are hippos everywhere around Soweto. These men which are called boers [Afrikaners, literally "farmers"] run shoot beat and kill our students they even rape them. Our students are burning cars and stoning buses. If you go to school having books they [comrades] burn you books. They say people mustn't go and buy in town. The soldier are very cruel and when we see hippos come we run away because we are afraid that they would arrest, shoot, beat or kill us. I don't like what is happening in Soweto.[46]

Despite their reservations about fighting in the street, Nhalpo, Thulisile, Mathabane, and other children often participated in the antiapartheid movement during the later 1980s and early 1990s. In Nhalpo's case, he made murals for labor and community organizations. He was born with full use of only one arm, which in itself probably served to keep him off the front lines of street battles. But his street smarts and his dexterity were put to other creative uses as he grew from young boy to young artist. During 1995 he was staying in Troyeville, a bohemian suburb of Johannesburg, and was a business partner of painter Andrew Lindsay. During an interview about his school days the conversation took an interesting turn that I reproduce here in full:

> PEFFER: You grew up, post-1976, in Meadowlands [in central Soweto], so there must have been a lot of street fighting and political activity going on in the township.
>
> NHLAPO: Yeah. There was a lot going on.

PEFFER: Were you ever involved in those things?

NHLAPO: No, I wasn't really involved, but I remember in '76 when there were uprisings. You know, it was the first time I saw things happening like people burning things down, like shops and offices. To me, I was only excited then because now I wouldn't be going to school. I'd be staying at home having a lot of holiday. We were also excited as soon as we started to see the cars that we called Hippos for the first time. Everyone, like people who were making [toy] cars, also started making the Hippo itself.

PEFFER: In wire?

NHLAPO: Yeah, in wire. There were many people making those. And we started making them very big. You could actually drive them when you were inside.

PEFFER: Really?

NHLAPO: Yeah, they were big ones.

PEFFER: Why? Just because you saw it coming down the street and it was a strange kind of truck, so you imitated it in wire?

NHLAPO: I think it was that we had never seen it before, and now we saw it for the first time.

PEFFER: And you made one yourself.

NHLAPO: And then we started making these cars. In that year the schooling was really disrupted, I think, for six months. We only returned to school in the following year. That was in 1977. We had a lot of time to play. And so making Hippos and playing with them was really something new and we made them for a long time. Everyone wanted a Hippo. For people like me who were already into making things, it meant I was having a lot to do in those days.[47]

Nhlapo claimed that many of the children in the townships made wire toys when he was growing up, as they still do today. But why would they make wire cars to ride in that resembled the police trucks that kept them under surveillance and harassed them every day? Why would everyone want a Hippo? In order to address this question it is important to first consider the world of toy trucks more broadly. According to Nhlapo, when he was growing up the young boys who were particularly adept at making things were asked by friends and neighbors to make trucks and cars with wire for other children, for a small payment. Thus the better toy makers among them could earn individual distinction for their talent, and they could also earn pocket change. One indication of the popularity of these wire toys in the late 1970s was the 1979 edition of the antiapartheid literature magazine *Staffrider*. In an effort to attract younger readers to the magazine, and also to provide reading exercises for children who had missed a year or more of school

because of the uprising, *Staffrider* ran a short story titled "Vusumzi and the Inqola Competition" by Marguerite Poland (Figure 33).[48] In the story, young Vusumzi competes for "manly" status among his friends by making the finest-looking, most ingeniously constructed wire car. He uses bits of real tire for wheels and discarded tiny springs for the suspension. The editors at *Staffrider* clearly meant to tap into a ready interest in wire cars among all of South Africa's children.

In Africa, as elsewhere, the materials used to make handmade toys depend largely upon local availability and individual ingenuity. Writers often make the mistake of isolating and categorizing wire toys solely according to the materials and formal techniques of their manufacture, and indeed each novel medium does bring its own technical demands and its own potential for innovative design. But in terms of content, what is made of wire in one place may be made of pop-tops and cut up fruit boxes, or canvas and bamboo in another. All of these toys belong to a wider category of objects that, as Patricia Davison has described them, "fulfill a positive recreational function in communities subject to poverty and stress. From materials that might otherwise have been relegated to the garbage heap

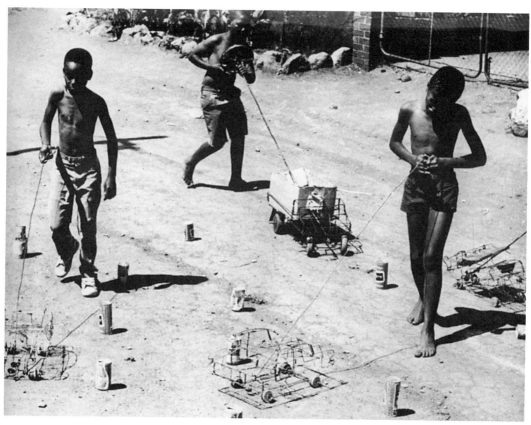

Figure 33. Children steering wire cars through an obstacle course of Black Label beer and Coca-Cola cans. From "Vusumzi and the Inqola Competition," *Staffrider* 2, 2 (April–June 1979).

emerge small vehicles as inventive and well-designed as they are fun to use."[49] Davison relates the manufacture of African children's toys from found materials to the older history of toys made from materials found in nature, whether wild grasses, shells, corncobs, or clay. She sees modern wire cars as signs of industrialized Africa's aspirations in the present era. They are "substitutes" for the traditional clay bovine figurines that used to represent the most crucial symbolic element in the economy and culture of southern Africa's cattle-herding native peoples.[50] In Zulu, wire cars are called *inqola*, "wagon/car," and are often driven by hand from above and behind, using a thin steering wheel attached to a sturdy wire or stick and secured to the front axle of the toy.

According to Davison, Southern African construction materials for homemade toys are still "found around" as they were in premodern times.[51] Today these materials include stiff wire from packing boxes or coat hangers, used for structural elements. Copper remnants begged from hardware shops and plastic-coated telephone wire are used for decorative touches and finer work. Bits of cloth, bicycle inner tube, or empty tins are made into wheels. Just as they change according to locale, the range of available materials also changes over time, and this affects the look of the toy cars made. When the history of images shifts dramatically, whether through the technology of war or the mass marketing of new types of automobiles, the kinds of toy cars children desire also change.[52] And so the phenomenon of hand-constructed army vehicles in wire was widespread among South Africa's children after 1976, in the black neighborhoods of Johannesburg, Cape Town, Pretoria, and other cities and rural towns. But the production of wire army trucks by children did not merely mirror the state of siege under which the children lived. These toys' functional representations of violence, and their response to the experience of violence, were a curious combination of competition and identification.

In her classic book, *Resistance Art in South Africa,* Cape Town–based artist Sue Williamson included an image of two homemade Hippo toy trucks as the frontispiece to her section titled "Confrontation and Resistance."[53] These and other toy trucks were exhibited in a show of handmade toys at the South African National Gallery in 1989 (Figure 34). The toy Hippos were built upon a basic wire frame and wrapped in camouflage-painted cut tin sheeting. They have wheels made of a variety of leftover parts from other toys and (what appears to be) a discarded container for snuff tobacco. They also have khaki-colored cloth covering both the passenger section and the engine compartment. Real Hippo trucks also had canvas tops, but the advantage with the toys was that things usually hidden inside (whether motors or soldiers) could be exposed and re-covered for the curious viewer.[54] The manufacture and use of this kind of toy helped explain the secret internal life of what were really dangerous things for the little boys and girls who played with them.

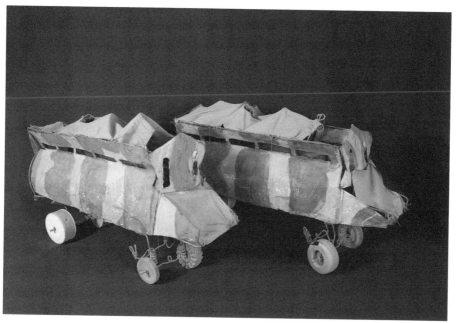

Figure 34. Two toy Hippo APCs, 1986. Creator unknown. 75 cm (length) and 78.5 cm (length). Courtesy of Iziko Museums of Cape Town. SAM AE 128 96 a, b.

The artist Titus Moteyane began his career by making toy cars in wire when he was a boy. According to Elizabeth Rankin, he also made miniature versions of armored vehicles when he observed them "during the school boycotts of 1976 and the violent confrontations with police and army."[55] Rankin claims Moteyane's toy cars were "a reflection of his dreams and aspirations, his wish to possess one and the power it symbolized for him."[56] As with Agrippa Nhlapo's comments on his own toy trucks and Hippo go-carts, I find Titus Moteyane's comment puzzling at first, and then fabulous. The brutal, heavy-handed use of the law choked their days with tear gas and crashed through their nights to bring horror into their homes. Did the boys and girls of '76 and '85 also desire to play at being the aggressive men in uniform? Is that how they handled the brutality of the misuse of the law and its cruel machines: by making those machines, in miniature, with their own tiny hands? Interestingly, neither Nhlapo nor Moteyane mentioned anything about making toy police trucks just to smash them up, as the comrades were attempting to do to the real things. They only claim to have wanted to play with them, or to possess power through them.

"The toy world presents a projection of the world of everyday life; this real world is miniaturized or giganticized in such a way as to test the relation between materiality and meaning," claims Susan Stewart in her seminal study of the figure of the miniature, *On Longing*.[57] Following Stewart (and Moteyane), we might conclude that township boys made toy Hippos by hand, in order to *handle* the

power the Hippos symbolized for them, to *test* it—to *play* with it, and to gain mastery over it. Was this also a classic example of what anthropologists used to call "sympathetic magic"?[58] Did it correspond to the notion that a representation, if manipulated properly, might influence the character of its original, or transfer the power perceived to rest within the original to the one who manipulates the representation? According to Rankin, Moteyane wished to acquire the power represented by real cars and real army trucks. Magic or not, clearly there was a strong sense of creative visualization at work in the making of these toy trucks. They were not only simple, tiny, mimic versions of the world of adults, nor were they merely a childish and unconscious emulation of the oppressor. In the black townships of South Africa, toy armored trucks were products of the imagination that turned vehicles of state terror into objects for mastery.

Perhaps sensing the potential uses of play for positive identification, the South African Defense Force handed out plastic toy troop carriers to township children as part of an image-polishing campaign in 1985. As reported in the Committee on South African War Resistance's publication, *Resister,* in 1986:

> In August [1985] the SADF launched a campaign to improve its image, specifically to present the army as a force independent of the police and not responsible for repression. "Know your Army" leaflets were distributed and toy plastic Buffel and Casspir troop carriers were handed out to black schoolchildren. Complaints offices were established in townships to hear reports of army misconduct, but these were boycotted. An SADF spokesman concluded that there were no complaints against the army.[59]

It is possible that these store-bought toys were used by the township youth in the same manner that the wire and tin trucks were. It is likely too that, as with the army complaints department, this effort at psychological operations in the townships missed its mark. First, there was no guarantee that the plastic toys would not be incorporated into some preexisting township game. Also, the way that a mass-manufactured toy is handled differs radically from the way a child interacts with a toy made at home from materials "found around." The act of making a Hippo, Buffel, or Casspir tended to invert the usual order of alienation from the products of labor that is characteristic of industrialized societies like South Africa's. The child makers of these toys (as with the mocking nicknames for APCs and the struggle songs) de-alienated the *image* of the agents of state sanctioned violence by bringing it in close and making it their own. Stewart observed that model kit–type mechanical toys "produce a representation of a product of alienated labor, a representation which itself is constructed by artisan labor. The triumph of the model-maker is that he or she has produced the object completely by hand, from the beginning assembly to the 'finishing touches.'"[60] This is a crucial point, since those doubly alienated by apartheid's curious formulation of the

capitalist system were the black consumers in South Africa whose children likely made wire cars. Black workers manned the factories for ARMSCOR. Their labor produced the guns, munitions, uniforms, and trucks used by the South African armed forces to lay siege to black neighborhoods. In South Africa, especially during the states of emergency, African industrial workers were not just sold back the alienated products of their labor—sometimes they were even attacked, and their desires suppressed, by the work of their own hands. Handmade toy APCs inverted this order of things, even more than in Stewart's example, since they were not constructed from a store-bought kit.

It would be a mistake to see these wire trucks, as most commentators on the subject of African toys have, as appropriating materials and icons of the modern world in order to resist modernity itself.[61] To do so is to view Africa as perpetually back in time, existing in a simpler economic mode characterized at its most authentic by use value and bricolage. It is more useful to understand wire toys today as critical elements *within* a modern economic and technological world that sometimes address *modern* inequities. Seen as a metaphor and not just as a mirror of their world, these mechanical toys made by the children of Nhalpo and Moteyane's generation de-alienated the industrial products of a heavily militarized, race-obsessed, capitalist society. Wire township toys were handmade, from found and familiar materials, and mostly for personal use. These elements all stood in dramatic contrast to the machined materials, factory labor, and military use of real-world army trucks.

The making of these toys derived from a desire to know, to understand and make sense of the very thing that violates. The children thus identified themselves with the signs of their own oppression, in a process partly related to what Anna Freud once described as "identification with the aggressor": "there are many children's games in which through the metamorphosis of the subject into a dreaded object anxiety is converted into pleasurable security. Here is another angle from which to study the games of impersonation that children love to play."[62] In her classic text, Freud claimed it is normal, especially for children, to react to objects of anxiety by imitating them. In the case of toy police trucks, the anxiety of a neighborhood under siege by police coalesced around the object of the police armored truck, which summed up the township predicament and imitated it in miniature. The toy police truck was put through its paces in elaborate miniature towns drawn with sticks on the ground, or on the very real streets of Soweto if one was lucky enough to ride in one of Agrippa Nhalpo's Hippo go-carts. As a handmade toy, the armored truck was in the hands of the kids and as such became part of the imaginary play world under their control, a place they could own and manipulate and shield, even while making a microcosm of a real world that threatened their safety. The small makers of these tiny trucks reversed the real order of the streets where, at least during the 1980s, the world and its police cars really were beyond

coffers. Interestingly, those middle-class artists and curators who had already been given access to overseas travel and connections, and to university education under apartheid, were in the best position to take full advantage of the situation. Many of the top names in South African art even today, most of them white, really started clicking in 1995. There was plenty of maneuvering room, too, for ambitious young art students to get themselves included as exhibiting artists or as catalogue editors. Unfortunately, after being hailed as the rationale for expenditure, the "community" artists were mostly relegated to the back rooms and the fringe exhibitions. Then, a Mello-Yello was rolled right into the middle of this potentially volatile scene.

Since the 1980s, a loose collective of young men from the Germiston industrial area south of Johannesburg had been making a small business of their art at the Katlehong Art Centre. In their thirties by 1995, they continued to use their boyhood skills at making wire toys to produce new and unique designs for the area craft markets. Some of the artists from the Katlehong Art Centre, using a grant from the Biennale, constructed a huge Casspir out of tubular steel and canvas, and placed it outside in a corner between exhibition halls for the duration of the event. Spectators could not be sure whether it was an affront to the whole event or just another art installation. It was based on the wire sculptures that children make, but this one was a striking full-size replica of a police vehicle, painted yellow with a light blue stripe around the middle. For the most part it stood silently on the grounds of the Biennale, protecting art from unsavory elements. Its presence in town was a bit shocking, since these kinds of vehicles (whether toy or real) were rarely seen in the central city, which was coded as "white" space under apartheid. Occasionally the artists made their installation even more obtrusive by tying a rope to its face and dragging it around the Biennale campus. Thus they occupied the space of the Biennale by using an image that epitomized the former military occupation of the black townships.

Theirs was not a Casspir nor a Mello-Yello, not really. It was a gigantic toy, a *giant miniature*. The collective from Katlehong had taken the kind of toy that helped them handle the violence of their township home, and made it into a spectacle for an international art fair in downtown Johannesburg. As a sort of billboard for third-world ethnic tourism, this giant wire police truck shared some of the semantic qualities I have discussed in reference to mass-produced Africars. Tourists, as I was told repeatedly in South Africa, were only interested in "the struggle, the lion, and the Zulu." For Biennale visitors, then, the big toy Casspir signified "the struggle." It also represented "children's crafts," even though it was made by grown men. The Katlehong collective was clearly hoping to round up some big art business with their giant toy. They were also somewhat frozen in time, keeping themselves in a state of suspended animation by continuing to model children's games long into their adulthood. As such they were appropri-

ate, if unfortunate, representatives of the larger generation of children who had missed out on school and on growing up without the threat of terror during the two decades of civil war that had swallowed so much of their lives. Their Casspir reproduced, this time as art world theater, the somewhat masochistic relationship of township residents and police under apartheid.

In her writing on "the gigantic," Susan Stewart paraphrases Guy Debord in claiming that "the spectacle in mass culture exists in a separateness which locates history outside lived reality at the same time that it locates lived reality within the realm of consumer time, outside the time of production."[68] Following this idea, we could conclude that the gigantic toy Casspir displaced the lived time of apartheid's violence and masochism and horrific machines into the shallower image world (and the dehistoricizing time frame) of spectacle and of commodities on display at the Biennale. Still, as a giant miniature the Katlehong art Casspir also retained some of the multivalent quality of competition and identification characteristic of the small toys handled by township boys that were used to domesticate the frightening unknown and to work through the frustration of childhood desires during a state of siege.

The presence of this mock-up version of the apartheid war machine on the grounds of the Biennale can also be read as commentary on a state of affairs that these men from Katlehong perceived to still be in place, including in the art world. The gigantic toy from Katlehong, placed in the context of the adult and cosmopolitan art arena, was, in my view, also a giant reflection upon the blinkered hubris of the Africus enterprise itself. If that is more projection on my part than intentionality on theirs, at the least is it safe to say that the artists from Katlehong themselves meant to use the art event as a public forum to broadcast their social concerns. Ephraim Ramabya, one of the Casspir builders, told me he wanted "to depict the armored vehicles once used to crush the people . . . to show the international artists and curators about the life we have lived here, and get them involved."[69] He wanted them to know what was happening in the townships and to support their work with funds for the Katlehong Art Centre. Victor Mpopo added: "The outside world doesn't know these were used against people. . . . In the township these armored vehicles are the only thing in the mind. Even a small boy knows the vehicle and what happens—you run away." These artists believed that the Biennale curators and officials benefited but "the people" weren't helped so much, and that few groups were properly represented by the selection (which did of course include them). The sculpture was vandalized after the Biennale, and I was told by the artists that some policemen had fired rounds at it and that part of it had been spotted (some wire figures of policemen from inside the truck) in a "Chicken Licken" fast-food commercial on TV. The artists were too upset to savor the irony that the police were shooting at a representation of themselves. I was informed that the vandalism and the fast-food advertisement were part of

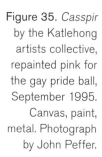

Figure 35. *Casspir* by the Katlehong artists collective, repainted pink for the gay pride ball, September 1995. Canvas, paint, metal. Photograph by John Peffer.

an elaborate conspiracy—one in which the police and the Biennale officials were involved—to crush the hopes of the young black artists of Katlehong. Rebellious, and hungry, these men were determined to resist the remnants of the old political system and also to fight for a position in the rapidly expanding international market for South African art.

The biggest problem for the Biennale groundskeepers was the size of the mock Casspir. It simply would not go away. It was too big to be moved, and the artists, having not found a buyer for it, were unable to transport it all the way back to Katlehong, not to mention uninterested in doing so. They just left it standing in a field next to the Biennale buildings. Then one day it disappeared. Where could such a huge thing have gone? Someone had moved it into the Electric Workshop, a former power plant that had been converted into a cavernous exhibition space for the Biennale (Figure 35). There it stood alone at the back of the empty hall like a discarded party favor, painted Day-Glo pink, with big black lettering scrawled in graffiti on one side: "PRISCILLA QUEEN OF THE CATERERS." These words were a playful reference to the Australian movie about transvestites on a road trip across the outback in "Oz."[70] Here the old-school apartheid rubbish was recycled and reseen. No longer yellow, and much more mellow, the war machine was domesticated back into (mostly) white society, this time as a policemen's prop done up in drag for the gay pride ball.[71] Gay Pride '95 was the hottest event on the Jo'burg club circuit that weekend, and this pink hippopotamus of a transvestite police van was all made up and ready to party.

Conclusions for the Struggle and the Images of Violence

Did homemade Casspirs and Hippos put some joy into the state of terror in South Africa's black townships after 1976? If they did, they achieved this in part by momentarily imagining something marvelous in the place of the truly horrific

menace of the armored cars of the police. After 1976 the state had turned the black townships, more than ever before, into highly policed zones. New methods for urban onslaught and new machines, like the Hippos, were introduced to daily terrorize and "pacify" the residents in the black locations. Children ran from these monstrous vehicles of state repression. They also viewed the "Hippos," in particular, as fascinating technological beasts. In a paradoxical way, as Agrippa Nhlapo told me excitedly, the Hippo could be seen as responsible for terrorizing the youth, but equally well for liberating them from former paternalistic constraints of the family, from the hated Bantu Education system, and from authority in general.[72] These children under duress were able to have a little fun with the image of their oppressors. It should not be forgotten that for the average South African the awesome technical aesthetic of the armored personnel carrier could be the cause of some excitement and visual pleasure, as well as a source of terror. Still, we should not forget that children's fantastic solutions to the immediacy of violence in their environment, if repeatedly frustrated (for instance, by real police aggression), might lead to more destructive forms of identification with the aggressor.[73]

In this chapter I have traced some of the movements of images of South African armored trucks through various media and different social contexts, marking the ways that audience and interpretation have shifted. My primary interest has been to note those instances when real-world violence has been displaced into visual and verbal signs, and the image of the oppressor is de-alienated in the process. There are images such as the armored truck that in art or in song may stand in for forms of violence that are not depicted fully. Such common types of references to the violence of the war machine, in South Africa and elsewhere, are something whose interpretation is not necessarily as transparent or stable as some progressive activists would wish. The sign for violence displaced onto the figure of the war machine may be useful as a tool for protest (and for private resistance), but it also must always be understood as contingent, strategic, and ultimately co-optable. While it is still in play, the image of violence is up for grabs, and the struggle continues.

Refrain

Did anyone think at the time that by singing "Nayi iMello-Yello," the song's words might come true? Or that by some trick of sympathetic magic, the real Hippo trucks could be commandeered by the people who as children had imitated them in wire? In 1994 the country had changed hands, and I was driving with friends in Soweto to the state funeral of Joe Slovo, white leader of the South African Communist Party. Slovo had also been head of Umkhonto we Sizwe, the army of the African National Congress, which had only recently been merged with

Figure 36. Children "riding staff" to the funeral of Joe Slovo in Soweto on January 15, 1995. Photograph by John Peffer.

the regular South African Defense Force. Cars and buses crammed with people streamed past us. Then we saw them. Mello-Yellos, Casspirs, Hippos, and Buffels painted that ugly bush war brown and speeding toward Orlando Stadium covered with scores of singing schoolchildren (Figure 36). They were "riding staff" on these armored trucks, township slang for "getting a free ride" by hanging on to the outside. They were heading to the funeral of a comrade and hero from their days of battling with the police. And they were singing, "Nayi iMello-Yello," again, but this time the other, the old enemy, had become a memory:

> Here comes Mello-Yello,
> We'll be ready.
> Mother, don't cry,
> because we'll gain victory over them.

5 | ABSTRACTION AND COMMUNITY
Liberating Art during the States of Emergency

South African artists adapted an abstract expressionist aesthetic from the United States during the 1980s. Today, art students learn that abstract expressionism was born in America in the context of the cold war, but few are aware that this aesthetic had another life, in another place and time, or that the endgame of abstract painting was played again by proxy in Africa during the decade before the fall of the Berlin Wall. This was a pivotal moment in South African history, when the struggle for political representation was intensified by the gathering of the United Democratic Front and the Mass Democratic Movement against apartheid. The corresponding struggle over aesthetic representation became increasingly disputatious during this period. During the 1980s, black artists' experiments with non-figurative abstract art took place at the same time that pressure was mounting, in the wake of the historic Culture and Resistance festival in Gaborone, for all cultural workers to conform to a critical, realist, committed art. One effect of the transnational translation of an art style was the creation of a new idea of art as community, against the grain of the social separateness of apartheid. This chapter is a case study of how one group's "formalist art exercise" became another's "community art movement." The story of this transition is part of the history of the often-overlooked dispersal of international modernism beyond the borders of the United States and Europe. It has profound significance for the deeper understanding of the tension between "Western" and other modernities, and for the interpretation of the politics of culture in South Africa.

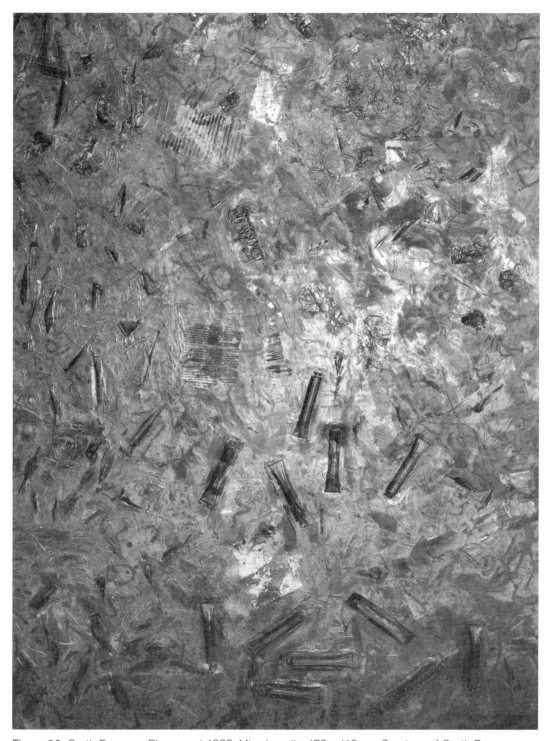

Figure 38. Garth Erasmus, *Playground,* 1985. Mixed media, 170 x 110 cm. Courtesy of Garth Erasmus.

The 1985 FUBA–USSALEP Workshop was so inspirational for the artists who attended that it was repeated annually until 1991, each time with a slightly different group. During its second year the workshop moved to the conference hotel at the Alpha Training Centre in Broederstroom and its name was changed to "Thupelo," a South Sotho word meaning "to teach by example." The choice of the name Thupelo mirrored other slogans popular within the progressive movement at the time, including the Congress of South African Students' motto "Each one teach one" and the title of the literacy magazine *Learn and Teach*.[3] The name indicated the project's initial aim as an enrichment program for black artists: a small group of professional artists would be brought together to learn and share skills that could later be spread more widely among students and colleagues.[4] Along these lines, one of the conditions for seed money from USSALEP was that the workshop would provide an opportunity for artist exchanges between South Africa and the United States. It was with that stipulation that Peter Bradley was brought over as a guest artist in 1985. Bradley, a painter associated with the "third wave" of abstract expressionist American art, also learned from his experience of working in South Africa. For the first time, he tried his hand at making large-scale sculpture from scrap metal.[5] According to Thupelo records, the other international visitors included Lucy Baker and American art critic Kenworth Moffett (1986), Canadian artist Graham Peacock (1987), British painter John Hoyland and Canadian painter Robert Scott (1990), and British artist Andrew Sloan (1991).[6] Prominent local artists were also invited as honorary visitors, including Sydney Kumalo, Fikile Magadlela, and Ezrom Legae.[7]

Aside from its stated purpose as a venue for black artists to widen their scope of expression, Thupelo was a historic point of intersection for a number of local and international aesthetic, philanthropic, and political interests. At the center of all of these interests was the life's work of Bill Ainslie. When he was a student at the University of Natal in Pietermaritzberg during the early 1950s, Ainslie became friends with Selby Mvusi, an artist living in Durban. Mvusi piqued Ainslie's aesthetic interest and his political conscience. According to Ainslie, "It was my first contact with a black artist and my first liberal education as a white South African . . . Selby alerted me to the needs of the country. He was the first person to teach me about the situation here, and through him I began to see the demand for the development of black art. The work I have done in my life was a consequence of the formative period I spent with him."[8] After Ainslie's friendship with Mvusi made him aware of the dire situation of black artists under apartheid, for the next three decades he dedicated himself to improving access to art training for black South Africans. Upon completion of his MFA studies in 1958, Ainslie worked with the Reverend Ned Paterson at his workshop for black artists at Cyrene Mission in Rhodesia, a school organized on an apprenticeship model derived from the ideals of John Ruskin's nineteenth-century Arts and Crafts movement. Ainslie moved to

his 1952 oil painting *Mapogga Women* integrated the postcubist aesthetic of Rufino Tamayo and the primary color designs of the Ndebele.[16] Here the look of the Ndebele women was used as a formal exercise for the artist's exploration of color and volume. Following a study trip to the United States in 1952, Portway embraced the American intellectual currents of abstract expressionism (especially the paintings of Jackson Pollock and Franz Kline) and Zen Buddhism, and his subsequent paintings explored the possibilities of saturated pigment and nonobjective form. Even in these works there are often hints of Ndebele mural art (Figure 40). Frustrated by what he saw as the provincialism of the South African art scene, Portway moved to Ibiza in 1956, and later to Cornwall and London.

Although living in exile, Portway continued to exhibit in South Africa and his shift to purely abstract art encouraged Bill Ainslie to follow suit. Portway's later technique of floating linear marks over fields of intense color also made an impact on the art of Louis Maqhubela, who had worked at Polly Street and was a friend of Ainslie's (Figure 41). In 1966 Maqhubela toured Europe on a travel award and met Portway in England. He moved to Ibiza in 1973 and eventually settled in London in 1978.

According to Ainslie's son Sholto, the family home was a regular meeting place for artistic and political radicals in the 1960s and early 1970s. During times of increased repression, the South African police and the Security Branch were also regular visitors at Ainslie's house in Parktown. Bill's daughter Sophia recalled that her father was a firm supporter of the banned African National Congress and that their family was kept under constant surveillance. "The state's security police spied on our house continually," she wrote. "They sat in 'undercover' cars 'reading' newspapers on our street, itching for an excuse to arrest Bill . . . [Our parents'] privacy was invaded through phone taps, their mail being opened, and midnight police searches of our home."[17] Sholto reported that in 1968 the political situation had become "too hot" for Ainslie's family, so they moved to Spain, and later to England.[18] Bill Ainslie also sought out Portway as a mentor, and in 1969 he moved his family to St. Ives, Cornwall, near Portway's studio.

The Ainslies returned to South Africa in 1970, and a teaching studio modeled in part on the apprenticeship method at Cyrene was set up in the garage behind the family house. There, according to Sholto Ainslie, art classes for "suburban housewives" supported a more informal multiracial workshop.[19] By 1974 Ainslie's Studios had evolved into a full-scale school open to all races, and its collaborative environment implicitly contravened the color bar of the Group Areas and Separate Amenities acts. During the mid-1970s, a decade before the two-week Thupelo format was "invented," Ainslie was already well known in South Africa for expounding upon what he then called the "workshop concept." In 1979 he explained how his workshop was a "social sculpture" that operated "between the poles" of a South African society divided by fixed notions of elite

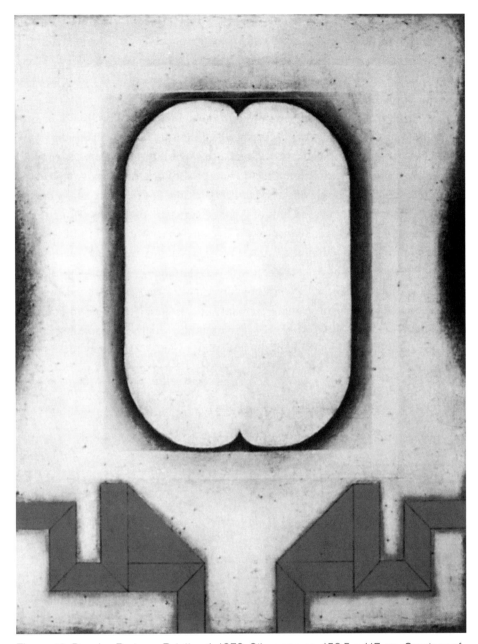

Figure 40. Douglas Portway, *Painting 1*, 1972. Oil on canvas, 153.5 x 117 cm. Courtesy of the Johannesburg Art Gallery.

and popular art, race, and class privilege: "In the workshop we have people of all sorts, rich and poor, new and old, black and white, and it works. We watch people's lives changing and thereby changing ours; everybody contributes. We don't need 'political' art, or 'relevant' art, or 'folk' art, or 'african' art, or 'sub-urban' art, or 'township' art—it's all too self-conscious. What we need is to get

on with the job of discovering ourselves, and let the labels be used by the ideologists."[20] Sophia Ainslie has commented that the police continued to watch the activity at the Ainslie household. The police were "itching for an excuse to arrest Bill and close the school, but the informality of the school made it difficult to incriminate anyone."[21]

By 1982 Ainslie's school had moved to the upscale neighborhood of Saxonwold and was officially incorporated as the Johannesburg Art Foundation, a certificate-granting nonracial institution. Both the establishment of the foundation as a nonprofit organization and the purchase of city property to house the school were backed by some of the wealthiest and most powerful business leaders in South Africa, including the heads of the De Beers and Anglo-American mining corporations, Harry Oppenheimer, and Clive and Irene Menell.[22] In theory, the Ainslie Studios and the Johannesburg Art Foundation were multiracial endeavors, think tanks for things to come in South Africa. In practice, though, only a small percentage of the student body was not white, and those students were dependent upon a limited number of available scholarships essential for them to continue attending classes. The majority of the students came from the surrounding upper-class Johannesburg suburbs. As in the late 1960s and 1970s, it was these "pay-

Figure 41. Louis Maqhubela, *Two Figures with a Bird,* 1970s. Monotype and paint stick on paper on board, 50.2 x 72.4 cm. Courtesy of Louis Maqhubela and the University of the Witwatersrand Art Galleries.

ing" students who supported the workshop-style studio that Ainslie shared at his house with black artists.

In 1976, in response to the national education crisis that was exacerbated by the boycotting of black schools after the Soweto uprising, Ainslie met with the organizers of the Market Theatre and the African Music and Drama Association at Dorkay House to develop a plan for a new interdisciplinary school. In 1978 this initiative was merged with a similar one headed by Gibson Kente in Soweto, and the Federated Union of Black Artists was begun under the directorship of Sipho Sepamla.[23] Durant Sihlali, who taught at FUBA, recalled that although it was essentially a black-run endeavor, since apartheid law kept the institution dependent on its white patrons, FUBA had to pretend it was a white-run school in order to stay legal: "As the Group Areas Act was still enforced, blacks could not rent buildings or apartments. So to bridge this law, organizations had to co-opt white liberal educationists . . . into their council committees, who then could lease buildings in their capacity fronting for the organizations as 'theirs.'"[24]

FUBA evolved into a full-time arts school, located across the square from the Market Theatre complex in Newtown. But, as a separate institution for black students, FUBA was only a reactive and partial solution to Bantu Education, since it did not in practice contest the apartheid principles of segregated tuition and separate amenities. In addition, FUBA received operating funds from the Urban Foundation, a white philanthropic initiative whose mission was to create a black middle class as a buffer between the state and the black majority, but not to challenge the basis of apartheid segregation. Ainslie outlined a more comprehensive longer-term goal for art education in a resolution prepared for the State of Art in South Africa Conference at the University of Cape Town in 1979: "[for] all colleges and schools of art to be opened to all people in South Africa and that an effective system of bursaries accompany such legislation."[25] The resolution, signed by Ainslie, Cecil Skotnes, and Andrew Verster, urged artists to commit themselves to creating a postapartheid society, and until then to boycott all state-sponsored art events.[26]

From Culture and Resistance to Modernist Art Workshop

David Koloane was a schoolmate of Louis Maqhubela's at Orlando High School in Soweto during the 1950s, and received his first art instruction from Maqhubela. During 1974–77, he studied at Ainslie Studios. He became a close collaborator with Bill Ainslie on a number of projects, including the Gallery, a black-run exhibition space in downtown Johannesburg that was directed by Koloane from 1977 to 1978 and incorporated (on paper) by Ainslie as a way of getting around apartheid restrictions on black business ownership.[27] In 1982 Koloane was teaching at FUBA, and he was a visual art coordinator for the Culture and Resistance festival

in Gaborone. For him, the significance of the festival was that it highlighted the need for improved access to knowledge, if the condition of South African black artists was ever to improve beyond the constant need for charity. He was struck by how poorly trained black artists had been, how that limited their expressive potential, and how he could personally contribute to the struggle by helping to broaden the purview of black artists:

> I think what I got out of it was the urge to learn more about art, formally. Because we were always given the impression that somehow we didn't need education, in the creative sphere, because we were, in a sense born talented . . . it really made me feel inadequate. I needed to go and learn— and come back and impart [professional skills] effectively . . . Then you are doing it from a professional viewpoint . . . You are not just pamphleteering, sloganeering, about not having opportunities—but not doing anything about it. You are actually contributing positively. By learning more you are sure to influence younger people, and show them the right direction, and encourage them . . . to move away from that emotional kind of program.[28]

Koloane's experience at Gaborone was very much in keeping with the revolutionary role for artists outlined in the speech given by Thami Mnyele at the 1982 festival: "It was in the Medu Art Ensemble where the role of an artist concretized itself: the role of an artist is to learn; the role of an artist is to teach others; the role of an artist is to ceaselessly search for the ways and means of achieving freedom. Art cannot overthrow a government, but it can inspire change."[29] But Koloane's and Mnyele's aesthetic preferences were vastly different. Koloane was interested in modernist abstract art along the lines developed by Maqhubela and Ainslie, but by 1982 Mnyele was committed to social realism. In addition, while Mnyele emphasized the need for a didactic art that was visibly rooted in the struggles of the people, Koloane, after 1982, became more interested in opening up access to technical knowledge and breaking down the barriers between artists that had been created by apartheid. At the end of 1982, Koloane found an opportunity to expand his own idea of liberation through art when the FUBA Collection was opened by Sir Anthony Caro and Sipho Sepamla at the Market Theatre Gallery in Newtown.

Two years before the opening of the FUBA Collection, Anthony Caro, the prominent British sculptor, was invited to judge the Arts '80 competition in Durban.[30] Caro was a protégé of both Henry Moore and David Smith. He taught at St. Martins School in London from 1953 to 1981, where he had had several South African students.[31] His open format horizontal constructions of geometric shapes merged Moore's and Smith's approaches and helped pioneer the genre of abstract "field sculpture." Caro's technique was considered a challenge to the former vertical emphasis of most modernist sculpture, and the American critics Clement Greenberg

and Michael Fried heralded it as an analog to late abstract expressionist–style color field painting.

During his visit to South Africa in 1980, Caro gave a talk on his work at the University of the Witwatersrand in Johannesburg, and afterward Bill Ainslie, who was in the audience, asked Caro if he had noticed that there were no black persons in the room. Ainslie then took Caro on a tour of art centers for black students, including FUBA and Ainslie's own shared workshop. Caro was inspired by the collective (and multiracial) atmosphere at Ainslie's studio, and he was dismayed by the poor facilities available to black students at FUBA.[32] According to Amercian sculptor and Caro associate Willard Boepple, Caro "marveled at the fact that the suburban white colleges and schools had these fantastic studio setups in their art schools, and the black art centers had nothing."[33] In response, Caro sponsored the provision of art supplies and books on art, music, dance, and theater for FUBA.[34] It was Caro's perception, further, that access to current art trends abroad was wanting in general in South Africa. And so, for the next two years he dedicated one day of each week to the construction of a representative collection of painting and sculpture by important living Western artists.[35] The collection eventually included more than 122 works of art by a spectrum of modernist artists, including Henry Moore, David Hockney, and Caro himself.[36] It also had examples of classical African art and was meant to be supplemented by works by prominent South African artists. The Caro collection filled a large shipping container, and this was sent to South Africa.

The collection toured South Africa to raise awareness and funds for a future school for black artists. It was eventually renamed the FUBA Collection, held in trust by FUBA Academy, and housed in a new gallery in the basement of the FUBA building in Newtown as a facility for students' studies.[37] David Koloane was to be the curator of the collection at FUBA. The tour was managed in South Africa by Sandy Summerfield. From the British side it was organized by Robert Loder, who had previously worked for the Anglo-American mining company in South Africa during 1957–65. During that time he also worked in Sophiatown with Father Trevor Huddleston and was involved in the black art and jazz scene that clustered around Huddleston. Loder, who is white, had also promoted multiracial art, music, and theater ventures, including the traveling musical *King Kong,* as chairman of Union Artists at Dorkay House. During the 1970s, he was chairman of the Institute of Contemporary Arts in London. By the early 1980s, as a financier, art patron, and philanthropist, and through his continued connections to the black art scene in South Africa, Loder helped facilitate the collection tour for Caro.[38]

As preparation for Koloane's future role as curator of the FUBA Collection, Caro arranged for him to study for a diploma in museum studies at the University of London on a British Council fellowship in 1983. While in London, Koloane researched alternative printmaking techniques that could be used by cultural

workers with limited facilities.[39] But on the way to London a different idea about how to learn and teach art in the black South African communities presented itself. Koloane had also been invited by Caro to participate in the second Triangle Artists' Workshop in New York in July 1983. At Triangle, as we will see, Koloane found that the international workshop format could be a powerful way to create community in addition to imparting valuable technical skills to black artists.

The Triangle Artists' Workshop had a South African origin, since it was a venture that resulted from the friendship built between Robert Loder and Anthony Caro when they worked together on the FUBA Collection project.[40] Triangle began in July 1982 and continues to this day. It is an intensive, two-week, all-expenses-paid retreat, partly modeled on the historic art workshops at Emma Lake in Saskatchewan, Canada, in the 1950s and 1960s.[41] Arguably, too, if to a smaller degree, it was inspired by the collaborative environment that Caro had witnessed at Bill Ainslie's studio in 1980. According to art critic and Triangle board member Karen Wilkin, the Triangle Artists' Workshop was founded "in response to Caro's growing awareness of what he perceived as a lack of connection between young painters and sculptors in Britain and their counterparts elsewhere."[42] In a letter to Clement Greenberg, Caro linked this desire to his own search for a source of vitality now that his teaching days at St. Martins were over: "I suppose my own motives are to keep in touch, now St. Martins is off limits to me. However I really do believe London art will benefit from it and the increasing isolation felt by good artists everywhere will be relieved."[43] Triangle, like Emma Lake, was intended to inspire a crossbreeding of ideas between working artists, especially those who felt alienated from the fabled New York art scene.[44] According to Robert Loder:

> The story is a very simple one, really. Anthony and I were in New York to-gether, and I suggested he should come and look at this dairy farm in which I had an interest in upstate New York. It's about a hundred miles from Manhattan. And when we were there Tony saw these great disused dairy barns: large, almost cathedral-like structures which he thought would make ideal artist studios. So, in a fit of enthusiasm he said to me, "Do you want to start a workshop? We could do one in one of these buildings. Let's give it a go." He conceived the idea that a very short and very intense period of work would not necessarily produce any works of great quality in the sense of great finished works, but would provide a very necessary stimulus for people to find new directions, explore new ideas, make them rethink the basis on which they base their art . . . There was a good clubhouse where in the evenings we could have slide shows and people could talk about their work, and so on.[45]

The workshop was called "Triangle" because the invited artists initially came from the United States, Canada, and England.[46] These three countries constituted a triangle that matched Caro's own intercontinental studio and exhibition circuit.

In terms of the nationalities of invited artists, this triangle soon turned into a polyhedron of global locations, including South Africa, France, China, Spain, Australia, Japan, and other countries.

Most of the artists invited to the early Triangle sessions were either Caro's students or followers of his aesthetic.[47] They were more or less followers, as was Caro, of late abstract expressionist approaches to art making that emphasized the play of form over attention to iconic imagery or direct social content.[48] Referring to the leading theorist of the formalist school of modernist art that Caro followed, Robert Loder noted that "stylistically, or aesthetically, the nature of the Triangle Workshop was always quite closely in line with Clement Greenberg's sort of precepts."[49] Greenberg was himself a regular visitor to the annual workshops. For Greenberg, who had valorized the work of Jackson Pollock and the first generation of abstract expressionists in the 1950s, the object of any art was truth to medium. A painter, for instance, ought to be primarily concerned with the problems of frame, flatness of surface, color, and line that are unique to painting as a discipline.[50] An example of the later "formalist" type of art criticism in a Greenbergian mode that was associated with Triangle may be found in an essay from 1986 on "the present state of abstract art," by Kenworth Moffett, a Greenberg protégé who was a curator at the Museum of Fine Arts in Boson and a regular visiting critic at the Triangle workshops:

> Within the work of this younger group . . . I see emerging a major shift . . .
> what might be called "Post Olitsky" or "Post color field" or "third wave"
> painting . . . The color key expands from the dominance of middle or
> close valued color to include greater brightness, brilliance, saturation, and
> contrast . . . the 80s and the youngest painters are bringing in a far more
> coarsely physical and sculptural approach to the surface. Also, acrylics are
> no longer perceived only as a happy alternative to oils, but now as a whole
> new substance with its own unique physical properties and possibilities.
> Working with painters, the chemist Sam Golden of Golden Artist Colours
> Inc. (formerly a partner of the Bocour Artists Colour Co.) has developed
> a great variety of new acrylic paints and mediums, many of which permit
> effects impossible with oils. It looks as if, for the foreseeable future at least,
> the greatest abstract painters are going to be those who handle the rapidly
> developing acrylic medium with the greatest feeling, imagination, and
> freedom.[51]

There is a commercial pitch for Golden Acrylics, linked to an evocation of aesthetic "liberation," in Moffett's analysis. Sam Golden was a regular sponsor of the Triangle Artists' Workshops, as were the André Emmerich and Salander-O'Reilly galleries, whose stables of artists included many of the painters and sculptors who attended Triangle in the 1980s. Consequently one may surmise that it was not just an ethos about the making of art that was shared at Triangle in

the early years (i.e., "truth to medium") but also the use of specific materials that was promoted: acrylic paint and welded steel.

The styles that predominated at the early Triangle sessions—postpainterly abstraction, color field, and other techniques in this range—all had antecedents in the New York school of the 1940s and 1950s, and in the critical writings of Clement Greenberg. These later forms of abstract expressionism had for the most part fallen out of fashion in the major American contemporary art magazines by the late 1970s, that is, in the decade *before* Triangle. Triangle was a meeting place for artists and ideas who had fallen out of visibility in mainstream art criticism by the 1980s, even while their work continued to sell well in the galleries.[52] These artists had also lost touch with each other, and their sense of community was coming undone. According to Willard Boepple, who first attended Triangle in 1987 and joined the board of directors in 1988, rekindling the excitement of collaboration, and competition, of art school was a fundamental component of the workshops:

> At Triangle the notion is to re-create some of the exchange and conflict and tumult of the student days. Not in the teacher–student sense, but in the sense of exchange . . . Frances Barth, a painter who is on the Triangle board, once said that Triangle reminded her of the sixties. When she was coming up as a young painter in her early twenties in New York . . . and no one had a bean, they would all meet at the diners and cheap bars in the area, and each other's lofts.[53]

After each session Triangle produced a volume of testimonials and photographs by participants, similar to a school class yearbook. The content of these yearbooks highlighted the community building, even clubby ambience of the endeavor Frances Barth described. A number of Triangle artists returned in subsequent years or were later folded into its boards of directors and advisers, for example, Larry Poons (1983, 1988, 1989), Willard Boepple (1987, chair since 1992), Randy Bloom (1983, 1985, 1986, 1987), Sheila Girling (1983, 1987), Jon Isherwood (1988, 1990), George Hoffman (1988), Susan Roth (1987, 1990), and Roger Mack (1988, 1990). This is a partial list, gleaned from the introductory pages of several of the Triangle yearbooks from the 1980s. In addition, regular visiting artists and critics at multiple Triangle sessions included Anthony Caro, Peter Bradley, Kenworth Moffett, Clement Greenberg, Michael Fried, Helen Frankenthaler, Frank Stella, Kenneth Noland, Karen Wilkin, Frances Barth, and its cofounder and patron Robert Loder. During the 1980s, these names constituted the core membership of what Karen Wilkin referred to in the yearbooks as the "Triangle tribe."

The ethos of communalism and stylistic experimentation characteristic of the 1950s and 1960s in America was briefly relived at each Triangle workshop.

The experience was meant to resonate later in the invitee's art, long after the workshop was over. Boepple underscored this point: "A lot of experimentation results. The two-week period is not about finished product, it is about experimentation and exploration."[54] The formalist art program of Greenberg and Caro, the delayed effect on each artist's studio practice, and the "sixties" communal working atmosphere referred to by Boepple and Frances Barth are what we might call the "three sides" of Triangle. Karen Wilkin outlined these three sides to the program in her introduction to the 1983 Triangle yearbook:

> The workshop is an effort to bring together like-minded, ambitious artists who have not been seduced by fashion. All of the artists who come to Triangle share a common belief in the continuing validity of modernism . . . Of course, the real results of Triangle are not visible during the workshop . . . Much later, after everyone has settled back to more normal patterns of working, we will see what happened . . . Certainly, we have made friends. It's a beginning.[55]

Wilkin also noted that David Koloane's participation was frustrated by the refusal of South African authorities to grant him a travel visa until the final three days of the 1983 workshop. Because of the constraints imposed by Group Areas legislation on black South Africans' mobility at home and abroad, black artists tended to work in even more isolation than the European and American artists who predominated at Triangle. This predicament was thrown into high relief when the South African sculptor Ian Redelinghuys, who is white, was also invited to attend Triangle in 1983, but, unlike Koloane, had easily obtained a travel visa. Koloane recalled:

> In 1983 . . . it was very difficult, they wouldn't give a black person a passport. There had to be exceptional reasons. You had to be going to represent the state in some capacity to get a passport. They were trying to enforce the Bantustan system, where every black belonged to a "homeland," irrespective of where you were born or where you grew up, they couldn't care. Because I was "Tswana," they said I was a citizen of Bophuthatswana and I must get my passport from Bophuthatswana, and I refused. I said I was born in Alexandra . . . I didn't even know where Bophuthatswana was . . . So they gave me a travel document called "nationality undetermined."[56]

Koloane experienced further difficulty during his first brief visit to New York. He had never been abroad, had only recently spent time in jail for Pass Laws violations, had missed almost the whole Triangle workshop, and had limited funds. The other Triangle artists pooled their resources so that Koloane would have something to work with and to live on. While the rest enjoyed the traditional end-of-session open day for visitors, Koloane worked nonstop day and night on

a series of abstract paintings. The following week he stayed in Manhattan with Randy Bloom, and he spent time with her former art teacher from Franconia College, Peter Bradley, who had also visited Triangle during the open session. Koloane and Bradley, who is African American, discussed the problem of the marginalization of black artists by the mainstream art world and the idea of exporting the Triangle model to South Africa. The concept for a South African Triangle-like workshop solidified after Koloane was reinvited to Triangle in 1984. Afterward, he returned to London for his studies and proposed the idea to Bill Ainslie, who was also visiting London at the time: "David introduced Peter to Bill, and together they developed the idea for Thupelo."[57]

Koloane especially valued the aspect of the workshop format that brought artists together who for political reasons were ordinarily kept apart: "I was actually enthralled by the whole concept that artists could be brought together from different parts of the world. I felt this was the kind of idea that we needed here, that could bring artists from different parts of the country together."[58] He also appreciated the shared intellectual and social space afforded by Triangle, and the professionalism of the event. These were possibilities he had already glimpsed at the Culture and Resistance festival in Gaborone and while working with Bill Ainslie during the 1970s. But in New York the scale of interaction was much grander, and the bar was raised in his mind for the potential the workshop model held for undoing the social alienation felt by black South African artists. According to Koloane, "I thought the workshop concept would be a starting point. From there we could move on to other things."[59]

Bill Ainslie was able to secure funding for an annual workshop in South Africa through his connections in the philanthropic community. This included a two-year commitment from the United States–South Africa Leadership Exchange Program, a private initiative for two-way cultural exchange begun by the American Friends Service Committee in 1955 that had previously given U.S. travel grants to Sidney Kumalo (in 1967) and Ezrom Legae (in 1970). USSALEP backed the workshop initiative for two years and sponsored one South African artist's travel to Triangle, and one person from Triangle to Thupelo each year (Figure 42).[60] Ainslie also gained access to free parcel delivery in the United States Department of State's diplomatic pouch. Through the U.S. Information Agency (USIA) and the diplomatic pouch, Peter Bradley and Sholto Ainslie (who was living in New York) were able to gather and ship acrylic paint and other art materials to Thupelo that were either unavailable or prohibitively expensive in South Africa.

Although the Triangle experience had inspired Ainslie and Koloane to begin Thupelo, the South African workshop differed from the New York workshop in terms of its purpose, scale, and results. The atmosphere at Triangle was meant to be, in Caro's phrase, "a pressure cooker," that is, a competitive arena for making better, newer art, and a place where artists could collaborate outside their

Figure 42.
Lionel Davis
at the Triangle
workshop,
1987. From
*Triangle 1987
Yearbook.*
Photograph
by Ferriel
Waddington.

studios.[61] In South Africa, on the other hand, the only time most of the artists had access to studio space and abundant materials during the year was at the two-week Thupelo session. So the atmosphere at the South African workshops tended to be more a combination of holiday retreat and art class. Durant Sihlali explained this difference from Triangle:

> At Rustenberg we had our first international workshop. That was a most exciting period in my life. To work big, and to be using foreign materials that I had never used before: [acrylic] gels and so forth. We came back from that experience, we imparted that onto our students . . . America does things in a big way, so there is no comparison . . . Food, accommodation, everything is just bigger . . . the sponsorship of Golden Materials, they come in tons. At Thupelo we had to be careful because everything was in small piles. You don't have the same kind of freedom that one found at [Triangle].[62]

Sihlali noted the overall difference in scale between Triangle, with its broad international reach, and Thupelo, which for all its importance in South Africa was essentially a small regional art program. Nevertheless, he claimed that Thupelo was "a luxury" for South African artists, one characterized more by sharing than competition: "There [in New York] you find you are under pressure because you look around, you are being pounded by different forces that you come across: people of international standing. And you come from the 'Bundus,' you know?

'Southern Africa? Who are *you*?'"[63] Conversely, Robert Loder recalled that "as the workshops grew in Africa, artists came because they were virtually the only mature and committed group of artists in that country."[64] One consequence of the pool of talent being smaller for Thupelo was that the invited artists combined a wider variety of approaches and styles than at Triangle, whereas in New York, "it was always abstract painting and mainly steel sculpture."[65]

Access to precious resources and the ethos of collaboration are the two main points of distinction for the Thupelo Project. The goal of helping jump-start the studio practice of midcareer artists at Triangle in New York was of lesser importance in South Africa. Along these lines, Willard Boepple observed that the issue of the isolation of modern artists was even more acute in Africa. Given the scarcity of studio space and art supplies, "For an awful lot of artists who came to these workshops, these two weeks would be the first solid two-week period one even had to work."[66] While concurring with Sihlali, Loder, and Boepple, David Koloane's recollections about the significance of Thupelo tended to integrate its aesthetic with its social dimensions. Thupelo could "bring artists from different parts of the country together," and it was "a facility where artists could experiment with new materials, because most artists work from their homes . . . Very few artists could actually venture to do big-scale work, because of space limitations. I saw the workshop as a facility where artists could have room enough to explore scale, explore techniques and material."[67]

From these recollections we can reasonably conclude that Thupelo offered artists an opportunity to work, period—and to work on issues of technique and concept instead of merely struggling for survival. For a fortnight these artists could work on a scale and with materials that were formerly "foreign" to them. Whereas at Triangle the artists welcomed the opportunity to get out of their studios and work next to other artists, at Thupelo the artists welcomed the luxury to get into a studio near other artists. Willard Boepple described Triangle as recreating the excitement of art school. Thupelo was also "like art school," but in the sense that it was a small compensation for the dearth of art training available to black South Africans. Although Thupelo was intended for artists who were already working professionally, most had received only informal art training.

The skills learned and the ethos shared at Thupelo were meant to trickle down to the wider art scene, through participants' roles as teachers at various grassroots community art projects throughout the country. One of Koloane's goals for the project was that artists who were also teachers at community-based art centers should be included in the roster of Thupelo participants. Lionel Davis (from the Community Arts Project in Cape Town), Anthusa Sotiriades (from FUBA and the Alexandra Art Centre), Anthony Nkotsi and Dumisani Mabaso (from the Johannesburg Art Foundation and the Hammanskraal Art Project), Kay Hassan (from the Alliance Française in Soweto), Helen Sebidi and Bongiwe

Dhlomo (from Alexandra Art Centre), and Durant Sihlali (from FUBA) were among the teachers who attended Thupelo. Despite this intention, Durant Sihlali claimed that access to art materials at places like FUBA was nowhere near the level available at Thupelo (or at white colleges): "as the materials were very expensive to handle this didn't have any immediate results as things that could be used as a facility for students."[68] And yet some of the new ideas about art-making methodology as practiced at Thupelo *could* be shared with students, for example, the use of found objects and self-made materials, free drawing and painting exercises, and the use of collage and mixed-media techniques. These more experimental approaches to image making slowly found their way into student work from community centers during the late 1980s and early 1990s, and they helped black artists expand beyond naturalistic drawing and printmaking techniques and formulaic depictions of township life. Still, while Thupelo did offer development opportunities as sought by Koloane, these were only fully available to the small number of artists invited to the annual workshops. Initially, even for these artists there was little opportunity for follow-through, since the Thupelo experience was only replicable at the annual workshops themselves (Figure 43).

As Robert Loder observed, Thupelo could be characterized as a facility for gathering a diverse group of artists in contravention of apartheid laws, and less by any uniform style of art produced. That said, Ainslie, Koloane, and the international visitors to Thupelo actively encouraged the exploration of modernist, experimental, nonfigurative approaches to art at the workshops.[69] According to Elsbeth Court, "As director of the Johannesburg Art Foundation, Bill Ainslie promoted abstract expressionism, after the approach of the 'New York School.' He felt that this kind of art making could transcend both vernacular and urban experiences . . . African Modernism, as he called it, would offer the possibility of a significant and qualitatively new aesthetic . . . which could contribute to the non-racial culture of post-apartheid Africa."[70] As at the Art Foundation, this was a matter of choice, one embraced by a group of artists who otherwise had little access to these "new" technical and material options. The results could be seen in the addition of acrylics, collage, and welded metal into the Thupelo artists' repertoires. At Thupelo artists were also encouraged to incorporate the environment in their art through use of found objects and mixed-media construction, and not just to reflect the environment in their imagery.[71]

In principle Thupelo was a nonracial endeavor. Anthusa Sotiriades, a white sculptor and a teacher at both FUBA Academy and the Alexandra Art Centre, was a regular participant. Bill Ainslie and a handful of other white artists and guests were also active at the annual sessions. The ratio of black to white artists at Thupelo more closely reflected the ratio of black to white people in the country as a whole, and thus was the inverse of the ratio at the Johannesburg Art Foundation. Koloane claimed Thupelo "was primarily intended for black artists,"

Figure 43. Eric Mbatha pouring paint at the Thupelo workshop, 1990. Photograph by John Peffer.

though white artists were frequent contributors and were welcome.[72] If one includes the significant contribution of corporate sponsors and visiting artists into this equation, then the "multiracial" aspect of the workshops becomes even more pronounced. Multiracialism, or more accurately a "Freedom Charterist" policy of nonracialism, was both cause and effect of the Thupelo Project. Thupelo, in retrospect, constituted a social group around a developmental program. Using the cultural worker rhetoric of the Culture and Resistance festival, Koloane described the Thupelo Art Project as "a collective forum for learning and teaching which is sensitive and adaptable to the social conditions which are found within the communities. Our objective is to inspire artists to research and experiment medium and technique so that they are able to expand their creative vocabulary. To coin a phrase: You cannot make a statement if you are not able to speak the language."[73] Here Koloane seemed to be paraphrasing Abdullah Ibrahim's challenge to all self-appointed commissars of culture at the 1982 festival in Gaborone, when he declared, "It's no good shooting if you shoot in the wrong direction." Except that Koloane's meaning was closer to "It's no good shooting if you have not learned how to use a gun."

The Thupelo Group

As we have seen, the Thupelo Art Project presented new opportunities for black South African artists, but there was difficulty at first in generating creative momentum among participants after they left the annual workshop. One way continuity was established was by simply including many of the same artists every year. This sort of repetition was already a characteristic feature at Triangle in New York, where it constituted what Karen Wilkin called the "Triangle tribe." But in South Africa, given the greater need to combat isolation and the smaller pool of professional artists to draw from, this repeater phenomenon often extended to the majority of participants each year. Koloane, Ainslie, Sotiriades, and Bongiwe Dhlomo organized the workshops and attended every year; Kay Hassan attended in 1985 and 1989; Lionel Davis participated in 1986, 1987, and 1988; Durant Sihlali attended every workshop except when he was abroad in 1986; Patrick Mautloa, Sam Nhlengethwa, and Dumisani Mabaso attended every year; and Madi Phala attended the first five workshops. This is just a partial list of the Thupelo regulars. If one were to attempt the designation of a "school" of artists emanating from Thupelo during the 1980s, these names would head the list. Together these artists carved a place for themselves out of the South African art scene in the late 1980s. This core group would also see dramatic results in terms of altered styles of art making in subsequent years. In 1987 members of an informal "Thupelo group," which included Tony Nkotsi, Dumisani Mabaso, Patrick Mautloa, Sam Nhlengethwa, and Koloane began to continue their Thupelo-type

formal experiments in between the annual workshops in a collective studio that met under an overhang on the grounds of the Johannesburg Art Foundation.[74]

Many of the Thupelo invitees had also attended the Rorke's Drift art school, and this led some critics to charge the project with nepotism, an allegation that seemed to be substantiated by the repetition of attendees.[75] It should be noted, though, that since Rorke's Drift was the only full-time school for black students to receive comprehensive art instruction during the 1970s, its graduates formed the majority of professionally trained black artists active during the 1980s. According to Lionel Davis, the Thupelo Project created a network of artists that supplemented the one already begun at Rorke's Drift.[76] Several members of the informal group that resulted from Thupelo had known each other for many years, but before the workshops and the later collective studio at the Johannesburg Art Foundation, they rarely had the opportunity to work together on any regular basis. Thupelo facilitated a pattern of cross-influences and interpersonal relationships between artists that brought a *community of artists* into being.

A number of other regional workshops following the Thupelo model were initiated in African countries beginning in 1988. Members of the core group from Thupelo were also guests at these other regional workshops, often acting as experienced facilitators.[77] The list of workshops following the Thupelo model (new locations continue to be added) includes Pachipamwe, Zimbabwe (begun 1988); Thapong, Botswana (1989); Ujamaa, Mozambique (1991); Mbile, Zambia (1993); Thulipamwe, Zambia (1994); Tenq, Senegal (1994); Shave Farm, Somerset, England (1991); and Xayamaca, Jamaica (1993). Most of these workshops were started, as was the case with Koloane after Triangle, by one of the invited artists setting up a workshop in their home country. For example, Fatima Fernandes returned from Pachipamwe and organized Ujamaa in Maputo. Tenq was started when Senegalese artist El Hadji Sy met David Koloane in 1993, during the planning for the Seven Stories exhibition.[78] Triangle and Thupelo remained the focal points for other spinoff workshops. Aside from the influence of David Koloane in Africa, the common foundational element among all of the international workshops was the patronage and coordination assistance of Robert Loder. From a distance one could map the whole system of workshops as a nodal entity with indefinite shape. Today the system still operates as a loose network of independent national satellites, with Robert Loder's input and a growing handful of workshop regulars as their common denominators.

The particular histories of these other workshops fall outside the scope of my study, but according to Sidney Kasfir's book *Contemporary African Art*, each African workshop had its own local character, beyond what she called the basic "imported" workshop model from Triangle.[79] She noted the process of making "offspring" from the workshops, and claimed that this presumed "that the key to creativity lies elsewhere, in encounters with unfamiliar cultural models and

artistic practice." Kasfir also pointed to the tremendous potential afforded at the African workshops for artists on the periphery of the major international art centers to engage in both local and international networking. For Thupelo itself, my own research has sought to further contextualize the connotation of "foreignness" that Kasfir described. In my view, too, just as they had expanded their annual workshop experiments into a regular and collective studio practice, it was through a process of repetition and fission that the group that formed around Thupelo was able to keep the workshop method vital.

The last year the Thupelo workshop was held in Johannesburg was in 1991.[80] By then the group that had grown up around Ainslie and Koloane and the workshop had moved past the immediate need for the sort of technical experiments possible at the two-week sessions, and their interest had shifted to the need for regular studio space. Already in 1990, a vacant factory building in Fordsburg, a "grey area" near downtown Johannesburg, had been identified as a potential location for a collective studio. Again, on the initiative of David Koloane, and again with the backing of Robert Loder, the former Speedy Bag Factory was purchased and converted into rudimentary artist studios.[81] The Bag Factory studios were opened to provide an atmosphere in which cultural diversity and professionalism could be combined. According to Koloane, one of the main functions of the studios has been "to develop a professional ethic by coming to the studios daily, like any professional to work, and this in itself is a first for South Africa."[82] In terms of the background and "race" of the artists, and in terms of the range of styles practiced there, the Bag Factory is more diverse than the Thupelo group was. Though many of the artists who have kept studios there were associated with Thupelo in the 1980s,[83] others, including a number of university-educated artists such as Joachim Schönfeldt, Kendell Geers, Penny Siopis, and Wayne Barker have also worked at the Bag Factory, and the Artists' Press, run by master printmaker Mark Attwood, was also housed there at its inception.[84]

The Trouble with Thupelo

Thupelo was plagued by difficulties from the start. It faced accusations of elitism and exclusivity, of a lack of political commitment, of succumbing to American cultural imperialism, and of not being South African enough. The artists chosen as guest leaders were contentious. Many of these problems were already present before Thupelo began, since they had also factored in the reception of Anthony Caro's FUBA Collection, the initial spark for the project. Before examining these criticisms of Thupelo, it is worth briefly relating the story of the FUBA Collection as a cautionary tale about the scramble for resources within the progressive art scene during the twilight years of apartheid.

The FUBA Collection courted controversy from its birth in 1982 to its dispersal in 1999. When it was first shown at the end of 1982, some observers were not impressed with the quality of works donated by Caro's artist friends. According to *Johannesburg Star* art critic John Dewar, in his review of the inaugural FUBA Collection exhibition, "What is astounding is that most of this work which in the main can only have been the barrel scrapings from the studios of the artists concerned, was ever accepted for exhibition . . . [and] has a quality that in most cases could be outstripped by a good South African student show."[85] Viewers like Dewar were not content that South Africans should be expected to study and emulate what they thought was the bottom end of international contemporary art. Dewar and others saw even the stated desire for foreign models as problematic. The most vocal of these critics included the group of activist artists living in exile in Botswana associated with the Medu Art Ensemble. In an unsigned review of the FUBA Collection exhibition at the Market Theatre published in the *MEDU Art Ensemble Newsletter,* the Medu collective was fierce in its appraisal. They began by comparing the FUBA Collection to the earlier Art Towards Social Development exhibit that had accompanied the Medu-organized Culture and Resistance festival:

> The FUBA Collection exhibit raises similar questions about the structure and direction of our cultural community. It has mobilized that community certainly—to admire once again European and American art . . . We could never wish to discourage the development of facilities for our artists, but is this the best way to develop such facilities? To present more foreign art, more abstract art, more art which speaks to its own society and background and not to us, as an example?[86]

More than the fear that "foreign" art would become the exclusive point of reference for South African artists, and more than their anger at Anthony Caro for his lack of in-depth knowledge about the South African art scene, the Medu group was suspicious of the "apolitical" packaging of the FUBA Collection exhibition. They saved their harshest criticism for Caro's comments at the opening ceremony, where he had argued against the politicization of art:

> [Caro] says: "Anyone who tries to make a political statement through art generally ends up with propaganda instead. No one who eats art for breakfast would dream of trying to make statements through their work. I am interested in mastering form, light, and colour."
>
> But as we have said: our people eat poverty for breakfast; we live in the light and color of political oppression; and our art cannot ignore that and remain true to our own realities. For us the real propaganda lies in the art that pushes an abstractly pure "form, light, and colour" instead of our own experience. This is not our direction: it can only be pursued by denying the aesthetics of our own lives.[87]

These comments from Medu presaged the kind of criticism by other activist groups that also worried the Thupelo Art Project throughout the 1980s. Interestingly, Cecil Skotnes mirrored Caro's words in an interview later the same year but shifted their meaning:

> It is extremely difficult to make a political statement through the visual art medium. A few great artists, like Goya or Picasso, did do so. I prefer in the main to make my statements verbally. I have done so in the past and will continue to do so. I believe every artist should. If the theme of his statements comes through in his art, well and good . . . When I was involved with the Polly Street Art Centre, I set out to teach art to black pupils and came into contact with many young artists, some of whom were very promising. But the centre was closed down after the prohibition on private adult education classes . . . Now again I teach and perhaps this is the best way for me to make my particular statements.[88]

Skotnes claimed his political statements were made more in his personal life and through his methods of teaching and working directly with black artists, than by any specific foregrounding of current events in his art. During the 1980s, the activities of the Thupelo artists and the art of all cultural workers generally, were similarly caught on the sharp points of the compass of polemical debate about the proper relation of art and community to the struggle. Still, despite the criticism of its quality and accountability, the FUBA Collection remained very popular among audiences in South Africa, and its tour of the country raised a substantial amount of money to help fund future art programs for black students. Nevertheless, after the original tour arranged by Robert Loder in 1982, and despite the fact that David Koloane had been sent to London for training to be its curator, the FUBA Collection was never again on display in its entirety.

The virtual disappearance of the FUBA Collection was the result of a dispute between the manager of the traveling exhibit and FUBA's director, Sipho Sepamla, over the use of funds generated by the tour of the collection.[89] The disagreement was over whether the moneys raised should be used to develop the art program, as the manager Sandy Summerfield felt Caro had intended, or whether, as the director argued, the income should be absorbed into the general account for FUBA. The result was that FUBA retained the collection, and Summerfield and other disgruntled former board members used the money it had generated to set up a separate trust for a new art school. This became the African Institute of Art, which opened in 1985 under the directorship of Steven Sack at the Funda Centre, a teacher-training facility in Soweto run by the Urban Foundation. Some of the momentum generated by the FUBA Collection tour, and many of the personalities who had worked on the effort, were also funneled into the development group for the FUBA–USSALEP workshop that became the Thupelo Art Project. Because of a further dispute with the FUBA director, this time over what to do

with the resources granted by USSALEP for the workshop, Thupelo's institutional association with FUBA ended in 1987.[90] That year USSALEP also shifted its philanthropic assistance to the education initiative at the Funda Centre. In the meantime, the FUBA Collection gathered dust in storage.

In 1994 the FUBA Collection was moved to Sotheby's Johannesburg for safekeeping after concerns were raised about the conditions under which it was being housed in FUBA's basement. In 1999 the collection was seized by the police and sold at a hastily arranged auction for a bargain price. The sale had been arranged for Sam Bass, a South African real estate magnate who was owed rent by FUBA totaling R195,000 (about $30,000). The auction was poorly advertised, and Bass was the main bidder. Afterward, the bulk of the collection was moved to Bass's private home in Australia.[91]

Thupelo encountered local resistance similar to that faced by Caro's gift collection. According to Lyn Soudien, a former office head for USSALEP, the workshop "caught some flak at low levels."[92] She was referring modestly to a group of students from FUBA Academy who, prompted by the FUBA director, showed up at the first workshop and protested against visiting artist Peter Bradley because he split most of his time between the University of the Witwatersrand and Bill Ainslie's house in the northern suburbs. After all, in 1985 the workshop had been billed as the "FUBA–USSALEP" project, and Sipho Sepamla was disappointed that the visiting American artist was not working with his students at FUBA.[93] Also, according to Bradley (who admitted to knowing very little about what was happening in South Africa before he arrived there), he was approached on several occasions by persons on the street who asked him threateningly, "What do you think you are doing here?" He claimed, further, that he could not figure out whether those accosting him were from the police Special Branch or from one of the black liberation organizations.[94] Bradley was originally supposed to keep a temporary studio at FUBA, but after arriving there he found that he was unable to work given the available facilities. He had studied at Yale in the 1960s, and according to Sholto Ainslie, "Peter demanded the best facilities and the best materials when he was in Johannesburg . . . Coming from a black man at that time, his directness, and the standard he was used to, outraged a lot of people . . . He was outspoken and really blew South African whites and blacks away."[95]

The only place Bradley found to work in steel at the scale he wished was the University of the Witwatersrand.[96] Even there some of the teachers and students in the Fine Arts Department were not happy with Bradley's approach to art or his presence in their studios, and his sculptures were vandalized. Bradley recalled that he worked at the university with his assistant (and Thupelo organizer) Anthusa Sotiriades fifteen to sixteen hours a day, seven days a week, "and I'd come back sometimes the next day and the things would be destroyed with

hammers and paint thrown all over them."[97] Bradley admitted that, in the spirit of visiting artists anywhere, the work he was doing in South Africa was new for him, and that he and Sotiriades had proceeded by trial and error. But apparently, as far as some students in the highly competitive art program at the university were concerned, his aesthetic was dated, not appropriate to South Africa, and not relevant to the struggle against apartheid. For his part, Bradley idealistically believed he *was* contributing to the revolution, since, as he framed it, "It always starts in the art world. Then it spreads over into the literature world. From the literary world it spreads into the common man, because only the common man can lead. And then you have a full-scale revolution."[98]

Aside from the interference encountered by its first guest artist, the 1985 workshop did not run smoothly, especially as it became clear to participants that abstract expressionist–style work was what was supposed to be "tried out" there. According to Elizabeth Rankin, "Some of the artists at the first workshop had themselves been resentful of a rather prescriptive approach, which tended to demean art that did not fit a modernist model."[99] But, she added, "they resented even more the suggestion that they had been 'brainwashed' into adopting an imposed 'foreign' idiom and should rather be producing socio-political works in a representational style, when white students at art institutions were free to sample whatever they pleased."[100] Thupelo artists were not forced to continue working in the same manner after the two-week workshop. Most, in any case, could not afford to do so even if they had wanted to. In a review of the 1986 Thupelo Workshop exhibition, Marion Arnold commented similarly:

> One wonders just how committed to abstraction are the black artists whose work is on display . . . At issue would seem to be the whole concept of art training, and of introducing people to the process of making visual images. If a period of working in an abstract idiom does nothing more than introduce aspirant artists to a formal vocabulary, much has been achieved.[101]

Canadian painter Graham Peacock, the Thupelo visiting artist in 1987, was even more poorly received by local artists and art critics than was Peter Bradley. Peacock was a regular on the latter-day abstract expressionism workshop circuit, having attended the Emma Lake Artists' Workshops in 1979, 1980, and 1981, and the Triangle Workshop in 1986. Peacock's painting technique entailed dumping gallons of acrylic paint into a frame and allowing it to dry, crack, and reveal shapes and layers of color as it desiccated. Although this sort of painting was technically interesting to them, it was difficult for South African artists to learn from Peacock's example. According to Sholto Ainslie, who claimed he had originally recommended Peacock, "He didn't go over well . . . because he used gallons of paint . . . which in one year could be used to make many paintings. He was seen as excessive, arrogant too, and not keyed into the real problems in South Africa."[102]

A number of local art critics were also unkind in their initial appraisal of Thupelo. In his book *Art of the South African Townships* (1988), Gavin Younge contested the statement made by Kenworth Moffett when he was guest art critic at Thupelo in 1986 that "a sophisticated, ambitious abstract art . . . an art which is wholly 'life affirming' is emanating from the townships."[103] In retrospect, it seems that Moffett's declaration that "the periphery" of the art world could now be "the center" of something merely repeated a supportive statement once made by his mentor Clement Greenberg. After Greenberg's own historic visit to Emma Lake in 1962, he had given local artists a similar boost by praising Canada as a new center for abstract art.[104] Moffett's and Greenberg's words were intended to give hope to local artists working far from the hotbed of international art trends. They may also have been a means to underscore their own relevance as leading critics in an art world that increasingly looked to other voices for affirmation. But for Younge there were more urgent local issues at stake, especially during the states of emergency. He argued, "Firstly, it is not emanating from the 'townships,' it is emanating from the Thupelo Workshop in the heart of a white farming district for two 'all expenses paid' weeks. Secondly, the connection between 'abstraction' and 'life-affirming' art is sententious." Younge also questioned the consistent choice of proponents of abstract art to run the workshops, and he worried aloud that "it seems inappropriate that the formal remnants of abstract expressionism's legacy should be pushed by an agency as powerfully connected as USSALEP," since, "despite all the claims that African art is primarily geometric, African art has a demonstrably figurative tradition."[105]

This searching commentary was an attempt to evaluate the "Africanness" of the workshop. Younge's comments were rooted in a common concern among artists and activists at the time: to imagine a uniquely South African national culture for a postapartheid future. He clearly feared that the kind of art produced after the Thupelo experience might neglect a vital commitment to local cultural models and to local political affairs. In the process, Younge's comments reduced the trouble with Thupelo to a simple polarity between figuration and abstraction. This dualistic view of art had been a recurring theme in the history of modernist art in Europe, and Younge translated it into a polemical distinction between good "committed" art and morally suspicious "apolitical" art.[106] This kind of dichotomous thinking had great appeal among leftists in the South African art scene during the 1980s. But the effect of isolating such a polemically paired distinction as a tool for evaluating the commitment or "Africanness" of contemporary art was that it obscured other potential influences and motivations, as well as older local art practices. According to Barbara Ludman, writing in the popular magazine *Tribute*, in 1987, this sort of "search for roots" did in fact form a part of the discussion among participating artists at Thupelo:

Thupelo has been accused of "cultural imperialism"—because of the tendency of participants to create abstract works instead of the politically relevant etchings, township scenes and pastel character studies which are recognizably South African. This puzzles some of the participants, including Johannesburg Art Foundation director Bill Ainslie, who points out that Ndebele designs are also abstract art; that abstraction is "at home in Africa".[107]

Those searching for traditional or foreign roots for the abstract art made at Thupelo often overlook the facts of a long history of socialization and artistic experimentation between black and white artists, a history that included forays into various degrees of abstraction. The critical appraisal of work by artists who were in dialogue about aesthetic concerns over the years, such as Skotnes, Kumalo, Ainslie, Koloane, Sihlali, Portway, and Maqhubela, fell prey to urgent (and sometimes unnuanced or intemperate) concerns for political commitment during the 1980s. In addition, much of what was labeled the product of "foreign influence" at Thupelo was often more local than supposed. Younge's statement on Thupelo claimed that abstract art was foreign to black South African artists, with the question left open whether figurative art in modernist media that followed in the footsteps of the Popular Front aesthetic of the 1930s was not foreign. An expressionistic art popular in Germany at the turn of the last century, and later adapted in South Africa as "township art," might likewise also not be seen as "foreign." Younge implied, ultimately, that the local idiom "appropriate" to black artists was that which pointed directly to the resistance of the South African people to racial and class repression. On this essential point, he was in agreement with other cultural workers in the UDF movement, including exiled activists like Thami Mnyele and Wally Serote. However, what these cultural workers called the "tradition of resistance" really only became popular in South Africa with the rise of Black Consciousness during the 1970s and again after the Culture and Resistance festival in 1982. It was difficult to reconcile this tradition with what transpired at Thupelo, since artists like Koloane had hoped to move beyond "sloganeering" and self-referential art through experimentation at the workshops. While Younge rightly questioned those, like Thupelo's visiting critic Kenworth Moffett, who hyperbolically proclaimed the liberatory potential of abstract art, he did not distinguish between the wishful thinking of a visiting critic whose specialty was American painting, and the desires and intentions of the black artists actually attending the workshops.

Art dealers and collectors also rejected Thupelo. The art made during the first workshops was not very popular outside the group of artists who had attended and their sponsors. Most of the work was sold to members of subsidizing organizations like USSALEP, or to Robert Loder, who was a major collector of African and modernist art. According to Anthusa Sotiriades, the works produced

were considered "elitist" because of their scale.[108] This initially tepid interest in art from Thupelo may also have been due to the general distaste for modernist nonobjective painting among popular audiences everywhere. According to David Craven, abstract expressionism in particular frequently signifies "the 'illegitimacy' of art experts and the culture they represent, all of which supposedly involves the 'duping' of 'ordinary' people."[109] Furthermore, even though David Koloane and Bill Ainslie were South African, Robert Loder and Anthony Caro were British, and Graham Peacock was Canadian, some South African observers perceived that "the Americans" were trying to "dupe" the people, and the art experts hoped to save the black artists from themselves. Marilyn Martin, a champion of the Thupelo endeavor, cited one instance when "one of the Thupelo workshops was rudely disrupted by 'concerned individuals,' including gallery owners, who had come to protect black artists and serve their interests."[110]

Even more patronizing was one academic's concern with Ainslie's style of multiracial workshopping, claiming, "Where contact between a less developed person or group and a more developed culture occurs, it is argued that the former tends to be more influenced and dominated."[111] Surely, too, as Ivor Powell has argued, the "transcultural" claims for a "common and identical humanity" made for modernist abstract art could be perceived as threatening to "those who insist on upon difference as definitive."[112] Lionel Davis responded heatedly to such unwelcome concerns: "We are not dummies. They must leave us to explore and reject and then we will develop and grow."[113] Bongiwe Dhlomo further confronted the criticism of the "Americanization" of black artists, by accusing the art market itself of having forced black artists into cultural isolation and political sloganeering:

> No-one ever talked about the "Spaniardisation" of American artists when they were influenced by people like Picasso. Artists can't grow if they never experiment with other art forms . . . [W]hite artists aren't expected to . . . dig into their Dutch or English colonial roots for inspiration. But black artists, as the political situation gets fiercer, are expected to carry the banner for the liberation struggle in one hand while holding on to the goat-hide skin of their ancestral roots in the other . . . There is a need for black artists to break out of the small, tight world apartheid has imposed on them.[114]

It is also likely that the majority of works produced during the two weeks at Thupelo appeared unfinished. Indeed, much of the work was in sketch form, or was the result of first-time experiments whose technical aspects had not yet been mastered. The "results" of the workshop were only expected to show up weeks or months after the workshop session, as was the case at Triangle. The fact that most Thupelo artists had no studios to return to, and thus no place where they might hone the new skills practiced at the workshop, only complicated the matter of

finding suitable "finished" pieces for sale to collectors. The lack of proper studios also delayed the time between the workshops and their desired results.

The most strident objection against Thupelo was raised by Colin Richards in the pages of the *Weekly Mail* in 1987.[115] Richards's comments, which he would later refer to as "intemperate,"[116] were in response to a presentation given at the Johannesburg Art Foundation by Thupelo visiting artist Graham Peacock titled "Abstract Indoctrination: The Present Situation. Canada, USA, and Europe and Its Relation to SA." Peacock made what Richards considered a shallow proclamation about "affinity" between Ndebele mural art and abstract art at Thupelo. To him, Peacock's comments sounded like an unexamined repetition of the Museum of Modern Art in New York's widely criticized exhibition Primitivism in 20th Century Art: Affinity of the Tribal and the Modern (1984).[117] The reference to Ndebele art was especially irksome, since at the time the KwaNdebele "homeland" was undergoing severe repression. He also took issue with what he saw as the cultural imperialism behind the Thupelo enterprise.

Richards's essay referred to the Johannesburg Art Foundation as "the last outpost of abstract art in an artworld inconsiderately out of step with such things."[118] And he dismissed Bill Ainslie as a "missionary" among black artists. Richards felt that Ainslie made exaggerated claims for the Thupelo Project as "'the central unifying forum' for virtually all of art culture in his self-styled black constituency."[119] Instead, as Richards saw it, "The actual organizational base of the project, however, is a little more limited than this large claim admits. It appears to be a collaborative venture between the foundation, the Federated Union of Black Arts and the United States/South African Leadership Exchange Programme [*sic*]."[120] Richards then declaimed the raison d'être of Thupelo, and accused its artists of producing lousy art:

> Clearly the Thupelo Art Project has noble aims. The first is to overcome the "restrictions on the creation of good art caused by apartheid" while the second involves "stimulating the best possible work through developing a workshop and exhibiting workshop interchange between artists on a local, national, and international level". So much for the theory. The practice of "good art" and the "best possible work" is another story.[121]

Richards's primary contention with Thupelo was made explicit at the end of his article:

> Do we want, or need, to heed [Kenworth] Moffett and "produce a real movement (and) become like one of those centers of abstraction, New York, Edmonton, or Toronto"? Are the considerable resources of the contributing groups being appropriately utilized in the community? . . . These questions seem all the more urgent if we remember the historical role of "apolitical" abstract expressionism in the years of the Cold War . . . Certainly [Thupelo's]

cult of the individual, its rhetoric of "freedom of expression", its "apolitical" posture have precedents in the history of American cultural politics and foreign affairs. And these seem to have more to do with the maintenance of American hegemony than the cultivation of an indigenous or "alternative" culture.[122]

Richards's argument, like Younge's, tended to suppress the black artists' input in Thupelo. Ainslie was the only local participant named by Richards. It was as if the perspectives of the black artists who predominated at the workshops and who clustered around Koloane (since, after all, it was also Koloane's initiative) were not themselves important, and that Ainslie's (or Moffett's or Peacock's) personal enrapture with Clement Greenberg's formalist theories (and their implicit cold war heroicism) was all that was at stake at Thupelo. That said, the rhetoric of Ainslie, Moffett, and Peacock was indeed depoliticized and formalist. It was made even more suspect given the political climate in South Africa, and by their spurious references to "Ndebele art" as a "local" rationale for an art practice that was clearly in thrall to the New York school of the 1950s.

While Younge and Richards had astutely isolated some troubling aspects about Thupelo, certain factual inaccuracies muddied their larger critique of its alleged cultural imperialism. For instance, as I have shown, the idea that USSALEP "initiated" or "organized" Thupelo was erroneous. Although tantalizing, it is also difficult to prove the claim that the sponsorship of Thupelo by USSALEP was a blatant attempt to repeat, in South Africa, the American government's cold war–era promotion of abstract art as a representation of "freedom" and the "American way." USSALEP, at least on paper, was solely a private philanthropic organization and not an entity of the United States government, though it is worth noting that the U.S. Department of State does have a history of running exchange programs, to boost America's profile abroad, through similar private contract agencies.[123] Nevertheless, by the time Colin Richards's article appeared in 1987, USSALEP had ceased supporting Thupelo and shifted its attention to other educational initiatives.[124] In the end the overall intimation that Thupelo had in some way sold out to the Americans was a powerful one, especially given the (justifiable) paranoia that permeated the progressive movement during the states of emergency of the 1980s.

The sources for Richards's and Younge's accusations of cultural imperialism were essays by Max Kozloff and Eva Cockcroft published in *Artforum* magazine in 1973 and 1974. Kozloff and Cockcroft revisited, in light of its cold war context, what Irving Sandler had once termed "The Triumph of American Painting," that is, the rise of the New York school in the 1950s. They claimed that abstract expressionism fit well into the zeitgeist and the rhetoric of the early post–World War II period. Kozloff and Cockcroft also chronicled how, during the 1950s and

1960s, the United States government and the Museum of Modern Art in New York conspired to promote the "New American Painting" abroad as propaganda for "freedom" in a new era of American-led capitalist democracy. Their essays were anthologized in Francis Frascina's *Pollock and After: The Critical Debate* in 1985.[125] Given its publication date, Frascina's anthology itself may have inspired South African critics of the Thupelo Project. Also coincidental was the publication in 1983 of Serge Guilbaut's *How New York Stole the Idea of Modern Art,* a book that traced the earlier history of the politics of abstract art.[126] Whether or not the Guilbaut or Frascina texts were their source, the South African critiques of Thupelo were grafted to a fashion pervasive within American academia at the time. By the 1980s, challenging Clement Greenberg's formalist paradigm and its nebulous discourse of "quality" in light of its historically fraught relation to cold war distinctions between "us and them," "Communist and free," "artistic and political," and so on had become a rite of passage for mainstream scholars of post–World War II American art. Although their contents militated against the status quo of the 1950s and 1960s, the publication of books like *Pollock and After* and *How New York Stole the Idea of Modern Art* also marked a growing academic institutionalization of critical, if not dismissive, positions vis-à-vis Clement Greenberg's 1960s formalist dictum for "truth to medium." This mainstream approach was humorously referred to as "Clembashing." The concurrence of the founding of the Thupelo Project with the publication of these canonical texts likely bedeviled art critics who were ensconced in the South African universities and had followed the academic trends emanating from abroad. Furthermore, Paul Stopforth, who taught at the University of the Witwatersrand during the Thupelo years, recalled that "something about Bill Ainslie" in particular "freaked out" local academics:

> There were certain postmodern artists and intellectuals in South Africa who just raised their hands in horror every time Bill Ainslie was mentioned, because of this kind of "cultural imperialism" embedded in what they saw as his position. But we were all culturally colonized. We all sat there, whites as well, and what did we learn about? America, New York, Paris. We weren't looking at Africa . . . Bill Ainslie got a lot of bad press that was not deserved. These are the people who sit in academic institutions, and put their fingers together, and do nothing.[127]

David Koloane's response to Thupelo's critics was similar: "The irony is that such presumptuous assertions emanate from some academic quarters. Surprisingly when the same academics pursue their studies in American Universities, as they often do, no negative slur is made."[128] Unfortunately, as Stopforth suggested, though one may read hypocrisy, sententiousness, or even the pursuit of academic fashion into the various criticisms of Thupelo, this does not close the book on

the larger trouble with cultural imperialism and potential efforts to co-opt the struggle through the arts. And so we must take this argument seriously, and examine more closely the role of USSALEP and Thupelo in relation to the South African revolution.

Cold War Redux

The executive director of USSALEP during the first years of Thupelo was Steven McDonald, a Foreign Service career man who had worked during the Carter administration as a political officer in the Pretoria embassy. McDonald had also worked on the Rockefeller Foundation–funded policy study for the book *South Africa: Time Running Out* (1981) before taking up the USSALEP post from 1982 to 1986. McDonald's recollections about USSALEP's involvement with Thupelo go to the heart of the matter, and I quote him at length:

> When I came to USSALEP . . . I saw it as time to move away from the old
> dialogue/exchange basis . . . and begin to work with the black community
> on training/development issues to help break the chains of apartheid . . .
> Also, there was no "arts policy" per se in USSALEP . . . [T]he arts also
> offered a field where blacks were involved and there was an outlet for
> growth, professionalism, and impact. I worked with FUBA and we began
> sponsoring someone annually for the Triangle Workshop in upstate New
> York . . . Those years were full of paranoia amongst black South Africans.
> The paranoia was pretty wide spread, but America was a prime target. It
> was pretty well deserved . . . [T]he US had now elected Reagan, promoted
> "constructive engagement", declared the white regime a valuable ally in
> the fight against communism, and focused all policy initiatives on keeping
> SA government cooperation on regional solutions in Angola, Namibia, and
> Rhodesia/Zimbabwe. Black South Africans, and their aspirations, were
> very secondary . . . USSALEP was inextricably tied to the US[;] there-
> fore, many black South Africans assumed some official influence. I had
> been [with the] State Department and many current and past USSALEP
> people had government connections . . . [but] US government influence on
> USSALEP was not a factor. We took no government money . . . If there
> was an "ominous" influence, it had nothing to do with government, but
> reflected the corporate membership of our board. We had reps . . . from
> Exxon, Firestone, Deere, and other big corporations, who, of course were
> very anti-sanctions . . . But, we chose to not . . . have a public profile on
> the issue . . . So, there was no promotion of "apolitical" art. In fact, almost
> all the art we were involved in had a definite "liberation" theme . . . Art in
> USSALEP offices, here and in SA, reflected the liberation theme strongly.[129]

Steven McDonald's remarks clarify three things. First, that USSALEP op-posed the official U.S. government line during the Reagan years.[130] Second, that

the pressure of U.S. and South African corporations on their decision-making process outweighed any government influence. And third, that during the period of USSALEP sponsorship of Thupelo, the promotion of black empowerment and the theme of "liberation" took precedence over any specific aesthetic interest in abstract or "apolitical" art on the sponsor's part.[131] It is also important to consider the context of the Rockefeller Foundation study that Steven McDonald worked on before he joined USSALEP in 1982. Its introduction ended with the following lines: "The formulation of new approaches to the problem is urgent. There is already violence in South Africa. If genuine progress toward meeting the grievances of South Africa's blacks is not made soon, it will intensify and spread. Time is running out."[132] These introductory words demonstrated a desire to promote the struggle against apartheid while avoiding militancy and violence. While the Reagan White House sought to "minimize Soviet influence" in the region at the expense of a human rights focus and a forceful opposition to apartheid, the Rockefeller study proposed a set of more humane alternatives. Among its five "Objectives for US Policy," two recommended applying more pressure on the South African government to share power with other racial groups; one encouraged support of structures within South Africa that promoted black aspirations and welfare; and the remaining two were concerned with minimizing the impact of potential economic sanctions on the United States. The third objective, the development of "black leadership," was explained with the following rationale:

> Aid for black leaders will benefit the individuals themselves and may indirectly contribute to the process of change . . . U.S. assistance to black South Africans will also increase their understanding of our values and help us to understand theirs. This base of common experience and personal contact, especially at the leadership level will . . . help protect U.S. interests when those individuals reach positions of power in South Africa . . . [and] will also help in the task of monitoring and assessing changes in that country.[133]

Under this same "objective," USSALEP was mentioned as an organization that, by 1981, had pursued similar goals for more than twenty years.[134] The United States–South Africa Leadership Exchange Program, as its name suggests, fit in the section on the development of contacts with black leaders and the creation of a black elite. USSALEP's sponsorship of Thupelo may be understood as being similarly motivated by the trickle-down theory of black empowerment.

In their comments about Thupelo, Durant Sihlali and David Koloane each asserted that professionalism for black artists was something they had been historically denied, with the effect of curtailing their iconographic range as well as their ability to generate a sustainable income from their art. Thupelo for them represented a small step out of what they felt was a cul-de-sac of amateurism. Judging from the Rockefeller study and from Steven McDonald's later recollections, USSALEP

held a similar view of what was needed, though one that leaned more toward "U.S. interests" and the buffering of a feared Communist (i.e., "Soviet-influenced") takeover in South Africa. Through their development and "monitoring" of a black elite, USSALEP was interested in helping the overthrow of apartheid inequities, by nonmilitant means if possible. For a short period this strategy included funding for "liberation" through the arts.

Under the umbrella of the United Democratic Front, any organization in opposition to the nationalist regime was supposedly a welcome ally in the struggle, as long as it supported the principles of the Freedom Charter—which USSALEP and Thupelo did. At least that was the ideal UDF line. In practice the more militant UDF activists objected to collaboration with "softer" contributors to the struggle, fearing that the struggle would be sold out to "liberal interests" and that the class struggle would be disengaged from the wider goals of black liberation. Early during his presidency, Ronald Reagan jokingly referred to his relations with his more conservative supporters: "Sometimes our right hand doesn't know what our far-right hand is doing."[135] In the South African struggle, too, the relationship between the more pragmatic leadership in exile and the more militant rank and file in-country was sometimes out of sync in terms of clear procedural policy: the left hand could not always control what the far-left hand was doing. Steven McDonald's comments about the "justified" paranoia of South African blacks spoke to very real concerns about contributing to the definition of the struggle without offending the activists at the center of the struggle who might eventually become South Africa's leaders.

In a related vein, South African political historian Tom Lodge has traced the history of the African (Native) National Congress, from its early days as a moderate advocacy group founded by members of the university-educated African elite, to the beginnings of the UDF movement. He characterized the ANC leadership as more pragmatic and less "Communist-terroristic" than its opponents in Pretoria consistently alleged, despite its historical alliance with the South African Communist Party.[136] Likewise, in his analysis of the UDF, Keith Gottschalk observed that the rhetoric of socialism and the use of Soviet iconography were highly popular tools for mobilizing the people to insurrection. Yet, "as soon as the government moved towards unbanning the ANC and negotiations, socialist slogans swiftly became marginal or disappeared altogether," in favor of the promotion of "a mixed economy."[137]

The cold war split the world into polemical "with us or against us" camps, and the chaos that accompanied the slow death of apartheid made the South African art scene a fractured mirror of the larger world caught, unimaginatively, in the vise between the "the triumph of America over Communism" and the tactical use of socialist rhetoric by leaders in the struggle. The Thupelo Project's origins and goals were obscured by observers who viewed the project solely within

the confines of this conflicted paradigm. But if the trouble with Thupelo was reducible to its political dimension, it had as much to do with the politics of privilege as it did the politics of aesthetic choice. There was, in my view, an accurate intuition on the part of some members of the radical white elite that Thupelo was contributing to the making-up of a new black elite. The most insightful take on Thupelo was perhaps that made by its very first visiting artist, Peter Bradley. He surmised that there were potentially three "cards" in play with USSALEP's sponsorship of Thupelo: (1) American interests; (2) a real desire to make a positive impact upon the revolution in South Africa; and (3) the artist's individual desire for fame in the international art world.[138]

Art's Community

The American art history of the cultural cold war was replayed in South Africa in the 1980s—but oddly and with mixed results. For one thing, there was a divergence of opinion regarding the teleology of the project among the participants in Thupelo. Bill Ainslie, and Robert Loder, though certainly keen on the social development aspects of the workshop movement, tended to emphasize the aesthetic and autonomous qualities of art, and to evacuate the immediate political stakes of making any kind of modernist art. Artists like David Koloane, Helen Sebidi, and Durant Sihlali focused on the integration of the social and aesthetic dimensions of their shared art practice, and were more likely to foreground the political ramifications of their change in art practice. Arguably, too, the political stakes were much higher for these black artists. Was the formalist appearance of modernist abstract art a sign for them of a new kind of community in the making, in addition to being something appropriate for cosmopolitan artists like them to explore? The optical qualities of the experiments in painting conducted at Thupelo had much in common with the abstract expressionist "look" (for example, automatic drawing techniques and copiously flowing paint). But in the main, the rhetoric of the Thupelo group differed from those who adhered to a hard-core "Greenbergian" approach to art.

Homi K. Bhabha, at the end of an essay on cross-cultural translation, related the following story that has a bearing on the interpretation of Thupelo:

> Once, as a boy in Bombay . . . I opened a museum catalogue and discovered a late Giacometti. The attenuated figure, stilled in the petrified forest of his body, the straightened flesh turned inwards: who was this man? And suddenly the museum opened onto a thousand village squares and city centres, in every part of India, where the main street . . . leads to a familiar, diminutive piece of statuary . . . the icon of Independent India: Mahatma Gandhi.
>
> From that moment on, for me the Father of the Nation lived in the shadow of Giacometti's "Walking Man 1" (1960). And when I read of the

Mahatma's defiant march to the seashore at Dandi, to draw a handful of free salt from the water and thus oppose the British Government's iniquitous salt tax, I saw the other figure marching too . . . In that walk . . . that turns salt into the symbol of freedom, or bronze into a human image, I felt the need to translate, to create something else, somewhere between art and history; and with it the desire to go *beyond*.[139]

Bhabha's argument was that "mistranslation" and "misuse" are at the core of any act of culture, and that making art is about making a "difference." This becomes even more apparent when one culture's objects are put to work in another's cultural (or historical) context. Although his example was a more extreme case of "foreign" borrowing of art for one's own ends, his insight is appropriate to our discussion of the context of the Thupelo workshops. In South Africa, the history of European modern art was already known to the (adult) artists, and the materials explored at Thupelo were "foreign" only in their newness. "Western" art media and techniques had long been culturally familiar items for black South African artists. What was unique at Thupelo was how it enfolded the opportunity to practice new skills into the social and political landscape of South Africa in the 1980s.

During their years with the Medu Art Ensemble, Thami Mnyele and Wally Serote were eloquent polemicists in exile for the cultural policies within the liberation movement during the 1980s. They spoke clearly of the necessity for aligning artistic practice with the struggle against apartheid, and they conceived of the struggle as a phenomenon that would bring a new community into being. In their view, art was something that serviced the needs of "the people" and in turn was informed by the community. Theirs was a creative model for community, but a reflective model for the relation of art to history and society. The Thupelo group followed a complementary trajectory for the making of community, but a somewhat contrary trajectory for the making of art. Its members' commitment to the struggle against the social effects of apartheid manifested itself in the making of a new community that was opposed to the racially separatist, culturally isolating, and developmentally demeaning status quo, rather than a literal illustration of the community-as-struggle in their art. For them the coming community was not their wider audience, it was the working group of artists themselves. Community art, for them, became "a community of artists." In its small way, too, it was hoped that the resulting group would become a model to inspire change for a postapartheid South African society. Owen Kelly, a participant in the community arts movement in Britain during the 1970s, described a position sympathetic to that of the Thupelo group:

Community . . . is not an entity, nor even an abstraction, but a set of shared social meanings which are constantly created and mutated through the actions

and interactions of its members, and through their interaction with wider society . . . The community is not available for "development" by funders or "management" by externals. Rather it grows by member participation . . . One does not work "with" a community. One participates in bringing a community into being.[140]

The form Thupelo took, a two-week workshop where materials, lodging, and food were provided for the chosen artists, though similar to that of Triangle in New York, held a very different significance in South Africa. I would suggest further that the Triangle idea itself was to a large extent born in South Africa and in the end served to reinvigorate formalist, abstract expressionist art internationally as much as or more than vice versa. Whichever direction we might plot the vectors of influence, what at Triangle was taken as an intensive refresher course for midcareer studio artists, at Thupelo was an incredible luxury for the black artists. This luxury provided more than a taste of the middle-class experience of white South Africa. It also allowed the possibility of thinking beyond the immediate needs of the present, beyond producing art for a market (or a political program) that made demands on content in black artists' work. A door was opened to thinking about what else art could be. The door was opened by the community created around Thupelo, and the thinking took the form of experiments with modernist abstraction.

Postscript: Beneath the Blanket Boycott

One of the curious things about the Thupelo workshops, given the accusations of American imperialism laid against them in the press, is that the antiapartheid Cultural Boycott was not applied to the project. South African artists were not supposed to be traveling overseas, and international performers were routinely blacklisted by the progressive movement for playing in South Africa. David Koloane explained why Thupelo had been excused from the boycott:

> The Cultural Boycott was on already. From the beginning, the ANC Cultural Desk made a distinction between money meant for educational purposes, and other kinds of projects. We approached them for a black artist educational project [Thupelo], and were given a special concession . . . They knew me because I had curated the visual art section at the Culture and Resistance Festival . . . Bill [Ainslie] was also in constant touch with the ANC.[141]

From the pragmatic point of view of the ANC in exile, Thupelo looked like a sound project. But the deeper reason for their special concession is only hinted at in these remarks. David Koloane's struggle credentials were good, since he had helped organize the art exhibition shown in Gaborone with Dikobe Martins, an artist with underground connections to ANC sabotage cells. He also knew people

like Thami Mnyele, Wally Serote, Albie Sachs, Joe Manana (later the ANC Cultural Desk head), and other key players in the struggle movement and the ANC upper ranks. They had all been regular visitors at the Ainslie household. Ainslie himself had shared his studio with these men, and he even helped some of them escape the country. Despite all his rhetoric about painting outside of ideology, his commitment to working in a nonracial manner and the company he kept garnered for Ainslie the profoundest respect among those who would later go on to leadership positions within the African National Congress. They gave the Thupelo Project a special concession because they already knew from personal experience what kinds of social riches the workshop method could produce, no matter what the art looked like. One might conclude erroneously, from the hardened public positions taken by various actors on the South African art scene, that an artist like Thami Mnyele would have had little common cause with one like Bill Ainslie. Despite the angry dialogue in print these artists were actually part of the same social circle. What really mattered, the day-to-day politics of survival against the grain of apartheid, was hidden beneath polemic debates about the "commitment" of art to the struggle.

Following the clear gains of the United Democratic Front and the growing surge of cultural activism, ANC president Oliver Tambo announced in 1987 that the Cultural Boycott from then on would be applied "on a more selective basis."[142] Even before 1987 there had been special cases, like Thupelo, that had been condoned by the struggle leadership in exile. During 1989–90, President de Klerk sped up the process of permanently dismantling apartheid from the inside. His decision to act, he claimed at the time, was only possible because the danger of an African communism, perhaps the biggest fear of the Afrikaner nationalists, had finally passed with the disintegration of the Soviet Union. As these events were unfolding, and as bans on the ANC and other groups were lifted and they were brought to the bargaining table, the ANC again adjusted its official cultural policy. The role of art became both wider and more diminished: diminished because it was no longer needed as one of the few conduits available for money for the struggle, nor as a public platform for dissent, since opposition parties were now legal; expanded because definitions of what "committed" art could officially be were relaxed. A position paper released by the ANC in Lusaka, Zambia, in May 1989 noted one such shift in policy:

> The document represents a considerable rationalization of boycott policy, and extends the notion of a selective boycott adopted by the organization in 1986 and vigorously debated at various conferences since then—notably at the Culture in Another South Africa conference held in Amsterdam in late 1987, and a United Nations sponsored conference in Athens late last year . . . The document notes that the culture of democratic South Africa, "though distinctly South African, is infused with an internationalist,

humanist spirit that draws upon the best of the cultural heritage of all the population groups of our country and the rest of humanity."[143]

Then, following de Klerk's formal unbanning of the opposition in February 1990, the *Weekly Mail* published a portion of Albie Sachs's "Preparing Ourselves for Freedom," a position paper he had originally delivered at an in-house seminar of the ANC in 1989. Sachs, who had survived a car bomb attack by the South African government in Mozambique and would later head the new South African constitutional court, suggested somewhat tongue in cheek that the ANC "ban" itself from saying "culture is a weapon of the struggle" for at least five years. He claimed, further, that such a narrow view of culture impoverished the struggle itself. He also proposed that rather than making images of petrol bombs and Casspirs (police trucks), poets and visual artists should strive instead for the kind of emotional depth achieved by musicians like Hugh Masekela and Abdullah Ibrahim.[144]

This was an important document. It set out new priorities for the politics of artistic representation after the fall of communism and after the demise of apartheid. But what Sachs was suggesting was the kind of openness in the arts that those associated with groups like Thupelo had already been working on for at least half a decade—some of them since the 1960s. Thus it should come as no surprise that when, in 1990, David Koloane was asked by the ANC to curate exhibitions to accompany its Zabalaza festival in London, the "committed" art he chose was made by Louis Maqhubela, Dumile Feni, and artists from the Thupelo group. These three generations of artists had all worked in Ainslie's workshop over the years and had tended toward the abstract in their compositions. While the politicians were busy trying to figure out what the new postapartheid South African culture might look like, artists like Koloane were able to show what had been going on all along in the grey areas of art during those black-and-white years.

6 | THESE GUYS ARE HEAVY
Alternative Forms of Commitment

Cape Town artist and activist Lionel Davis recalled that during the late 1980s, given all the censorship and repression of the political opposition, art events became some of the few situations in which political gatherings, and multiracial gatherings, could surreptitiously take place in South Africa.[1] Culture was a door, artist and Thupelo organizer Bongiwe Dhlomo also said, and a great deal of the overseas money that suddenly became available for antiapartheid organizations in the 1980s was funneled through it.[2] By the end of the decade most progressive art organizations were also political organizations, either as fronts or as groups that were participating in small acts that could bring a postapartheid culture into being. Artists were not only used by the progressive movement to serve its needs, artists were in the forefront of the changes happening in the country and they were often ahead of the game when it came to figuring out what the next step should be.

One of the strategies of forward-looking artists in South Africa after 1976 was to reflect upon the quotidian in their work, and not just to mirror it. Variations on the theme of "everydayness" had been prominent in international intellectual circles after 1968 among followers of French cultural theorists Michel de Certeau, Michel Foucault, and Henri Lefebvre. During the 1980s in South Africa, the theory of the "everyday" was brought forward, revitalized, and posed as a positive alternative for an art with semantic richness aligned to democratic struggle, one that did not wish to fall into the traps of doctrinaire and heroic art by committee or

apolitical art for art's sake. Much of the art produced in the wake of the Thupelo workshops, for instance, also dealt in some way with imaginative explorations of the ordinary. This introspective look at ordinariness was in part a natural progression for South African artists, since it was close to the thematic emphases on everyday rituals already seen in township art. But the iconographic field was broadened in the 1980s. It moved beyond the usual stereotypes of poverty (i.e., "class") and black life (i.e., "race"), and style became less bound by the previous poles of expressionist or realist depiction. This chapter examines several examples of how this trend played out in practice, and through these examples seeks to break ground for a more complicated study of art and struggle at the end of apartheid.

The Struggle and the Ordinary

In the May 1988 issue of *Tribute*, the Urban Foundation's magazine aimed at a middle-class black readership, renowned Sophiatown writer and one-time *Drum* magazine fiction editor, Ezekiel Mphahlele, castigated those in the UDF movement who had taken it upon themselves to publicly chastise artists for being uncommitted to the struggle. His essay was general in tone but could very well have been referring to the controversy surrounding the Thupelo Project:

> There are activists who visit art and educational centres making veiled threats against artists and educators unwilling to allow their creative energies to be placed at the service of a particular political organization or its ideology . . . Do our public activists even know the labour pains the artist suffers in the creative process, or are they only interested in the finished product which they then arbitrarily label relevant or irrelevant or bourgeois? Then they throw in prescriptive words like "community-based", as if artists were not members of a community . . . Let us get this clear in our heads concerning commitment, revolution, relevance. The artist . . . is a member of a community. He takes this for granted . . . He is a product of ghetto life, a descendant of slaves, dispossessed, exploited and terrorized by the law and its agents. The artist also has private yearnings, aspirations, if he is passionately committed to art and life . . . Good art is what elevates us, compels us to see in it ourselves as we were, are and hope to be . . . The artist's revolution is an on-going process, not an ad hoc historical event. He is engaged in a revolution of mind and feeling. He is a teacher, interpreter, a historian of feeling.[3]

Mphahlele understood, as Albie Sachs had, that art needed to do other work in addition to chronicling oppression and directly propagandizing the struggle. It needed to open out onto new terrain beyond the boundaries of oppressive culture, and the more doctrinaire forms of counterculture. To break out of what he saw as an impasse in representation, the author and critic Njabulo Ndebele made a

dramatic proposal during the zenith of the UDF movement. His emphasis was on writing, but his ideas could be applied equally to the visual arts. He claimed that a truly revolutionary culture in South Africa needed to go beyond the limits of a pamphleteering art. Art needed to help bring a new South Africa into being, and not just shake fists against the old South Africa. Art that truly serves people needed to help find new solutions to old problems and not just fight against the system in a reactive manner:

> [T]he greatest challenge of the South African revolution is in the search for ways of thinking, ways of perception, that will help to break down the closed epistemological structures of South African oppression. Structures which can severely compromise resistance by dominating thinking itself. The challenge is to free the entire social imagination of the oppressed from the laws of perception that have characterized apartheid society. For writers this means freeing the creative process itself from those very laws. It means extending the writer's perception of what can be written about, and the means and methods of writing.[4]

One strategy Ndebele proposed for opening out the iconographic and stylistic range of committed artists was to pay more attention to the everyday struggles of people, the smaller stories of how people go about their daily rituals, and how through these acts they resist oppression. Such an approach to the problem of representation would point to the contradictions within the enemy, and within the actors in the struggle as well. Part of the reason for South African writers' tendency to imprint the South African scene into history in black-and-white terms, claimed Ndebele, was the profound intellectually stunting effect on their thinking of a Bantu Education policy that had reduced the repertoire of the imagination of artists.

Among visual artists, what sort of space was being cleared, or reclaimed, by the Thupelo artists, besides the general desire to be able to work in novel ways with new media? According to Ivor Powell, it took some time before the artists found their feet and for substantial changes to gel: "It took a while, though, before Thupelo really began to bear fruit. My memory is that the first workshops threw up work that, considered as final product, was frankly awful . . . There was a sense of people struggling to find new styles and real expression in the new modes of working. The real liberation happened only after a few years."[5] David Koloane agreed: "I saw Thupelo more as a facility than as a movement. I saw it as a process and I knew it was going to take time, like it takes time for an artist to develop a character of his own in his work."[6] Despite all the euphoric communal energy of the early Thupelo workshops, its critics agreed that most of the really interesting art in formal and even political terms only came a little later. And yet, contrary to the flak they had received in the press for being "apolitical" artists,

outside of the context of the two-week workshops, consistent attention was paid in the work of the Thupelo artists to social and political currents, and even to "liberation" themes.

David Koloane's *Made in South Africa,* a small mixed-media and collage work on board from 1979, is a striking instance of socially conscious abstract art produced by Thupelo group artists (Figure 44), one that also addressed the micropolitics of daily routines. This piece dates from Koloane's early engagement with the work of Louis Maqhubela and Bill Ainslie, and it exemplifies the extent to which a kind of allover abstraction was already being practiced by some black artists in South Africa even before Thupelo. Thupelo did not introduce this technique; it reintroduced it in an anti-individualist social context. *Made in South Africa* is equally a marker of Koloane's early concern with politically oppositional themes. In the bottom right corner is a scratched-up photograph of the artist, a page ripped out of his *dompas* identity document. *Made in South Africa* is a new kind of document, an imagined passport to beyond the border of South Africa's then draconian politics of ethnic identity. Koloane's version of the passbook is much more colorful than the original. In fact, this small painting enacts a sort of soft iconoclasm, a metaphorical erasure performed in private against the image of the passbook. Here the insulting, racially categorizing reference tables are swept under a swirl of colorful paint. The photographic picture of the man remains,

Figure 44. David Koloane, *Made in South Africa,* 1979. Mixed media on board, 59.5 x 63 cm. Courtesy of David Koloane.

but the oppressive bureaucratic grid of apartheid is overwritten, unreadable, and the "identity" of the artist is now freed from determination. Here too there is a hint of the kind of thematic differences to come in art of the Thupelo group, and in the rise of protest art during the early 1980s. This small painting prefigures both tendencies. Art for Koloane was a means to look beyond, or at least work through, the violent immediacy of the social conditions at hand and not merely a means to record what was going down. Koloane commented on his own work five years after the Thupelo Project began, situating his art in relation to the struggle in a manner that resonated with the writing of Ezekiel Mphahlele and Njabulo Ndebele:

> There is not a single black artist today whose work does not reflect the human concern in his or her community. And they need not be reminded of this . . . My work, like most urban-bred black artists, has unavoidably been influenced by the township environment. The squalor, grit, grime and dongas of Alexandra, where I was born, have been my only source of inspiration, of form, colour and content in my work. It is for this reason that I feel my work should challenge the expectations and perceptions imposed by social conditions and discrimination, with whatever available resources.[7]

Another painting by Koloane, *Workers* (1987), was included in Gavin Younge's book *Art of the South African Townships* on page 23. In it three men look blankly, if nobly, from above the viewer's own plane of vision. Are they waiting in a queue, sitting in the back of a police van, or hanging out in a shebeen drinking after a tough week's work? Koloane's emphasis is on the murky atmosphere that surrounds the figures, more than on their physiognomy. The image is reminiscent of another by Garth Erasmus, a Thupelo regular, Triangle attendee, and cofounder of Vakalisa, an art group dedicated to bringing art "to the people." Titled *Third Class Carriage*, Erasmus's small collage, though not itself social realist in style, was a clear homage to Honoré Daumier's realist painting of 1856 with the same name. Erasmus, through his citation of Daumier, pointed to the substandard conditions on the trains running between South Africa's black locations and its white cities. In a body of drawings and collages titled *Emergency Series* (1992), Erasmus chronicled the black versus black tensions, the ongoing police brutality, the endless mass funerals, and the general state of panic under the states of emergency during the time of political transition.[8]

Sam Nhlengethwa studied at Rorke's Drift and attended both Thupelo and Triangle.[9] He developed an evocative collage technique while at Rorke's Drift and later experimented further with mixed media at Thupelo and at the Art Foundation. Nhlengethwa's *Putco Strike* (1987), a mixed-media on paper work, is concerned with the mass boycotts of the township bus companies in response to rate hikes (Figure 45).[10] Inspired by his memory of the turmoil in KwaThema

Figure 45. Sam Nhlengethwa, *Putco Strike,* 1987. Collage and mixed media. Courtesy of Sam Nhlengethwa.

Township during his youth, the image was neither photographically realist nor somber in the manner of protest art. His take was whimsical, and his style was reminiscent of the collages of African American artist Romare Bearden, whom Nhlengethwa claimed as an influence.[11] The top register depicts protesters marching in the street, and the rest of the frame is given over to women, children, and workers making their way on bicycles and on foot. But this picture wasn't all about fun and games or smiles and bikes. The Putco strike may have had its day-to-day whimsy, but it was also an event intertwined with the larger history of often deadly mass resistance against the regime.

A later collage by Nhlengethwa depicted the apartheid martyr Steven Biko, lying dead on the cement floor of a prison cell after being beaten by police during interrogation (Figure 46). Titled *It Left Him Cold—the Death of Steve Biko* (1990), it was similar to Paul Stopforth's *Elegy* (1980), an image of Biko's broken body on a wheeled tray in the clinical setting of a morgue. Nhlengethwa's title referred to Minister of Justice James Kruger's bloodless statement after Biko's murder: "I am not glad and I am not sorry about Mr. Biko. It leaves me cold."[12] Nhlengethwa, through his use of the Beardenesque style, drew on a photo collage of archival images and recombined them to retell the scene of death during interrogation. Unlike Stopforth's image of martyrdom in a field of red, Nhlengethwa imagined Biko's crushed body in a cold grey cement room. On the wall, the only "art" is a framed picture of a policeman, a sign that the (police) state had overseen Biko's murder. From outside, the sun slants in through an open door, its golden light

Figure 46. Sam Nhlengethwa, *It Left Him Cold—The Death of Steve Biko,* 1990. Collage, pencil, and charcoal, 69 x 93 cm. Courtesy of Sam Nhlengethwa.

washing the dead man's feet. This door opening into the light should have been an avenue to freedom, from confinement and from isolation. But facing the exit outside the door is the grill of one of those yellow-and-blue armored police vehicles called "Casspirs" (or "Mello-Yellos"), and cops mill around in the distance, looking bored. There are multiple layers of historical reference in the work, including the black-and-white photograph of police next to the Casspir, which appears to be a press image from the Sharpeville massacre of 1960. Biko's singular ordeal was taken by many in the struggle to be symbolic of the daily humiliation, segregation, and brutality that the black population was made to suffer. Here a cup of coffee, a pair of glasses, and a hat sit on a small table next to the cold corpse: signs of another day's work done. As Andries Oliphant has noted, the inhumanity of this infamous scene was made nightmarish and was brought up-close in Stopforth's well-known series on Biko. For Nhlengethwa it is the nonchalant and routine aspect of the murder—its banality is what chills the heart.[13]

Kay Hassan, a graduate of Rorke's Drift and a Thupelo attendee, also worked with collage, but on a monumental scale. The poorer townships in South Africa, like U.S. ghettos, are dominated by billboards for soap products ("Omo makes your whites whiter") and ads for liquor, cigarettes, and junk food. According to Steven Sack, "The advertising billboards in Soweto tend to dominate the landscape and become transient landmarks. They get woven into the social fabric and

serve as literal and metaphoric indicators of the underlying social forces."[14] As with working-class neighborhoods in the United States, there was little concern on the part of apartheid city government to keep the quality of life at a bearable level in the black urban areas. One consequence was that advertisements were placed on almost every surface, and they appeared wherever the eye turned. The billboards were mostly for the kinds of things that held the quick-fix promise of making people "feel good" when they are down and out. In 1994 Kay Hassan began converting billboard ads like these into ready-made raw materials for what he termed "paper constructions." Hassan acquired unused advertisement sheets from printing companies, tore them up, and reconfigured them into large-scale collages.[15] These works depicted images from quotidian experience, in a painterly and "blown-up" fashion. Oppressive commodity culture was reimagined in mundane scenes such as a queue of voters, workers on their lunch break, or passengers crammed into the back of a VW "combi" minibus. In *Emva Komhlangano* (1994), the huge, abstract, torn sections of bubbles from a soda ad are redistributed into the form of three comrades emerging upbeat "After the Meeting" (Plate 4). The soda bubbles that form the shapes of their bodies are like the effervescent conversation among friends after a galvanizing political rally.

Patrick Mautloa collaborated during the early 1990s on installation pieces with Kay Hassan, and he also constructed his own abstract images using the refuse of the townships. Mautloa's art career began while he was still in high school, in 1969, when he sat in on Ezrom Legae's classes at the Jubilee Art Centre, the successor to the Adult Non-European Recreation Centre on Polly Street in downtown Johannesburg. During 1978 and 1979, he studied at Rorke's Drift. Mautloa learned welding with Peter Bradley during the first Thupelo workshop, and after Bradley's example he began searching for scrap wood and metal from which to compose his images. He is one of a number of artists from Thupelo, including most notably Durant Sihlali, whose work in the early 1990s turned to an emphasis on "the wall" as a sort of optical and metaphorical zooming-in on images from the old township art repertoire. Instead of illustrating a street of shacks, he took actual parts of shacks and built abstract images from these fragments (Figure 47). The results were often striking, spiritually evocative, and introspective. Mautloa applied minimal bits of pigment to punch up the look of his found object constructions, and used washes of color over large areas of canvas in juxtaposition with the found metal. Although his technique was different, these works were reminiscent of the spiritual effects achieved by the best Mark Rothko paintings, married to the nostalgic pathos seen in William Christenberry's "Southern Wall" constructions.

Mautloa did not use ready-made objects in a nonobjective manner. Each added element in his constructions retained an indexical reference to where it was found, which was often his own neighborhood in Alexandra Township. Until

Figure 47. Patrick Mautloa, *Metamorphosis Wall,* 1995. Acrylic on metal, canvas, and wood, 1220 x 1650 cm. Courtesy of Patrick Mautloa.

recently Alexandra was mostly a jumble of roughly banged-together corrugated iron and found-scrap houses whose look from a distance resembled Mautloa's constructions. During the violent period of transition to democracy between 1990 and 1994, Alexandra was the scene of some of the most horrific internecine bloodshed. In response, Mautloa made serene, flat, wall-sized pieces using bullet-riddled squares of metal found on the streets after armed attacks on houses. Later he covered similar pieces in gauze and painted them in pacific tones of pink, purple, and sky blue. Mautloa referred to these works as images meant to evoke the healing that would be needed if the "new" South Africa were to survive its long history of brutality.[16] He took pieces of the real world and placed them in a new frame: the fine art space of contemplation. In doing so, he followed in the footsteps of a history of conceptual art from Marcel Duchamp's ready-mades to William S. Burroughs's shotgun paintings—except that the bits of reality were taken from Mautloa's own neighborhood, and this placed the work at a greater depth in terms of social introspection.

Another direction in Pat Mautloa's work was begun with his collabora-tion with Johannesburg-based conceptual artist Ian Waldek. In 1994 Waldek invited Mautloa to work with him on an installation for an exhibition at Ricky Burnett's Newtown Gallery. The piece was a full-sized squatter's shack placed in the space of the gallery. The contents of the house were then shrink-wrapped as a commentary on the prurient gaze of anthropologists and tourists, who were then streaming into South Africa in record numbers and asking to be taken to Soweto to look around. Mautloa and Waldek's critique was aimed further at the rationalizing gaze of, for instance, those German ethnologists at the turn of the century who packed up whole villages in Africa, numbered the contents, then put them in storage in European museums. They also meant to take a jab at those from overseas who all of a sudden felt they needed a piece of South Africa for themselves after the transition to democracy. The title of the installation was *Mokhukhu,* which roughly translates from South Sotho as "shack." *Mokhukhu* is the name given to shanties built at informal settlements, out of cardboard and metal and parts of discarded signage. Such constructions, after 1986, began ap-pearing in the "grey areas" south of Johannesburg, as the apartheid urban areas laws were being repealed. The urgent need for cheap new housing was so great, for instance, that a swampy area north of Soweto, called Snake Park by the locals, was transformed into "Silver City," a small hamlet of zinc shacks that the city of Johannesburg provided with basic water and electricity services. Other former squatter settlements in Johannesburg have since been granted permanent status through the city's leasing of the stands and the servicing of the sites. Shacks like these have been a part of the everyday life of black people in South Africa since colonial times, and Waldek and Mautloa called a different kind of attention to them in the spotlighted setting of the art gallery.

Mokhukhu is also the name South Sotho traditionalists give to the temporary shelter built during the period of young men's initiation into adulthood. That period is one of considerable duress, and the name of the rickety structure built for the boys to live in is one that conjures thoughts of temporariness, hardship, and an ordeal that must be accepted if one expects to become a real man, and by extension a fully civilized person according to tradition. Furthermore, in the rural village context, *mokhukhu* is the name of a small temporary storage shed. Thus, in addition to their marking of the place of an invasive foreign scrutiny, there was an internal sort of critique at work in Waldek and Mautloa's installation. Through their reification and preservation of the shack in a modernist art context, they indicated the tragedy of the increasingly permanent status of the way of life represented by such informally built structures. Where *mokhukhu* once implied temporary shelter under duress, by the 1990s it had come to represent a state of suspended internal exile for thousands of South Africans.

These Guys Are Heavy

Writing about Thupelo in retrospect in 1996, Colin Richards viewed the legacy of the project as less about indoctrination into American-type abstract art than he had once thought:

> Given the restrictions on freedom of association, of movement, of habitation, given also the pressures exerted by the demands of political struggle, the Thupelo workshop focused on important aspects of the human dimensions of process. Amongst these we must count the sensual, existential, site-specific experience of freedom. Specifically the freedom of association, movement, collectivity of sensual embodiment of space both social and personal.[17]

This commentary was presaged by Marilyn Martin in 1989, in a moving defense of what she called "Black Abstract Art" against then-current writing by critics like Richards and Gavin Younge. In a paper on Thupelo artists, Martin pointed out that Gavin Younge neglected to comment on the work pictured above his own paragraphs on the Thupelo Project in *Art of the South African Townships*.[18] The image was a mixed-media work on canvas by Madi Phala that contained several stick figures and what appeared to be a hint of the corrugated metal wall of an urban slum shack (Plate 5). According to Martin, these figural elements, together with Phala's title, *These Guys Are Heavy,* actually contradicted the thrust of Younge's own argument about a nonreferential, apolitical art emanating from the Thupelo workshops. Marilyn Martin was herself notorious for speaking out against the "people's culture" movement during the later 1980s, and thus her defense of Thupelo could be read as disingenuous. But in my view her remarks on Madi

Phala's work were quite perceptive, and I am inspired to take her idea even further and to scratch beneath the surface of this painting. By doing so I mean to show how much of the people's art despised by Martin (and by President De Klerk) was not really that distant in spirit from the abstract work made by Thupelo artists such as Madi Phala.

First, the title of the piece was a reference to the black American slang term "heavy," with its connotation of ponderous, serious, or deeply significant political or emotional implications—as in the name of the 1990s rap group with a retro 1960s "Black Power" aesthetic: "The Brand New Heavies." Martin's essay cited other titles of abstract works by Phala, to strengthen her case that they held political implications: *Garrison* and *Adversity I*.

Who are the figures in *These Guys Are Heavy*? Are they some township toughs, some youths, or comrades, confronting the viewer with their crazed eyes and meaning to make him or her a bit uneasy? Are they security police come to harass the youth? Are they political prisoners, sitting in their jail box waiting? Planning their next revolutionary move?

If one were to study Madi Phala's earlier graphic art, as published in the radical culture journal *Staffrider*, it becomes clear that his Thupelo-inspired paintings evolved from earlier figural work in what was locally referred to as an "African surrealist" mode.[19] The style of this graphic work was similar to the early art of Thami Mnyele and to the mystical figural landscapes of Fikile Magadlela. Both of these artists were associated with the Black Consciousness movement during the 1970s and were early admirers of Dumile Feni's expressive distortion. Madi Phala's own drawings followed the example of these other artists, too, in his use of the theme of woman as a sign of the African soul, as something rooted in the soil and bursting under stress. An illustration of the popularity of this "Mother Africa" theme, and of its application among Black Consciousness–oriented artists of the period, appeared in the March 1979 issue of *Staffrider*, in a poem by Bonisile Joshua Motaung titled "Black Woman, Black Woman":

> Black woman, Black woman
> Beautiful like sunset across the horizon,
> With plaited hair and a face
> Shining with vaseline, making her
> More black in the night:
> Her face wears the look of nature.
> . . .
> Black woman, Black woman
> She moves with the
> Dignity of a funeral,
> It is not tears
> Shining in her eyes

But petals of blood[20]
Mourning the history
Of her suffering:
Obituaries of her children
Deeply line her face
Leaving freckles to mark
Their graves.

. . .

This poem at first seems to so closely paraphrase Léopold Senghor's "Femme noire" (1945) that it might be considered an homage to the poet who was a co-founder of negritude philosophy and a touchstone for the Black Consciousness movement. Compare the final two stanzas of Senghor's poem:

Femme nue, femme obscure
Huile que ne ride nul souffle, huile calme aux flancs de l'athlète, aux
 flancs des princes du Mali
Gazelle aux attaches célestes, les perles sont étoiles sur
 la nuit de ta peau
Délices des jeux de l'Esprit, les reflets de l'or ronge ta
 peau qui se moire
A l'ombre de ta chevelure, s'éclaire mon angoisse aux
 soleils prochains de tes yeux.

Femme nue, femme noire
Je chante ta beauté qui passe, forme que je fixe dans l'Eternel
Avant que le Destin jaloux ne te réduise en cendres pour
 nourrir les racines de la vie.[21]

Naked woman, dark woman
Oil no breeze can ripple, oil soothing the thighs
Of athletes and the thighs of the princes of Mali
Gazelle with celestial limbs, pearls are stars
Upon the night of your skin. Delight of the mind's riddles,
The reflections of red gold from your shimmering skin
In the shade of your hair, my despair
Lightens in the close suns of your eyes.

Naked woman, black woman
I sing your passing beauty and fix it for all Eternity
before a jealous Fate reduces you to ashes to nourish the roots
 of life.[22]

"Femme noire" was a statement, in verse, of the place of woman in negritude philosophy. Senghor's language reified black woman as the embodiment of sensuousness and as a place of comfort and warmth for men. In this poem, too, death

was a metaphor for the entombment of Africa's mythical past, as well as a source of sustenance for Africa's future. Motaung's description was more somber. For him the African woman suffered, she aged, and her tears bespoke the tragedy of the early death of her children. This perspective was shared among Black Consciousness writers in South Africa, most notably Mongane Wally Serote, whose poem "The Three Mothers" began with the lines:

Yes;
This the silence of our speedy uncurling youth-tangles
Forms folds, curves little surprised faces
That gape at our heritage,
Our age,
That grab son from mother like the cross did Jesus from Maria
The faces that have eyes that are tears
Tears from mothers,
Lord,
This has left me so silent!
. . .[23]

Through Motaung's and Serote's poetry, as well as that of other Black Consciousness writers, the rhythmic sensuousness of Senghor's negritude was translated into the cruel realism of the South African revolution. They described women's hardships as much as their sensuality. Their women carried the most unbearable burden: the sacrifice of their children. Sections of Motaung's poem also seem to have been a direct inspiration for Madi Phala's images. Motaung's lyric so closely approximated in word what Phala's drawing achieved with line that it might as well have been an illustration of the drawing, or vice versa. In addition to mirroring the poet's theme of "Africa as a woman," the images published by Phala in *Staffrider* also adapted and improved upon a theme then common among black South African artists: the black musician as a metaphorical sign of the condition of the race. Along these lines, it is noteworthy that the drawings that accompanied an article on Bob Marley, in the January 1981 issue of *Staffrider,* were credited not as "art" but as "Music by Madi Phala" (Figure 48). Each of two untitled graphite on paper drawings depicted a nude woman playing an instrument similar to a saxophone or a bass clarinet. The figure's beaded flesh seems to drip like sweat or blood from her ponderous breasts, her elbows, her mouth, and her bald head. She is completely covered with bubblelike spots, or freckles. Her fingers stick deep inside the instrument, which itself wraps around her body like a snake, and represents the horn's music visually. The instrument and its player become soulfully one.

Phala's pictures were far out compared with the quaint genre of street musicians associated with township art, and entered the weirder terrain of mystical

Figure 48. Madi Phala, illustration for an article on reggae music in *Staffrider* (December–January 1980–81).

and surreal allegory. He extended the musical theme so that musicians could also be seen as interpreters of the crushing effects of apartheid on human bodies, and of an irrepressible desire for resistance. This perspective on the expressive and revolutionary role of the musician—as a stand-in for all types of artists—can also be seen in the photograph of Abe Cindi by veteran *Drum* photographer Alf Kumalo, on the cover of *Staffrider* for February 1980. The shirtless musician was photographed as he sprayed his horn defiantly in the face of the viewer. And there is the photo of jazz saxophonist from the 1950s Sophiatown era, Kippie Moeketsi, in the November 1981 *Staffrider* (Figure 49). The musician, whose tragic story was recalled on the pages that followed, stares intently at his own horn, as if wondering what kind of noise the thing is going to produce next. How will it speak for him? This photograph of Kippie was one of the images that was copied over into drawings by Thami Mnyele during the 1980s and distributed by the Medu Art Ensemble. Mnyele used it in a montage with photographs of the uprising in Soweto and an image of comrades in battle on the South African border.

Senghor, Motaung, Serote, Mnyele, Dumile, Kippie, Fikile, and Madi Phala. Why not call attention to connections made between these artists—and between music, the body in distress, and poetry? Why reduce the work of South African artists during the last decades of apartheid to a polemic distinction between abstract and figurative art that only seeks to ask whether the one is more committed to the struggle than the other? Why diminish this art by assuming that only "local" influences are appropriate, and that artists "of color" must necessarily address "separate" issues?

Moving beyond this boundary, it is possible to discern that there were also European art references in Phala's image from Thupelo. Clearly the work owes a debt to Paul Klee, especially in its economical use of line to simply make figures out of sticks, thread, or squirts of paint direct from the tube. And its theme riffs off Picasso, especially the Picasso of *Guernica* and even more so the *Three Musicians* of 1921. These two are works from Picasso's planar and colorful studies in synthetic cubism. In purely technical terms, Phala's work is not synthetic cubism; its style is more a marriage of Klee's spare technique with some abstract expressionist flourishes. But *These Guys Are Heavy* seems to jump off directly from several key aspects of *Three Musicians*: the flat frame with three men staring out flatly from it, the hatch marks indicating a beard, and the light square ground surrounded by a darker rectangular ground. The overall feel of the abstraction itself is more in line with Klee's childlike glyph style, but the thematic influence here is certainly Picasso. Phala's painting scat-sings over the form of a famous Picasso, itself an icon for all modernist painters, but that does not mean that Phala meant to depict the same thing as Picasso. There is memory work in this piece: a memory of township art, the art of shacks and squalor. There is also a consciousness of protest art, with its titular hint, an evocation of heinous conditions and of their

Figure 49. Photograph of Kippie Moeketsi published in *Staffrider* (November 1981).

refusal through music. This is a tough mixture. The eye, if attentive to art and to history, is led from the discovery of the Picasso *Three Musicians* reference to Phala's earlier work on musicians, and back again.

Are Phala's musicians swinging, bluesy, and heavy with political portent? Are they singing *yakhal'inkomo,* "the cry of cattle" at the slaughter house that could also be seen in Dumile's tortured drawings, heard in Kippie's jazz, and read in Wally Serote's poems? Abdullah Ibrahim had already suggested the conflation of music and political protest at the Culture and Resistance festival in 1982. If Ibrahim's purely tonal piano music could have a revolutionary appeal, could not the abstraction of color and line in visual art do the same? Phala mined this golden vein in his painting. Seen in light of his earlier drawing, Phala's painting seems to be searching for a further means to make the visual more musical. I read it as a kind of acid-dipped sheet music, wherein the body and the music and the visual sign are as one, and are heavy with radical political intention. These are some of the meanings of *These Guys Are Heavy.*

7 | RESURFACING
The Art of Durant Sihlali

Durant Basi Sihlali was a teacher, a collector of visual memories, and a quietly influential art world figure in South Africa.[1] His oeuvre spanned the apartheid era and beyond, from the 1950s until his death in 2004 at age sixty-nine. Through a discussion of his work, one can historicize the politics of art in South Africa from an individual's perspective. In retrospect, Sihlali's art created a purposeful archive and a meditation on the conditions of black South African life under apartheid, and it performed subtle forms of aesthetic and individual resistance. In this chapter, I have chosen a selection of Sihlali's work for contextual analysis. I focus on the artist's pictorial interest in collecting personal memories of place that contested the official view of the apartheid landscape. I discuss Sihlali's early documentation of the historic places of black habitation in South African cities and his shift, in the 1980s, to aesthetic appropriation of popular ideas about African tradition through an engagement with forms of women's mural art. And I consider Sihlali's negotiation of the tension common in South African art between the terms "urban" and "rural," and "primitive" and "modern."

Vukuzenzele (Do It for Yourself)

Durant Sihlali was born in 1935 in Germiston, an industrial area southeast of Johannesburg. His first art experience came when he was five years old, when his parents were living in Johannesburg. Because of the harsh living conditions for

blacks in the segregated urban locations, they sent their son to Cala, in the rural Eastern Cape, to stay with his paternal grandparents. Sihlali recalled watching with fascination the making of mural designs on the walls of Xhosa homesteads in Cala.[2] He also recalled wishing he could join in, but was admonished when he copied house designs on the ground, being told, "Boys are not supposed to be doing drawings of murals, it's a woman's job," so instead he copied cartoons from newspapers on the only other paper at hand: toilet rolls.[3] By 1949, at age fourteen, he was back with his parents, who were then living in Moroka, outside of Johannesburg.

The early term for black residential neighborhoods was "location," a word crudely descriptive of the colonial practice of setting up separate ethnicity-based reservations in the rural areas and segregated residential areas in the urban areas. Later, the more euphemistic word "township" was used to describe the black urban areas. Keith Beavon has written that for white residents the term "township" meant, "a 'town' that was separate from their own," even though Soweto (and other "townships") did not share the usual characteristics of a proper town, such as a town square, formal industries, a shopping district, or adequate spaces for recreation and leisure.[4] Residents of the South-West Townships preferred to call the area "Vukuzenzele," "get on and do it for yourself."[5] The first ex-urban location in what would later become "Soweto" was established at Klipspruit (later named Pimville) in 1904. In 1935 the municipality built houses for black workers in nearby Orlando, and in 1946 the Moroka Emergency Camp (in the area today called Rockville) was established as temporary shelter for the growing number of black residents who had moved to Johannesburg during the Second World War.[6] Sophiatown, Newclare, and other black neighborhoods nearer to Johannesburg were bulldozed and their residents were moved to new houses in the sprawling zone that would officially be called South-West Township (which included Klipsruit, Orlando, and Moroka) after 1963. Residents eventually domesticated the bureaucratic acronym SOWETO as the proper place-name "Soweto."[7]

In Moroka, Sihlali attended informal art classes in an old farmhouse led by Thabita Bhengu, a social worker who introduced activities for the youth of the shantytown.[8] In 1950 he joined art classes taught by Alphius Kubeka at the newly built Chiawelo Recreation Center in Moroka. Kubeka was a naturalist easel painter, and he had attended night classes at the Polly Street Recreation Centre in downtown Johannesburg, then under the direction of Gideon Uys. In 1953, Sihlali (then eighteen) and other students from the Chiawelo group read in *Zonk!* magazine about the fame of black artists from Polly Street, and they began joining in the informal classes led by Cecil Skotnes at the center.[9]

Sihlali claimed to have not gotten along well with Skotnes (though the two later reconciled). As a teacher, Skotnes, he said, "encouraged a particular direction among the students which was that of painting in an expressionist manner . . .

I was working directly from observation at the time and not from imagination, so I don't think he had much interest in my kind of work."[10] Many of the best-known students from the period of Skotnes's tenure shared their teacher's interest in traditional sculptural forms from West and Central Africa, as translated by European modernists like Picasso, postcubist artists like British sculptors Henry Moore and Lynn Chadwick, and the Mexican artist Rufino Tamayo. Two students, Sidney Kumalo and Ezrom Legae, later became teachers themselves at Polly Street and at its successor institution, the Jubilee Social Centre.[11] During the 1960s, Legae, Kumalo, and Skotnes participated in exhibitions of the Amadlozi Group at the Egon Guenther Gallery. Sihlali's determination to work from observation resisted the dominant aesthetic current at Polly Street. He preferred to document the world around him instead of drawing inspiration from African tradition. This sentiment was conservative, in the sense that it bucked the avant-garde trends in South Africa at the time. It was also radical for its day, especially in its insistence on representing black life as it was lived in South Africa's cities, and on not filtering observation through the aesthetic lens of a romantic view of African "spirits of ancestors." Sihlali's aesthetic models were to be found in the world around him, and not in the kinds of African sculpture favored by artists like Skotnes, Legae, and Kumalo, and by gallerists like Guenther.

Sihlali claimed his perspective (and his facility in drawing) was appreciated by a number of other students at Polly Street who joined him in private working sessions on weekends, and on outdoor painting excursions.[12] Durant Sihlali's "group" included Ephraim Ngatane, Isaac Hlatshwayo, and Louis Maqhubela, all of whom were associated with what contemporary critics called the "township art" movement. This term is now considered to have derogatory racial connotations. At the time it was used to describe the sudden rise to prominence of a number of urban black artists on the South African art scene in the 1960s. These artists, by default, lived and worked in the black townships. Most of them were also in some way associated with Polly Street. The artists who closely followed the model of Sihlali and Ngatane developed an iconography of everyday life in the black ghettos of Johannesburg, along a spectrum of styles from realist to impressionist, mostly in watercolor, gouache, or graphic media on paper, and distinct in tone from the more expressionist or postcubist, Africanized forms of Legae, Kumalo, Lucas Sithole, and later Dumile. Although they were not aware of it in the early 1950s, this group of young black artists working closely with Sihlali were in fact heirs to a tradition of respectful illustration of the conditions of urban black life that was begun in the 1930s by two black pioneers of south African modernism: John Koenakeefe Mohl and Gerard Sekoto.[13] Louis Maqhubela recalled that only in 1958 did he see an article in *Protea*, a white-oriented society magazine, that mentioned that Sekoto's painting *Yellow Houses* could be seen at the Johannesburg Art Gallery. Maqhubela, Sihlali, and their

group immediately recognized the similarity between Sekoto's themes and their own painting.[14]

While he was often exhibited together with these other artists, Sihlali was adamant (in retrospect in 1995) that though he was painting scenes of the black townships, his own work was not "township art." He claimed instead that he was a visual reporter, along the lines of Thomas Baines and other earlier landscape artists in South Africa.[15] While Sihlali's perspective was that he should paint what he saw, his iteration and insistence on the place of black people in the cities of South Africa were implicit forms of resistance to apartheid policy.

During the 1960s, Sihlali worked closely with the white artists Carlo Sdoya, Ulrich Schwanecke, and Sydney Goldblatt. He and Schwanecke painted outdoor scenes together from 1964 to 1966, and through this experience he perfected his watercolor technique. Sihlali is today most revered for his thousands of water-color studies dating from the late 1960s to the early 1980s. But already in the 1950s he made what he called "recordings" of the landscapes, housing conditions, and daily lives of people, especially women (in the streets, at markets, going about domestic work) in the African urban slums of South Africa.[16] Every week Sihlali took his easel and paints out into the streets of Soweto (Figure 50). Anywhere else he went, too, whether city street or rural lane, he set up his easel outside, often using rainwater from roadside puddles to wet his brushes. In the process of re-cording, he repeated a set of formulas for rendering his immediate impressions in watercolor: for instance, his background atmospheric effects, which he achieved with a broken-bordered, fading, abstract stain.[17] In some respects, Sihlali's re-cordings did not challenge the conventions for artistic representation that were popular in South Africa in the 1950s and that emulated European painting of an earlier era. While recording the life around him, he sometimes reproduced generic types of picturesque images. In this he followed his acknowledged mod-els, the nineteenth-century Eastern Cape war correspondent Thomas Baines and the early-twentieth-century painter of charming views of crumbling Cape Malay homes, Gregoire Boonzaier.[18] Louis Maqhubela recalled that Sihlali preferred to paint dilapidated houses because "beautiful neat houses were not as interesting as slums."[19] Especially in his paintings of women, either washing clothes outdoors or going about their chores in courtyards, Sihlali depicted the same kinds of generic scenes of black city life common among black artists of his generation, as well as among their shared antecedents in nineteenth-century French art. And yet, compared with his friend Ephraim Ngatane, who aestheticized everyday town-ship scenes with a masterful stained glass impressionist technique (Figure 51), or Hlatshwayo, whose aerial views made black life in the slums look diminutive and quaint, Sihlali's township scenes were more objectively realist in their docu-mentation of how his subjects made do with the conditions they were given. He

Figure 50. Durant Sihlali at his easel, Soweto street, ca. 1974.

also painted landscapes beyond the confines of the black urban areas. His work thus located aesthetic pleasure in things not always directly related to the township experience as it was narrowly imagined by the popular white audience for so-called township art.[20]

Sihlali's income during his early career came in part from the sales of his genre scenes. He claimed the white-run galleries and their middle-class patrons demanded this of him. In order to support himself, from 1965 to 1969 he also sold work at Artists under the Sun, an outdoor market for mostly amateur artists. Artists under the Sun took place on Sundays in Joubert Park, in the garden facing the entrance to Johannesburg's premier institution of elite art: the Johannesburg Art Gallery (whose doors, until the 1980s, were not open to blacks unless chaperoned by a white person). Like most black artists of his

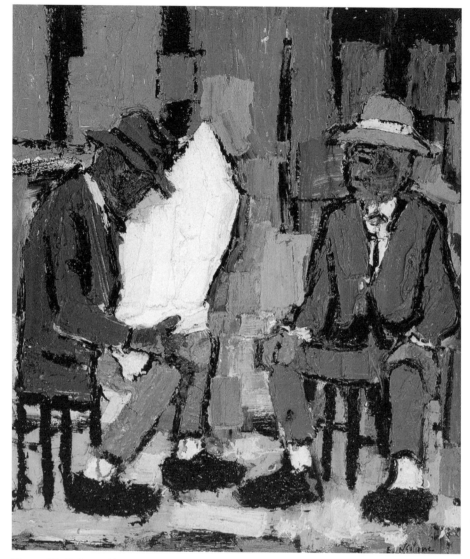

Figure 51. Ephraim Ngatane, *The Latest News,* 1970. Oil on board, 77 x 64.5 cm.

generation, fine art sales were not enough to support his family, so for most of
the 1960s he could only work in the studio in his spare time. He worked for
many years for a number of commercial art firms, including Creasant Potteries
from 1959 to 1961, and the Atlanta Wholesalers factory from 1961 to 1972.
There he designed ceramics and jewelry, and produced hand-painted curios, such
as miniature scenes of Mombassa, Kenya, safari animals, and the Eiffel Tower. He
also made greeting cards with his wife, Annah, and Ephraim Ngatane (Figure 52).
During an interview published in 1974, he dryly referred to his curio work as
"African Art."[21]

Figure 52.
Greeting cards
by Durant
Sihlali, 1955.
From the artist's
scrapbook.
Photograph by
John Peffer.

Race against Time

When Sihlali quit curio factory work and began devoting more time to his art in the early 1970s, his main medium continued to be watercolor on paper, a medium popularly associated with amateurs and Sunday painters.[22] Watercolor is also associated with the kind of nineteenth-century sketch work characteristic of Thomas Baines's military and ethnographic field reportage, and Constantin Guys's blasé depictions of everyday life.[23] Sihlali, in awe of these earlier artists but also in contrast with them, painted Johannesburg's harsher modernity, a hundred years later, using some of the same direct-sketch techniques.[24] By the 1970s, too, the artist's watercolors had become less picturesque and more programmatic, and he began recording in earnest the destruction of the old neighborhoods of black Johannesburg. In one work, an otherwise quaintly decrepit house is about to be run over by a bulldozer—a deadpan reminder of the crushing humiliations of the forced population removals enacted by the apartheid machine, in the guise of an actual machine (Figure 53). In another image, people stand by, waiting to scavenge the rafters and doorframes after municipal wreckers have done their job.

These pictures from the 1970s do not echo generic conventions. They also have an enumerative weight: there are hundreds of them. Most crucially, there is an obsessive, dream-calming aspect to these watercolor studies, something that might offer an antidote to the traumatic experience of what Sarat Maharaj has called the "internal diaspora" of black life in South Africa under apartheid: subject as it constantly was to forced removals, pass books, the sundering of families,

Figure 53. Durant Sihlali, *Race against Time,* 1973. Watercolor, 45 x 68 cm.

and the designation of ethnic "homelands" set up by the state.[25] According to Maharaj, each of these types of removal in South Africa gave the people a dually conflicted sense of longing and belonging—whether for the older types of racially mixed urban neighborhoods, or for a mythic history on the land that was itself frayed at its origins. Sihlali recalled (in 1995):

> I was a reporter . . . that came from the experience of my childhood, whereby my parents were moving from one area to the other. This trek affected my whole life. I'd be dreaming of the places we had been staying at—dream about the people—and this gnawing feeling kept on hammering at me. The only time I got a release was when I recorded . . . my places of stay . . . Through that, I have been able [to] feel relaxed and peaceful.[26]

During the 1970s, at the peak of his skill as a watercolorist, Sihlali's pictures of the destruction of old houses in Pimville epitomized this dialectic he spoke of: traumatic removal, recapture through artistic rendition, and relief from psychological pressure.[27] He told Joy Kuhn, when she visited his studio in Jabulani, Soweto, at the time:

> [T]he memory of past places used to haunt me. The only time I used to find satisfaction was when I had recorded the area in a drawing. Up to this very day I am concentrating mainly on that, not now recording for myself, but for the whole African population.[28]

Pimville was the later name for Klipspruit, where, at the turn of the century temporary shelter was set up ten miles from the city, on a hill overlooking a municipal sewage dump. It was where black South Africans formerly living in Johannesburg's mixed-race city slums with names like "Coolie Location" and "Brickfields" had been moved to—and thus isolated on racial grounds—after a bubonic plague scare in Johannesburg in 1904. These areas had included poor white, Chinese, Indian, African, and Malay residents, all living in close quarters. The plague outbreak of 1904 was possibly a false scare, designed to allow the city to remove unwanted people from the area. Half a century before Afrikaner nationalist rule, this forced relocation set in motion the early machinery of an urban apartheid. At Klipspruit the people were placed in barracks and temporary shelters that had been used previously in concentration camps for Afrikaners during the Second Boer War (1899–1902).[29] Given that Klipspruit was also a slum, and that it was located near a waste disposal facility, municipal officials clearly were less concerned with the health of the black population than they were with the potential impact of disease and racial mixing on the white population.[30] The result was that by 1947, Johannesburg had become the most segregated city in South Africa. When the National Party took over in 1948 and instituted its intensive policy of apartheid, it merely expanded upon the southwestern townships as it had inherited them from the previous Union government.[31]

At the Klipspruit/Pimville location, land was leased for house building, but the area soon became overcrowded and the infant mortality rate, by 1929, was more than 900 for every 1,000 births.[32] Despite these depressing statistics, Pimville was also an early center of black urban culture in South Africa. Miriam Makeba, the famous South African jazz singer, grew up there.[33] Pimville's earliest houses, the type around which Durant Sihlali also grew up in neighboring Moroka Township, were demolished by the municipality during the early 1970s as part of a corporate scheme to create an "elite residential node" for senior black staff.[34] The intention, in anticipation of a future democracy, was to create an African middle class, still segregated but enjoying enough of the trappings of economic success to form a buffer between the struggles of the masses and the white middle class who would retain most of the access to capital. In his work from this period, Sihlali revisited the geography of his own (and Johannesburg's) youth and recorded its destruction. Sihlali's images from the 1970s constitute an alternative archive of the many common scenes of everyday life in Johannesburg's older black neighborhoods, before their demolition: flooded homes after rains, families camping on roofs, women washing clothes at communal water taps, displaced persons living amid the ruins, crumbling yellow houses, and residents gleaning used building materials from among the debris. They are painted with a hurried brush, in acid colors—yellow, grey, and pale green. The artist claimed this bleak atmosphere was intentional:

> If you look at the brooding mood of the painting, the colors are not bright . . .
> There's no vibrancy in them. They are cold—whether it's in summer or winter.
> If you look at them—study well—you will find that the bulk of the work was
> mainly done in winter when everything is dead . . . In winter they looked like
> Soweto.[35]

In their iconography and in their color, the images of the Pimville series are emphatically not the kind of quaint and gemlike genre scenes of ramshackle shanties, penny whistlers, and street urchins associated with the styles of art by black artists that have been such a popular commodity among South Africa's liberal elite since the 1960s, nor are they characterized by the kinds of angst-filled distortions of the figure popularized by Dumile. Curiously, these works were only selectively shown. The majority remained until the end of his life in Sihlali's personal collection. The watercolors were his private record of what life was like for the black people of South Africa, before and during apartheid. "It wasn't good, Pimville, but it is good for Africans to remember it," he told Joy Kuhn, adding, "You can see the conditions—terrible. The small rooms. If they have to do their dishwashing they do it outside because there is no room in . . . These [pictures] I want to preserve for the Africans."[36] The artist's discretion about exhibiting these images is remarkable, even if it at first seems contradictory. Despite his initial re-

serve, saying, "It is a collection I will never exhibit or show anyone," he showed the Pimville series to Kuhn, and decades later to me, and to Colin Richards, and as far as I can tell, he showed them to anyone else that asked.

According to Ellen Hellmann, during the early decades of the twentieth century, white South Africa's attitude about black "urban Natives" was at first "based upon the fiction that an urban Native population as such did not exist."[37] By the 1940s, as industrial demands for black labor increased, the administration sought to officially curtail blacks' access to urban areas. This was a decade when Sihlali's family and thousands of other black families already lived in Johannesburg. Areas like Pimville were built as part of a pernicious system of racial separation, and the recording of the demolition of these earlier residences in Soweto saved the evidence of this African residential population in town, despite the willful ignorance of that history on the part of many of Johannesburg's white citizens. Sihlali's repetitious recordings of these places in the urban areas where black families had lived since the first half of the twentieth century were clearly personal acts of countermemory, an insistent yet discreet eruption of what Michel Foucault called "subjugated knowledge," against the official history of the state of South Africa.[38] According to Elizabeth Rankin, "It was important to Sihlali to record places that had meaning for him, and to transcribe in images the urban life of black people that was largely ignored in official accounts."[39] His watercolors give evidence of the daily lives and everyday locales of black people, who did not think of themselves (as the state did) as "temporary sojourners" in the urban areas, or as anonymous labor or sources of entertainment (as much of the white public did). Why, then, were they kept secreted away in his personal collection?

Part of the answer may be found if we consider both the local reception of his paintings, and the reception of his *performance* of the "artist" role in the context of the black townships under apartheid. Sihlali's career was often blocked by others' apprehensions about the power of art to change the relation of power between viewers and the represented. He faced fear wherever he chose to paint *en plein air*. Black residents were suspicious of him. Jealous husbands mistrusted him for painting their wives.[40] He was beaten and threatened by black township residents who did not want their picture "taken." "Sometimes," he told Joy Kuhn, "they tried to murder me because I painted them. This man here drove his horses off so I wouldn't paint his place."[41] According to Colin Richards,

> [Sihlali] often had to negotiate with inhabitants to paint the pictures he felt the need to paint. These discussions were often delicate, partly because the figure of the painter and the practice of painting were strange to those inhabitants. And in those dark days strangers were often as not harbingers of doom . . . [He also encountered] a common image taboo . . . if one makes an image of someone you "steal their shadow."[42]

Sihlali emphasized this danger when he recalled (in retrospect in 1995) that, though his documentation of all the places he had been—in all their facets and moods, and in different seasons—were challenges he enjoyed:

> At the same time, they were very hazardous. I'd be attacked, in some places, for recording those people. They said "I take their shadow." It is believed that once you draw somebody you have removed their spirit, and as such, he can die. So for that you must pay heavy [he said, laughing]. That means *anything.* You can be killed.[43]

He was undeterred, adding, "Nothing could stop me. Not even the '76 riots. I had been attacked several times, but I continued."[44] On June 16, 1976, during the Soweto uprising, schoolchildren marched en masse to protest unfair national education policies, and police responded with tear gas and bullets, sparking months of unrest that eventually left almost six hundred dead. In response, students burned cars, schools, and other city property in the township. During the turmoil on June 16, Sihlali returned to Pimville and painted the municipal rental offices in flames (Figure 54). Even then, he was not content just to paint scenes of urban blight and civil strife, and he went out from Soweto soon after the June uprising to paint landscapes in a favorite spot in the farmlands outside Potchefstroom.[45]

In an era when documentary images, especially photojournalistic ones, were being used to powerful effect to expose the malfeasance of the state, the police and township managers suspected the painter might also use his images to indict

Figure 54. Durant Sihlali, *Government Offices on Fire, Pimville, June 16, 1976.* Watercolor, 48 x 70 cm.

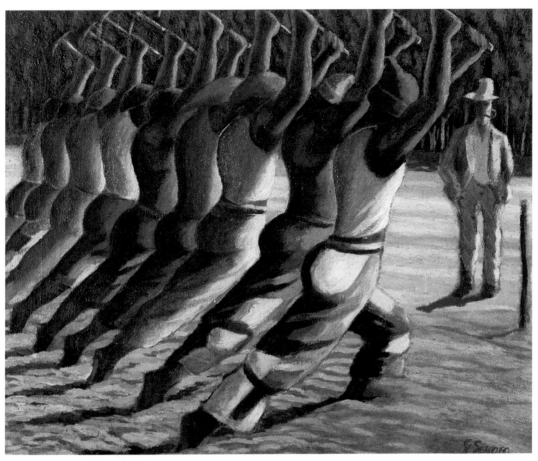

Plate 1. Gerard Sekoto, *Song of the Pick*, 1946–47. Oil on canvas board, 49 x 59.9 cm. Courtesy of the Gerard Sekoto Foundation.

Plate 2. Thamsanqa Mnyele, *Remember me/i am going/Time calls me*, 1974. Mixed media, 122 x 96.4 cm. Courtesy of David and Janet Adler.

THUPELO ART PROJECT

THUPELO is a Sotho word meaning to teach by example.

Dumisani Mabaso - Untitled - 1986 Workshop.
Triangle Participant.
(Purchased by the Johannesburg Art Gallery.)

Plate 3. Front cover of Thupelo Workshop fund-raising brochure. Dumisani Mabaso, Untitled, 1986. Mixed media on canvas, 166.4 x 286.4 cm. Painting, Collection of the Johannesburg Art Gallery.

Plate 4. Kay Hassan, *Emva Komhlangano,* 1994. Paper construction, 136.5 x 172 cm.

Plate 5. Madi Phala, *These Guys Are Heavy,* 1987. Mixed media on canvas.

Plate 6. Durant Sihlali, *Wall Impressions*, 1987. Reduction color linoleum print, 42 x 44 cm.

Plate 7. Wayne Barker, *Apies River*, 1989. Oil and enamel on canvas, 140 x 130 cm. Courtesy of Wayne Barker.

Plate 8. Chris Ledochowski, *Crowded Lounge, Lavender Hill*, 1992. Archival pigments on coated cotton paper, 34 x 50.8 cm. Courtesy of Chris Ledochowski.

their actions.[46] *Race against Time*, from the 1973 Pimville series, was the result of a sort of contest with the township manager, who had noticed the artist setting up his easel at other demolition sites earlier in the week. Sihlali desired to capture the image of an old home before the house itself was eliminated. Sihlali claimed, perhaps wistfully, that he won this contest.[47] Did the township manager, in his own way, also fear that his spirit might be stolen through the constructive painting of his destructive actions? What we can say with certainty is that Sihlali viewed his own practice as an artist as one of reclaiming the history of these places for future generations, by recording in successive images that which was slowly being erased, in progressive layers, by the apartheid system. He did not mean to destroy any memories of lost places by secreting their spirits or their images away. Rather, he meant to compile and safely store something of a personally recollected history by amassing and organizing these soon-to-be-forgotten scenes.

There is a further dimension to Sihlali's protectiveness about his paintings. He firmly stated his frustration with an art market that demanded a sentimentalizing view of the slummy living conditions of the majority of black South Africans.[48] He did not want his recordings (what I would call his memory archive) confused with an aesthetic seen as entertaining by a naive (white) audience.[49] Although forced to make commercial work in order to earn a living, a process he referred to glibly as "painting and selling,"[50] he held most of the paintings of the ruin of Pimville back for his personal collection. He saved them for the edification of future generations: for the children who, he said, "don't know how we were forced to live."[51]

Evening the Score

Sihlali's paintings from the 1980s on were so different from his earlier watercolors that at first the viewer might suspect they were by a completely different hand. His palette became luminous and his approach to the object shifted radically. But in their immediate, close-up exploration of the surfaces of everyday life, they have a great deal in common with the spirit of the 1970s Pimville series. These late works took the form of tracings from rural and urban surfaces that were then reworked in two dimensions using oils and acrylics, handmade paper, and a variety of printmaking processes. They simultaneously referenced political graffiti and the traditional art of annually repainting mural designs in the rural areas, both of which are inscriptional forms that share a palimpsest-like aspect.

One of Sihlali's reduction color prints from 1991 is titled *Wall Impressions* (Figure 55). This and other prints from the early 1990s were cut into the surface of linoleum floor tiles salvaged by Sihlali from the old indoor produce market in Newtown, which he then stored on the floor of his studio.[52] The Newtown market had been built on the site of the old Coolie Location, the place from which

Figure 55. Durant Sihlali,
Wall Impressions, 1991. Reduction
color linoleum print, 131 x 59 cm.

the earliest residents of Pimville were removed in 1904. Its linoleum tiles held the
scuff marks of a thousand footsteps, the scrape marks made by debris during the
renovation of the market building, and the impressions of Sihlali's own movements
in the studio. In a related print, *Spiritual Pillars* (1991), the linoleum has again
been gouged out in layers to form a field of graffiti-like floating patterns. These
are bounded forcefully, their chaos contained, by a rectilinear motif derived from
the decorated pillars that frame the entrance to a rural Ndebele homestead. The
same form appears in the reduction color lino, *Mapoga Pillar* (1991), and in an oil
painting titled *Ancient and Modern I* (1993).[53] This last title indicates that the art-
ist was consciously combining (and comparing) abstract art styles from the history

of European modernism with contemporary traditional art forms. It is not easy to determine which forms are the ancient ones and which are modern in this work.

Another example is a large handmade paper piece titled *Viva ANC Graffiti,* from 1992 (Figure 56). Although its overt subject is political sloganeering, it was constructed by spreading wet pigment-imbedded paper pulp in a manner analogous to the smearing of colored earth and dung to decorate a rural homestead. (Note also the cartoons of a face and a cat. These lend some levity to the composition, and they may further relate to Sihlali's early interest in copying cartoons and to nostalgia for his childhood.) The tactile process of the work's manufacture embodied the very sense of internal exile and the concomitant seeing in two worlds, urban African and rural African, that was officially denied by the apartheid homeland ideology—even while it was experienced literally and dually by the majority of South Africans. This work was not a literal recording of an outdoor scene like the Pimville watercolors were. Instead, Sihlali retraced with his own fingers the signatures of graffiti vandals and the wet-work designs of rural women—in a single gesture. Within one frame the work contains the visual politics of the city streets and the country farmlands during the 1980s in South Africa, a time when the revolution permeated all of the surfaces of everyday life.

Figure 56. Durant Sihlali, *Viva ANC Graffiti,* 1992. Handmade paper, 99 x 133 cm.

It also combined a Jackson Pollock–like effort to be "in the painting" with a will to be politically engaged. And it ascribes the role of art from an older African tradition to the artist's contemporary (and modernist) work.[54]

Until 1985, when the artist was fifty years old, Durant Sihlali's work had been more concerned with recording everyday scenes and the literal features of urban and rural landscapes, than with the exploration of inner landscapes or self-reflexive constructions of identity. Several events combined to change his perspective on his practice: the death of the artist's father in 1977; a papermaking class at Rand Afrikaans University in 1982; a series of two-week abstract art workshops supported by the United States–South Africa Leadership Exchange Program beginning in 1985; the Tributaries exhibition curated by Ricky Burnett in 1985 at the Africana Museum, a show that included rural artists and urban modernists all in the same space; a six-month residency during 1986 at the Pilot International School of the Arts in Nice, France; and an emotional reunion that year with old friends living in exile in London. Upon his return from Europe in 1987, Durant Sihlali announced he had discovered his "true identity."[55] He began to acknowledge publicly what he claimed to have long kept secret: that when he was a young man a traditional healer had informed Sihlali that he was *umtwana omhlophe*, a "white child . . . a medium through which the spirits spoke."[56] In the mid-1980s, after his own feelings of interior exile and his childhood memories of visits to the rural areas resurfaced during his travel abroad, he was haunted by the urge to use his art to directly address the neglected art of his ancestors and the "tragedy and tenacity" of his country.[57]

If we hope to chart the dramatic changes in Sihlali's work, we should not discount the effects on the artist of the dramatic political upheaval in South Africa after 1985, when for the first time since the 1960s the struggle for an end to apartheid actually seemed winnable. As the mass democratic movement was changing the course of South African history, critical questions about the look of a future democratic South Africa were debated by artists and leaders in the struggle. Other influential events were the mainstream current of intellectual discourse about "identity" in the 1980s, and the artist's exposure to international contemporary art trends, including the work of Jean-Michel Basquiat and other "graffiti artists," during his year abroad. Also significant was the kind of introspection possible for a man approaching seniority.

The event that pushed all of these elements to an epiphany, according to the artist, was simply the respite of his extended tour abroad. Sihlali was finally given the opportunity to work and learn on a professional level with a group of international artists. He also went from being a well-known artist in South Africa to being a virtual unknown in Europe. Sihlali's reaction, a common one among artists from outside the West who have encountered the "center" of art world power firsthand, was to turn inward, to look deeper into himself, and to

question and explore the meanings of home and the self that he had formerly taken for granted. These new opportunities to study art abroad, and the personal and political changes the artist lived through, made him examine himself as an "African" subject, now linked even more closely to the historical artistic traditions of his ancestors and to the modern political revolution in his own country. "I had to go out of Africa," he told Barbara Ludman in 1988, "to find what I should have been doing all along."[58] And he added, "During this period . . . I was closer to my ancestors spiritually. I was sort of haunted."[59]

Sihlali claimed he did not care to keep informed about current events in South Africa when he was abroad. The tragic toll of daily life was precisely what a Soweto resident could be spared from during his months overseas. What consumed him instead was his search for the meaning of his place in the world as a modern African person during a time of euphoric and violent social change. His *ancestral* past haunted him, not just the threat that recent experiences would be lost to memory or that old friends could be forgotten. After his sojourn in France, Sihlali reached back to a singular core memory, a sort of iconic master key, which for him was intimately linked to the idea of the ancestral and to things "African." This memory image was one bound by a specifically gendered proscription and followed by an intense and private art practice. Sihlali recalled:

> The first impressions I had [as a child] were the murals, which I found in the Eastern Cape done by the Xhosas [on my father's side]. And immediately I was made aware that it was taboo to do these things as a man. Boys are not supposed to be doing drawings of murals, it's a woman's job. . . . *My interest was so deep that I would have liked to have shown these women a thing or two* . . . I used to watch all that, and have a craving, that, ooh! I wish I could do the same thing.[60]

In an interview with Colin Richards, he stated further:

> I would usually do these things where I couldn't be seen by others, especially boys my own age. If they came and found me doing a drawing [with a stick in the dirt] I would quickly erase it with my foot. When they asked me what I was doing I would say "drawing a cow," and it would end there.[61]

Rudimentary drawings of cattle, as well as images of women in traditional dress and boys with slingshots, appeared in much of Sihlali's art in the mid-1980s. In one example, *Wall Impressions* (1987), the central cartoon is of an antelope or cow—possibly copied from a San rock art image (Plate 6). In this reduction color lino print, the animal floats above an abstract field of scored marks and diamond shapes suggestive of traditional architectural decoration. These are the things that routinely occupied young boys in South Africa's rural areas during the artist's youth. The herding of sheep and cattle is still entrusted to small boys in the rural

areas today. Sihlali's copies of cartoon cattle and women's designs thus referred to the same remembered childhood events, of an aesthetic, a set of images, and of art traditionally made by women.[62] Daily life, too, in the apartheid "homelands" was dominated by women, children, and old men, due to the outward migration of able-bodied men who left to sell their labor at the mines and in the industrial centers of South Africa.

The aesthetic that surfaced in Sihlali's art during the late 1980s embraced the current of graffiti art and adapted it to his concern with developing an "African" image appropriate to the revolutionary political climate in South Africa. Sihlali's 1980s images also contained iconographic and stylistic references to the art of his former student and colleague from the Polly Street days, Louis Maqhubela. Maqhubela had gone into exile in 1973, and Sihlali spent two weeks during Christmas in 1986 reminiscing with his old friend in London. During their re-union, Sihlali began a visual dialogue with Maqhubela's aesthetic while the two worked side by side in Maqhubela's studio.[63] Some of the emulated aspects in-cluded Maqhubela's application of a flat abstract color field as the background for allegorical cartoons, and his symbolic palette of barbed wires, doves, and traditional geometric designs. These motifs appear in an etching made in trib-ute to his friend and titled simply *Louis Maqhubela* (1987) (Figure 57). Sihlali also began exploring the use of crosshatched and meandering lines that, like Maqhubela's, were incised as sgraffito or drawn thinly on the surface in black. A number of Sihlali's paintings and prints from the later 1980s intermingled aspects of Maqhubela's technique, along with a controlled set of symbolic images from his own early childhood memories, and newly translated these elements in hom-age to the style of his old friend in London. From this basis, Sihlali developed a unique style that not only recorded history, as had his earlier work, but also reflected upon the process of historical recording itself and on the politicized practice of memory.

Colin Richards has related the secretive and proscriptive aspects of Sihlali's earliest childhood art experiences to the artist's perspective on both his real-ist watercolors and his later abstract 1980s work.[64] I would like to build upon Richard's insight by specifically recalling the houses demolished in Pimville, and the women's everyday world so often depicted in Sihlali's early watercolors.[65] In his own commentary on his formative art experience, Sihlali was a sensitive observer of what one might call, at least in South African cultural terms, the "feminine" in art and domestic life. Much of the artist's oeuvre depicts the lives of women. Perhaps this was, in part, because during his years as a watercolorist it was mostly women who were at home during the day when the artist was on his outdoor paint-ing excursions. Regardless, Sihlali's profession (his role as an artist) did not fit into any of the overinflated masculine ideal types that still have great valence in South Africa: he was an artist and a teacher, a father and a husband, but not an industrial

Figure 57. Durant Sihlali, *Louis Maqhubela,* 1987. Etching, 35 x 30 cm.

worker, or warrior, or antiapartheid comrade hero, or a *tsotsi* thug and woman-izer. Arguably, too, beginning with his late 1980s work, his perspective challenged the kind of gender fixity common to both rural and urban experiences in South Africa.[66] In my view, Sihlali's art practice stubbornly broke a spectrum of taboos about representation across South Africa's urban–rural nexus, across its official racial divide, and even across its stridently bipolar definition of gender. Toward the end of his long career, he sought a "way out" through a novel image of women's work in relation to art, the land, and the contemporary social world.

It is worth recalling that as a self-appointed community archivist of sorts, Sihlali's desired role in his urban and cosmopolitan community was to be a teacher, and "to show them a thing or two." This sentiment may be related to the artist's feelings when, as a child in the rural Eastern Cape, he watched, frustrated, wanting to participate as the women made beautiful designs on their houses. Later, he had stubbornly resisted the mode of instruction at Polly Street, insisting (though he just a teenager), "By the time I went to Skotnes I was already a professional artist, having long started exhibiting, so there was no way that Skotnes had any influence on me"; and had even held his own separate classes for Polly Street students.[67] He summed up this attitude, retained since he was a young man, by saying: "I believed in what I was doing and how I was doing it . . . and as a result I would not take any remark from somebody who has not got artistic skill."[68]

In his later work, Sihlali was finally able to return to the art forms he first had marveled at during the wonder years of his youth, but had been forbidden to do himself. It was also a return, but different in tenor, to the "spirit of the an-cestors" that Skotnes, Legae, and Kumalo had sought in art but that Sihlali had rejected in favor of an art of direct observation during the Polly Street years. This "return to origins" was not as sudden as the artist's late shift in style, since Sihlali had already painted an Ndebele-themed panel on commission for an Afrikaans poet during the 1950s. Also, in the 1960s he did a series of Ndebele watercolor studies in his realist style, but he maintained that the galleries' preference for his township scenes continually frustrated his desire to openly paint his traditional culture (Figure 58).[69] In the 1980s, the artist would return to this theme, now in a more introspective mode and with renewed conviction about its relevance.

Sihlali himself claimed a circular (and rather tidy) trajectory for his interest in traditional mural art: from early childhood in the Eastern Cape; to the com-missioned 1950s panel; to the "Mapoga" watercolor studies of the early 1960s; to images of fossilized rocks painted in 1964 as a "reflection . . . on the evil of this system which seemed impenetrable," as apartheid laws tightened; to reflections on ancient San rupestral art in the early 1980s; to a series on shields; to the late "Mapoga" wall series of 1988–93.[70] In fact, other historical accounts complicate the artist's autobiography.

Figure 58. Durant Sihlali, Ndebele (Mapoga) study, 1966. From the artist's scrapbook. Photograph by John Peffer.

Aside from his own recollections from early childhood, one of the main visual resources for Durant Sihlali's explorations into nonliteral art was, as I have mentioned, the murals painted by women on the homesteads of the Ndebele people—not the Xhosa and South Sotho murals made in the areas he had lived in as a child. He called the Ndebele by the term popular at midcentury, "Mapoga," after the name of the famous nineteenth-century head of the Ndzundza Ndebele, Mabhogo.[71] Ndebele art played an ambiguous (though central) role in the development of twentieth-century modernism and modernity in South Africa.[72] During the first half of the twentieth century, women in Ndebele communities asserted an African identity in the face of dispersal among white-owned farms north of Pretoria, by adapting mural forms derived from other ethnic groups. The apartheid government seized upon this new art form by setting up tourist villages

as showpieces for the ideal separation of ethnic groups. During the 1950s and 1960s, the "Mapoga" were a common subject for progressive artists and photographers in South Africa. This was especially true for those "settler modernists" who searched for indigenous models on which to base their engagement with European modernism. These white artists challenged the characteristically generalizing forms of European modernist primitivism by referencing their familiar (though often ambiguous and paternalistic) relations with local "primitive" cultures. The hybrid forms these white artists created helped clear a space for their own place in a cosmopolitan colonial, and postcolonial, South Africa.

Ndebele art was also shown to students at Polly Street.[73] The white artist Larry Scully, for instance, had painted a mural in Ndebele style inside a classroom when he was a part-time instructor at the center.[74] Sihlali was certainly exposed to these things, and there is evidence that the artist experimented with both abstract art techniques and traditional culture themes—on and off—from as early as the 1950s.[75] Sihlali's initial inspiration to seek out instruction at Polly Street came, we recall, when he saw a special issue on black artists and art centers in the tabloid magazine *Zonk!* One photograph in that issue showed a student sketching a model dressed as a worker, in front of Scully's Ndebele-type mural at Polly Street (Figure 59).[76] This one photograph is a fascinating document, since it appears to combine in one early image both of Sihlali's lifelong aesthetic concerns: the realist recording of everyday life and the modernist translation of African traditional culture by means of the Ndebele image.

In my view, traditional mural themes are apparent in many of the phases of Durant Sihlali's work. More than the contents or the themes, it was the *style* that changed in Sihlali's oeuvre over time: from genre painting and realism in the 1950s to early 1980s, to symbolist painting along the lines of Maqhubela in the 1980s, and eventually to a more postmodern type of stylistic overlay based in formalist principles and with a deeply spiritual investment in the object. His general outlook on the social role of art also shifted: from exterior depiction, to interior reflection upon real-world events. Regarding the work made after his study in Nice, Sihlali noted, "One important aspect of the work was its strong affinity with the paintings I had done 20 years before in collusion with my ancestors."[77] In our interviews, he also agreed that the late mural work approached many of the same kinds of surfaces seen in his previous realist watercolors of urban slums, except that the later images were made with an extreme close-up (and more introspective) view.

Sihlali's late 1980s work made an explicit and complex connection between the terms of the domestic/structural, the ancestral, the artistic, and the feminine. After naming his 1991 linoleum print in the form of a traditional architectural design *Spiritual Pillars,* he used the same architectural metaphor to describe what was both politically and aesthetically at stake in the collapse of apartheid. For him,

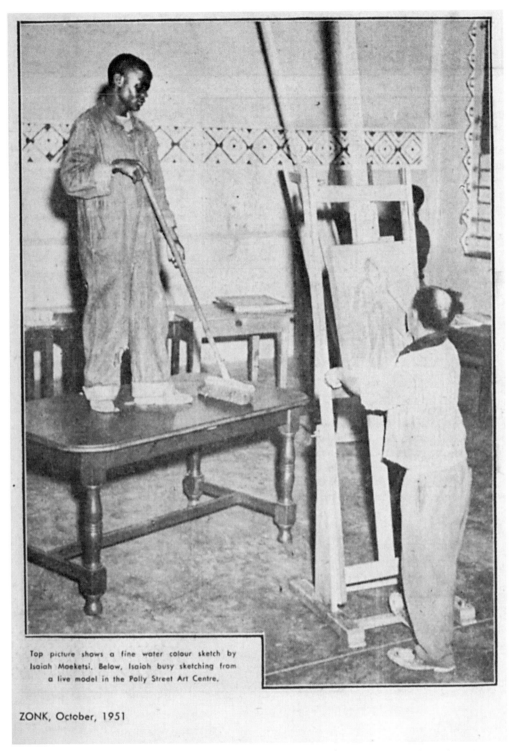

Top picture shows a fine water colour sketch by
Isaiah Moeketsi. Below, Isaiah busy sketching from
a live model in the Polly Street Art Centre.

ZONK, October, 1951

Figure 59. Photograph of Polly Street from *Zonk!* (October 1951): 13. The Ndebele-style stripe on the back wall was painted by Larry Scully. Image courtesy of the Beinecke Rare Book and Manuscript Library, Yale University.

as for many other artists of his generation, the coming postapartheid era held out an artlike promise of a new social configuration, constructed from a revisionist archaeology of memory traces. In a catalogue on his mural works he wrote:

> As the pillars of apartheid started to crumble in the late eighties my output showed significant changes . . . The Mapoga wall series . . . celebrates freedom of expression. In this series the spiritual power of my work is related to . . . our beliefs in a Trinity (Umvelinqangi) which encompasses our ancestral connection with the past, present and future. On these walls appear prayers, messages and secret maps, love songs and sloganeering, religious symbols and graffiti.[78]

Notice the rhetorical switchback in this statement and title, between "pillars of apartheid" crumbling, and an alternative kind of "spiritual pillars" connecting the past to the future. The common metaphor in both instances is the safety and order of the "house," a place that was traditionally the domain of women, though it was protected by men. With these images and words, Durant Sihlali was suggesting a method for putting South Africa's untidy house back in order, after the chaos and the violence at the end of apartheid. In his mural images the traces of history on the linoleum floor of the old Johannesburg produce market combine with the scrawled battle cries of activists and the graffitied signs of the resentment of the disenfranchised—what Sihlali called "signatures of the sick."[79] These free-floating elements are contained (and visually controlled) within a rectilinear form indicating the healing power of the artist's vision of traditional African family values.

Against the Wall

During the post-1976 era, there was an overtly political dimension to modernist muralism in South Africa. Antiapartheid cultural activists often referred to the example of traditional mural painters as a model for the kind of collective art-making process that they were promoting in South Africa. Thami Mnyele—an artist who worked in exile in Botswana with the ANC-aligned Medu Art Ensemble and produced agitprop art for distribution in South Africa during the 1980s—made this connection explicit in his writing during the 1980s (see chapter 3). By lionizing Ndebele art, Mnyele and his activist colleagues attempted to pry something useful for the revolution out of the indigenous cultures of South Africa. In theory, their aim was the establishment of a nonracial future for South Africa, free from the clutches of an apartheid ideology—one that held up every visible manifestation of the continuation of older African culture as an example of its ideal separation of races and ethnic nationalities. In practice, their expectations for the "cultural worker" and the "art committed to the struggle" could appear overbearing or even threatening to allies in the struggle. In this respect,

Durant Sihlali was ahead of his time by already thinking, more than a decade in advance, about what art could be *after* apartheid.

Although at first he had braved the streets during the 1976 uprising, eventually the danger that he would be attacked or his car burned by rioting youth made it more difficult for him to paint outdoors in the townships.[80] Still, in 1987, at the climax of the struggle period he began a project near his childhood home, using some of the earliest houses built in Soweto: the "elephant houses" (called this because of their curved roofs) of White City (the houses were whitewashed) in Jabavu. The plan was to obtain sponsorship from the paint manufacturer Plascon in order to paint tribal-type designs "transformed geometrically to modern non-tribalistic designs" on two dozen houses. Since it would be the only area in Soweto with such designs, Sihlali hoped that the publicity and the funds raised through charging tourists and film companies to shoot pictures in front of the decorated houses would help the impoverished elderly pensioners, the workforce of the 1950s who were still living in Jabavu thirty years later. With the support of Annette Loubser, sponsorship was found and permission given by the residents.[81] Loubser was enthusiastic about the White City project, because at the time, with the assistance of Gary van Wyk and backed by Plascon, she was herself organizing a comprehensive exhibition of wall art from rock painting to graffiti. Clearly the fashionable international discourse on graffiti and art, which was folded into the discourse on "mural art" in the South African context, was part of the zeitgeist of the 1980s. Sihlali sought to bring this interest back home to White City.

Work on the first house began on June 14, 1988, two days before the anniversary of the Soweto uprising. The newspapers reported it, and the following day the painter and his crew faced an angry mob "claiming the mural was not at all in line and in keeping with the political graffiti and slogans" written on the walls across the country by the youth belonging to the different antiapartheid organizations. Residents feared that the designs on their houses would attract *too much* attention and would make them targets for intimidation by the comrades. Sihlali was forced to abandon the project after completing only one house.[82] Years later, around the time of the elections in 1994, the attitude of the country toward public art changed. Township residents and the national government began encouraging community mural projects. Sihlali was then invited to paint murals in Soweto, including commissions for the Meadowlands Public Library in 1993 and the Diepkloof library in 1995.

Final Remarks

The question remains: Did Durant Sihlali's recontextualization of "Mapoga" women's art function in the same way as the primitivism of midcentury modernists who embraced indigenous traditional culture in their art, whether they were

"settler modernists" (like Battiss or Preller) or evoking "the spirit of the ances-tors" (like Skotnes, Legae, or Kumalo)? Was his use of "Mapoga" art merely as a conventional stereotype that foregrounded contemporary African traditional cultures, only to reify them as remnants of the past? In my view, Ndebele art was indeed the sign of something ancient and spiritual for Sihlali, but it was also a symbolic structure for healing at a time of social chaos in South Africa. It was a resource to be reharnessed in the urgently present circumstances of the revolu-tionary visual culture of the 1980s.

The artist's evocation of the role of his ancestors in his work after 1986 was also a more deeply personal sort of engagement with traditional culture. Unlike the work of white midcentury modernists, the indigenous art iconography in Durant Sihlali's work was a reference to his *own* people, and not to a local but ultimately inscrutable (and thus foreign-seeming) culture. His white colleagues' affinity for the "mysteriousness" of tribal art differed significantly from Sihlali's more intimate familiarity with indigenous traditions. Sihlali underscored the im-portance of his familial connection to the Ndebele when he informed Elza Miles in 1994 that he was descended from a branch of the "Skosana" clan that had broken off generations before from the Ndebele and settled in the Eastern Cape.[83] Sihlali claimed his family were closer cultural relatives of the Ndebele up north than they were of their Xhosa neighbors in the south. I have been unable to con-firm this direct connection that Sihlali spoke of, although it is quite likely that his ancestors had moved into the predominantly Xhosa area of the Ciskei during the great upheavals of Southern African populations at the time of the *mfecane,* the "great crushing" dispersal during the rise of the Zulu nation in the early nineteenth century.[84] If this was so, then as refugees, outsiders, and "beggars," they would have been referred to by the resident Xhosa as *Mfengu.* This is a term similar in meaning to "Ndebele," a word that itself derived from the North Sotho *Matabele,* for the Nguni-language-speaking "strangers from the east" who lived among them. Direct connection or not, Sihlali associated his own family history of internal African exile with the historical condition of the Transvaal Ndebele. As a black male artist he was further considered an outsider within his own com-munity and within the mainstream art world in South Africa. Accordingly he viewed the art of the "Mapoga women" (and the resistance to internal exile that it represented) as his birthright—and so he viewed them not as objects for study living in a place outside present time, but as contemporary, coeval, subjects with critical knowledge to share about his ancestors' traditions and about the potential value of art in a future South Africa.

By the 1980s, Sihlali, though not an activist himself, was intent on finding a method for linking the community-based aesthetic spoken of by cultural workers like Thami Mnyele to the signs of the revolutionary struggle and to his recollected images of the geographic locations of his own community's history. He was a medium, a ghost child, born, he said, to mediate between his urban cosmopolitan

community and their ancestral spirits on the land. He was also an artist whose mural-inflected work mediated the difference, and the artificial distance, between modernist aspirations and an indigenous aesthetics by surmising that every mark begets another, that all cultures were bound to each other by the primal inscription. "You can read through the surfaces of the walls," he told Colin Richards in 1994. "Magnify it, and you can read volumes, right back to the first mark made by humans on a rock surface. It is a chronicle of continuity."[85]

In retrospect, Sihlali's mural work was done with foresight. His studies thought through what the world might look like beyond apartheid, ten years before its end. As I wrote this chapter, I imagined the artist sifting through his hundreds of watercolors from the 1950s to the early 1980s. His collection was like a history book whose leaves contained images of the places that once haunted him, including his childhood memories, rural sketches, and rubbings from ancient rock etchings. He retraced each of these forms, successively laying all their lines out on the same surface in order to reconfigure them, and to selectively bring the past forward into the future. In the late 1980s and early 1990s, all of this personal experiential material was metaphorically brought out of private storage and exposed to the public light. In works that preceded the end of apartheid, such as *Viva ANC Graffiti* and *Reminders of Past Apartheid* (1987)—in which Africa became "Azania," and *Amandla* (Power) became "Mandela"—he predicted and helped define the political changes and the more fully integrated national culture to come, by attempting to reconcile the immediacy of realistic depiction and a romance with the idea of Africa (Figure 60).

Figure 60. Durant Sihlali, *Reminders of Past Apartheid,* 1987. Acrylic on paper, 79 x 56.7 cm.

Throughout this chapter I have suggested that Durant Sihlali was an archivist. Perhaps it is more accurate to say that, after 1986, his art began to *reflect upon* the archive, in the dual sense of forward projection and remembrance. That is, he reconsidered his own inventory of "recordings" and established their relevance both back in time and for the future. In *Archive Fever,* his meditation on the concept of the archive, Jacques Derrida notes that the creation of an archive "takes place at the place of originary and structural breakdown" of memory, and can never supplant "spontaneous, alive and internal experience."[86] The establishment of an archive thus enacts an authoritative measure of control over living memory, and dooms to secrecy and obscurity that which it does not deem necessary to include.[87] If this is what an archive does, then Sihlali's private accumulation of watercolor recordings created an *anti*archive out of his own lived memories. Its contents silently contested the official stories of apartheid, and even the supposedly heroic history of the struggle. His later reflections upon the idea of recording memory through art also countered the many levels of personal repression enacted through his own earlier archiving of images. They gave a many-layered riposte to the popular, art historical, and settler modernist archives of images of black South Africans. They proposed an alternative against the official archive of the apartheid state in relation to the bodies, labor, education, mobility, and visual cultures of black South Africans. Sihlali expressed all of these elements onto the surfaces of his late paper works and paintings, so that through overcrowding their censoring lines eventually crossed each other out. The remaining scars were smoothed over by the artist's hands and brushes, leaving behind a template for a future visual culture in South Africa.

8 | CENSORSHIP AND ICONOCLASM
Overturning Apartheid's Monuments

In 1986, on the tenth anniversary of the June 16 uprising in Soweto, the editors of the *Weekly Mail* were faced with a dilemma. Should they report on the events of the day and risk being shut down or having copies of the paper removed from newsstands by police? They decided to go to press as usual, but with the advice of their lawyers they excised all content that might contravene the censorship laws under the state of emergency. Borrowing from the tool kit of modernist artists (for whom iconoclasm worn on the sleeve is a rite of passage), the editors of the *Weekly Mail* decided to retain their own redaction marks on the printed pages (Figure 61). The result was an entire issue filled with black lines covering "objectionable" passages and the names of detainees, and empty spaces filling in where banned images would have been placed. This act of auto-iconoclasm was a potent statement about the extent of censorship under the states of emergency. It exposed the fact that in South Africa an age-old strategy of the censor in authoritarian societies was being applied, in which the public is forbidden to know that censorship is even taking place. By publishing its redaction marks, the *Weekly Mail* placed the government in the absurd position of having to ban blank spaces in newspapers.[1] But it was too late. By uncovering censorship through an act of visible erasure, the *Weekly Mail* had also revealed to the public the extent to which the government had been concealing the state of affairs in South Africa from its own citizens.

On page 23 of the same issue of the *Weekly Mail,* an empty frame was placed in the middle of the page, with a bar marked "RESTRICTED" across its

The State of Emergency

● **From PAGE 1**

● If it is subversive to favour ▮▮▮▮▮▮▮▮▮▮▮ ▮▮▮, we plead guilty.

● If it is subversive to believe that a newspaper's role is to inform the public, we plead guilty.

But we do not believe these are subversive. If South Africans are to make reasonable decisions about their future, they need all the information they can get.

The alternative is to face the future in ignorance. ▮▮▮▮▮▮▮▮

And this — not our newspaper — is most likely to undermine public confidence.

Nothing we do is likely to contribute to racial tension as much as the ▮▮▮▮▮▮▮▮ ▮▮▮ of thousands of South Africans.

Nothing we say about ▮▮▮▮▮▮▮▮ will promote them as much as the government's action in ▮▮▮▮▮▮▮▮ ▮▮▮.

Nothing we say about ▮▮▮▮▮▮▮▮ will cause people to doubt it as much as the actions of the ▮▮▮▮▮ ▮▮▮ themselves.

It is not we who are subversive. ▮▮▮▮▮▮▮▮ ▮▮▮▮▮▮▮▮

● This newspaper has been vetted by our lawyers in terms of an agreement with our printers and distributors.

— The Editors

Figure 61. *Weekly Mail*, June 20–26, 1986, page 2. Detail.

center. Its caption claimed the missing image would have shown artist Manfred Zylla's mixed-media diptych *Bullets and Sweets* (1985). We are led to assume that the image would have been banned because it contained references to the 1976 June uprising in Soweto (which may in fact be false). Zylla was already known in South Africa for having staged an event at the Community Arts Project in Cape Town four years earlier. There, on June 5, 1982, the artist pinned up several large drawings: of scowling military men, of good old boys at the *braai* (the Afrikaner barbecue), and of sinister-looking businessmen. Zylla invited a reggae band to play behind bars and asked the public to add whatever they wished to his drawings, thus allowing "the people" to finish his art with their graffiti (whether poignant or facile)—and thus appealing to a popular form of iconoclasm as a contrast with the government's authoritarian form of censorship (Figure 62).[2] *Bullets and Sweets,* the work cited but not pictured in the *Weekly Mail,* was a pastiche of photographs and newspaper images similar in approach to what Thami Mnyele was producing as agitprop with the Medu Art Ensemble in exile.[3] Children in school uniforms alternately shake their fists and crouch in fear, a policeman looms over them with a machine gun emerging from his crotch, and a line of armored vehicles lumbers toward the scene from the distance. Above and below, brightly colored candies

Figure 62. The results of Manfred Zylla's interactive art event at the Community Arts Project, June 5, 1982: *The Generals* and overdrawings. Crayon and mixed media, 200 x 300 cm. Courtesy of Manfred Zylla.

and newsprint frame these images. The penciled-in newspaper text describes "Operation Sweetie," a psychological operations campaign in which candies and toys were handed out to township youth—in order to try to convince them that the police were in the townships to protect and serve, and that frightening armored vehicles like Casspirs were "not just that which brings death." The *Weekly Mail* article that accompanied the absent picture referred the reader to a glossy architecture magazine called *ADA,* which, as primarily a white-oriented elite art venue (and not a mainstream newspaper), could more easily publish Zylla's work without being banned.

What is the relationship of iconoclasm to censorship? According to David Freedberg, iconoclasts of all varieties enact a form of censorship: a blotting out of obscene or fleshy or morally repugnant scenes.[4] For Freedberg such obliterative acts against art reveal the hidden power of images to be precisely that which stirs our passions. Michael Taussig has argued further that defacement in general tends simultaneously to unmask and to enhance the power of images.[5] Looking specifically at the European avant-gardes, Dario Gamboni has written that an iconoclastic attitude toward earlier art, and to bourgeois culture in general, can be considered a convention for modernist artists.[6] In South Africa at the end of apartheid,[7] a number of artists followed their European peers and turned to the modernist tradition of image breaking as a way to engage critically with repressive images from their recent past. They used the iconoclastic gesture to attack censorship. Their actions inverted the expected hierarchy of iconoclasm as censorship, revealing instead that censorship itself is a form of iconoclasm.

Aside from the symbolic erasure of "township art" by artists of the Thupelo group when they explored nonfigural abstract painting, or the graffiti event staged by Manfred Zylla in Cape Town, how was the general condition of censorship countered by South African artists?[8] In my approach to this question, this chapter examines several instances of symbolic defacement of public monuments in South Africa: Wayne Barker's overpainting of landscape scenes by Hendrik Pierneef, a striptease at the Voortrekker Monument in the pornographic magazine *Loslyf,* and a performance by Tracey Rose at a police monument in Oudtshoorn. Through these examples I suggest the general relevance of iconoclasm to countermemory, in opposition to officially and unofficially sanitized versions of history. And through them we can witness individual attempts to come to terms with the problems of political and artistic representation, entangled as they have been, in the contradictory terms of the ideology of apartheid. Each of my examples was an action that unsettled older images formerly held in high regard. They belong to a specific class of iconoclastic acts that Gamboni would call "metaphorical," in that they did not make permanent material changes to their objects, but only to the reproduced image. They performed a type of *détournement,* to borrow from the language of the Situationists.[9] That is, through acts of witty erasure or intrusive addition

they displaced the potency of a symbolism that had bolstered whites-only rule. Paradoxically too, and most crucially, each of these acts of violence against images set iconoclasm to work against the concrete manifestations of censure that had propped up the ideology of apartheid. This was possible because the original images, the monuments themselves, were founded on erasure and repression.

Wayne Barker's Pierneefs

In order to understand the conflict over images in South Africa during the time of the first democratic elections in 1994, it is useful to look to a slightly earlier time, before the liberal political transformation. By 1989 hundreds of political activists had been murdered, thousands had died in inhumane conditions in the mines, the last scraps of arable land were being appropriated from the native black population, and tens of thousands were banned or detained, many of them children, many of them without trial. By the late 1980s, too, the resistance movement had made the black townships ungovernable and was bombing "soft targets" in the cities. Mass protests in the form of funerals had become a regular feature of South African life. And *Apies River* was destroyed.

This is how Wayne Barker described the creation of his own painting, made in a performance before a live audience in downtown Johannesburg in 1989:

> I destroyed *Apies River* in a performance in a black working-class bar for an SABC television show on the artist Braam Kruger, who was living in town. The bar was called Avanganye, "let's be friends." I destroyed the work while being filmed and interviewed, saying, "This is the violence, this is the workers."[10]

Barker arrived at the bar, in what was then and is still a rough part of town, with a very large, and exacting, copy in oil of an idyllic scene by South Africa's best-known landscape painter, Jacob Hendrik Pierneef, titled *Apies [Monkeys] River* (Plate 7). As he would do in subsequent years with other well-known works by Pierneef, Barker made his copy by projecting the image onto canvas and then adding color in paint-by-number fashion. Once finished, the Pierneef was then erased, crossed out, or painted over with images of consumer goods, cartoons after the style of Jean-Michel Basquiat or Philip Guston, targets in the colors of the national flag, and splashes of blood-red enamel paint. In Barker's *Apies River,* the landscape was first roughly smudged out, then various organs and disembodied heads drawn over its surface. The cartoons look stressed out; they sweat and cry under halos of exclamation marks. A large saw with two heads sewn together at the mouth threatens the whole scene from above, and a large diamond pops out of a chute and rises into the middle of the picture. As in Basquiat's art, these are very goofy-looking images, claims Barker, but they are also quite heavy. They are

images of pain and torture, murder, emasculation, and a hard labor that bloodies the hand, pisses red, lobotomizes. In Barker's grim view, this beautiful South African landscape defecates diamonds and gold, and buries its shattered men in their place.

In order to understand Barker's attack on this painting, we need to also consider Pierneef's original monumental picture that preceded it and that seems so innocent to our eyes (Figure 63). *Apies River* is one of thirty-two panels commissioned by the South African government in 1929 for the Johannesburg railway station. Other panels include similarly majestic rural scenes of the Drakensberg Mountains and the Karoo, as well as picturesque depictions of quaint towns like

Figure 63. J. H. Pierneef, *Apies River, Pretoria,* 1932. Oil on canvas on panel, 140 x 126.5 cm.

Hermanus and Graaf-Reinet. Pierneef's landscapes are often dominated by an expanse of sky with a heroic stack of clouds, or a mountain silhouette taking up two-thirds of the frame. Pierneef rarely painted people into these pictures. Characteristic too was his stark, flat, and almost monochromatic use of color, his prismatic atmospheric effects, and his imposition of "the logic of science on his perception of the logic of nature."[11] Through his travels abroad in 1925–26, he became aware of roughly contemporary developments in art in Europe, and postcubist forms of geometric abstraction and decorative ideas from art nouveau made their way into his designs for landscape painting.[12]

Although he was one of the earliest South African artists to integrate European modernist trends in his work, Pierneef has also been called "the foremost interpreter of the South African landscape." In her discussion of the Johannesburg Station panels, Rina de Villiers claimed:

> Pierneef had so intensely made the South African landscape his own, had interpreted it in such a way, that South Africans learnt to see their country through his eyes. Just as certain parts of Provence are regarded as Cézanne's landscape, and the environs of Arles carry van Gogh's stamp, so we identify Pierneef with the Transvaal Bushveld.[13]

Indeed, as one of South Africa's first international artists, Pierneef was preoccupied with evoking the *national spirit* of the Afrikaner in his art. His benevolent-seeming cumulus masses, dramatic rock formations, diminutive placement of architecture, and pyramidal construction of space declare, not so subtly, the presence of the divine in the South African countryside. The artist's vision was not simply the sight of God in His creation. For Pierneef it was imperative, too, to promote the idea of manifest destiny. He was "an earnest crusader for the cause of Afrikaner art and culture."[14] And he declared, "You must travel with your own people on the ox wagon,"[15] at a time, after the Second Boer War and before the establishment of the apartheid ideology, when like-minded intellectuals and artists were still endeavoring to create a sense of cultural unity and a political voting bloc, in opposition to British rule and against competition with African wage laborers for jobs in the cities.[16] This defensive form of cultural unity, often referred to as a *laager* mentality, was one rooted in a repressive Calvinist theology and a nationalist ideal synonymous with religious righteousness.[17] In the words of Piet J. Meyer, a prominent leader in the nationalist movement, head of the Broederbond secret society, and chairman of SABC, "The Afrikaner accepts his national task as a divine task, in which his individual life-task, and his personal service to God has been absorbed in a wider, organic context."[18]

Pierneef's paintings cast the South African landscape as God's land, and by extension the exclusive province of God's Chosen People, the Afrikaner *volk*. His view of Apies River, Pretoria, was one purged of any evidence of the Ndebele

and other African people who were defeated by Boer commandos and scattered as labor onto white farms near Pretoria after 1883.[19] Also virtually erased from the picturesque landscape of rolling hills and bubbling stream was any hint of the city of Pretoria itself, especially the Union Buildings (here diminutive and hardly recognizable in the background), which would have been an irksome reminder of British rule for the Afrikaners.[20] Pierneef's landscapes represented a form of idyll more extreme even than the utopian fantasies of some of his Afrikaner nationalist colleagues. He grew up in Pretoria at the turn of the century, when it was still a small town. In his pictures of the place, it seems, he wished it had stayed that way. His art blocked from view the urban industrial congestion and the presence of gold and diamond mines. His view of the country was void of the Afrikaners' fears of a *swart gevaar,* of the impending danger of blacks swamping the cities—an idea that was used to bring the nationalists to political power in 1948.[21] For Pierneef the landscape was frozen in a state of empty apartness, perpetually ready for white settlement, and timelessly open for the prospect of white prosperity.[22] His Station Panels were a utopian fantasy of what the South African landscape never actually was, and they performed a symbolic rubbing out of the history of the land.

For Ashraf Jamal, what is at stake in Wayne Barker's attack on Pierneef's paintings is a double indictment "against the classical landscape art of Pierneef, [and] against the lies upon which power—aesthetic and imperial—subsists."[23] Barker's iconoclasm brought to the surface that which the Johannesburg Station Panels repressed: all the horrors censored behind a screen of white purity, the empty land presided over by God, and the political ideology of apartheid that was their bolster. It also recast the Station Panels, in their simplicity and in their placement, as a kind of South African popular art, monumentally ensconced in their niches in the large central hall of the train station. Everyone coming and going to work would have seen them, distractedly, as part of their everyday lives.[24]

Barker, like Pierneef, grew up in Pretoria and his upbringing was also in a military family—his father was a pilot—and staunchly Afrikaner nationalist. But he identified with a different generation of Afrikaner youth, many of whom wanted nothing to do with apartheid and chose to live in the inner city, where the streets were dangerous and the art scene, and the party scene, was more multiracial than in the suburbs. Most white people fled the inner city of Johannesburg after the Pass Laws, designed to keep black Africans out of the cities, were abolished in 1986. But a small number of intrepid artists of all races moved into downtown, which became a de facto "grey area"—neither purely "black" nor "white" according to apartheid urban areas restrictions. At the time he painted over the Pierneefs, Barker was living in the center of town, squatting in a gallery he had founded and wishfully named the Famous International Gallery. As if still angered by the memory in 2002, Barker described his relationship to Pierneef's paintings:

My initial feeling was instinct: there were these paintings, and they represented [President] Paul Kruger, the [Voortrekker] Monument, the [train] stations, the air force—it was like one melting pot of like this f——ing apartheid that I was against. There was a state of emergency in Johannesburg. There was chaos.

. . .

I was very interested in pop art. For me they were the first pop images, they were the [train] station panels, originally. So the third class citizen comes to work for the white guy . . . And then he gets these magnificent landscapes that are overwhelming. And he's the worker. That can really f—— with your mind.[25]

At the time he claimed to take offense at these "cleansed landscapes, uninhabited by people, least of all blacks."[26] Ashraf Jamal comments: "The land was never an Eden, never a site for pure contemplation, never a sphere which affirmed the perceiver's being in a manner which could be regarded as 'pure'. Rather, the South African landscape has always invoked anxiety and fear, has always been subject to the 'dreamwork' born of cultural and material domination . . . a boundless zone condemned to exploitation."[27]

Barker recalls that his Pierneef series "dealt with *breaking down the icons* of the apartheid era."[28] In retrospect, he chose Pierneef because

his monumental landscapes represented the newfound land of the Afrikaner nation, which they believed was given to them by God in a covenant against the black people, which were heathen and barbarian in their view. They saw themselves not only as superior, but also as a "chosen people" in a "promised land." The irony of Pierneef's paintings is that they are "landscapes" of the land taken from the native black people. The style of these monumental portrayals of the land enshrined a white supremacist-colonial view, which was used to consolidate the Afrikaner national identity.

I re-created the paintings in 1989 as almost perfect pastiches of the originals commissioned by the government for exhibition at the main railway station in Johannesburg. . . . *I then created an intervention on the surface* of these pastiches using found objects that deconstructed these images and questioned the appropriation of land, exploitation of labor and raised notions of culture in transit.[29]

And, in 1989, he stated succinctly:

As I understand it, Pierneef was a kind of propagandist for the white view of South Africa. He belonged to a ruling class and invented South Africa for that class. *I try in my work to pull that vision apart by bringing in other possibilities.*[30]

Barker meant to lower the Pierneefs from their place high in the train station, from their exalted place as premier examples of South African art, and from

their semidivine association with manifest destiny. His earlier series, *Images on Metal,* had used the "pop" packaging and the detritus of the inner city—Oros men, snuff tobacco boxes, and lithographs of popular icons like Voortrekker and President Paul Kruger—to hold a mirror to South African life at street level.[31] By taking down the Pierneefs, he meant to reveal that they were already "pop" images themselves, that they were already pedestrian, and doubly insidious because of that. In his own words, he speaks like one of those mad iconoclasts enumerated in David Freedberg's writings on art, iconoclasm, and reception. He shares, with those Freedberg discusses, a desire to attack persons in authority (and the nature of authority) by attacking the symbols of authority and the images of those in power.[32] He wanted to "break down the icons" of apartheid, but he also meant to "re-create" them by "pulling that vision apart" and "bringing in other possibilities." Imagine the Pierneef landscapes as an accordion folder, stretched to its limits, with bomb casings, targets, snuff wrappers, an undertaker's shovel, and bleeding hearts all stuffed inside.

In his discussion of nudity in art, Freedberg notes that in the history of Christian censorship, a central motivation has been to keep the spiritual uncontaminated by the "fleshy," by the material sensual world. The divine and the everyday need to be kept clearly separate.[33] Where Pierneef's art enacted a similar kind of censorship, separating the image of the "divine land" from the people living within it, Barker's overpainting slapped them back together roughly. He put manifest destiny back into bed with the mine dumps and the mass graves. It is important that Barker's Pierneefs do not remove the hated symbols of the old order. These are kept around, roughed up a bit, and cast in a new mold. Or perhaps the faults in the mold are what are revealed through overpainting, and the faulty mold is what we are left with? Here destruction is in the service of re-creation, and in this case of a reinclusion, by means of scratching over, what is censored out iconographically, aesthetically, and ideologically from pictures of the South African countryside. Barker's iconoclasm enacted a return of repressed things. Pierneef's paintings, though calm on the surface, are anxious—and Barker's symbolic destruction of them displaced all the censored anxiety onto their surface.

Going Commando

In 1949, a year after the National Party had been voted into power, a grand ceremony announced the dedication of the Voortrekker Monument in Pretoria. The monument was designed as a focal point for the celebration of Afrikaner nationalism, in the context of commemorating "The Day of the Vow," a mythic event in 1838 when the Voortrekkers, greatly outnumbered by their enemy in Zululand, were said to have made a covenant with God in exchange for the defeat

of the Zulus at the Battle of Blood River. One official view of the monument that neatly described the relationship of ideology, architecture, and performance from an Afrikaner nationalist perspective can be seen in the brochure *Picturesque Pretoria,* published by the Pretoria Publicity Association in 1965 (Figure 64). It includes an image and the following caption on its second page:

> The Voortrekker Monument, a national shrine commemorating the Great Trek, was dedicated in 1949. It is a visible tribute to a group of people who played a mayor *[sic]* part in the establishment of Western civilization in South Africa. Famous for its marble friezes and museum, its *pièce de résistance* is the crypt in the basement hall of the monument, where, precisely at noon on 16 December each year, a beam of sunlight shining through an opening in the dome, illuminates the words "Ons vir jou Suid-Afrika" (We for thee South Africa) chiseled in gold letters on a sarcophagus in the centre of the floor.

A very different view of the same monument can be seen in a strip-tease centerfold from the premier issue of the first Afrikaans-language pornography magazine, *Loslyf,* published the year after South Africa's historic general election

Figure 64. From *Picturesque Pretoria* brochure, Pretoria Publicity Association, 1965.

in 1994 (Figure 65). This was a period when the question of what to do with the old regime's monuments was the subject of heated public debate. The text reads (in translation):

> *Loslyf* (loose body/morals) indigenous flower of the month: Dina.
> Dina, *Loslyf*'s very first indigenous flower, is a Boer gal in her bones and marrow. "My great-great-granddaddy, Hendrik Potgeiter, was my hero since I was very small. He was the sort of man who could inspire people to walk barefoot over the Drakensberg Mountains, so that our Boer folk can live in freedom and peace in the Transvaal. If only today we could have a leader of his caliber," she sighs.
>
> The 24-year-old nurse from Pretoria (lit.) doesn't change her nappies (i.e., is very direct/coarse) when she speaks about her love of Afrikaans language and culture. "All those people who want to chastise the Afrikaner folk and want to trample and to profane their monument, are playing with fire. They must know: when you grab my symbols, you grab me."[34]

According to the current editor of *Loslyf* (in 2003), the original intention of its founder, J. T. Publishers, a South African subsidiary of *Hustler* magazine, was to sell an "entertainment" magazine to a local niche market of Afrikaner

Figure 65. "Inheemse blom van die maand: Dina" (Indigenous flower of the month: Dina), *Loslyf* 1 (June 1995): 124–25. Original photographs by "Antonelli." Courtesy of *Loslyf*.

readers.[35] But the editor of the magazine during its first year of publication was Ryk Hattingh, a dissident member of the Afrikaans literary set. Hattingh was known for his work as subeditor at the left-leaning Afrikaans newspaper *Vrye Weekblad,* and for the scathing critique of the South African military in his 1988 play *Sing Jy Van Bomme* (Sing about Bombs).[36] Under Hattingh's direction, the first issues of *Loslyf* had a distinctively avant-garde aspect, including articles on famous writers and copy shot through with double meanings.

Between its political essays and naked ladies, *Loslyf* printed irreverent and obscene cartoons by "Joe Dog" (Anton Kannemeyer) and "Konradski" (Conrad Botes). Kannemeyer and Botes had founded the graphic magazine series *Bitterkomix* in 1992, and they were sympathetic with Hattingh's mission for *Loslyf.* In 1994 their own sexually explicit collection of cartoons, *GIF,* was banned for obscenity (Figure 66). *Gif,* which means "poison" in Afrikaans, but also "cool," "great," or "foul medicine" in South African slang (and riffs off the English "gift"), included ribald parodies of folktales with scenes of interracial sex and incest added. It was meant to be, as the cover described it: "Double-Barrel Comics," shooting from the front and from behind; the first "Afrikaner Sex Comics"; "Nasty!" and "Only for Grownups." On the back cover was a cartoon of a drag queen in stiletto heels, firing a pistol, and farting, but saying nothing. The front cover depicted a prim Afrikaner couple: he prepares to swallow a bullet and imagines scoring a field goal (i.e., "kicking the bucket"), and she pours *gif,* his "foul medicine," into a spoon. These Afrikaner sex comics are a bitter pill to swallow.

Through interventions like *Bitterkomix* and *Loslyf,* these artists and writers (and performers) hoped to corrupt the stale image of the Afrikaner. According to Hattingh, "Afrikaners have always been portrayed as khaki-clad repressed people and I wanted to show them as normal, sexual, f——ing human beings."[37] "Dina at the Monument" did more than that. It reinserted what the monument itself, as a quasi-divine symbol of Afrikaner nationalism, had pulled out of the picture. The *Loslyf* pictorial was iconoclastic, in the sense that it slyly assaulted the image of the monument by profaning it, while at the same time claiming to be on the side of its founders.

Annie Coombes has argued that the *Loslyf* spread of "Dina at the Monument" is subversive.[38] Coombes identifies what she terms the "hybrid nature" of the iconographic schema of the Voortrekker Monument, by pointing out that other indigenous African monumental architectures, in Egypt and at Great Zimbabwe, were important models for Gerard Moerdijk, the architect of the Voortrekker.[39] These models, she argues, point to the "anxiety of the Afrikaner's originary claims" and to "the imperative for the Afrikaner nationalists to appropriate Africa to itself."[40] The Dina pictorial openly miscegenated the divine and the profane, as well as these native and European aspects of the monument. For instance, the photo shoot was set strategically in the landscape of indigenous

Figure 66. Anton Kannemeyer (Joe Dog), *GIF (Afrikaner Sekskomix)*, front cover of *GIF* (1994). Courtesy of Anton Kannemeyer.

wildflowers at the base of the monument—thus situating Dina "in nature."[41] Also, unlike the girl in Voortrekker drag shown entering the scene in the 1965 brochure, Dina stands barefoot in the veld. In the brochure there are mock versions of traditional Zulu beehive homes that are, like Dina, similarly positioned in the bushes below the Monument.[42] Here the Zulu are intended to be seen as a "natural" part of the landscape. Both Dina and the Zulu symbolically await exploitation by the (white, masculine) viewer. But Dina only feigns innocence, as in the days of crossing the mountains with her great-great-granddaddy and the Voortrekkers, for she is also dressed (temporarily) in a commando's belt and vest. She wears leopard-print shorts, suggestive of a randy sexuality but also of camouflage. She is white, a bit butch, and a "native girl" ripe for the taking at the same time.

The Afrikaner national myth brought "civilization" to Africa by taming nature, subordinating women, and subduing the local inhabitants, which all amounted to the same thing: colonization as a sexualized form of violence. For Coombes, "the conceit of Dina as an 'indigenous flower' plays with the implicitly sexual content of such an ideology and the violence that underscores it."[43] While the original form of the monument censored the violence from the myth of the Afrikaner nation, "Dina at the Monument" meant to reveal and to redirect that violence.

There are further reasons for interpreting the *Loslyf* spread as an instance of anticensorial provocation. For instance, the "l" in "inheemse blom" (indigenous flower): it is a *poppie,* in Afrikaans slang, a little doll (a "sweet little girl"). If you pluck the poppy in the picture, *blom* becomes *bom*—the flower becomes a bomb. Her name also has a double meaning: Dina is dynamite. Hattingh's editorial introduction on page 2 even predicts Dina's name with its title *LOSBARS!* (explode!/bust loose!)—whose exclamation point has a sparkling fuse running out of its top like a stick of dynamite. Dina says, in effect, "Don't mess with the monument or you are messing with me," in the context of a girlie magazine where the reader is supposedly desirous of messing around with the models. Following Alfred Gell, one may claim further that Dina is a model for the Afrikaner viewer's own self-image and behavior. Gell, in his reading of Michael Taussig's *Mimesis and Alterity,* proposes: "To see (or to know) is to be sensuously filled with that which is perceived, yielding to it, mirroring it—and hence imitating it bodily."[44] To enjoy the pictures of Dina, must one also imagine oneself in her place, doing what she does? For an Afrikaner population raised on a strict diet of Calvinist self-denial, this sort of pleasure is potentially caught up in double guilt: the guilt of sexual joy, and the guilt of having gone along with the cruel lie of separatist ideology. By using the vehicle of pornography to conflate self-flagellation and self-abuse, Ryk Hattingh's and Dina's subversive spread worked not simply to bring down the monument metaphorically—it also meant to make the Afrikaner appear

less "repressed," and to give the Boers a new self-image for a new South Africa. She is the little bombshell, the Dina-mite nurse who comes to heal the old wounds of apartheid by exploding them with her mongrelizing sexuality.

"Dina at the Monument" took advantage of a particular moment in South African history: the reconsideration of old truths and of historical legacy after the first democratic elections. André Brink, whose writing was banned in the *old* South Africa, once remarked in relationship to state-sponsored censorship, that when "the lie has become established as the norm: truth is the real obscenity."[45] If the Voortrekker Monument, and the divine myth it concretized, represented a "cover-up," then celebrating (and assailing) it in the profane manner proposed in *Loslyf* consisted of denuding it, revealing the naked truth, and thus making an obscenity of it, not just for the fun of it. Afterward the monument was stained and left to stand for more than its authors intended.

Cocooned

I would like to conclude my examples of iconoclasm resisting censorship by narrating an unfinished performance by Tracey Rose, at the Little Karoo National Arts Festival in April 1998 (Figure 67). The festival took place in Oudtshoorn, a small and predominantly Afrikaans South African town that was one of the earliest places where the racially exclusionist landscape of apartheid was laid out. Each designated "race" group was given its own residential area, and no one who was not white was allowed to live in town. Things have changed somewhat since the elections of 1994, but it is still a very conservative place. The town, and its environs in the Karoo, is to this day one of the last holdouts of an anachronistic white separatist mentality. In 1997, Miriam Makeba was pelted with beer cans by rowdies at a concert there, and a sculpture by Willie Bester was urinated upon by a local gentleman. This despite the fact that a very large section of the population is "colored" under the (still tenacious) arbitrary apartheid definitions for persons of "mixed race." Tracey Rose's performance received the following review from Lauren Shantall of the *Mail and Guardian*:

> [Tracey] Rose's attempt to unravel 25 crocheted doilies—some given to her by her grandmother, others made by women in a colored community outside Oudtshoorn—and wind the threads around a police monument of an officer and his dog in the town's main road was halted when she was surrounded by several officers demanding that she cease work. Finally, one of the officers cut the doily threads with a knife.
>
> For Rose the physical act of unraveling constituted a laying open of the past, making visible those events and those race groups previously oppressed under apartheid, and yet still glaringly absent from the festival. Yet

Figure 67. Tracey Rose, *Unravel(led)*, 1998. Performance, Oudstshoorn, South Africa. Photograph by Abrie Fourie. Courtesy of Tracey Rose.

her intentions and the nuances of the piece were lost on the visibly threatened Oudtshoorn police, who dismissed the performance as "an embarrassment" tarnishing their image and demanded that she leave.[46]

Rose's art has often problematized issues of color and race-designated identity. She would have been classified as "colored" herself under the old regime, and though she is literate in Afrikaans and speaks what she terms "a brutalized form," she is uncomfortable with this language that was part of the culture of those who destroyed her ancestors' way of life and "the tongue that stole my own." By using herself as much as the location as her medium, she made a point of confronting the tensions in this small town and the contradictions of an Afrikaner festival that was hardly nationally representative in its content.

Why doilies? "In Afrikaans *naai* means 'stitch', but it also means 'sex.'" Rose was adamant about this point:

> Where I grew up all the women are shut up in this thing, in a women's knitting circle, from age sixteen and up. . . . [D]oilies were like a trophy of f——ing female worth. They were female damage control. Doilies reek of oppression. They represented so much oppressed p——. Bottle it up. You don't want to speak, and even if you do, the gross incapacity to speak is tied up in these little knots. Your busying hands shut you up in the box of self-censorship.[47]

By unknotting the doilies and stringing them around the police monument, Rose meant her performance not as destruction (of the doilies or the police image) but as re-creation, as re-formation of something already created: the tension between colored women and white men in South Africa, especially in small *dorpies* (towns) like Oudtshoorn:

> You need to understand the relationship of the colored female to that town, within the general misogyny of male–female relationships in South Africa— especially in this small separatist town where a sizable number of the population are "colored Afrikaans." The role/stereotype of the colored female in South Africa is summed up in the joke: "All the men who come through want to pass through the colored girls here." Not black nor white nor Indian, her [colored] body stands for a sex act. Because of this, their bodies were controlled or displaced.

The image of a "colored" person brings to mind a sex act, and an image of miscegenation, which was the biggest contradiction for race purists. How could there even be such a thing as a colored or black Afrikaner? According to Rose, if you were colored it was as if you were the product of some kind of "illicit sex." It appears that "Everyone has been f——ing and raping to make you." Of course, everyone is the product of some sexual encounter—but that is not the point. The point is that being labeled "colored," one was (and still is) being labeled semi-criminal, a bastard, but also exotic, sexy, and desirable. It is this double sense—of being made in the image of a sex object, but also repressed, contained, kept in one's place by apartheid and the general misogyny of South African society, and more so the self-contained fear within those black women subjected to the rule of white men—that Rose referred to in her remarks on doilies and women's self-silencing. The doilies sublimated repression.

"I didn't choose this body but am expected to represent it," claimed Rose. If asked, she will represent it in a manner that differs from what is expected. Wrapping a monument to the police in doilies was meant to be a contradiction of the publicly imposed terms of colored identity. It was meant to be a revelation, too, an unraveling of that which lay behind the public image. For Rose, the gesture was a "romantic" one. She saw the police statue as kitsch, but also very sexy: "It was big, and intimidating, but also sensitive looking with the German shepherd [which reminded her of her own knock-kneed German shepherd]—it was incredibly sexy." It epitomized the position of white men in authority in the old South Africa. The previous day Abrie Fourie's camera caught the artist posing like a pinup girl on the monument, practicing for the following day's performance, her hand resting provocatively on the cop's belt and her leg dangling over the side of the police dog. At the actual performance Rose wore a sheer white gown, and nothing underneath.

The performance was an effort to make peace with the fractured past of the country: to put desire back on the table and to bring love back into the picture; to have a little sexy fun with a boorish image from the past. It opened up the repressive loops of the doilies, and wrapped them lovingly around a public image of the oppressor (but also the mate), covering it and enfolding it. But the gesture fell incomplete: "I felt frustrated afterward," Rose said. "It felt like the beginning of the middle."

The performance began with a gathering of artists and friends, in town for the festival, at the police monument.[48] Rose calls these spectators *her* "cocoon" and claims she would not have been able to go through with the performance if it hadn't been for the protective white, art world bubble that surrounded her.

The monument was backed by a semicircular wall to which plaques depicting the duties of the police were attached. The plaque that illustrated "fighting communism" had been taken down after the 1994 elections. A stain was left in its place, marking the edges of the missing bronze. In the place of this plaque, Rose affixed museum labels with the names of women who made the doilies she would unravel. From the moment she stepped up on the sculpture the local police were there, unnerved by what was going on. In under ten minutes it was over:

> The police said in Afrikaans, very politely, to get off the statue: "Hey, hey lady. Please, would you . . ." "I said back to them, in Afrikaans: 'I'm sorry I don't understand Afrikaans.'" Then they were forced to speak in broken English. "Can you climb off?" "But I'm not finished yet."

One of the policemen started sobbing, begging her to get off. Another said, "Don't insult us." The artist Willem Boshoff, who was standing in the crowd (and was also exhibiting at the festival), told the offended officer, in the purest Afrikaans: "But these are doilies, they are made with love. How could they be an insult?" The policeman replied, aggressively "Ja. But how would you like it if I put one on your head!" Then Boshoff took one of the doilies from the stack in his arms, placed it on his head, and just stood there. One blond policeman was visibly angered. He placed his hand on the base of the statue, opened a penknife, then climbed up and began cutting the strings as Tracey laced them around the figure of the man and his dog. Eventually the captain came out, smiling, and told Rose "You'll have to come down now or I'll have to arrest you. You are upsetting the guys." At which point the performance was ended and the group of artists departed. The captain waved them off, saying, "Send me a picture."

For Rose the whole event restaged (and inverted) the very sexualized competition between men and women, between white men and colored women, and between the police and the rest of South African society. Who protects, and who serves whom? For her it was refreshing to see "male sensitivity" from these supposedly hardened men. What was so unsettling for these white police about the

brief performance? Was it their fear of the *black peril*—now that the Africans had taken over the country, were they planning to invade this small town, too? I do not think that was the whole story. The group around the performance was composed of ragtag white artists and the police themselves. Where was the *swart gevaar* in one lone colored woman climbing on a statue? The answer lies in what Tracey Rose identified as the structured sexual competitiveness between white men and colored women in South Africa, where the men protect (and keep down) and the women serve (and keep quiet). Her performance untied the strings that held up the usual order of things: it exposed the ways that the small town's monuments and its doilies stood for its gendered race relations, and it also temporarily confused these roles. By dressing sexy and actively embracing the kitsch statue with her kitsch doilies, Rose took the passive sexuality of the colored woman and made it active, and she took the dominating image of the white masculine oppressor and "protector" and wrapped it in love. Her goal was to make a giant doily out of the police statue. In doing so, perhaps she also meant to wrap the big white phallus of a sculpture in a giant womb woven by the colored community. A strange act of reconciliation.

But a failed one. She claims the curator of the show, who was helping with the performance, at one point got really nervous. His break in confidence brought down hers. The art world cocoon of white artists she relied on for protection had broken down, so the cocoon of reconciliation she was trying to wrap around the police monument also fell apart. For a moment, though, she had unsettled that small-town image of the ideal way of life, and her performance, including its frustrated "ending at the middle," had enacted an unsettling metaphor for the continuing sexualized state of South African race relations.

Censorship at a Remove

Is the slippage between censorship and iconoclasm a universal aspect of iconoclasm, especially when it comes to the abuse of historical monuments? If not, what do the South African cases I have explored have in common with other types of iconoclasm from elsewhere? The examples I have given share all of the motivations discussed by Freedberg and Gamboni for iconoclastic acts: seeking attention, depriving an image of its power, and diminishing a political power by assailing its symbols. They also took place during periods of social upheaval (Barker) and regime change (Dina and Rose). It is fascinating to note in this regard that though it is not his primary area of concern, almost every instance cited in Freedberg's remarkable four-page sweep of the history of image smashing, from ancient Egypt to the Reformation, contains some component of social upheaval or popular grievance.[49] It is intriguing to consider that revolutionary times not only encourage iconoclastic acts but may also contribute to the longevity of the

semantic turn accomplished through acts of desecration. During periods follow-
ing civil war or social revolution—whether in South Africa or Lebanon or Britain
in the 1980s after the race riots—artists have tended to see the potential for social
change in their work with a seriousness to which many of their colleagues else-
where around the world pay only lip service.[50]

What is less immediately apparent is that particular images, like the
Voortrekker Monument or Pierneef's Johannesburg Station Panels, are more anx-
ious than others. They are more inherently contradictory, and thus lend them-
selves more readily to powerful acts of desecration during periods of great social
disturbance. In one similar instance, Gamboni describes the problem of Soviet-
era monuments in a manner that resonates with the South African examples.[51]
Monumental images of Stalin often physically displaced previous signs of local
culture, and forcefully inserted the new monumental figure as a stand-in for the
homogenizing collective state. The destruction of those Soviet images after 1989,
whether symbolic or real, has entailed a process of self-detestation and guilt
analogous to what transpired in South Africa, where breaking the image of the
old order meant also admitting that what many had gone along with had been a
grave mistake.[52]

Another relevant aspect of post-Soviet iconoclasm can be seen in the film
by Laura Mulvey and Mark Lewis titled *Disgraced Monuments* (1993).[53] In one
scene, the historian Victor Misiano states that the people might be content to
paint polka dots or scribble words on the statues of reviled former leaders. But
at the moment these monuments are officially removed, the "performance" ends
and history takes over. I disagree with this conclusion, since in my view it is when
the images of a despised past are eliminated by a subsequent regime that history
begins to *repeat* itself and the space is opened for the reiteration of old abuses.
One key to retaining the revolutionary element of iconoclasm (in the democratic
sense), and to not eventually folding back into the tyranny or the censorship of
the past, is to keep it *performative,* to keep it moving and "on its feet" but off
balance. This brings the destructive event in touch with an ongoing and shifting
reality, and it places authoritarianism in perpetual disgrace.

It is precisely when the contradictory nature of the original censoring image
is somehow kept on the surface of the new object that is formed through icono-
clastic intervention that the usual relation of iconoclasm to repression and censor-
ship is inverted. What is most profound about the acts I have described in this
chapter is that the attacked image still stands and is even enhanced afterward.
Wayne Barker's avant-garde appropriation of Pierneef as a "kitsch artist" has
helped secure the latter's status as a historically important South African painter.
The Voortrekker Monument, which in 1994 was a dinosaur threatened with
extinction, is now cared for by a private Afrikaner historical society. It is also a
touchstone for a new generation of artists, mischievous young Boers, and tourists

looking for signs of the old South Africa with which to play around. Finally, in Oudtshoorn today the police and residents are likely more defensive about (and more aware of) their quaint statue than they were before Tracey Rose and her artist friends came to that small town. Following Taussig, we might call the artists' actions "defacing defacement," or defacing censorship, recalling that defacement or sacrilege only succeeds if it reinvests the object with power, with a semantic twist.[54] Their kind of iconoclasm is revelation, more than it is obliteration.

Each of the South African artists had a personal investment in the objects they assailed, and a desire to ridicule the object while keeping it whole. Their objects were also themselves. The effect of this personal kind of reinvestment in the object, rooted in self-reflection, is that the artist's iconoclasm is blocked from falling into a new kind of censorship—and further precludes a repetition of the cycle.[55] The South African artists also correspond to what Bruno Latour has called "B"-type iconoclasts, since what their destructive actions fight against is "*freeze-framing*, that is, extracting an image out of the flow, and becoming fascinated by it, as if it were sufficient, as if all movement had stopped."[56] Latour adds: "The damage done to icons is, [for "B"-types], always a charitable injunction to *redirect* their attention towards other, newer, fresher, more sacred images: not to do without image."[57] From this we may conclude that where top-down censorship supports a static conception of history and a semantic freezing of images, iconoclastic modification from below promises to thaw the visually reified regime.

A truly revolutionary approach to images does not suffice to bury old (or ideologically oppressive) images in the waste heap of history. It gives them a swift kick—and keeps them in play. There are many ways to unsettle a monument. One can remove the offending object, or one can *détourn* the meaning of the thing and reveal a new semantic wealth by opening up previously occluded meaning. One can attempt, as Wayne Barker described it, "to pull that vision apart by bringing in other possibilities." For like-minded iconoclasts and artists, the image attacked is a "found object." It is a screen pulled back through acts of desecration.

9 | SHADOWS

A Short History of Photography in South Africa

The history of photography casts a long shadow over contemporary artists' attempts to create a new image of community for a new South Africa. From its beginnings at the middle of the nineteenth century, there has been tension between the factual/documentary and artificial uses of the camera, a tension made profound by foreign domination and racial classification in the colonial world. South African camera work continues to be haunted by more than a century and a half of dispossession, by continued assertions about the "novelty" of black cosmopolitanism and urbanity, and by the dearth of images of black people taking self-conscious control over their own affairs.[1] This history was created in part through the political uses of photographic images in South Africa. In this chapter, I select several key moments from the history of the photograph in South Africa, with an eye to the camera's past use as a medium for negative codification. Against this background I conclude with a discussion of the work and reception of two prominent contemporary artists in the postapartheid era, Santu Mofokeng and Zwelethu Mthethwa. The chronological scope goes wide in the following pages. It both predates and postdates the material discussed in the rest of the book, as well as reviewing, reinterpreting, and bringing to resolution the fraught history of representation in South Africa through the eye of photography.

Imagination, Authority, and the Purloined Portrait

In Africa, as in Europe, a cult of likeness was stimulated by the accessibility of portrait photography during the second half of the nineteenth century. Members of the middle class could have themselves depicted in ways previously reserved for the aristocracy. The photographic studio became a socializing place in two senses: it was a place to meet others and it was a place where the visual image of bourgeois status that was presented to others was negotiated and imprinted in a portable, reproducible form. Early portrait studios in Europe were often located near theaters, and, as Jean Sange notes, they "worked on the same principles and used the same tricks."[2] In the colonial setting, such tricks of photography—whether in studio portraits, documentary images of indigenous persons and environments, or pseudo-ethnographic images of "natives" for the commercial market—also served another purpose: to differentiate the settler elite hierarchically from their colonized subjects. Elizabeth Edwards has noted that photography was part of Europe's new arsenal of technological advancements during the age of empire. As such, it served both to symbolize the power differential in the colonies and to bring it into visible order. The technology of the camera was claimed as "Western" to make sense of the colonial encounter on European terms, and photography was used to frame the character and physiology of the colonized as a series of ranked types.[3] What Edwards has observed in a general sense also applies to the South African Cape Colony under British rule, where photographers were active as early as 1842—a mere three years after the public introduction of photography in France by Louis-Jacques-Mandé Daguerre.[4]

Photography was one of the tools used to define and to place in order the life of the colony.[5] This can be illustrated by comparing two early photographs—one for private and one for scientific use—now housed in the National Library of South Africa archive. Both were made around 1860–70 by commercial studios in Cape Town. The first is a small portrait of a white woman made by F. Heldzinger in Cape Town during the 1860s (Figure 68).[6] Although the name of the subject is now lost, she was likely one of the aspirant middle class or elite of the colonial capital. She wears an elegant silk dress and stands, holding herself still for the long exposure, in what ends up looking like a timeless, statuesque pose. The dress is dark in the photograph, but was not necessarily black, since sitters were often instructed to wear darker colors to produce a more vivid effect.[7] A subtly sensual dynamism is lent to the picture by the young woman's raising of a plumed riding hat to her waist level, near the tip of a necklace that falls from the brooch at the neck of her jacket. Her other hand, bracing her for the duration of the exposure, is curled upon a clasped book—possibly an album of similar photographic portraits.[8] Numerous small portraits of this type were produced by commercial studios in South Africa and were collected in private albums between roughly

Figure 68. Photographic visiting card (sitter now anonymous), F. Heldzinger studio, Cape Town, after 1861. 11.5 x 6.5 cm. Courtesy of the National Library of South Africa.

1860 and 1900. The conventions for scenery and attire were similar to those of Victorian Europe, and thus they depicted colonial settlers in the provinces as equivalent to those living in Europe.

The image of the young woman in Cape Town is a *carte de visite*. It follows the format patented by André Adolphe Disdéri in 1854, in which eight small images of the same sitter could be exposed on a single plate in the same camera, cut into individual photographs, and glued to pocket-sized printed cards. Photographic *cartes de visite* served many of the same functions as standard visiting cards, with a portrait in the place of the name and address. They were stored in albums or kept in decorative frames by relatives and friends. They served as highly personal keepsakes or mementos, and could be carried about in a pocket or slipped into a fold of a dress. Studios also made *carte de visite* reproductions of famous politicians, actors, and artists for mass distribution. Since they carried an image, photographic cards helped to communicate and codify general standards of beauty and fashions in hairstyle and dress. In some measure, they also followed earlier conventions for mise en scène established by the genre of aristocratic portrait painting: the use of classical architectural details, brocade curtains, and idyllic garden landscapes on painted backdrops.[9] These background scenes and props evoked, in a generic way, the luxurious interiors of well-appointed homes, though they were likely staged out of doors or in a skylighted corner of a studio in order to take advantage of the strong sunlight needed to expose the early photographic plates. Distinctive facial features, fashionable attire, and the way the figure was isolated and inserted into the previous conventions for painted portraiture all combined to create an image of an individual within a given social class, but one securely rooted in tradition. At a time when the bourgeois class with its characteristic materialism and concept of individual will was establishing itself in Europe and in the colonies, photographic portraits helped create the illusion of a novel, singular, "civilized," and modern character fixed within a timeless, classical setting. In this way, portrait photography both broke with and sustained previous terms for representation of the human subject. It created a lasting image for an emergent class by inserting the individual figure within an image type linked to the authority of aristocratic tradition. The backdrop, clothing, and other props were all carefully chosen by client and photographer to result in the best possible image of the person portrayed. Such props and scenery were critical elements in the new theater of the self, the new masquerade of individualism that was coming into being during the middle of the nineteenth century.

The difference in treatment between portraits of the white colonial elite and their subjects can be seen by comparing the *carte de visite* with a photograph from the archive on San-related peoples deposited by Wilhelm Bleek and Lucy Lloyd in the South African Public Library after 1870 (Figure 69). Photographs like this were often made by commercial studios for anthropological use by Bleek,

Figure 69. *Túma (with shooting bow and arrows)*, ca. 1870–80. Courtesy of the National Library of South Africa. INIL 17236.

a noted ethnographer of the San.[10] Descriptive details about the names, ethnic affiliations, and cultural implements appear ("Túma, with shooting bow and arrows"), as well as the devices used to objectively "measure" the indigenous people. The ruler on the wall in this photograph takes the place of the kinds of idyllic or classically composed scenes that more often made up the backdrop to commercial photographers' images. Here the subject is not part of the creative act of depiction, but is instead merely an object for scientific rationalization, of categorization according to racial type within a colonial hierarchy of the "races." While white subjects would have been able to negotiate the terms and setting of their pictures as well as to control the distribution of their images, black subjects had little or no control over the process or use of their depiction. In a small way, then, it is ironic that the anthropometric desire to rationalize and to preserve aspects of native cultures of southern Africa for posterity has also helped preserve the name of this young man, whereas the sitters in many other early portraits are now anonymous.[11] Nevertheless, images of indigenous people that submitted them to a regime of authoritative knowledge only portrayed them as objects in the environment to be classified and measured by natural science.

Local studios and itinerant photographers, using painted backdrops of country scenes and a variety of "tribal" props, also reproduced stereotypes of "natives" as postcards for the popular markets at home and overseas. Images of solitary male Zulu warriors and seductively arranged female groups blurred the edges between factual document and paternalistic fantasy.[12] Ultimately, as photographer Santu Mofokeng has argued, these types of images, whether popular or "scientific," helped subject the black population to the authoritarian power of the state.[13]

Toward the end of the nineteenth century, the use of portrait photography had spread to the small black elite in the colony. These black Africans were educated in mission-run schools, owned property, were teachers or ran businesses, and considered themselves cosmopolitan, civilized, and modern. They lived and dressed in a manner similar to the European settlers in the colony.[14] Through photography, their Christian faith and their civilization was expressed, recorded, and validated in visual form. Two photographs in the South African Library archive illustrate this point. One is a portrait of Knox Bokwe, a former student and later postal officer at Lovedale College, a missionary-run school in the Eastern Cape. Bokwe was also well known as a minister, composer, and journalist.[15] His portrait, produced in a studio in nearby Port Elizabeth, helped create an image of a self-consciously modern, educated, and accomplished individual. Another photograph in the South African Library archive is a portrait of Tause Soga (d. 1877), a niece of the famous Xhosa minister Tiyo Soga, who also studied at Lovedale (Figure 70). It was taken in the studio of Thomas Annan in Glasgow, when Soga was in teacher training in Scotland.[16] The fashionable dress and the calm countenances of both Bokwe and Soga in these pictures are radically different from the pitched shoulders and

Figure 70. Tause Soga, photographed in Glasgow, Scotland (before 1877). Courtesy of the National Library of South Africa. INIL 14210.

nervously shuffling feet seen in the anthropometric picture of "Túma" from the Bleek collection. And yet, even studio portraits of mission-educated Africans like Soga and Bokwe, in which the sitter was more likely a self-motivated client—as opposed to an unwilling or unwitting object of study—could be subjected to a regime of scientific rationalization. According to Karel Schoeman, both photographs were given as gifts to Jane Waterston, a teacher at Lovedale. This exchange of the image may have been meant as a memento of friendship, or as a token of gratitude for past mentorship. Whatever sentiment may have been behind the gift, Waterston eventually donated the images to an album of "racial types" in the South African Library as examples of educated "kaffirs."[17]

These two intentionally ennobling portraits and others like them were made with the consent of the sitters in order to establish a measure of class difference. They were turned into items of disciplining knowledge through their later reception as part of a visual archive that put into order, as much as it created, a typology and hierarchy of racial difference. Regardless of their original use, early portraits of sitters like these often ended up consolidated as evidence of "native types." Through their relocation from studio to archive, the site of authorship for these old images was shifted. The right to name them and to ultimately control the location and creation of meaning for them was also purloined. In short, control was removed from the site of negotiation between photographer and sitter to the site of the library and the authority of the archivist and scholar.

The six-thousand-image archive of "native types" compiled by Alfred Martin Duggan-Cronin, a Scottish émigré and former employee of De Beers Consolidated diamond mines at Kimberley, is situated awkwardly between studio portraiture and natural science. Several hundred of these photographic studies were published in the four-volume *The Bantu Tribes of Southern Africa (1928–1954),* including an introduction to each section by anthropologists who were authorities on the pictured ethnic groups.[18] Duggan-Cronin photographed individuals who were part of the great diversity of African and European people who had come seeking work in the mines after the diamond rush of 1867. Following the First World War, with backing by the McGregor Museum and the Carnegie Institute, he traveled the country making portraits among the rural black population according to ethnicity. His images are classically composed with figures centrally placed, and they were generally complimentary toward his sitters. His portrait subjects look directly at the viewer, often with a gentle expression, or they sit solidly in a three-quarter pose. The backdrops are simple, either a plain white cloth or a landscape in the distance, and though his sitters were sometimes given items to wear, they are just as often—especially his town subjects—shown in their regular street attire and included many of the signs of South Africa's complex modernity. A sitter's clothing in a typical image might include a combination of factory-made textiles and jewelry along with body decoration and local beadwork (Figure 71).

Figure 71. Alfred Martin Duggan-Cronin, *Bakgatla,* from his "Bantu studies," ca. 1920–50. Courtesy of the Duggan-Cronin Collection, McGregor Museum, Kimberly, South Africa. D. C. 4334.

Duggan-Cronin's portraits were often shot just below the subject's eye level, giving them a look of dignity and strength. Unfortunately, in the four-volume album of his work the tribal categorizations seem somewhat forced and almost none of the people portrayed is named. Rarely do they reflect the great degree of interrelationship between southern African peoples, whether historically or in the modern era. Although given dignity, Duggan-Cronin's subjects are depicted not as sentient beings but as part of South Africa's natural landscape. Ultimately these images could be used as evidence by apartheid ideologists for what they saw as the ideal separation of peoples along arbitrary "racial" and ethnic lines. This supposedly "natural" apartness was a state that nevertheless would need to be enforced through strict policing of borders, inferior education, and national legislation if black people were to be kept (or made) perpetually distinct from each other as well as spatially, culturally, and genetically separated from Europeans.

The Town and the Slum

Images of informal urban settlements, of shacks and shantytowns, like portraits of black subjects generally, have had a troubled history in South Africa. In the Union of South Africa, as established into law by the Land Act of 1913 and the Natives (Urban Areas) Act of 1923, all towns and cities were officially zoned as whites-only areas, and plans were made for the building of "locations" for blacks-only townships as well as ethnic enclaves (or "native reserves") in the rural areas. These acts were amended in order to legalize forced removals of "redundant" black tenants in urban areas in 1954, six years after the rise to power of the National Party. During this period, photographs of shacks and slums were used in sociological surveys to bolster the segregationist ideology by illustrating the "insanitary" and "undesirable" aspects of native life in town. This politicized use of images of black residential areas is evident in a two-page spread taken from a government-sponsored sociological survey of the black locations in East London during 1955–58, under the direction of D. H. Reader of Rhodes University (Figure 72). Reiterating the findings of the "Tuberculosis Commission of 1914," Reader opined about the living conditions in the black informal settlements that

> the majority of such locations are a menace to the health of their inhabitants and indirectly to the health of those in towns . . . the dwellings are mere shanties, often nothing more than hovels, constructed out of bits of old packing-case lining, flattened kerosene tins, sacking and other scraps . . . Overcrowding is frequent, and altogether one could hardly imagine more suitable conditions for the spread of tuberculosis.[19]

The reality, Reader claimed two pages later, was that the "Natives" living in town were considered a nuisance by the white population, and it was preferred that they live outside of town or in the rural areas "near to their tribal customs."[20]

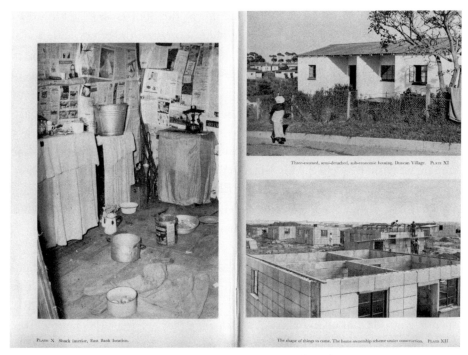

Figure 72. Plates X–XII from D. H. Reader, *Xhosa in Town* (1961): "Shack interior, East Bank location"; "Three-roomed, semi-detached, sub-economic housing, Duncan Village"; and "The shape of things to come. The home ownership scheme under construction."

In the illustrations from Reader's book, a cramped interior, with food on the floor and walls covered in newsprint "for insulation," represents the "bad" kind of informal settlement. The structures in the adjacent image exemplify the "preferred" type of native housing developed and controlled by the municipality, where the sites were minimally serviced and the location is rationalized into orderly rows. By the 1970s, hundreds of black townships had been built on this rationalized model, as satellite communities for the labor reserve of every South African city. Perhaps with a cynical eye to the type of degrading visual comparison made by Reader, it became a standard exercise for urban reformers and antiapartheid activists to illustrate the disparity of living standards between the races, by contrasting aerial views of row after monotonous row of government-built "matchbox" houses, with the grandiose, high-walled white neighborhoods that look more like provincial copies of suburban Los Angeles architecture.[21]

Photography in the Struggle

By the 1960s, apartheid had become more thoroughly embedded in all aspects of South African life, and its negative spatial and social effects were exposed and contested by the rise in popularity of series-oriented photojournalistic photography. The white-owned but black-oriented and mostly black-staffed magazines *Drum*

and *Zonk!* followed the successful formula for picture journalism established by the American magazine *Life* in featuring photo-essays on the politics and social life of the day. With *Drum* this also meant coverage of the absurd application of separate amenities laws at public facilities, depictions of the dire conditions of black poverty, illegal drinking establishments in the black townships, syncretic Christian/traditional religious ceremonies, and the despair of exile in the apartheid homelands. The stylishness of the African middle class and its charismatic political leaders was also featured in *Drum*. At a time of growing racial tension, militant activism by Nelson Mandela and the African National Congress, and increasing government repression, *Drum* printed work by photographers including Alf Khumalo, Jürgen Schadeburg, Peter Magubane, Ranjith Kally, G. R. Naidoo, and Bob Gosani, thus giving the first mass exposure to a mixed-race group of outstanding photojournalists.

Black photographers were treated with particular roughness by the authorities. In 1969 Peter Magubane was placed in solitary confinement for two years for suspicion of organizing for the then-banned ANC, and he was himself subsequently banned from taking photographs for another five years. He later worked for *Time* magazine and published several books on the 1976 Soweto student uprising and the revolutionary struggles of the 1980s. His colleague Ernest Cole was less fortunate. Cole was forced to go into exile after he was asked, and refused, to become a police informer. He fled South Africa with his negatives and published them abroad. Cole's book *House of Bondage,* published in 1967, was a book-length version for an international audience of the kind of photo-essay seen in *Drum* (Figure 73).[22] *House of Bondage* was banned in South Africa, but copies were circulated underground, and Cole's work influenced several subsequent generations of photographers in South Africa. Unable to return to South Africa after the publication of his book, Cole eventually died of cancer, penniless in Manhattan.

In the wake of the 1976 Soweto uprising, the rise of the UDF, and the states of emergency, the period of the 1980s saw the rise of collective work among progressive artists. The period also witnessed the growth of a socially relevant style of documentary photography in league with the antiapartheid struggle. Much of this work was committed to undermining overdetermined concepts of race, by pointing to the ambiguities of everyday life in South Africa. This trend was foreshadowed by the publication during the 1970s of *Some Afrikaners Photographed* (1975) and *On the Mines* (1973) by David Goldblatt, and *Letters to Farzanah* (1979) by Omar Badsha.[23] The movement was also given a boost during the 1982 Culture and Resistance festival in Gaborone, when artists debated the meaning of commitment, the role of the cultural worker, and the appropriate means for promoting democratic change in South Africa. At the time a number of photographers' collectives were organized around the principle that through a coordinated

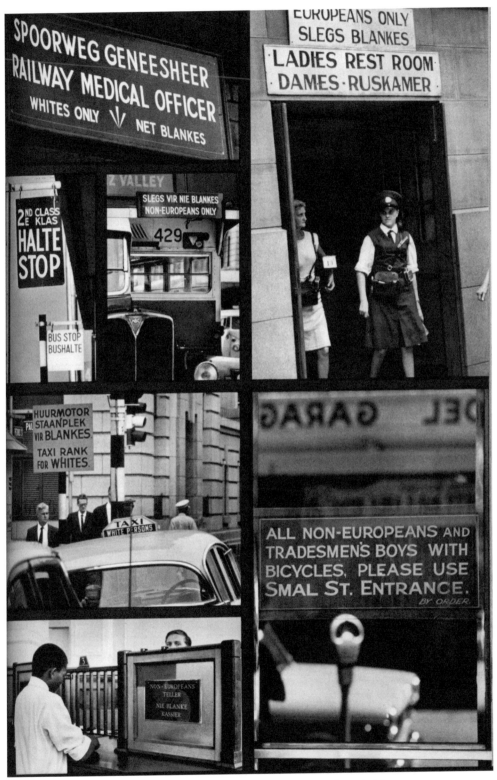

Figure 73. Ernest Cole, *For Whites Only.* From *House of Bondage* (1967), 85.

effort photography could be a potent tool to fight apartheid. The most influential organization of this sort was Afrapix, a multiracial collective whose work helped give shape and direction to the wider trend toward committed camera work in the 1980s. The objective of Afrapix, according to cofounder Paul Weinberg, was to be "an agency and a picture library and to stimulate documentary photography."[24]

Afrapix was modeled after the historic Magnum Photos cooperative set up by Robert Capa, David Seymour, Henri Cartier-Bresson, and George Rodger in 1947, in response to their experiences covering the Second World War. Magnum was (and is) owned by its members, and it sought to support projects outside the established formulas dictated by commercial picture magazines. Like its predecessor, Afrapix mixed more artistic work with reportage, with the understanding that "the facts" are colored by how they are portrayed. Its early members included Omar Badsha, Jeeva Rajgopaul, Paul Weinberg, Cedric Nunn, and Peter McKenzie. Later members included Santu Mofokeng, Guy Tillim, Steve Hilton-Barber, and Chris Ledochowski. Together they supplied the radical press, workers' organizations, and struggle culture magazines like *Staffrider* with low-cost images that documented the activities of the UDF and the occupation of the townships.[25] Afrapix also ran visual literacy and photographic training workshops in the black communities. Following the struggle slogan "Each one teach one," Afrapix members shared their technical skills on an individual mentorship basis. A similar idea was the founding principle behind the Market Photography Workshop, a nonracial, hands-on technical training course founded in Newtown by David Goldblatt.

Afrapix members produced photojournalistic images of the struggle with immediate impact. They also engaged in social documentary photography in the tradition of Walker Evans, Dorthea Lange, and other Depression-era American photographers associated with the Farm Security Administration (FSA). South African photographers, following the FSA and picture journalism precedents, used the series format to establish complex visual narratives about life under apartheid. As such they sometimes fell into a mode that also characterized the photographers of the FSA. As Abigail Solomon-Godeau has noted, in the effort to make an artistic statement, individual "objects of compassion" were produced as a "pictorial spectacle usually targeted for a different audience and a different class."[26] But unlike the FSA photographers, South African cultural workers in the social documentary movement during the 1980s also attempted to expose the root causes of subjugation and to illustrate the organized resistance of the UDF and the Mass Democratic Movement.

From the late 1970s to the early 1990s, a genre known as "struggle photography" flourished. Struggle photography usually entailed selecting poignant scenes and using high-contrast visuals in a realist mode. These were images with a clear message, ready to go to press for the antiapartheid cause. They included a range of subject matter, but the most common images documented protest rallies, police or internecine brutality, or the private dramas of the poor.[27] Images of joy

(except at political rallies) were less common. As with the earlier photojournalism, these images were mostly shot in black and white. There were several reasons for this. First, color photography was not seen to be appropriate for "serious photography." Also, black and white was easier to work with. It could be developed more simply and affordably, and its techniques could be more readily shared. Another factor was that due in part to the economic boycott, professional color printing facilities and color chemicals did not become widely accessible in South Africa until the 1990s. Finally, and most crucially, black-and-white images could be sold to newspapers that also did not publish in color until the 1990s.

In practice, there was a wide spectrum of formal approaches deemed "appropriate" by those who hoped to chronicle and aid the struggle. This can be illustrated through a comparison of two photographic anthologies that bracketed the 1980s: *South Africa: The Cordoned Heart* (1986), prepared for the Carnegie Inquiry into Poverty and Development in Southern Africa, and *Beyond the Barricades: Popular Resistance in South Africa* (1989), a project by the Afrapix collective.[28]

The Cordoned Heart is a condensed version of an exhibition that accompanied the Carnegie Conference on Poverty and Development in South Africa at the University of Cape Town in April 1984.[29] It is a collection of texts and photographic studies that were either extant or commissioned for the project. The sequence of words and images in the book progresses from a historical background to the causes of poverty, the documentation of the effects of structural violence under apartheid, squatter settlements, forced removals, and individual acts of resistance, to the gathering of antiapartheid unions and political groups during the early 1980s under the UDF. Many of the images are straightforward depictions of the daily resourcefulness of the poor in domestic settings, such as Paul Alberts and Chris Ledochowski's photo-essay on the informal community at Crossroads in Cape Town, and Omar Badsha's portraits of pensioners (Figure 74). The only overt image of the apartheid state is the last one: in another image by Omar Badsha police appear at the airport in Durban as Paul David of the Natal Indian Congress is released from detention in 1982.

The pictures featured in *The Cordoned Heart* make use of oblique or wide angles of vision to give environmental context, and strategic use of shadow and tonal complexity to bring out the emotional depth of their subjects. Many of the indigent subjects look directly at the viewer with eyes that are neither pleading nor accusatory. In one exceptionally moving sequence by David Goldblatt, a series of blurry high-grain shots depicts commuters from the KwaNdebele homeland traveling by bus as early as 2:40 a.m. on a daily eight-hour journey to and from jobs in Pretoria (Figure 75).[30]

In contrast, *Beyond the Barricades* is less lyrical, more stridently realist, and more pointedly political. The main focus in *The Cordoned Heart* is on exposing the causes and conditions of poverty and on documenting acts of resistance. *Beyond the Barricades,* though it shares the same editor and includes work by

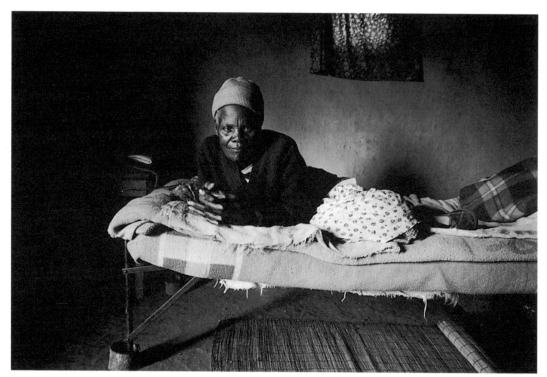

Figure 74. Omar Badsha, *Pensioner, Transkei*, 1983. From *South Africa: The Cordoned Heart* (1986), page 62. Courtesy of Omar Badsha.

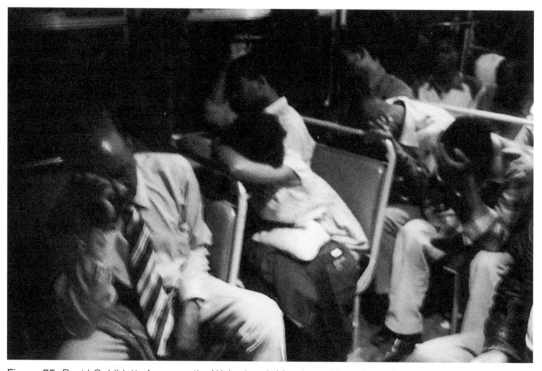

Figure 75. David Goldblatt, *4 a.m. on the Wolwekraal–Marabastad bus*. From *South Africa: The Cordoned Heart* (1986), page 39. Courtesy of David Goldblatt.

many of the same photographers, shifts its attention to the scenes of popular un-
rest and police violence that permeated South African life during the later 1980s.
The difference in approach between the two anthologies is partly explained by
the fact that the first was organized for a special commission on poverty and the
second was organized by an antiapartheid collective for its own purposes. The
scale of police violence and of mass resistance had also increased dramatically as
the decade progressed. The difference between the two books also amounted to
a shift in strategy, from the sensitive exposure of how apartheid's victims lived,
to the active denunciation of the violence of the state.

Its opening sequence sets the tone. On the cover, police attack protesters
with *sjamboks* (whips); on the title pages, township youths scatter for cover, and
police line up office workers at the Congress of South African Trade Unions.
On the contents page, schoolchildren rally waving signs; on the foreword page a
crowd salutes "Amandla" with their fists; and next to the list of photographers
is Guy Tillim's close-up of a teargassed man at a funeral, crying in pain as he
marches with a comrade's coffin (Figure 76). Protesters, banners, and blood, and
the menacing presence of the heavily militarized state are everywhere in these

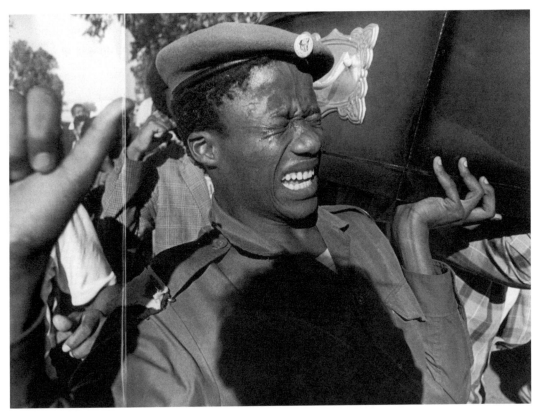

Figure 76. Guy Tillim, *A pall bearer presses on through tear gas at the funeral of one of 50 people killed by "Witdoeke" vigilantes, Crossroads, Cape Town, May 1986.* Detail. From *Beyond the Barricades* (1989), pages 10–11. Courtesy of Guy Tillim.

images. There is also a section without images and a text that makes clear that photography—even antiapartheid photography—could be used by the state as an instrument to surveil and silence by recording the attendees at political rallies for later identification and arrest.

One problem of the representation of black life at the end of apartheid was the question of the supposed neutrality of "evidence." Given the general context of the censorship of images of popular resistance and of state repression—pictures of police actions, vaguely defined, were generally off limits under the states of emergency—just getting any image of the struggle into the public's eye became an imperative for sympathetic artists and photojournalists. Photographs of black bodies in pain were circulated by antiapartheid groups and also widely disseminated by the foreign press during the late 1980s and early 1990s. Furthermore, when seeking the most striking images to sell, many of the more prominent photojournalists too often zeroed in on the extremes of brutality during the transition to democracy. In the process they were frequently heedless of the long-term implications of their reiteration of the stereotype of the black body in a state of abjection. Instead they sought out only violence, seeing themselves as combat photographers objectively covering a war in the townships. With some irony one such group of photojournalists was referred to as the "Bang-Bang Club."[31] Together with the other common representation, of people (however nobly) living in poverty, these types of pictures came to constitute the majority of images of South African black people in the public domain.

Jane Taylor and David Bunn have remarked that such images also tend ironically to render "fixed a certain theory of representation: the belief that images are indeed mimetic and that they narrate, have intention and can therefore subvert an audience."[32] From this perspective, some of the images of black poverty that were used for the struggle could in another context be understood to be almost undistinguishable from the kinds of photographs used in support of apartheid by D. H. Reader and other state-sponsored sociologists. It is important to distinguish between these dire images, with their emphasis on a partial view of black experience, and the experiences of a society not bracketed by the immediate demands of photojournalistic or social documentary "struggle" imagery. The popular archive of images of black life during the struggle has too often been taken as representative of the majority South African experience, just as, in an earlier era, the ethnographic coding of scenes and types robbed black South Africans of authority over their own images. The lives of these people included other scenes outside the stereotypes of impoverished homes, brutalized bodies, or heroic protest. The question is, do or did black South Africans imagine their own homes and their own exterior and interior lives populated exclusively by the popular images of their abject condition? If not, how can this absence, this empty space in representation, begin to be filled—and in a manner that is more resistant

to co-optation by the public's voyeuristic desire for grotesque or debased images of black bodies and black lives?[33]

Alternative Visions

As we have seen with *The Cordoned Heart,* during the 1980s a number of photographers produced images that contested the spatial and social vision of apartheid in more oblique ways. Paul Alberts, for instance, developed his own series of environmental portraits of women in a rural town titled *Rhodes: Some Women Photographed.* In his introductory text to the series, he clearly stated his aim of using photography to give dignity to the poor: "These are some of the women of Rhodes. They are amongst the most dignified and courageous people that I have encountered in my life. They endure a great deal of suffering and deprivation, and they must make do with difficult limitations."[34] Alberts's compositional style in the Rhodes portraits keeps the human figure front and center, with a straight-on, eyes-at-the-camera view. These are images of women who have opened their own spare homes to the photographer to portray them, and, perhaps out of gratitude, his images monumentalize them. The local name for the area, he notes, is "Zakhele," "to build with your own hands."[35] Appropriately so, since (as in the D. H. Reader report) the walls are made of earth and newsprint, magazine pages cover the ceilings, and the cabinetry is hammered together from odd ends of wood (Figure 77). The focus for Alberts is on respect for the person, set out like a statue from her modest interior. Through the individual portrait, the environmental effects that surround the subject and that have been built with her hands are also seen with respect.

Another alternative approach can be seen in the work of Chris Ledochowski, who first exhibited his "Hand Coloured Portraits from the Cape Town Flats" at the Market Photography Gallery in Newtown in 1986. This body of work was inspired by the requests of those he had photographed in the slums outside Cape Town, who asked him to artificially color in his black-and-white images after the popular style used in local portrait studios. By the early 1990s, Ledochowski had evolved this practice into a fully color process saturated with pigment. Using this technique, he has returned to the townships outside Cape Town for more than twenty years. There he has recorded the minutiae of how people who are struggling to survive have given life to squalid conditions by decorating their surroundings with informal structures, parlor paintings, murals, and domestic shrines (Plate 8). His pictures are accompanied by texts that give precise information on his subjects and the objects they have collected, constructed, and arranged.[36]

Another example is Santu Mofokeng, who began his professional career in photography in 1981. At twenty-five he took a job working as a darkroom assistant at the Afrikaans-language newspaper *Die Beeld.* That apprenticeship gave

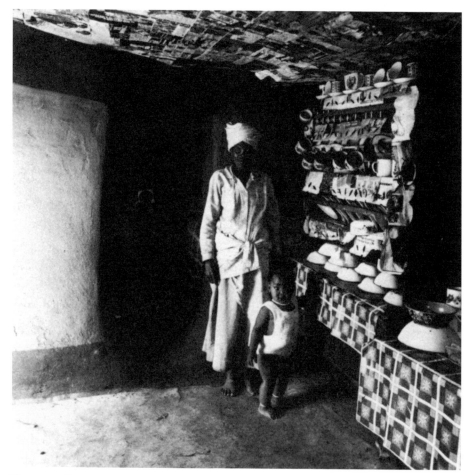

Figure 77. Paul Alberts, from the series *Rhodes: Some Women Photographed,* 1987. Courtesy of Paul Alberts.

him an inside view of the mainstream media's cynical view of struggle imagery. In an autobiographical essay published in 2001, he recalled one painfully instructive incident:

> I learned a lot in that newspaper darkroom. Mainly that black skin and blood make a beautiful contrast. This from a conversation overheard in the office: "come check at this. Isn't it beautiful?" The subject of this outburst of glee is a transparency . . . [depicting] a corpse, an ANC cadre bleeding in death, lying on asphalt near a kerb . . . "I don't get it . . . this is ghoulish, man." "You know fuck all china . . . There's nothing as beautiful as black skin and blood."[37]

In 1985 Mofokeng joined Afrapix and began helping to document the culture of resistance for the alternative press. Uneasy with the usual media depiction of black life, and concurrent with debates within the Afrapix collective,

Mofokeng adapted the social documentary style to imagine more quotidian images of the black townships. He recalled: "When I began my professional career I tried to make important interventions in debates over representation in South Africa, by exposing layers of lived reality that most photographers, in their rush for marketable 'struggle' photographs, had failed to see."[38] While working as a journalist, Mofokeng also began exhibiting his work in the context of the art gallery. His 1986 series *Train Churches* documented the religious services conducted on the crowded and dangerous commuter trains between Soweto and Johannesburg (Figure 78). David Goldblatt was an early mentor for Mofokeng, and *Train Churches* is similar to Goldblatt's essay on bus riders from KwaNdebele. Both series follow black workers on their difficult journey to jobs in the city. But where Goldblatt selected images that showed bus riders at a distance, slumping in their seats in near despair, Mofokeng's commuters stomp, clap, and sing immediately in front of the camera, performing a daily ritual that boosts their spirits and protects them from gangsters and pickpockets on the train. In work like *Train Churches*, Mofokeng replaced the distant and alienated view of black life under duress with a more intimate, but equally poetic view of popular resistance. The subject of *Train Churches* was neither monumental nor abject.

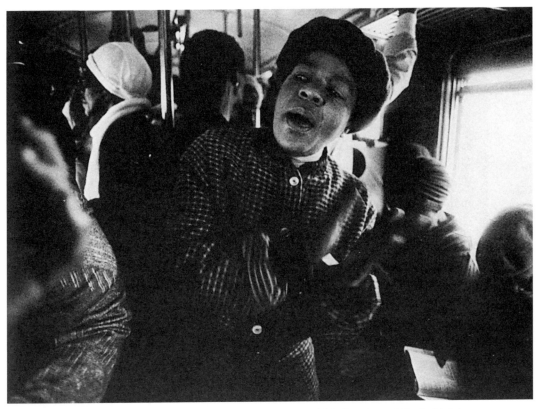

Figure 78. Santu Mofokeng, from the series *Train Churches*, 1986. Courtesy of Santu Mofokeng.

Mofokeng's emphasis on everyday life engaged current debates within Afrapix and in critical writing of the period, especially the work of Njabulo Ndebele. Ndebele claimed that a truly revolutionary art in South Africa needed to go beyond agitprop and reaction. Recognizing that the state "does not only send tanks into the townships," but also had a total strategy for domination that was "diversified to take advantage of a complex industrial society," Ndebele urged artists to open up their iconographic and stylistic palette to include the everyday struggles of the people.[39] This approach, he argued, would create the space for a future democracy by battling the enemies within and without. Artists and writers like Alberts, Ledochowski, Badsha, Mofokeng, Goldblatt, and Ndebele fought apartheid on two fronts: they were critical of systematic oppression, and they redefined the basis for imagining a different South Africa. Not content with merely depicting life under apartheid, they sought to intervene in the everyday, to expose its structure and then redirect the eye toward a future transformation.[40] Their work laid the foundation for the postapartheid critiques of race, class, and "identity" that would predominate in the South African art world during the 1990s.

Zwelethu Mthethwa's Cape Town Interiors

By the late 1980s, apartheid Urban Areas segregation had ceased to be enforced with any regularity by the state. The so-called grey areas began to grow in the midst of the major city centers, and new squatter settlements rose up on the urban peripheries. Informal settlements and shantytowns also appeared with greater frequency in backyards and in peripheral areas of the townships. Many of the residents of these new settlements came directly from rural areas and had little previous experience in the city. Crossroads is perhaps the best known of these sorts of informal camps. Located on the airport road leading to Cape Town, it mushroomed during the 1980s from a small settlement to a sprawling shantytown with tens of thousands of residents, and it became a symbol for the activist community of the wholesale rejection of urban apartheid. Images of heroic resistance to forced removals at Crossroads were broadcast internationally.[41] Since 1994, in the postapartheid period, the new South African government has had difficulty keeping pace with the growing underdevelopment of its urban areas, with unemployment hovering at around 40 percent. According to Owen Crankshaw and Susan Parnell, informal shelters now outnumber the old matchbox houses in South Africa's cities. But, they claim further: "Built outside the law, these settlements are vividly opposed to the order and regularity of state-built formal housing, and, within the constraints of poverty, they reflect the individual aspirations and styles of the residents."[42]

The city of Cape Town is today split between a mostly white, European, and middle-class-oriented city to the west of the Table Mountain range, and mile after

mile of townships and shanties in the sandy, wind-swept area to the east called the Cape Flats. Since the late 1990s, the photography of Zwelethu Mthethwa has focused on the residents of the Cape Flats. He began in 1996 by shooting at the infamous squatter camp at Crossroads, and then moved out to the informal settlements surrounding the nearby wine country of Paarl. Mthethwa's portraits of the periurban underclass were first shown to an international audience at the Second Johannesburg Biennale in 1997. Since then, he has exhibited at the Museum for African Art, at P.S. 1, at the International Center of Photography in New York, and at numerous international art fairs and biennales. He has gallery representation in Italy, South Africa, and the United States, and his work is well enough known to have the dubious honor of being the subject of a term paper offered for sale online at term-paper.net.[43] In 1984 Mthethwa was one of the first black South Africans to receive a diploma in fine art from the University of Cape Town (UCT). Photography was not offered as a degree subject at any of the black-only colleges under the apartheid system, so Mthethwa was offered a special dispensation to study at UCT. Photography was not even an early interest of the artist—it was a vehicle and a strategy for getting into an elite art program.[44] Nevertheless, Mthethwa went on, as a Fulbright scholar, to earn a master's in fine art from Rochester Institute of Technology in 1989. This was an exceptional achievement during a period when access to advanced art education, and experience in the international art world, was limited for most black South Africans under the apartheid Bantu Education system.

Mthethwa's 1990s work was part of a first wave of postapartheid South African art made by college-educated black studio artists with art circuit savvy who had been privileged to study for advanced degrees and to spend time overseas. Their art has mostly been directed at redefining the past as well as addressing issues arising *after* the struggle to end apartheid. Mthethwa's work has been promoted as following a trend described by Michael Godby: since the democratic transition and the resulting decrease in either local or international public interest in "heroic political activism," photographic work has split between either straight photojournalism or art photography for the galleries.[45] This assessment is not historically accurate, however. We have seen that Mthethwa's approach was clearly presaged—though this is rarely acknowledged—by earlier work by Mofokeng, Goldblatt, Alberts, and especially Ledochowski. As I have shown, photographers during the 1980s also split their time between assignments for the press and more artistic work. Nevertheless, in interviews about his work, Mthethwa has consistently stated that he wants his portraits, which respond to conditions *after* apartheid, to differ from the kinds of images made during the highly politicized environment of the 1980s. Back in the 1980s, when he was a student at the Michaelis School of Fine Art at the University of Cape Town, and Crossroads was, in his words, "in fashion," he too went out to make images in

the famous squatter camp, like so many other artists and students at the time.[46] Taking pictures and engaging with the affairs at Crossroads was a rite of passage for young artists and progressive activists of his generation. But in retrospect, after art school, and after apartheid, Mthethwa began to repudiate both the content and tone of this earlier type of purely documentary work. The result did not diverge substantially from the theme of portraying the lives of the poor that had been a mainstay of committed photography in South Africa for more than a decade. Mthethwa claims to have found a novel approach to this subject by introducing color and an interactive element to his portraiture.

Within the documentary tradition, the allure of color has historically been considered a distraction from the foregrounding of the "truth" of a socially progressive narrative. As we have seen, for economic reasons as well, color images were simply too technically difficult and too expensive to print for many struggle-oriented photographers who were themselves struggling just to get by. Even the art department at Michaelis, one of the elite art schools in South Africa, did not have color printing facilities when Mthethwa was a student there.[47] Yet for the artist, after 1991, what was most striking about these earlier photographs was their *lack* of color. Black-and-white photographs of the urban poor seemed to him to create sociological objects more than individual human subjects.[48] In an interview with Bongiwe Dhlomo in 1999, he stated:

> I have found that the common objective is to sensationalize and to draw
> attention in a distasteful manner. When I view some of these photographs
> I cannot help but think of these people who have been photographed as
> victims of abuse. The choice of photographing in black and white by most
> photographers gives an acute political angle of desertion and emptiness.[49]

In 2003 he expanded on this idea in an interview with Sean O'Toole:

> At RIT I also realised that the mythology of black-and-white photography
> is attached to a political agenda, which is used for both good and bad. I
> decided I would employ colour to represent the colour of the places my sub-
> jects inhabited. Colour is just so beautiful. When you see beauty you think
> less of poverty. You think of design and composition.[50]

One danger with documentary photography, especially "victim photography," is that it may *create* its victims as much as it finds them.[51] In South Africa, the well-known archive of images of the black body derived from struggle-oriented imagery (especially of the less circumspect journalistic variety) was likewise, as I have argued, only a partial view of black experience. Such images were often misrepresentative in the sense that they tended to neglect any view that did not show the black body as either engaged in heroic protest or brutalized by poverty and violence.[52] Mthethwa's solution to this crisis in representation was to nar-

rowly conflate color with "dignity," to add vibrant hues to his pictures, and to place his art in the gallery instead of the newspaper. Color, he claimed, "restores people's dignity." Color also shows the "humanness of the occupants in their private spaces."[53]

Where documentary photography sociologizes, art photography tends to aestheticize. This is especially so, as Annie Coombes has argued, when images of poverty, including Mthethwa's, are seen in international art or museological contexts.[54] In one of his first and best-known images from the series of color portraits taken in informal settlements, what strikes the eye first is the red of the serial pattern that wraps around the tiny room, and its contrast with the blue checks of the tablecloth and flooring. The hues are cranked up in intensity, as if someone has meddled with the tint knob on a television set. Next, the man on the couch seems to be emerging from this optical field, which it turns out are composed of sheets of Lifebuoy soap wrappers. One might ask where the "dignity" is in photographs like these, since the color takes over the image, almost obscuring the human figure at its center. Here the man is also visually overwhelmed by the outward signs of the world of fungible goods, and (for the viewer at least) there is irony in this juxtaposition of extreme poverty and the world of commerce. One may also infer that there is some connection between the scene depicted and the well-known history of optical contrasts of line and color in traditional mural art, beadwork, and clothing design in southern Africa. In any case, it is unlikely, as a strictly functionalist perspective (or D. H. Reader) might have it, that these posters and industrial offprints that cover the insides of shacks are merely accidental arrangements of materials, or that they are only meant for their practical use as insulation against the cold and blustery winters of the Western Cape.

Coombes notes astutely that one of the achievements of Mthethwa's images is that they evoke human environments that make do against great odds, they are clearly the products of a self-made aesthetic, and they give evidence of a kind of lived-in-ness. These are homes, made beautiful, however humbly. Coombes observes, further, that Mthethwa's sitters "are represented in such a way that they 'own' their space. They are neither defined primarily as the 'victims' of apartheid, nor are they necessarily oblivious to the limitations of their environment."[55] If we recall that apartheid was foremost a politics of space, of racialized control over rights to mobility and over individual choice of location for living, the notion of "ownership" that is evoked through Mthethwa's work carries great significance. Clearly this was something very much in the artist's mind when he began exhibiting his series on informal settlements in 1996. At the time he claimed, "For me nothing has really changed [since the 1994 elections]. We have a new government but so what? My focus is on average people. We still have a lot of people who need housing, a lot of people who are out of jobs."[56] If we leave aside the obvious parallels with Ledochowski's color work, but still recall the images from *The*

Cordoned Heart, the question remains: does this evocation of "lived-in-ness" have something to do with the artist's use of color?

In later portraits by the artist, the use of color is in fact subtler than in the red Lifebuoy image, and the dialectic of social relations caught in the signage that papers over the daily lives of his subjects is more thoughtfully composed in relation to his sitters. In another photograph published in Mthethwa's 1999 monograph, the blue flowers on the dress of the shack resident, her brown skin, her impatient frown, and protectively wrapped arms mirror the dress, the bare white, thrown-back shoulders, and the dentist-perfect smile worn by "Amanda Coetzer in her heartland" on the poster behind her (Figure 79). The poster is an advertisement for *Sarie,* a South African women's magazine—somewhere between *Elle* and *Redbook*—whose target audience is white and middle class, at least in aspiration. According to its publisher, *Sarie* is the "biggest Afrikaans glossy for independent and sophisticated women, inspiring them at both work and at play."[57] This poster, and the woman herself who is seated on a wooden bench, is bordered on two sides by images of red-hot red chairs and green pillows in an upscale high-modernist interior on the cover of *House and Leisure.*

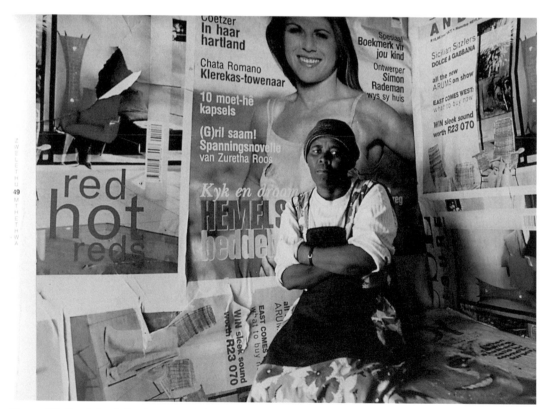

Figure 79. Zwelethu Mthethwa, untitled color photograph, 1996–97. Dimensions variable. Courtesy of Jack Shainman Gallery, New York.

As with conventional studio portraiture, the backdrop is prearranged and the clothing and props are made up, except in this case the wardrobe and the interior view have been selected from the sitter's own house. Here Mthethwa mixes the formal push-pull of rectilinear space and color juxtaposition, with the semiotic push-pull of the first world in the heartland—and the heart—of the third. This picture looks both ways. Whether its destination is the art gallery or the township mantle, this photograph is a window onto another world, as well as a window onto a world of the same.

One might imagine that the things in these posters on the wall—the lives and fashions of the global middle class—are, in the moment of the photograph, inaccessible to the woman portrayed. Yet they are also a sort of mirror and comprise many of the elements out of which a sense of personal style is made in the private space of the home. In a similar light, Arjun Appadurai has written of what he calls the "split character" of imagination. Given the conditions of a globalized economy of images, he notes that modern citizens everywhere are dominated by states and by corporate interests, through the imagination. "But it is also the faculty," he writes, "through which collective patterns of dissent and new designs for collective life emerge," beyond older ideas of ethnicity, race, or nation.[58]

In my view, the most intriguing aspect of Mthethwa's portraits from the informal settlements is his stated intention to act as both collaborator and artistic director. He claims to have developed relationships with those he has photographed through conversation and through the photo sessions, and that this aspect of his work (in addition to the play of color) differentiates his images from the classic corpus of struggle photography. One might say that where struggle photography more often claimed to *serve* the community, Mthethwa's interactive technique tends more to *create* community through the collective act of depiction. They "stop being 'subjects,'" he says, "and become collaborators." He claims further that "through understanding the people with whom I have interacted I have found it possible to understand myself and the work I am doing."[59] All of Mthethwa's photographs are consciously posed after a careful negotiation between both sitter and artist. He is adamant about not doing what he calls "happy snapping." Pictures of fake smiles and laughter, for Mthethwa, "immediately [raise] the point in photography about people wearing masks."[60] According to Michael Godby (who was a colleague of the artist at UCT in the 1990s), the individual and open-ended relationships developed by the photographer have resulted in a remarkable range of portrayals of individuals, with none of the standardization seen (or expected) in traditional studio portraiture.[61]

While Mthethwa's photographs of sitters in their Cape area interiors were constructed through a delicate choreography, they are also performative in the gallery setting, at least to a point. Although Mthethwa has gotten to know the people he has pictured, he shares none of that acquired familiarity with us—except

for the pictures themselves, which are the documents of his relationship with his sitters. His photographs were initially displayed in 1997 as notebook-sized prints at the Johannesburg Biennale, but they have more recently been printed as large as 120 x 170 centimeters. At that magnification they appear bigger than life size, and in the gallery setting they actually encroach upon the physical space of the viewer. Monumentalized in this way, the images become an installation, one that brings much of the claustrophobia, brilliant color, and earnest and stern faces of the shantytown into the viewer's own pristine space. But they are contained in the space of the gallery and remain a cipher. Their mouths are closed. They just stare back, mutely, inviting you to visit the colorful boxes they call home.

Unlike Chris Ledochowski's "Cape Flats Details," none of Mthethwa's portraits carries a name, and no information about the where and when of the photographs is given. Likewise, in the 1999 monograph on Mthethwa, the only information given is the page number and the artist's name on every picture page. Coombes also has noted this problematic aspect of Mthethwa's presentation, and she suggests that, in the end, the accumulation of details within these images and the social contradictions they imply override the issue of their anonymity.[62] I disagree, since the conscious lack of transparency in Mthethwa's presentation of his portraits effectively gives him claim to ultimate authority over these images, regardless of the supposedly collaborative contexts at the site of their creation. They may be documents of a collaborative performance, but the texture of that collaboration is effaced in the art gallery context where the monumentalized portraits of people in their humble shacks become, solely, "Zwelethu Mthethwas."[63]

A similarly problematic instance of Mthethwa's authority over his subjects can be seen in a more recent series on sugar cane cutters in Natal that was featured on the cover of an exhibition catalogue for the International Center of Photography in New York.[64] The *Sugar Cane* series (2003) depicts solitary men wearing layers of torn clothing and holding machetes like "samurai warriors" in the midst of sun-soaked fields. The tattered layers are worn to protect harvesters from the razor-sharp edges of the cane leaves. *Art in America* reviewer Nancy Princehall wrote that Mthethwa's farmers, with their stern expressions, look "heroic," while also registering "how small a payment that dignity is against the misery [hard labor] entails."[65] These images have a monumental feel about them, and they are meant to comment on the wider globalization of commodities and low-wage labor, as much as to point to the heroic context of survival under local conditions in Natal. What commentators on the *Sugar Cane* series neglect to mention is that these are not just *any* sugar cane cutters. They are employees on Mthethwa's brother's farm in Umzinto.[66]

With this information added, the question arises as to what extent these subjects are equal and willing participants in the picture-making process, as claimed by the artist, and of what kinds of class relations between the artist and

his subjects are elided through their aestheticization. This potential for abuse of authority and class-based insensitivity recalls an earlier incident involving the work of Steve Hilton-Barber. In 1990 Hilton-Barber exhibited a series documenting the circumcision rites of young North Sotho men on his family's farm in northern Drakensberg. A number of critics were appalled by what they saw as the photographer's indecent exposure of a secret rite. They questioned his claim to have received credible permission, given that he was white and his family controlled the labor of those depicted, and given the wide exposure of the images far beyond the local context of the sacred ritual.[67] Protests ensued, and the photographs and captions were eventually stolen from the exhibition hall at the Market Theatre. Controversy followed Hilton-Barber's decision to continue circulating these images, despite the fact that he was consistently direct about their context of production. Mthethwa's sugar cane portraits do not dwell upon the nudity or frailty of his subjects, as did Hilton-Barber's initiation series. But they have also not been exhibited along with any details about the photographer's relations of authority over the farmers, nor have they elicited the kinds of critical commentary experienced by Hilton-Barber, whose pictures, it should be mentioned, were in black and white. In the *Sugar Cane* series, Mthethwa's careful application of color (and, we may infer, the race of the artist) has been a sweet distraction for the consumer, one that ends up obscuring the dignity of his subjects.

Shack Chic

There is one exception to Mthethwa's use of anonymity for his subjects. The winter 2001–2 issue of *Nest: A Quarterly of Interiors,* an international interior design magazine directed by Joseph Holtzman, includes a photo-essay titled "Mrs. Zama's House" with text by Miriam Tlali and photographs by Zwelethu Mthethwa.[68] Tlali describes the location, contents, and design of the house of Mrs. Nothozamile Zama (whose name is given), and also interviews her. Zama, we are informed, lives in Thembani ("have hope"), a makeshift residential area in Paarl. Tlali, who was flown in from Johannesburg to do the interview, discovers to her delight that Zama speaks her same home language, South Sotho, and that the newsprint was affixed to the walls with wheat paste. She reports the terrible details about the absence of latrines and the danger of rape in the township. These are things that Mthethwa, who supposedly had known Zama since "long ago," did not seem to be aware of. The same woman was featured without her name in the second half of another monograph on the artist, published in 2000.[69] The photographer, who was born in Natal and thus grew up speaking Zulu (and English) had assumed Mrs. Zama spoke Xhosa like most of the other families in the area, and had brought along a translator for the *Nest* shoot.

The accompanying essay in *Nest* reversed the order of Mthethwa's earlier photographs portraying shack residents in their self-built homes covered with the signage of a middle-class world. In *Nest*, the former push-pull of the commodity images on the walls of the township homes was inverted, since the image of Mrs. Zama's home was itself inserted into a design magazine illustrating the "world of interiors." The effect is a mirror within mirrors, except that, oddly, the text of this essay, set in a bright pink ground, obscures most of the actual images of the featured house. Bordered as it is by other articles on high-end furnishings, the essay was meant to be dignifying, showing how "one house here does more than survive." Tlali, hamming up the design magazine context of the piece, at one point states, in reference to a blue tarp covering the earthen floor of the shack, "It felt like treading on the cozy flooring laid by experts in luxury homes of the 'white' suburbs of the city of Johannesburg."

Despite the addition of a name, details about the hardship suffered and the creative ingenuity exemplified by Mrs. Zama, the juxtaposition conceals as much as it reveals. The racialized history of underdevelopment that has continued into the second decade *after* apartheid is nowhere spoken of in the text. The result is a collaged cacophony of color and signage, with none of the subtle interplay of visual elements seen in Mthethwa's photos when they stand alone. To some extent, the earlier pictures had already aestheticized poverty as "design and composition." Then the article in *Nest* gentrified the impoverished ingenuity of the Cape Town flats. It accomplished this by further evacuating the references to the political and economic conditions that have produced the necessity to "make do" in order just to "make house" around Cape Town.[70]

Shack Chic, published by Thames and Hudson in 2003, went one step further. It is a glossy coffee-table book with images by white photographer Craig Fraser in collaboration with a multiracial team of designers and writers. It unashamedly cannibalized the aesthetic that Mthethwa had authored (or found), and it completed the act of gentrification that Mthethwa himself had already begun when he displaced the names from his collaborative Cape Town portraits with his own. Mthethwa himself had brought the existence of a "shack chic" to the attention of the international design world when he published his images in *Nest*. In *Nest*, in *Shack Chic*, and in the art gallery, the travails of homelessness have been served up as exotic entertainment for the leisure class. Sean O'Toole has written, paraphrasing Johnny Rotten's lyrics for "Holidays in the Sun," that "images such as these unceremoniously allow us to holiday in someone else's misery."[71]

Shack Chic is more like "black townships light" than Zwelethu Mthethwa's more somber portraits. It turns the brooding shack aesthetic lionized by Mthethwa, even in *Nest*, into bourgeois "how to" magazine fare, along the lines of *Martha Stewart Living* and *Real Simple*—even giving tips on where to purchase the same kinds of funky materials for the reader's own home. The interiors are clearly

cleaned up for the photographs, with household items reordered by the design team. They are mostly shot, invasively, without their owners present in the picture, with a tripod and full-flash lighting. The interiors appear crisp and bright—all lines are straight, all angles are square with the floor, and shadows are kept to a minimum. Images of township residents mugging for the camera are interspersed, along with aphoristic phrases about the creative uses of line, color, and light.

Next to the images in *Shack Chic*, Mthethwa's own photographs can only gain gravity. The comparison, in fact, helps bring out what is exceptional in his work. It verifies that Mthethwa has developed a visual intimacy with his sitters to the point that they do not feel the need to wear the same protective smiles they show to tourists. He has used a less invasive hand camera technique, working more sensitively with available light and thus evoking more realistically the shadow-filled look of the informal structures depicted. By comparison, Mthethwa's technique appears more tentative, and more respectful of the people who have humbly invited him (and us) into their homes. Ironically *Shack Chic* revealed how "Zwelethu Mthethwas" are closer in spirit to *The Cordoned Heart*.

We have a final clue to Mthethwa's perspective on his own practice of performative portraiture. The photographer is also known for his allegorical pastel works on paper, whose symbolic use of rich colors is reminiscent of the work of Paul Gauguin. In fact, his pastel works were much better known previous to the dramatic reception for his photographs at the Johannesburg Biennale in 1997. One large pastel from 1996 is titled *The Warrior* (Figure 80). In it a man sits on a stool in a portrait studio, wearing a horned and beaded headdress. He holds a knobkerrie in one hand, and with the other he holds a telephone receiver to his ear. The scene is framed so that the photographer and a painted backdrop of a traditional village—and thus the artificiality of the portrait—are exposed. Mthethwa has drawn the phone cord trailing over the man's leg and onto the floor, where it lies unplugged, thus adding a touch of levity to the picture. The image refers to a practice among working-class migrants to the cities, of having a humorously self-aggrandizing photograph made that depicts both their longing for home and their enhanced (technological and cosmopolitan) modernity in town. At the studio one might imagine oneself as a warrior in town, whereas in the rural areas one was really an ordinary farmer. Such images also encapsulate in one scene the moment of a phone call to the family back home. They are solipsistic in a way related to the inclusion of a framed photograph held in the hands in a nineteenth-century studio portrait, since such photographs might also be included in a letter to home informing the family of one's safe arrival in the city. They illustrate all at once where the rural migrant is now and what he dreams about. Mthethwa's pastel of this scene recognizes all of these perspectives, and it also demonstrates the artist's own circumspect view of the kinds of artifice at stake in the practice of photographic portraiture. Clearly Mthethwa does not see

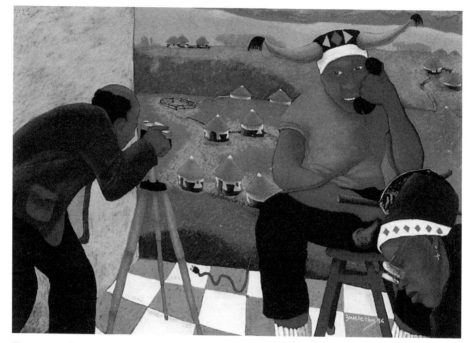

Figure 80. Zwelethu Mthethwa, *The Warrior*, 1996. Pastel, 100 x 127 cm. Courtesy of Jack Shainman Gallery, New York.

himself in the same role as the photographer in his pastel drawing, but neither is he above the use of artifice. Rather than producing an ideal identity, as studio photographers might in collusion with their clients, Mthethwa's best images work with his subjects to probe the construction of identity. His work is consciously in conversation with the history of photographic depiction of black people in South Africa, and, for all its difficulty, it aims to illustrate a different, more direct, and more cerebral kind of realism in dialogue with his subjects.

Chasing Shadows

Santu Mofokeng was instrumental in charting the turn to subtler investigations of the image of black life *before* the end of apartheid. Since the liberalization of South African politics and the first democratic elections in 1994, he has continued to address the problem of how to create images that break down, remember, rehumanize, and recast the worth of the black subject. Many of his photographs blur the human figure so that its time-bound aspect becomes manifest. His bodies are surrounded by mists and shrouded in an otherworldly or funereal air. Alternatively his figures are kept at a distance, far enough out from the viewer to confound any ethnographic interest. Since the 1990s, Mofokeng has countered the overdetermined sign of the black body by often explicitly obscuring the view

of that body. This work empties the human landscape of its contents in order to reinvest it with spiritual significance. He calls his practice a "metaphorical biography," because of his personal investment in the scenes framed by his documentary photographs.[72] As with Mthethwa, the body that is the off-stage subject of his photographs is ultimately, and invisibly, the artist's own. What Mofokeng documents is not things that should be remembered about South Africa's tragic past, but rather the forgetting of things, and the things forgotten.

Mofokeng's engagement with strategies of erasure and reinscription can been seen in his 1996 *Chasing Shadows,* a series originally conceived as an extension of his earlier project *Train Churches.*[73] This group of photographs lures the viewer into the photographer's nostalgic search for his own ancestral roots near the border of Lesotho.[74] Lesotho is a separate country surrounded by South Africa, though the historical lands of the South Sotho people include areas currently within the borders of South Africa. The country has provided a significant percentage of the migrant labor for the mines, industries, and homes of South Africa. Lesotho, like the former South African "homelands," was one of the places that apartheid regulations claimed a significant number of black people belonged, no matter how many generations their families had actually lived in the cities and towns of the Republic of South Africa. It was the statutory as well as imagined "home" for thousands of South Sotho people living in a state of internal exile within the republic. In *Chasing Shadows,* home as such is not located. In its place, Mofokeng hints at the shades of an ancestral inhabitation of the South African landscape. In one image, titled *Church of God (with shadow, ghost of ancestors),* a spectral figure passes along the base of a high wall in a shallow cave (Figure 81). The words "Church of God" are written on the rock face, behind an altar for a syncretic African Christian sect and a sacrificial stone. The location of this photograph is near the town of Clarens, at a traditional place of initiation called Motouleng in Sotho. The name of the cave is literally "the place where [ancestral] drums keep beating." It is also referred to by locals as the "holy cave" and the "fertility cave." Here, over centuries, ancient San rock painters, traditionalist *sangomas* (mediums for the ancestors), and contemporary members of African apostolic congregations have commingled in their rites.[75] Today the area is contested terrain between Afrikaners in nearby Free State towns and those they consider African interlopers.

The documentation of the Motouleng landscape was both a journey of discovery and a personal trial for Mofokeng, who was harassed in local bars and refused access to hotels in the "white" town of Clarens.[76] The locals also claimed that Africans come over the border "illegally" to worship at Motouleng. Yet nowhere in Mofokeng's depiction of the place is there a hint of the extreme tribalist mentality that was promoted under apartheid and that is still resonant in some quarters today. Quite the opposite, he preferred to explore "the traditions that have withstood the

Figure 81. Santu Mofokeng, *Church of God (with shadow, ghost of ancestors)*. From
Chasing Shadows, 1996. Courtesy of Santu Mofokeng.

influence of missionaries, but have been modified to accommodate change." For
Mofokeng, "what makes Africa survive is its ability to 'eat' other cultures and influ-
ences, to be receptive and eclectic. There is no place for 'purism.'"[77]

Among the more traditionally inclined, early photography and graphic or
painted portraiture were sometimes believed to be devices that could remove the
shadow from a person for potentially nefarious use.[78] This was a standard colo-
nial view of native attitudes that supposedly illustrated the "irrational" world-
view of the "natives." But the colonial archive, as we have seen, could in fact
"steal the shadow," precisely by exposing it to rationalization. Fears of theft by
image making were also noted by the Johannesburg painter Durant Sihlali, who
claimed to have been chased away by his Soweto neighbors during the 1960s and
1970s, because they were afraid he was trying to steal their "shade" when he
painted watercolor scenes *en plein air*. According to Mofokeng, the meaning of
seritilis'thunzi in Sotho and Zulu (literally "shade" or "shadow") is more complex
than its English equivalents: "In everyday use, it can mean equally aura, presence,
dignity, confidence, strength, spirit, essence, prestige or wellbeing. It can also
express the experience of being loved or feared."[79] He noted, further, that one's
shade must be defended against enemies and the forces of evil.

Chasing Shadows was the photographer's vision quest for an elusive essence
of a holistic picture of black South African culture. The series was a pictorial
search to recover lost dignity, strength, and a sense of spiritual well-being from

what remains in the South African landscape. It also confronted the double-edged history of photographic impoverishment of images of black South Africans under colonialism and apartheid, which resulted in the disenfranchisement of the black imagination. *Chasing Shadows* reversed the method of the colonial archive of images that catalogued Africans as ethnic types, by reinserting the spectral bodies of the ancestors of the African land through the romance of the photographic fiction. *Chasing Shadows* looked past the materialist rhetoric of the antiapartheid struggle and beyond the growing materialism of an increasingly globalized South Africa.

In *Appropriated Spaces* (1998), Mofokeng looked to urban Johannesburg, which was coded as "white space" during the colonial and apartheid periods, but whose actual history has been more mixed. In one photograph from the series, an African apostolic group holds a prayer session in the shadow of the M31 highway overpass near Doornfontein, a semi-industrial area just southeast of downtown (Figure 82). This is an area where black wage laborers once queued on the sidewalks around Albert Street, hoping to have their passbooks "endorsed" by finding work for the day.[80] Today it is a place where Zulu merchants sell food and wares informally on the sidewalks. For *Appropriated Spaces,* Mofokeng selected those places where the frayed postapartheid urban landscape is being re-populated through the eruption of everyday acts of ritual, conducted at the city's edges and out of common sight. He illustrated, this time for the urban areas, the intimate spiritual conjunction of the human body and the landscape through ritual. Mofokeng's photographic restitution of spirituality at the sites of apartheid exclusion and trauma was a step toward bodily reintegration in the realm of representation. *Chasing Shadows* and *Appropriated Spaces* each aimed toward a reconnection to a sense of self by means of the shades of the past. They created an image and a mythology for a new sense of community, and a new sense of security of place during a critical period of social reconstruction. In his statement for the *Appropriated Spaces* series, he wrote: "Home is an appropriated space, it does not exist objectively in reality. The notion of 'home' is a fiction we create out of a need to belong."[81] In these works Mofokeng asserted that home—and by extension the representation of identity—is not a given. It must be built from ashes.

Look at Me

Where *Chasing Shadows* and *Appropriated Spaces* actively contested the colonial and apartheid archive of images of South African lands and bodies, the process of archival recollection was even more central to another project of Santu Mofokeng's made during the politically transitional years between 1989 and 1996. Titled the *Black Photo Album/Look at Me 1890–1950,* the work consisted of compiling and rephotographing studio portraits of middle-class black sitters from the turn of the century (Figure 83). His subjects were people like Knox Bokwe and Tause

Figure 82. Santu Mofokeng, *Doornfontein, Johannesburg.* From *Appropriated Spaces*, 1998. Courtesy of Santu Mofokeng.

Figure 83. Santu Mofokeng, "Rozetta Dubula and friends. Rozetta Dubula, born Duma, was born in Thaba-Nchu in 1901. Her granddaughter, who was named after her, knows little about her life." From *Black Photo Album / Look at Me (1890–1950),* 1996. Installation detail. Courtesy of Santu Mofokeng.

Soga, whose images had been lost to the archive and stripped of their original meaning, or had been buried in private family collections. The work began as an oral history research project for the Institute for Advanced Social Research at the University of the Witwatersrand and evolved into an art installation. Mofokeng sought out these images, researched their provenance, and attempted to return some of their purloined context. Sometimes he found the old photographs abandoned in the bottoms of drawers or storage chests. Sometimes family members could no longer recall who the images were of or where they had been taken. Some thought the pictures must be of foreigners because the clothing and bearing seemed so strange.

Black life in South Africa was on hold for over fifty years, and after half a century and more of arrested development, of pass laws, Bantu Education, forced tribalization, and the wholesale disruption of family life, the "ancestral" images of an earlier African modernity were no longer recognizable to contemporary South Africans. Mofokeng claimed that during the height of the struggle he could not even talk about these earlier portraits because no one understood where they came from: "They didn't realize that while their manner and dress was similar to colonial Europeans, they still challenged the racism of colonial policies."[82] These middle-class black South Africans from a bygone era—people like John Tengo Jabavu, Sol Plaatje, and Pixley ka Isaka Seme (and later Walter Sisulu, Albert Luthuli, and Nelson Mandela)—far from being bourgeois sellouts, had in fact been the first to adapt to and resist, with modern means, the colonial encroachment upon African lives and lands. They were the early founders of the movement that became the African National Congress, and it was they who had initiated the struggle against racial discrimination even before apartheid. Their faces and their histories, and even more so the histories of their lesser-known black contemporaries, were already being buried by the time the painter Gerard Sekoto arrived in Sophiatown in the 1930s. Their ruined houses were the ones painted in watercolor by Durant Sihlali in Pimville in the 1970s. Mofokeng's *Black Photo Album* disinterred these old pictures and their old stories of black life *before* apartheid and re-created a narrative for them.

When exhibited in an art gallery, these photographs were usually shown in a small room, projected from a slide carousel one after the other. They were projected life size and alternated with text frames containing whatever information about the sitter and photographer Mofokeng had been able to discover. Enlarged (and recontextualized) in this way—with their eyes staring forward and with their bodies close by in the cozy room—their subjects were briefly reanimated. Viewers were moved to know more about who these beautiful, well-dressed people were. But the apparent loss of historical information—some of the text slides state simply: "No information is available about this photograph"—left a melancholy resonance hovering about the piece. It was as if the ghosts of the

old photographs were each given a moment to stand on a stage and whisper their names to those who had forgotten (or discarded or ignored) them—before they disappeared again.

John Tagg has defined a "colonial" photography, one that views "the natives" as passive objects incapable of speech.[83] Following Tagg, the *Black Photo Album* exemplifies an *anticolonial* photography. It gave back the context its photographs had *before* they were displaced into the archive. But, since the process of regaining the past was ultimately (and inevitably) incomplete, the traces of former abuse remained along with the rehabilitated images. Their new forms became documents of early black modernity as much as documents of its disavowal. Mofokeng claims that the research for the project "not only made me aware of my own ignorance about the past, but also made me scrutinize photography. I began to look at photographs as documents, and became aware of the private uses of images that are clues to the past."[84] In this work, the private rituals of consumption crossed the grain of the photographic rituals that produce identities.[85] The "work" of the *Black Photo Album* was that it brought a lost history of images to light, and also brought to consciousness the hidden history of everyday rituals of production and consumption through which we come to know pictures of ourselves and our others.

His approach is thoroughly postmodern, but Mofokeng, who began his career committed to the social documentary tradition, remains wary of a solely retinal reception of his camera work, insisting, "One [still] has to engage with the struggle."[86] He fears that despite his intentions, his work will be turned into an exotic commodity in the international art market, a risk that, as we have seen, has also haunted Zwelethu Mthethwa's commercial success: "In South Africa I am considered . . . a documentary photographer. . . . But when I travel internationally I am feted as an artist. I cannot decide if this is better, for I don't want my work to be consumed only at the aesthetic level."[87]

Today the borders of South Africa are no more limited to its geography than they were when Gerard Sekoto spoke of Sophiatown through his love of jazz and Vincent van Gogh, or when Madi Phala painted the heavy poetry of the revolution in dialogue with Senghor and Jackson Pollock. After the elections of 1994, "South African art" suddenly become a popular commodity among European and American collectors. Now there is a new scramble for Africa in the international art world, in search of its "vernacular" photography. Since the mid-1990s, the demand for 1950s portrait work by the Malian studio photographer Seydou Keïta has headed this trend, and the work of numerous other (and often minor) modern African photographers is also in high demand. Their images are highly collectible, in part because of the curiosity factor, and in part because what can be bought for a song and sold for a mint has always aroused interest among dealers in African art. Santu Mofokeng repudiates this fashion for the vernacular taken

out of context: "What makes me sad, especially about the *Black Photo Album,* is that the work functions, and is consumed at the level of aesthetics. . . . I once took the trouble to send images and text to a show only to find the images arranged like a mantel display without any text."[88]

This kind of misappropriation is the flip side of the new opportunities to show and sell overseas that have opened up since 1994. The situation is strangely reminiscent of the kinds of formal constraints placed on black artists at mid-century, if they hoped to sell their work in the galleries of white South Africa. Now visual artists who desire to create new images for a postapartheid South Africa—if they hope to make art that is relevant in a wider world—face a new dilemma. Can they resist the exoticization of their work abroad as a mute sign of "South Africanness"? Can they be the midwives of a new national culture, one that is conscious of its contested, but ultimately shared history? Even after apartheid, the struggle for the image continues.

NOTES

Introduction

1. Rory Bester and Katarina Pierre, "Stating the Nation," in *Democracy's Images: Photography and Visual Art after Apartheid,* ed. Jan Lundström and Katarina Pierre (Umea: BildMuseet, 1998).

2. Frances Saunders, *The Cultural Cold War: The CIA and the World of Arts and Letters* (New York: New Press, 1999), 397–404.

3. Rob Nixon, *Homelands, Harlem, and Hollywood: South African Culture and the World Beyond* (New York: Routledge, 1994), 214–17.

4. A. J. Christopher, *The Atlas of Apartheid* (London: Routledge, 1994), 136–38.

1. Grey Areas and the Space of Modern Black Art

1. Leslie Spiro, *Gerard Sekoto: Unsevered Ties* (Johannesburg: Johannesburg Art Gallery, 1989), 21–23. See also Luli Callinicos, *Working Life: A People's History of South Africa,* vol. 2, *Factories, Townships and Popular Culture on the Rand 1886–1940* (Johannesburg: Ravan Press, 1987).

2. Bob Nixon, "Harlem, Hollywood, and the Sophiatown Renaissance," in *Homelands, Harlem, and Hollywood,* 11–42.

3. For biographical notes on Sekoto, see Barbara Lindop, *Gerard Sekoto* (Randburg: Dictum, 1988); Elza Miles, *Land and Lives: A Story of Early Black Artists* (Cape Town: Human and Rousseau, 1997), 76–83; and Spiro, *Gerard Sekoto.*

4. Spiro remarks that the drawing lessons for students at Grace Dieu included the study of geometric counterchange patterns similar to designs seen in Pedi and Ndebele

art. Spiro, *Gerard Sekoto,* 67n131. Here she cites an interview between Elizabeth Rankin and the artist, in Paris during June 1988.

5. Miles, *Land and Lives,* 77.

6. Spiro, *Gerard Sekoto,* 33.

7. Miles, *Land and Lives,* 78–79.

8. Ibid., 80–81.

9. Miles, *Land and Lives,* 78; Lindop, *Gerard Sekoto,* 19.

10. Lindop, *Gerard Sekoto,* 19.

11. For a sociological analysis of this small but influential class of black intellectuals and professionals, see Leo Kuper, *An African Bourgeoisie: Race, Class, and Politics in South Africa* (New Haven, Conn.: Yale University Press, 1965).

12. Roland Barthes, "The Blue Guide," in *Mythologies,* trans. Annette Lavers (New York: Noonday Press, 1972), 74–75.

13. Spiro, *Gerard Sekoto,* 33, 42.

14. Work by Sekoto was also selected for the annual exhibitions in 1939, 1941, and 1942. Other black artists, including John Mohl, Moses Tladi, and Job Kekana, were also included in academy shows, but usually in special categories, as "Native Exhibits" or "Native Crafts."

15. *Grey Areas* is also the title of an anthology of writing on race and representation in art after apartheid, edited by Candice Breitz and Brenda Atkinson. The volume does not explain the official use of the term during the apartheid years, it only discusses work by black artists in a cursory fashion, and it does not speak significantly of the history of art before 1994. The primary concern of the volume is a defense of Breitz and a number of her white female artist colleagues (mostly by various friends, colleagues, and former teachers) against accusations by critics (primarily Okwui Enwezor, Kendell Geers, and Olu Oguibe) that their aesthetic appropriation of the image of the black body was insensitive. The art and controversy discussed, though important, belong to the postapartheid era and fall beyond the scope of my own study. Ironically, an earlier version of the present chapter was proposed for the anthology but was rejected on the grounds that it was "too historical." See Brenda Atkinson and Candice Breitz, eds., *Grey Areas: Representation, Identity and Politics in Contemporary South African Art* (Johannesburg: Chalkham Hill Press, 1999); Olu Oguibe, "Beyond Visual Pleasures: A Brief Reflection on the Work of Contemporary African Women Artists," in *Gendered Visions: The Art of Contemporary Africana Women Artists,* ed. Salah Hassan, 63–72 (Trenton, N.J.: Africa World Press, 1997); Kendell Geers, "Dangers Inherent in Foreign Curating," *Star Tonight,* 19 March 1997; and Okwui Enwezor, "Reframing the Black Subject: Ideology and Fantasy in Contemporary South African Art," in *Contemporary Art from South Africa* (Oslo: Riksutstillinger, 1997).

16. Cited in Tim Couzens, *The New African* (Johannesburg: Ravan Press, 1985), 253.

17. See Elza Miles, *Lifeline out of Africa: The Art of Ernest Mancoba* (Cape Town: Human & Rousseau, 1994); and South African National Gallery, *George Milwa Mnyaluza Pemba* (Cape Town: SANG, 1996).

18. Cited in Lindop, *Gerard Sekoto,* 150. Sekoto's comment also contains a hint of the negritude philosophy of Léopold Sédar Senghor, whom he knew in Paris.

19. When he first arrived in Paris, Sekoto worked at a piano bar, where he was sometimes mistaken for an American jazz musician.

20. During 1995 I watched the excavation of the ground for the future stadium at

Ellis Park, east of downtown Johannesburg. Each day teams of day laborers could be seen working, and white foremen perched on ladders shouted orders.

21. The work has alternatively been titled *The Future of Africa* and *Africa to Be*. According to Elza Miles, the models for the sculpture were Mancoba's younger brother and a friend. Miles, *Land and Lives,* 137.

22. In Europe Mancoba switched from naturalistic carving to abstract painting, and exhibited with the CoBrA group in 1950. During 1940–44, he was interned by the German army. Miles, *Land and Lives,* 137–38, 141–42. CoBrA was an avant-garde group composed of artists from Copenhagen, Brussels, and Amsterdam active from 1949 to 1952.

23. Elizabeth Schneider dates the earliest examples to the 1940s. Brenda Danilowitz places the date earlier, by surmising that Constance Stuart first began photographing in Ndebele villages in the company of Alexis Preller in 1937. See Elizabeth Schneider, "Art and Communication: Ndzundza Ndebele Wall Decorations in the Transvaal," in *African Art in Southern Africa from Tradition to Township,* ed. Anitra Nettleton and David Hammond-Tooke (Johannesburg: A. D. Donker, 1989), 103; Elizabeth Ann Schneider, "Paint, Pride, and Politics: Aesthetic and Meaning in Transvaal Ndebele Wall Art" (PhD diss., University of the Witwatersrand, 1986); Brenda Danilowitz, "Constance Stuart Larrabee's Photographs of the Ndzundza Ndebele: Performance and History Beyond the Modernist Frame," in *Between Union and Liberation: Women Artists in South Africa 1910–1994,* ed. Marion Arnold and Brenda Schmahmann (Burlington, Vt.: Ashgate, 2005), 90n10.

24. Franco Frescura, "KwaMsiza—An Ndebele Village," a special project for *South African History Online* (http://www.sahistory.org.za/pages/specialprojects/kwamsiza/menu.html); see also Schneider, "Paint, Pride, and Politics." Today the Ndebele are still portrayed as exotic strangers. At the Ndebele Cultural Centre in Mabokho, tourists are offered "a place to unwind from the stress of Africa's cities," to purchase "authentic" works of art, all "while enjoying a cup of tea . . . or expresso" (http://courtney-clarke.com/ndebele.htm).

25. The name is spelled variously, including Mapoch, M'poga, Mapogga, and Mabhogo.

26. See Schneider, "Paint, Pride, and Politics." Today the Ndzundza styles are commonly equated with the larger group term "Ndebele," even though there is great diversity among self-identified Ndebele groups, including many who do not make the characteristic murals or beadwork or are linguistically distinct. Mural making today, even among the Ndzundza, is increasingly rare. Another distinct group, also called Matabele but now resident in Zimbabwe, was a later splinter from the Nguni of Natal during the early-nineteenth-century rise of the Zulu nation.

27. Frescura, "KwaMsiza."

28. Peter Delius, "The Ndzundza Ndebele: Indenture and the Making of Ethnic Identity, 1883–1914," in *Holding Their Ground: Class, Locality and Culture in 19th and 20th Century South Africa,* ed. Philip Bonner, Isabel Hofmeyr, David James, and Tom Lodge (Johannesburg: Ravan Press, 1989), 228.

29. Ibid.

30. Ibid.

31. Frescura, "KwaMsiza."

32. Esmé Berman, *Art and Artists of South Africa: An Illustrated Biographical Dictionary and Historical Survey of Painters, Sculptors, and Graphic Artists since 1875*

(Cape Town: A. A. Balkema, 1983). Berman states: "The 'Ndebele are not alone among Bantu tribes in producing mural decoration, but their art is certainly the most outstanding, as well as the best known, (it also provides an interesting indigenous complement to the perceptual styles of SA rock-painting, or 'Bushman' Art)" (305).

33. Ibid., 306.

34. Walter Battiss, "A New African Art in South Africa," *Optima* 17 (1967): 25.

35. Isaac Schapera, "The Ndebele of South Africa, Photographs by Constance Stuart," *Natural History* 58, 9 (November 1949): 414.

36. Danilowitz, "Constance Stuart Larrabee's Photographs," 76. For a critique of the salvage paradigm, in which the present of non-Western cultures is perceived as the West's "past," see James Clifford, "Of Other Peoples: Beyond the 'Salvage' Paradigm," in *Discussions in Contemporary Culture,* number 1, ed. Hal Foster (Seattle: Bay Press, 1987).

37. Thanks to Lynn Thomas for pointing this out to me. See Isaac Schapera, ed., *Western Civilization and the Native of South Africa* (London: Routledge and Sons, 1934), and Isaac Schapera, *Married Life in a South African Tribe* (New York: Sheridan House, 1941). For a biographical profile and examples of the anthropologist's own photography, see John Comaroff, Jean Comaroff, and Deborah James, eds., *Picturing a Colonial Past: The African Photographs of Isaac Schapera* (Chicago: University of Chicago Press, 2007).

38. Schneider, "Art and Communication," 109.

39. Illustrated in Jan Nederveen Pieterse, *White on Black: Images of Africa and Blacks in Western Popular Culture* (New Haven, Conn.: Yale University Press, 1992), 105.

40. *Holiday* 22, 3 (September 1957): 141; *National Geographic* 112, 4 (October 1957): 417.

41. Berman, *Art and Artists,* 306; Schneider, "Art and Communication," 242n9. The museum moved from a town house to its present location on the Mall in 1986, though when I lived in Washington, D.C., in 1989, the Ndebele-style paintings could still be seen on the garages in the alley behind the former museum site on Capitol Hill.

42. Gary van Wyk, "Through the Cosmic Flower: Secret Resistance in the Art of Sotho-Tswana Women," in *Secrecy: African Art That Conceals and Reveals,* ed. Mary Nooter (New York: Museum for African Art, 1993). Van Wyk makes reference to Ndebele art, but his primary interest is the mural art of South Sotho peoples in the Orange Free State.

43. The best-known exponents of this sort are Esther Mahlangu and Francina Ndimande. One impetus for this transition to gallery art was the Tributaries exhibition curated by Ricky Burnett for BMW South Africa in 1985. This show was the first of its kind to display the whole range of visual art production by all groups in South Africa. Tributaries collected work by modernists, craft artists, and traditional and tourist artists under one roof. A number of unnamed "Ndebele" artists were first given wide exposure with the show. Tributaries toured South Africa and Germany, and it was an important precedent for the better-known exhibition Magiciens de la Terre, held at the Pompidou Center in Paris in 1989. Magicians included paintings by Esther Mahlangu. See John Peffer, "The Essentials," in *Entangled: Approaching Contemporary African Artists,* ed. Marjorie Jongbloed (Hannover: Volkswagen Foundation, 2006).

44. Scott Wilcox, *Constance Stuart Larrabee: Time Exposure* (New Haven, Conn.: Yale Center for British Art, 1995), 13.

45. Berman cites the influence of the Ndebele on painters Trevor Coleman and Rupert

Shepard. For short essays on Trevor Coleman, Rupert Shepard, and Douglas Portway see Berman, *Art and Artists*. For Preller and Portway, see Esmé Berman, *Painting in South Africa* (Johannesburg: Southern Book Publishers, 1993). Walter Battiss (1906–82) is best known for his lifelong engagement with San rock art, so much so that he was called the "Bushman painter." His earliest works were sketches of rock paintings in the Orange Free State. He also was a prolific publicist for both modernist and traditional black artists. For an introduction to Battiss, see K. Skawran, ed., *Walter Battiss, Gentle Anarchist* (Johannesburg: Standard Bank Gallery, 2005); Walter Battiss, *The Artists of the Rocks* (Pretoria: Red Fawn Press, 1948); and Walter Battiss, *Walter Battiss* (Cape Town: A. D. Donker, 1985). Etchings by Cyprian Shilakoe from the late 1960s and early 1970s are full of the pathos of rural poverty and geographic displacement, and in them rural women and their mural art are sometimes depicted, but they are of the North Sotho peoples living near where he spent his childhood on a mission station at Buchbeesreich in the Transvaal (now Mpumalanga). See Karel Nel, *Cyprian Shilakoe (1946–1972): Standard Bank Third Guest Artist Award 1990* (Johannesburg: 1820 Foundation, 1990).

46. Quoted in Wilcox, *Constance Stuart Larrabee*, 12–13.

47. Ibid., 12.

48. For further exploration of the pastoral conceit in Larrabee's Ndebele photographs, see Danilowitz, "Constance Stuart Larrabee's Photographs," 86–87.

49. This archive can be accessed online at http://siris-archives.si.edu.

50. Jane Livingston, *Constance Stuart Larrabee: Tribal Photographs* (Washington, D.C.: Corcoran Gallery of Art, 1984).

51. Berman, *Painting in South Africa*, 91. Danilowitz notes the frustration with the conservative local art scene among the more cosmopolitan-minded members of the New Group. Danilowitz, "Constance Stuart Larrabee's Photographs," 74. Gerard Sekoto also exhibited with the New Group during the 1940s. The group's activities ended in 1953.

52. Berman, *Painting in South Africa*, 93. Larrabee (who was not a member of the New Group, but was a close associate of Preller's) studied at Regent Street Polytechnic School of Photography in London (1933–35) and at the Bavarian State Institute for Photography in Munich (1935–36). She moved to the United States in 1949.

53. Ibid., 92.

54. Berman, *Art and Artists*, 352.

55. Berman, *Painting in South Africa*, 159.

56. Berman (ibid., 147) claims Preller "emphatically rejected" being described as a surrealist. But in my view his restrained use of color, his controlled use of light, his precise linear delineation of bizarre (sometimes melting) forms, and his foregrounding of sexually charged symbolism all had much in common with the work of Salvador Dalí.

57. The photograph appears at the bottom of page 414, in Schapera, "The Ndebele."

58. In the inset, this *Mapogga* also tips her toes toward the viewer, as in the Larrabee photo. The painting is reproduced in Berman, *Painting in South Africa*, 160.

59. Berman, *Painting in South Africa*, 148.

60. Berman, *Art and Artists*, 352.

61. "He was not influenced as much by African art forms as by the evidence within them of an inscrutable forgotten age." Berman, *Painting in South Africa*, 158–59.

62. Nicholas Thomas, *Possessions: Indigenous Art/Colonial Culture* (London: Thames and Hudson, 1999), 12–13.

63. Ibid.

64. Ibid.

65. Ibid., 141.

66. Thomas makes a similar comment with regard to the Australian artist Margaret Preston. Ibid., 140.

67. For further discussion of the Amadlozi Group and Egon Guenther, see Sheree Lissoos, *Johannesburg Art and Artists: Selections from a Century* (Johannesburg: Johannesburg Art Gallery, 1986). For examples of objects owned by Guenther and likely shown to members of Amadlozi, see *African Art from the Egon Guenther Family Collection,* auction catalogue, Sotheby's (New York), 18 November 2000.

68. Elizabeth Rankin, *Images of Metal: Post-War Sculptures and Assemblages in South Africa* (Johannesburg: University of the Witwatersrand Press, 1994), 128. Rankin notes (129n4) that other sources of imagery included pottery designs and aboriginal Australian art.

69. The devastating progress of this kind of increasingly racial approach to the administration of the education system is chronicled in Muriel Horrell, *Bantu Education to 1968* (Johannesburg: South African Institute of Race Relations, 1968). Black teachers' resistance to the growing impoverishment of content and resources for black schools, and their bitter disappointment, are recalled in Ezekiel Mphahlele's memoir, *Down Second Avenue* (London: Faber and Faber, 1959).

70. Cited in Gavin Younge, "Dead in One's Own Lifetime" in *Dead in One's Own Lifetime: Art in Apartheid Society,* papers presented at the National Union of South African Students Art and Liberation Week, University of Cape Town, 1–4 May 1979, 13–14.

71. For background on Polly Street, see David Koloane, "The Polly Street Art Scene," in Nettleton and Hammond-Tooke, *African Art in Southern Africa;* Amanda Jephson, "Aspects of Twentieth Century Black South African Art—up to 1980" (MFA thesis, University of Cape Town, 1989); Elizabeth Rankin, "Teaching and Learning: Skotnes at Polly Street," in *Cecil Skotnes,* ed. Frieda Harmsen (Cape Town: South African National Gallery, 1996); and Elza Miles, *Polly Street: The Story of an Art Center* (Johannesburg: Ampersand Foundation, 2004). See also chapter 7.

72. Cecil Skotnes, interview, 29 August 1995.

73. Sidney Kasfir, *Contemporary African Art* (New York: Thames and Hudson, 1999), 50–51, 97–98; Elizabeth Harney, *In Senghor's Shadow: Art, Politics, and the Avant-Garde in Senegal, 1960–1995* (Durham, N.C.: Duke University Press, 2004), 56.

74. Koloane, "The Polly Street Art Scene," 219.

75. Sylvester Ogbechie (personal communication, October 2006) suggests that this may also have been true in the case of Ulli Beier, Margaret Trowell, and other art teachers in Africa in the 1950s and 1960s. If so, then the theory of "natural development" did not play out in practice.

76. Steven Sack, *The Neglected Tradition* (Johannesburg: Johannesburg Art Gallery, 1988), 16.

77. During the later 1960s, black artists inspired by the art of Ezrom Legae and Dumile Feni merged these two tendencies and produced work characterized by figural distortions that were more reminiscent of expressionist and surrealist art (see chapter 2).

78. Rankin, "Teaching and Learning," 70–72.

79. Sack, *The Neglected Tradition,* 18n11.

80. See "David Koloane and Ivor Powell in Conversation," in *Seven Stories about Modern Art in Africa,* ed. Clémentine Deliss (London: Whitechapel Art Gallery, 1995), 263.

81. Spiro, *Gerard Sekoto*, 54.

82. David Koloane, interview, 1 August 1995. Koloane began his art career during the late 1960s, by working informally with Louis Maqhubela. He later worked in Bill Ainslie's studio in Johannesburg. He was the founder of the first black-run gallery in Johannesburg in 1977. In 1985 he initiated the Thupelo Art Project, and in 1990 he started the Bag Factory studio complex. He has witnessed or participated in all of the major art movements in South Africa since the 1960s and has been a central resource for my own understanding of that history (see especially chapter 5). For a discussion of the cross influences among black artists, see Agrippa Nhlapo, "The Influences of Black Artists on Other Black Artists" (BA fine arts diss., University of South Africa, 1996).

83. For a survey of early and lesser-known black modernist artists, see Miles, *Land and Lives*.

84. Sack, in *The Neglected Tradition*, makes a convincing case for John Koenakeefe Mohl as the proper "father" of black modernism in South Africa. In my view, while Mohl may have been the "first," Sekoto was far better known and his influence was more pervasive.

85. Sihlali, interview, 3 October 1995.

86. Ibid.

87. George Pemba was also featured in the May 1955 issue of *Drum*. Other features included Selby Mvusi (June 1958), Ben Enwonwu of Nigeria (January 1955, April 1958, and twice in July 1963), Central and West African traditional art (March, April, and May 1951), Job Kekana (February 1956), *Drum* photographers Alf Kumalo and Peter Magubane (July 1963, July 1964, and September 1964), and Michael Zondi (October 1963).

88. Note the awkward use of the double modifier "African African." Walter Battiss, "A New African Art," 28.

89. Louis Maqhubela (interview, 8 January 2007) recalled visiting the Johannesburg Art Gallery with Sihlali, with the express purpose of viewing Sekoto's work. He noted further that they had first seen Sekoto's art at the Adler Fielding Gallery.

90. One notable exception was the work of John Muafangejo, a Namibian artist who had studied at Rorke's Drift. See Orde Levinson, *I Was Lonelyness: The Complete Graphic Works of John Muafangejo* (Cape Town: Struik, 1992).

91. The Brooklyn Museum and the Brooklyn Public Library, *Black/South Africa/Contemporary Graphics* (New York: Brooklyn Museum, 1976). The exhibit was "facilitated" by the South African Department of Information and was inspired by a trip to South Africa by library director Kenneth Duchac, sponsored by the U.S.–South Africa Leadership Exchange Program.

92. Phillipa Hobbs and Elizabeth Rankin, *Rorke's Drift: Empowering Prints* (Cape Town: Double Storey, 2003).

93. Louis Maqhubela, interview, 8 January 2007.

94. Ivor Powell, ". . . us blacks . . . : Self-construction and the Politics of modernism," in *Persons and Pictures: The Modernist Eye in Africa* (Johannesburg: Newtown Galleries, 1995), 16.

95. Koloane, interview, 1 August 1995.

96. Kobena Mercer, *Welcome to the Jungle: New Positions in Black Cultural Studies* (New York: Routledge, 1994).

97. Koloane, interview, 1 August 1995.

98. Houston A. Baker Jr., *Modernism and the Harlem Renaissance* (Chicago: University of Chicago Press, 1987).

99. Powell, " . . . us blacks . . . ," 18–19.

100. Alan Paton, *Debbie Go Home: Stories* (London: Jonathan Cape, 1961), 94–95.

101. Jean le May, "Reform without Change: A Special Nat Party Skill," *Weekly Mail,* 8–14 August 1986, 15.

102. David Goldblatt, "Introduction," in *Sharp: The Market Photography Workshop,* ed. Brenton Maart and T. J. Lemon (Johannesburg: Market Gallery 2002).

103. "Art under Apartheid," *New York Times Magazine,* 28 March 1965.

104. Mphahlele, *Down Second Avenue,* 198–99.

105. Paul Stopforth, interview, 29 July 2000.

106. Ibid.

107. Nat Nakasa, "Johanesburg, Johannesburg," in *The World of Nat Nakasa,* ed. Essop Patel (Johannesburg: Ravan Press, 1985), 7. The essay was originally published in *Classic* 1, 3 (1964).

108. Sholto Ainslie, personal communication, 24 July 2001.

109. Cecil Skotnes, cited at http://www.iziko.org.za/sang/exhib/skotnes/index .html.

110. Letter to Elizabeth Rankin, 22 September 1994. Cited in Rankin "Teaching and Learning," 74.

111. Steven Sack, "Introduction," *Common and Uncommon Ground* (Atlanta: City Gallery East, 1996).

112. Paul Stopforth, interview, 29 July 2000.

113. Ezekiel Mphahlele, "Remarks on Negritude," cited in Harney, *In Senghor's Shadow,* 45.

114. Ezekiel Mphahlele, "The Cult of Négritude," *Encounter* 16, 3 (March 1961): 51–52.

2. Becoming Animal

1. Steven Sack, *The Neglected Tradition,* 16. According to Elza Miles, when he lived in Cape Town in 1936, Ernest Mancoba also experimented with the application of formal elements from African sculpture after being introduced to Paul Guillaume and Thomas Munro's book, *Primitive Negro Sculpture,* by the artist Lippy Lipshitz. Miles, *Land and Lives,* 138.

2. Rankin, *Images of Metal,* 132.

3. Sack, *The Neglected Tradition,* 16. Leonard Matsoso and Lucas Sithole were two other artists notable for their use of the beast-in-distress motif. Cecily Sash, an original member of the Amadlozi Group, was also known for her depictions of caged and flayed birds.

4. Legae's later sculpture was more in dialogue with the work of the British artists Lynn Chadwick and Henry Moore.

5. Rankin notes that "for Legae life forces are always constructive as well as destructive" and that the idea of resurrection was an ongoing concern for the artist. Rankin, *Images of Metal,* 137.

6. Biographical notes on Dumile have been gleaned from Barney Simon, "Dumile," *Classic* 2, 4 (1968); Berman, *Art and Artists of South Africa,* 118–20; and Ivor Powell, "Dumile Feni: Struggle for Identity," *Art South Africa* 3, 4 (Winter 2005). See also Bruce Smith, *Dumile: Artist in Exile* (Johannesburg: Art on Paper, 2004).

7. Dumile lived in London from 1968 until 1979, when he moved to the United States. He died in New York in 1991.

8. One of the earliest such descriptions in print also compared Dumile to Daumier and Breughel. See "He Rose from the Dead to Become a Genius," *Sunday Tribune* (Durban), 21 August 1966.

9. Brenton Maart, "Dumile Feni," *Art South Africa* 3, 4 (Winter 2005): 63.

10. Powell, "Dumile Feni," 35.

11. Ibid., 37.

12. Regrettably permission to reproduce this work could not be obtained from the University of Fort Hare. Examples of Dumile's art can be viewed at http://www.dumile .org.za.

13. Fernand Haenggi, personal communication, 29 November 2006.

14. Dumile held a one-man show at the Durban Art Gallery in 1966. In Durban he met black students who would later be associated with the Black Consciousness movement.

15. Although in practice the two were intertwined, "Black Consciousness" refers generally to the ethos of upliftment and "Black Consciousness movement" to the alignment of cultural groups in support of the BC philosophy.

16. Shannen L. Hill, "The Changing Legacies of Bantu Stephen Biko and Black Consciousness in South African Visual Culture" (PhD diss., University of Wisconsin–Madison, 2003), 16–18.

17. Ibid., 18.

18. Ibid., 27.

19. Ibid., 20.

20. Ibid., 19.

21. *Classic,* special issue titled "French African Writing," 2, 2 (1966).

22. Warren Siebrits, "Drawings of Beauty and Mystery," *Art South Africa* 2, 2 (Summer 2003): 22.

23. Mongane "Wally" Serote was born in Sophiatown and grew up in Alexandra Township in Johannesburg. He studied creative writing at Columbia University from 1975 to 1978 and was a leading writer in the Black Consciousness movement. He moved progressively toward the ANC politics of racial inclusion, and during the mid-1980s was the ANC cultural attaché in London. He authored several books of poetry, including *Yakhal'inkomo* (1972), *Tsetlo* (1974), and *The Night Keeps Winking* (1982)—all illustrated by Thami Mnyele—and the novel *To Every Birth Its Blood* (1981), a chronicle of the 1976 uprising. He was a leading contributor to the ANC's evolving position on the Cultural Boycott. In the early 1990s, Serote was the head of the ANC Department of Arts and Culture, and after the general elections of 1994, he became a member of parliament. See Anton Harber and Barbara Ludman, *Weekly Mail and Guardian A–Z of South African Politics: The Essential Handbook* (London: Penguin, 1994), 126–27.

24. Mongane (Wally) Serote, *Yakhal'inkomo* (Johannesburg: Renoster, 1972).

25. Edward O. Bland, dir., *The Cry of Jazz, Featuring Sun Ra and His Arkestra,* 1959. Published in DVD by Unheard Music Series, Atavistic Video, Inc.

26. Diana Wylie, "'From the Bottom of Our Hearts': Making Art in a Time of Struggle," *African Arts* 37, 4 (Winter 2004): 58.

27. Siebrits, "Drawings of Beauty and Mystery," 22.

28. Gene McFadden, John Whitehead, and Victor Carstarphen, "Wake Up Everybody"

(Warner-Tamerlane, 1975). This song became an anthem for the effort to "get out the black vote" during the U.S. presidential election of 1976.

29. Regrettably permission to reproduce this work could not be obtained from the University of Fort Hare.

30. The use of Pieterson as a symbol of martyrdom and resistance was in spite of the fact that young Hector had not joined the protest on June 16, but was drawn to the march out of curiosity and was a bystander caught in the crossfire.

31. Regrettably permission to reproduce this work could not be obtained from the University of Fort Hare. Legae's drawings may be viewed in John Peffer, "Animal Bodies/ Absent Bodies: Disfigurement in Art after Soweto," *Third Text* 17, 1 (2003): 72–73.

32. The passion of Christ is a recurring theme in modernist art from Africa and the Diaspora. See Kobena Mercer, "Eros and Diaspora," in *Reading the Contemporary: African Art from Theory to the Marketplace*, ed. Okwui Enwezor and Olu Oguibe (Cambridge, Mass.: MIT Press, 1999); and Mary Schmidt Campbell, ed., *Harlem Renaissance: Art of Black America* (New York: Harry N. Abrams, 1987). In South Africa, Christological iconography appeared prominently in 1960s drawings by Dumile Feni, 1970s linoleum prints by Charles Sokhaya Nkosi, in Legae's art, and in the art of numerous other contemporaries.

33. For a general theory of sacrifice on the continent, see Luc de Heusch, *Sacrifice in Africa: A Structuralist Approach* (Bloomington: Indiana University Press, 1985). For a general overview of the ritual life of southern African peoples, see W. D. Hammond-Tooke, ed., *The Bantu-speaking Peoples of Southern Africa* (Boston: Routledge and Kegan Paul, 1974). Legae was raised in Johannesburg, in a Sotho-speaking family. For an ethnography of the modern rural Sotho, see Hugh Ashton, *The Basuto: A Social Study of Traditional and Modern Lesotho* (New York: Oxford University Press, 1967); see also Gary van Wyk, *African Painted Houses: Basotho Dwellings of Southern Africa* (New York: Harry Abrams, 1998). For an incisive account of contemporary Christianized Borolong (a northern branch of the Sotho language family), see Jean Comaroff, *Body of Power Spirit of Resistance: The Culture and History of a South African People* (Chicago: University of Chicago Press, 1985).

34. Ezrom Legae, interview with Linda Givon (1984), cited in Barbara I. Buntman, "Ezrom Legae 1976–1986" (BA honors diss., University of the Witwatersrand, 1987), 18.

35. Mary Nooter-Roberts, "Ezrom Kgobokanyo Legae (1937–present)," unpublished version of a text submitted for the DAK'ART '95 catalogue, 1995, 1.

36. Regrettably the University of Fort Hare would not grant permission to reproduce this work from its collection.

37. "Ezrom explains that it would be too blunt to use human bodies in his work— the ugliness of the tortures that are imprinted in his mind's eye . . . are too much for most people to bear." Nooter-Roberts, "Ezrom Kgobokanyo Legae," 1.

38. For an introduction to ideas on San trance and art, see J. D. Lewis-Williams, "San Rock Art," in Nettleton and Hammond-Tooke, *African Art in Southern Africa*.

39. Gilles Deleuze and Félix Guattari, *A Thousand Plateaus: Capitalism and Schizophrenia*, trans. Brian Massumi (Minneapolis: University of Minnesota Press, 1987), 238–41.

40. Ibid., 238.

41. Ibid., 241.

42. Ibid., 243.

43. Cited in Buntman, "Ezrom Legae," 18.

44. See Mongane Wally Serote, "Culture, Literature, and Liberation," in *On the Horizon* (Fordsburg: COSAW, 1990). Serote asserts that the shift from Black Consciousness, which was essentially a student movement, to "Charterist" politics was also a move from "elite" to more popular forms of resistance.

45. Biographical details for Stopforth, unless otherwise stated, are from the author's interview with the artist, 29 July 2000.

46. Shannen Hill cites a more neutral title for this installation, as simply *Figures*. Hill, "The Changing Legacies," 48. Hill also explores the trope of martyrdom further, with specific reference to the reified image of Steve Biko in art of the 1980s and 1990s.

47. Ibid., 58.

48. The phrase is Hannah Arendt's, and it originally referred to the bureaucratic management of genocide under the Nazis. See Hannah Arendt, *Eichmann in Jerusalem: A Report on the Banality of Evil* (New York: Viking, 1963). Stopforth speaks of Arendt in relation to his own practice, especially his triptych *The Interrogators* (1979), in Sue Williamson, *Resistance Art in South Africa* (New York: St. Martin's Press, 1989), 112. In my view, the connection to Arendt can be seen in most of Stopforth's work from the late 1970s and early 1980s.

49. My gratitude to Amber Teng for suggesting the visual link to Golub.

50. Andries Walter Oliphant, "A Human Face: The Death of Steve Biko and South African Art," in *Seven Stories about Modern Art in Africa,* ed. Clémentine Deliss (London: Whitechapel Art Gallery, 1995), 258.

51. Isaac Julien and Mark Nash, "Fanon as Film," *NKA: Journal of Contemporary African Art* 11–12 (Fall–Winter 2000): 17.

52. Frantz Fanon, *The Wretched of the Earth,* trans. Constance Farrington (New York: Grove Press, 1963), 295.

53. Julien and Nash, "Fanon as Film," 17.

54. Paul Stopforth recalled that he had recently returned from a farm with a bag of discarded bones and horns, with the idea that "something could be made with them." Alexander used these bones to create her BA thesis work. Stopforth, interview, 29 July 2000.

55. Williamson, *Resistance Art in South Africa,* 42–43. Jane Alexander was awarded the MA fine art degree from the University of the Witwatersrand in 1988.

56. H. G. Wells, *The Island of Doctor Moreau: A Possibility* (1896; New York: Bantam Classics, 1994).

57. Cited in Sue Williamson and Asraf Jamal, *Art in South Africa: The Future Present* (Johannesburg: David Phillip, 1996), 22.

58. Elaine Scarry, *The Body in Pain: The Making and Unmaking of the World* (New York: Oxford University Press, 1985), 27.

59. Fanon notes similarly, with specific regard to torture practiced by the colonial Algerian state, that such acts amount to a perversion of the moral sense of the colonizer. Frantz Fanon, *Toward the African Revolution* (New York: Grove Press, 1967), 70.

60. Michael Taussig, *Defacement: Public Secrecy and the Labor of the Negative* (Stanford, Calif.: Stanford University Press, 1999), 5.

61. Ibid., 6–7.

62. Cited in Williamson, *Resistance Art in South Africa,* 43–44.

63. Biographical details and quotations by Sebidi, unless otherwise noted, are from

the author's interviews with the artist on 20 April 1995, 24 April 1995, and 10 October 1997. For further details on Sebidi, see Rose Nolan, "Under an African Sun," *Tribute,* (December 1988); and Jacqueline Nolte, "Narratives of Migration in the Works of Noria Mbasa and Mmakgabo Sebidi," in *Between Union and Liberation,* 174–95.

64. Sebidi's mentor John Koenakeefe Mohl was a founding member of Artists under the Sun, an outdoor fair for amateur artists, and he assisted in the preparation of her first show there in 1977.

65. In the early 1990s, Sebidi's work became less jumbled and congested. The tone of her postapartheid work is still allegorical, but is more monumental in scale and theme.

66. Nolan, "Under an African Sun," 105.

67. Ibid.

68. Williamson, *Resistance Art in South Africa,* 37.

69. Ibid., 37–38.

70. Ibid., 38.

71. Ibid., 36.

72. Annette Loubser, personal communication, 10 October 1997.

73. Williamson, *Resistance Art in South Africa,* 37.

74. In this passage, Agamben speaks through the words of Alexandre Kojève. Giorgio Agamben, *The Open: Man and Animal,* trans. Kevin Attell (Stanford, Calif.: Stanford University Press, 2004), 12.

75. Ibid., 92.

3. Culture and Resistance

1. Diana Wylie, personal communication, 3 July 2007. See also Mongane Wally Serote, "Thami Mnyele 1948–1985," *Rixaka* 3 (1986): 5–6. Here Serote recalls that Mnyele once performed the role of Malcolm X with Mihloti.

2. See "Thamsanqa kaMnyele," http://www.sahistory.org.za/pages/people/special %20projects/arts/thami/mnyele-menu.htm.

3. Diana Wylie, personal communication, 3 July 2007. See also Diana Wylie, *Art and Revolution: The Life and Death of Thami Mnyele, South African Artist* (Charlottesville: University of Virginia Press, 2008). This book was not available as we went to press, but it promises to be a valuable resource.

4. Wylie, "'From the Bottom of Our Hearts,'" 58–59. Other sources give the date of this exhibition as June 1976, but Wylie (personal communication, 3 July 2007) claims this is not correct.

5. For these and other details on Medu, I am grateful to Judy Seidman for sharing portions in advance from her book *Red on Black: The Story of the South African Poster Movement* (Johannesburg: STE, 2007).

6. Cited in "Thamsanqa kaMnyele." This line by Sékou Touré is also the epigraph to Frantz Fanon's essay "On National Culture" in *The Wretched of the Earth,* 206. Mnyele's use of this famous quotation may have been derived from his reading of Fanon. The original context was an address by Touré to the Second Congress of Black Writers and Artists, Rome, 1959.

7. Cited in "Medu and the Culture of Liberation," www.sahistory.org.za/pages/ people/special%20projects/arts/thami/cultural-liberation.htm.

8. "Mnyele's Skies," *MEDU Art Ensemble Newsletter* 2, 2 (1980): 11.

9. Judy Seidman, interview, 29 July 1995.

10. See chapter 1.

11. Gavin Cawthra, *Policing South Africa: The SAP and the Transition from Apartheid* (London: Zed Books, 1993), 20–24.

12. "Medu and the Culture of Liberation." See also Seidman, *Red on Black,* 71–75.

13. Ibid. Junction Avenue was founded in Johannesburg in 1975; the Community Arts Project was established in Cape Town in 1977; and *Staffrider* magazine was founded in 1978 in Johannesburg.

14. A range of visual artists was shown, including David Koloane and Dikobe Martins (who also acted as internal national co-organizers), Sydney Kumalo, Dumile Feni, David Mogano, Bongiwe Dhlomo, Peter Clarke, Keith Deitrich, Kim Berman, and Charles Sokhaya Nkosi, as well as a documentary photography section with Paul Weinberg, Cedric Nunn, Myron Peters, Lesley Lawson, Jimi Matthews, Ben Maclennan, Omar Badsha, Paul Alberts, Joe Alphers, Bee Berman, Paul Konings, and David Goldblatt.

15. The Poster Book Collective, *Images of Defiance: South African Resistance Posters of the 1980s* (Johannesburg: Ravan Press, 1991), 3.

16. Keorapetse Kgositsile "Culture and Resistance in South Africa," *MEDU Art Ensemble Newsletter* 5, 1 (1983): 23–24.

17. Ibid., 29–30.

18. Cynthia Kross, "Culture and Resistance," *Staffrider* 5, 2 (1982): 11.

19. Medu Publications and Research Unit, "Opening the Doors of Culture," *MEDU Art Ensemble Newsletter* 4, 1 (1982): 14.

20. Kross, "Culture and Resistance," 11.

21. Lionel Davis, interview, 2 May 1995.

22. Thami Mnyele, "Thoughts on Bongiwe and Revolutionary Art," *Staffrider* 6, 3 (1986): 27.

23. Ibid., 25.

24. Ibid., 27–28.

25. For the classic Marxist narrative of the development of a modern society from "primitive" communalism, see Frederick Engels, *The Origin of the Family, Private Property, and the State* (1884; New York: International Publishers, 1972). For an updated version of Marx and Engels's primitivism from *The Communist Manifesto,* adapted to define an "African socialism" for the postcolonial era, see Julius K. Nyerere, *Freedom and Unity/Uhuru na Umoja: A Selection from Writings and Speeches 1952–65* (London: Oxford University Press, 1967).

26. Fanon, "On National Culture," 232.

27. Ibid. For Fanon, the new independent nations of the former colonial world would find their new national culture through the violent struggles that united the people against foreign domination. For instance, his definition of Algeria's national culture: "The national Algerian culture is taking on form and content as the battles are being fought out, in prisons, under the guillotine, and in every French outpost which is captured or destroyed" (233).

28. Ngũgĩ wa Thiong'o, *Decolonising the Mind: The Politics of Language in African Literature* (Portsmouth, N.H.: Heinemann, 1986), 108. Ngũgĩ was a friend of Serote's and contributed to the Medu newsletter.

29. Wally Serote, "Politics of Culture: Southern Africa," *MEDU Art Ensemble Newsletter* 5, 2 (1983): 26. Serote's essay is prefaced by the statement: "The following

paper was presented by Wally Serote on behalf of the Medu Editorial Board at the Foundation for Education with Production 'Cultural Studies' workshop in Gaborone, September 12–17, 1983." See also "With the 'African Communist': The Role of Culture in the African Revolution—Ngugi wa Thiong'o and Wally Serote in a Roundtable Discussion," in Serote, *On the Horizon*.

30. Judy Seidman, interview, 30 July 1995.

31. Mnyele, "Thoughts on Bongiwe," 28.

32. P. J. D. Lourens, "Racial Tension and Pressure to Conform," *Frontline*, November 1982, 13.

33. Kross, "Culture and Resistance," 11.

34. Ngũgĩ wa Thiong'o, *Decolonising the Mind*, 3.

35. Although images of jazz musicians were a regular feature of realist protest art, the argument for a mimetic realism was better suited to the visual arts and literature. Jazz, as Serote's *Yakhal'inkomo* illustrated (see chapter 2), was already an art form privileged by the resistance movement.

36. Gavin Jantjes, "Paper on Fine Art. Culture and Resistance Symposium—Gaborone 1982," typescript, bound with other conference papers as *Selected Papers of the Culture and Resistance Symposium held at Gaborone, Botswana, July, 1982*, 7–8. Melville Herskovits Library, Northwestern University.

37. Nadine Gordimer, "Relevance and Commitment: Apprentices of Freedom," in *Selected Papers of the Culture and Resistance Symposium*.

38. Ibid., 5–6.

39. Ibid., 12.

40. Malcolm Purkey, "A Triumph of Non-Racialism," *Frontline*, November 1982, 13.

41. Lionel Davis, interview, 2 May 1995.

42. Keith Gottschalk, "United Democratic Front, 1983–1991: Rise, Impact and Consequences," in *The Long March: The Story of the Struggle for Liberation in South Africa*, ed. Ian Liebenberg, Bobby Nel, Fiona Lortan, and Gert van der Westhuizen (Pretoria: Kagiso-HAUM, 1994), 191. Gottschalk notes that the greatest source of funds for the UDF was the European Community, especially Norway and Sweden.

43. Lionel Davis, interview, 2 May 1995.

44. Ivor Powell and Charlotte Bauer, "Culture as You Don't See It at the City Hall," *Weekly Mail*, 21–27 November 1986, 14–15.

45. Linda, "Letter from South Africa," *MEDU Art Ensemble Newsletter* 5, 2 (1983): 18, 20. The pseudonym "Linda" was chosen because it was ambiguous. In South Africa someone named "Linda" could be white, black, male, or female. Judy Seidman, personal communication, 13 August 2007.

46. Wylie, "'From the Bottom of Our Hearts,'" 56–58.

47. Judy Seidman, personal communication, 13 August 2007. See also Dikobe Martins, "Corn in a Court of Chickens," *African Communist* 124 (First Quarter 1991).

48. The author's name, Albie Sachs, is misspelled as "Albie Sacks," "Letter from Maputo 22.11.81," *MEDU Art Ensemble Newsletter* 4, 1 (1982): 34.

49. These papers were collected as *Dead in One's Own Lifetime: Art in Apartheid Society* (Rondebosch: National Union of South African Students, 1979).

50. Gavin Younge, "Letters," *Weekly Mail*, 19 December–8 January 1987.

51. Ivor Powell and Charlotte Bauer, "Towards a People's Culture Exhibition Ad-

dressed to 'Immediate Concerns of the People'—But Submissions Differ," *Weekly Mail,* 21–27 November 1986, 14–15.

52. Emile Maurice, interview with Tyrone Appollis, 1988. Cited in Steven Sack, *The Neglected Tradition,* 26. Maurice was a co-organizer of the exhibition at the 1982 conference in Gaborone.

53. Colin Richards and Ivor Powell, "Storm over the 'Springbok Artists,'" *Weekly Mail,* 6–12 October 1989, 27.

54. "Own affairs" was a bureaucratic euphemism used by apartheid ideologists to describe their policy of separate but (supposedly) equal administration for each of South Africa's ethnic groups. This practice was ultimately derived from the British colonial policy of "indirect rule."

55. Richards and Powell, "Storm over the 'Springbok Artists.'"

56. Cited in Dan Cameron, ed., *William Kentridge* (New York: Phaidon, 2000), 14–15.

57. "Reviews of the Exhibition 'Art Towards Social Development' and the Fuba Collection," *MEDU Art Ensemble Newsletter* 5, 1 (1983): 19.

58. Ibid., 19–20.

59. Ibid., 20.

60. Ibid.

61. Ibid., 20–21.

62. Gottschalk, "United Democratic Front," 197.

63. Patrick Laurence, "451 at the Oasis," *Weekly Mail,* 28 June–4 July 1985.

64. Judy Seidman, letter to the author, 15 October 1999.

4. Here Comes Mello-Yello

1. See Nancy Scheper-Hughes and Philippe Bourgois, eds., *Violence in War and Peace* (Oxford: Blackwell, 2004).

2. Miriam Mathabane, as told to Mark Mathabane, *Miriam's Song: A Memoir* (New York: Simon & Schuster, 2000), 187–88.

3. Brian Bunting, *Moses Kotane, South African Revolutionary: A Political Biography* (London: Inkululeko, 1975), 221–22.

4. Kwela is also the name for South Africa's pennywhistle jazz of the 1950s, whose notes spiral and "climb." For expanded definitions, see the illuminating entries for "nylon," "kwela-kwela," and "mellow-yellow" in Penny Silva, Wendy Dore, Dorothea Mantzel, Colin Muller, and Madeline Wright, *A Dictionary of South African English on Historical Principles* (New York: Oxford University Press, 1996).

5. Judy Seidman also uses the term "nylon" for a police van, in "Soweto," her poem written for the children of '76: "A playground / Where hippos bark / And nylons rip into the crowd / And children die / For hope to be born." Judy Seidman, *Ba Ye Zwa: The People Live* (Boston: South End Press, 1978).

6. The Saracen, made by Alvis Limited of Coventry, UK, was also used by British troops in Northern Ireland during the 1960s. The name "Saracen" refers broadly to the European term for "Arab" Muslim fighters during the Crusades. For an early report on the events at Sharpeville, see "Police Fire Kills 63 Africans," *Guardian* (UK), 22 March 1960. Accessible via www.guardian.co.uk/world/1960/mar/22/southafrica.fromthearchive.

7. Following the Afrikaans Medium Decree in 1974, mandatory study of Afrikaans

and its use as a primary means of instruction in schools (in addition to English and an African language) became an impossible burden for black students. Black students were already frustrated by the large class sizes, restricted subject matter, and poor facilities allotted to them under the Bantu Education Act of 1953.

8. Pamela Reynolds claims the term "lost generation" is too paternalistic, if not facilely sympathetic, and serves only to elide a more nuanced history of community relations surrounding these youth of the 1970s and 1980s. See Pamela Reynolds, "The Ground of All Making: State Violence, the Family, and Political Activists," in *Violence and Subjectivity,* ed. Veena Das et al. (Berkeley and Los Angeles: University of California Press, 2000). For other sensitive accounts of the "young lions" during and after apartheid, see Nancy Scheper-Hughes, "Who's the Killer? Popular Justice and Human Rights in a South African Squatter Camp," in Scheper-Hughes and Bourgois, *Violence in War and Peace;* Mathabane, *Miriam's Song;* and Mamphela Ramphele, "Teach Me How to Be a Man: An Exploration of the Definition of Masculinity," in Das et al., *Violence and Subjectivity.*

9. This paragraph borrows substantially from Gavin Cawthra, "The Evolution of Policing Strategy," in *Policing South Africa,* 7–44.

10. Christopher Merrett, *A Culture of Censorship: Secrecy and Intellectual Repression in South Africa* (Cape Town: David Philip, 1994), 86.

11. Cawthra, *Policing South Africa,* 18.

12. According to Tom Lodge, this alliance was "tactical," but Marxist rhetoric and Soviet training were critical to ANC operations in exile after 1963. The head of the ANC military wing, Umkhonto we Sizwe (Spear of the Nation), was Joe Slovo. Slovo was also the head of the South African Community Party. See Tom Lodge, *Black Politics in South Africa since 1945* (Johannesburg: Ravan, 1983).

13. Cawthra, *Policing South Africa,* 18.

14. Large areas of Namibia and Angola remain off limits today because the land mines laid down during the cold war era are still in the ground. For further information on the global problem of land mines see http://www.mineaction.org.

15. The United Nations arms embargo against South Africa became mandatory in 1977.

16. The precursor to the Hippo was the Hyena, a smaller anti-mine troop transporter developed in 1972 for use by South African forces in South West Africa and Rhodesia. Except for the Casspir, the custom was to name these trucks after wild animals from the South African bush country. According to Peter Stiff, actual wild elephants and hippopotami fared less well than the trucks that took their names, in the mine fields of Southern Africa's border wars. Though it is beyond the scope of the present study, it is worth noting that the invention of mine-protected cars was the product of an entrepreneurial effort by men tinkering with models in imitation of foreign marques, and by working out of their garages in private homes. To some degree, these inventors shared some of the same kinds of pleasure through imitation discussed later in this chapter with regard to township children's making wire trucks—and in that sense they were "big toys" for "big boys." The difference was that they were creating killing machines, not children's playthings. Further details on the Hippo, Buffel, and Casspir APCs may be found in Peter Stiff, *Taming the Landmine* (Alberton: Galago, 1986); Helmoed-Römer Heitman, *South African Arms and Armour* (Cape Town: Struik, 1988); and Christopher L. Foss, ed., *Jane's Armour and Artillery,* 11th ed. (Coulsdon, UK: Jane's Information Group, 1990).

17. "Casspir" is an anagram of SAP and CSIR, a merging of the institutions involved in the development of the vehicle: the South African Police, and the Council for Scientific and Industrial Research, a government research and development unit.

18. For further official propaganda that foregrounds the image of the war machine, see the *South African Panorama* issues for April 1982, January 1984, May 1988, November 1988, and August 1989.

19. P. W. Botha, "Republic of South Africa 25 Years," *South African Panorama,* October 1986, 1.

20. Coen Groenewald, "ARMSCOR: South Africa's Shield," *South African Panorama,* April 1982.

21. See, for instance, the lone picture of a Hippo truck on page 3 of the *Star* newspaper (Johannesburg) for 18 June 1976, which carried the caption "A police 'Hippo,' a personnel-carrying anti-riot vehicle, moving towards Soweto."

22. Cawthra, *Policing South Africa,* 28.

23. Marshall Lee and Peter Magubane, *Soweto* (Cape Town: Don Nelson, 1978), 133.

24. Ibid., 148–49.

25. Afrapix was a collective of freelance photographers in South Africa who were committed to nonracialism and to ending apartheid; the group operated between 1982 and 1992. (See chapter 9.)

26. Iris Tillman Hill and Alex Harris, eds., *Beyond the Barricades: Popular Resistance in South Africa* (New York: Aperture, 1989), 71.

27. For further examples of the intersection of progressive art and popular media against state censorship, see Gillian Solomon, Sue Williamson, and Lindy Wilson, *Art and the Media* (Johannesburg: Gertrude Posel Gallery, University of the Witwatersrand, 1991); the Poster Book Collective, *Images of Defiance;* and Seidman, *Red on Black.*

28. Kaja Silverman, "Fassbinder and Lacan: A Reconsideration of Gaze, Look and Image," *Camera Obscura* 19 (1989): 78.

29. See chapter 8.

30. "David Koloane and Ivor Powell in Conversation," in Deliss, *Seven Stories about Modern Art in Africa,* 265.

31. Mathabane, *Miriam's Song,* 192.

32. Selope Maaga, interview, 30 August 1995.

33. Donovan Leitch, *Mellow Yellow,* lp, Epic LN 24239 (1967).

34. According to Sue Williamson (personal communication, 23 August 2004), these trucks were also called "Yellow Pages" in the Eastern Cape, a humorous name when one considers that phone books were commonly stolen from public phones for use as toilet paper in the townships.

35. The song has several versions in addition to adaptable verses according to situation. The core of this version was shared with the author during an interview with Selope Maaga on 30 August 1995, with verses added by Mpho Mathebula. Translation by Selope Maaga, Mpho Mathebula, and the author, with assistance from Tumelo Mosaka. Greg Marinovich and João Silva record another version of this same "freedom song," but do not credit their source: "Here comes mellow yellow, yes ma, people are going to cry / Here comes mellow yellow, yes ma, it brings troubles / Mama, please don't cry / Mama, don't cry." Greg Marinovich and João Silva, *The Bang-Bang Club: Snapshots from a Hidden War* (New York: Basic Books, 2000), 84.

36. According to Bonner and Segal, the *toyi-toyi* was a martial exercise that evolved into a taunting, celebratory dance at ANC rallies in South Africa. Philip Bonner and Lauren Segal, *Soweto: A History* (Cape Town: Maskew Miller Longman, 1998), 113.

37. Jessica Sherman, "Liberation Songs and Popular Culture," *Staffrider* 8, 3–4 (1989): 84–85.

38. Helena Cook, *The War Against Children: South Africa's Youngest Victims* (New York: Lawyers Committee for Human Rights, 1986), 29.

39. Ibid., 29–30.

40. These are all standard tactics of low-tech guerrilla warfare. The sabotage of moving vehicles by stringing a cable across a road, between two trees or poles, is cited as "extremely effective" against military vehicles by the author of the notorious *Anarchist Cookbook*. In reference to the "gangs of young kids" who run around "in any slum neighborhood," the author also notes the "wealth of energy, courage, and blind cruelty in the age group between 12 and 16 years old. These kids aren't scared, they have no concept of death, they love excitement, and with training could make the best commandos." William Powell, *The Anarchist Cookbook* (1971; Secaucus, N.J.: Barricade Books, 1989), 87–88.

41. Bonner and Segal, *Soweto*, 116–17.

42. Ibid., 85.

43. Mathabane, *Miriam's Song*, 208.

44. This sculpture is now in the collection of the South African National Gallery in Cape Town and is included in Williamson, *Resistance Art in South Africa*, 135.

45. Agrippa (twelve years old), quoted in the Open School, *Two Dogs and Freedom: Children of the Townships Speak Out* (Braamfontein: Ravan, 1986), 38–39.

46. Thulisile (thirteen years old), quoted in *Two Dogs and Freedom*, 21. Other children's drawings of 1980s township life, as well as classroom instructions for making wire cars, can be found in Lindy Solomon et al., *Khula Udweba: A Handbook about Teaching Art to Children* (Soweto: African Institute of Art, 1989). See also, Art Educators Association, *Imibono Yentsha, "De ungas utsikt"* (Helsingborg: Schmidts Boktryckeri, 1992); and Williamson, *Resistance Art in South Africa*, 122.

47. Agrippa Nhalpo, interview, 4 July 1995.

48. Marguerite Poland, "Vusumzi and the Inqola Competition," *Staffrider* 2, 1–3 (1979).

49. Patricia Davison, "Wireworks: Toys from Southern Africa," *African Arts* 16, 3 (May 1983): 50. Davison claims that wire toys are important outlets for environmental tensions. Her article does not directly mention the making of model police trucks by African youth.

50. Ibid., 52.

51. Ibid., 50.

52. See, for instance, the wide range of styles, materials, and construction techniques for homemade African toy cars illustrated in Marie-Françoise Delarozière and Michel Massal, *Jouets des enfants d'Afrique: Regards sur des merveilles d'ingéniosité* (Paris: UNESCO, 1999); Charlene Cerny and Suzanne Seriff, eds., *Recycled/Re-Seen: Folk Art from the Global Scrap Heap* (New York: Harry N. Abrams, 1996); Roy Sieber, *African Furniture and Household Objects* (Bloomington: Indiana University Press, 1980); Chantal Lombard, *Les jouets des enfants baoulé* (Paris: Quatre Vents, 1978); and Volker Harms, *Afrikanische Kinder als Konstrukteure, Spielzug aus Draht und alten Dosen* (Bremen: Ubersee-Museum, 1978).

53. Sue Williamson, *Resistance Art in South Africa,* 99.

54. The open section near the top front of both toys may be where a steering wire (now lost) was once inserted. There is evidence of a connecting element for such a device on the front axels.

55. Rankin, *Images of Metal,* 156. Moteyane grew up in Atteridgeville, in one of the many segregated black towns outside the capital, Pretoria. He is best known for his brief moment of fame in the South African art world, when his work was included on Ricky Burnett's *Tributaries* exhibition for BMW in 1985. By then he had moved on from making wire cars to constructing large-model Concorde and Pan Am 747 planes. He constructed these from metal sheet scrap and paint, covering a wire armature similar to the wire cars of his youth.

56. Ibid.

57. Susan Stewart, *On Longing: Narratives of the Miniature, the Gigantic, the Souvenir, the Collection* (Baltimore: The Johns Hopkins University Press, 1984), 57.

58. For a historiography and extension of the study of sympathetic magic to questions of culture contact and modern technology, see Michael Taussig, *Mimesis and Alterity: A Particular History of the Senses* (New York: Routledge, 1993).

59. From "Police, Army and the State of Emergency: The Killing Machine," *Resister* 41 (January 1986), as reproduced in Gavin Cawthra, Gerald Kraak, and Gerald O'Sullivan, eds., *War and Resistance: Southern African Reports—The Struggle for Southern Africa as Documented by Resister Magazine* (London: Macmillan, 1994), 106–7.

60. Stewart, *On Longing,* 58.

61. This is the position passed along without critical reflection by most authors on the subject of African toys, for example, Lombard, *Les jouets.* See also Guy Brett (who cites Lombard), *Through Our Own Eyes: Popular Art and Modern History* (Baltimore: New Society Publishers, 1986); and Suzanne Seriff (who cites Brett), "Folk Art from the Global Scrap Heap: The Place of Irony in the Politics of Poverty," in Cerny and Seriff, *Recycled/Re-Seen.*

62. Anna Freud, *The Writings of Anna Freud,* vol. 2, *The Ego and the Mechanisms of Defense,* rev. ed., trans. Cecil Baines (1936; New York: International Universities Press, 1996), 111. My gratitude to Moona Enwezor for suggesting the relevance of Anna Freud's formulation for the study of images from apartheid's townships.

63. This is also noted in Seriff, "Folk Art from the Global Scrap Heap"; and Brett, *Through Our Own Eyes.*

64. My gratitude to Emma Bedford, Patricia Davison, and Sue Williamson for their aid in tracking down examples.

65. Proudly South African, *Annual Report 2004/2005,* 9.

66. Christopher Till, "Foreword," in *Africus: Johannesburg Biennale Catalogue,* ed. Candice Breitz and Allan Bowyer (Johannesburg: Transitional Metropolitan Council, 1995).

67. This use of black artists for positive publicity, when it was white artists and curators who were really being showcased, was also common during the apartheid years. For many years the work of Gerard Sekoto, for instance, was used as a "front" for overseas exhibitions organized by the South African Department of Information and by the Johannesburg Art Gallery.

68. Stewart, *On Longing,* 85.

69. In this paragraph, I paraphrase and quote from my group interview with Moses

Seleko, Victor Mpopo, and Ephraim Ramabya of the artist collective in Katlehong Township, 27 September 1995. Earlier wire art from the Katlehong Art Centre may be seen in David Elliott and David Koloane, *Art from South Africa* (Oxford: Museum of Modern Art, 1990), 83.

70. Stephan Elliott, writer and director, *Adventures of Priscilla, Queen of the Desert*, MGM, 1994.

71. The extent to which the antiapartheid movement was antiauthoritarian and against intolerance more generally, as much as it was antiracist, is often forgotten. There are many examples of white artists who refused to serve their mandatory time in the military, or who made a mockery of their service. Wayne Barker claims he marched like Charlie Chaplin until given a discharge for being insane. Willem Boshoff spent his time during office duty typing out long treatises on pacifism in cryptic form. The End Conscription Campaign, whose membership included many young white artists, especially in Cape Town, was prominent in the progressive United Democratic Front movement of the 1980s, and produced many of its more striking posters. Many gay South Africans, too, saw the struggle as offering the potential of a future more tolerant society. Homosexuality was not considered an excuse not to serve in the army. Gay conscripts were sometimes placed in a special "moffie" barracks and were treated in humiliating ways. (*Moffie*, literally "hermaphrodite," is Afrikaans slang for an effeminate man.) Recent art by Clive van den Berg, Drew Lindsay, Steven Cohen, Hentie van der Merwe, and others has critically engaged the issues of homosociality and violence in the army and in South African society. For further reference, see the anthology edited by Neville Hoad, Karen Martin, and Graeme Reid, *Sex and Politics in South Africa* (Cape Town: Double Storey, 2005).

72. Nhalpo, interview, 4 July 1995.

73. For a cogent exploration of the problem of mob violence in postapartheid South Africa and its relation to popular justice and the history of duress among the "young lions" of the struggle, see Scheper-Hughes, "Who's the Killer?" Today, Force Protection, a company in South Carolina (with former South African technicians), manufactures an armored personnel carrier with an unoriginal name: the "Buffalo." The Buffalo resembles the Casspir and it has been used for urban patrol work in Iraq, where militants are already making a game of it. A *Washington Post* report on the "new" Buffalo states that "fliers have appeared in Baghdad's Sadr City neighborhood instructing militants to 'kill the Buffalo.'" Jackie Spinner, "Where the IEDs Lie, the Buffalo Roams," *Washington Post*, 29 October 2005, A19. See also J. Lasker, "Honkin' Big Trucks Head to Iraq," *Wired News*, 12 October 2005.

5. Abstraction and Community

1. This section paraphrases generously from Gottschalk, "United Democratic Front, 1983–1991," 187–88, 191, 194.

2. According to Thupelo records, the participants included Bill Ainslie, Peter Bradley, Peter Clarke, Garth Erasmus, Kay Hassan, David Koloane, Dumisani Mabaso, Philip Malumise, Patrick Kagiso Mautloa, David Mogano, Sam Nhlengethwa, Tony Nkotsi, Madi Phala, Durant Sihlali, and Kenneth Thabo. Mmakgabo Sebidi also appears in the foreground of the photo from the first workshop (Figure 37).

3. According to David Adler, former director of SACHED (personal communication, 2 July 2007), the South African Institute of Race Relations (SAIRR) imported the

slogan "Each one teach one" into South Africa in the late 1940s–early 1950s. Its origin was the "Laubach Methodology" ("Each one teach one, and win one for Christ") developed by Frank Laubach, an American missionary in the Philippines in the 1930s, as a form of hands-on informal education aimed at increasing adult literacy. In the South African context, this method (and its slogan) was combined with ideas from the Brazilian socialist and educator Paulo Freire and was taken up by those involved in alternative education within the antiapartheid movement.

4. "Thupelo Art Project" promotional brochure (Johannesburg: USSALEP, 1987), 2. See also Rankin, *Images of Metal*, 39.

5. Peter Bradley, interview, 26 June 2001. Peter Bradley first made his mark in the early 1970s, showing at the André Emmerich Gallery in New York and later working there as an art dealer. For a discussion of Bradley's paintings, see Whee Kim, "A Personal Definition of Pictorial Space," *Arts Magazine,* November 1974, 76–78. For an illustration of *Silver Dawn* (1985), a painted steel construction Bradley made while in South Africa, see *Art Forum,* March 1986, 76. Rankin (*Images of Metal,* 41) calls Bradley "the African-American sculptor," though the artist informed me that he had explored this medium for the first time during his trip to South Africa.

6. There is no record of any international visitor for 1988. Sholto Ainslie (interview, 23 July 2001) claims that African American painter Al Loving attended in 1991. American sculptor Willard Boepple is shown in the group picture for Thupelo in 1989, but he was not listed on the official roster. That year Boepple was the leader of a Thupelo spin-off workshop in Zimbabwe. Robert Loder (personal communication, 9 January 2007) recalled that the project was unable to invite international guests because of financial difficulties, since in 1987 USSALEP had cut off funding for the visiting artist program. In 1987, partly to save expenses, the workshop was held at the Johannesburg Art Foundation. The following year, Thupelo "squatted" in an unfinished portion of the Africana Museum behind the Market Theatre in Newtown.

7. David Koloane and Ivor Powell, "In Conversation," in *Seven Stories about Modern Art in Africa,* 265.

8. Pat Williams, *Last Paintings by Bill Ainslie 1934–1989* (Oxford: Wolfson College, 1990), 5. See also Elza Miles, *Current of Africa: The Art of Selby Mvusi* (Johannesburg: Johannesburg Art Gallery, 1996).

9. Berman, *Art and Artists,* 29.

10. "Art Supplement. Paintings by Bill Ainslie," *Classic* 1, 3 (1964): 33–38.

11. Along these lines, Claude van Lingen, an artist active in Johannesburg in the 1960s, recalled that Ainslie was "the one who hung out with the black artists." Claude van Lingen, personal communication, 12 July 2000.

12. Anne Sasson, "Ainslie's Last Paintings Were His Best Work," *Weekly Mail,* Weekend Mail Arts section, 27–29 July 1990, 12.

13. Bill Ainslie, "The Living Eye—A Letter to Ngatane, Motjuoadi, Maqhubela, and Sithole," *Classic* 1, 4 (1965): 44–46.

14. This sentence closely paraphrases Ainslie's own words in ibid., 46.

15. Berman, *Art and Artists,* 29.

16. Ibid., 347. *Mapogga Women* is illustrated facing page 335.

17. Sophia Ainslie, "The Voice of the Nation," in *A Decade of Democracy: Witnessing South Africa,* ed. Gary van Wyk (Boston: Sondela, 2004), 33.

18. Sholto Ainslie, interview, 23 July 2001.

19. Ibid.

20. Bill Ainslie, "An Artists Workshop—Flash in the Pan or Brick That the Builders Rejected?" in *State of Art in South Africa: Conference July, 1979, University of Cape Town* (Capetown: University of Cape Town, Michaelis School of Fine Art, 1979), 87.

21. Sophia Ainslie, "The Voice of the Nation," 33.

22. Ibid.

23. Ibid., 34.

24. Durant Sihlali, letter to the author, 17 November 1999.

25. Cited in Sack, *The Neglected Tradition*, 24.

26. Ibid.

27. David Koloane, interview, 1 September 1995.

28. Ibid.

29. Cited in The Poster Book Collective, *Images of Defiance*, 10.

30. Caro's selection for the Grand Award for sculpture at Durban Arts '80 was Ian Redelinghuys, an artist whose work then resembled Caro's own horizontal constructions. Redelinghuys was also the winner of a travel award at the Art—South Africa—Today competition in 1975, chosen by visiting critic Clement Greenberg. "[F]unnily enough found I had awarded first prize to Ian Redelinghuys to whom you also gave prize— also 3rd to Willem Strydom ditto!" Anthony Caro to Clement Greenberg, postcard from Cape Town dated 26 July 1980, Clement Greenberg papers, Archives of American Art, Smithsonian Institution.

31. Caro's South African students included Isaac Witkin (1957–60); Malcolm Payne (1972–73); Karel Nel (1978–79); Andrew Todd and Johan Moolman (1975–76); Willem Strydom (1977–78); and Hilda Kohly (1977–79). Rankin, *Images of Metal*, 21.

32. Sholto Ainslie, interview, 23 July 2001; Rankin, *Images of Metal*, 38; and Sandy Summerfield, interview, 1 August 1995.

33. Willard Boepple, interview, 12 March 1994.

34. Durant Sihlali, letter to the author, 17 November 1999.

35. Boepple, interview, 12 March 1994.

36. Sapa, "Landlord to Sell Art Treasures for Rent," *Independent Online*, 18 October 1999 [06:41:01]; accessible through the archive at www.iol.co.za.

37. Boepple, interview, 12 March 1994; Robert Loder, interview, 7 October 1994; and Durant Sihlali, letter to the author, 17 November 1999.

38. Loder, interview, 7 October 1994. Loder also noted that each of the venues for the tour was chosen in or near black townships or in semi-industrial areas, so that access would not be denied to black viewers under the Separate Amenities Act.

39. "When I went to London for my dissertation I did research on printmaking techniques without using machinery, using alternative methods. My dissertation was 'Initiating Printmaking Workshops in Urban Areas in South Africa, Using Alternative Printmaking Methods'" (MA in museum studies, University of London, 1995). Koloane, interview, 1 September 1995.

40. Loder, interview, 7 October 1994.

41. Anthony Caro to Clement Greenberg, letter dated 21 November 1981, Clement Greenberg papers, Archives of American Art, Smithsonian Institution. The Emma Lake workshops began in 1955 and have continued during most years since. They were initiated by Arthur McKay and Kenneth Lochhead, as a creative spark for regional artists in Canada who felt isolated from international trends. Each year a prominent modernist artist or critic was invited to Saskatchewan to lead a workshop, and most of the invitees

have been heavily invested in the legacy of abstract expressionism. Clement Greenberg was guest leader in 1962, and Anthony Caro led the workshop in 1977.

42. Karen Wilkin, untitled statement in John Cross, Francis Greenburger, and George Hofmann eds., *Triangle Artists' Workshop 1988 Yearbook* (New York: Triangle Arts Association, 1988), 18.

43. Caro to Greenberg, 21 November 1981.

44. Loder, interview, 7 October 1994.

45. Ibid.

46. Ibid.

47. Boepple, interview, 12 March 1994.

48. An architecture section was added, for one year, in 1987, and included Peter and Alison Smithson, Frank Gehry, and William McDonough. In 1989 Anthony Caro stepped back from his direct leadership role in organizing the annual sessions and in selecting the invited artists. After 1989 the former emphasis on "high modernist" practice, while still present at Triangle, was opened to include other aesthetic strategies.

49. Loder, interview, 7 October 1994.

50. See, for instance, the now-classic statement on "truth to medium" as the proper object of modernist painting, in Clement Greenberg, "Modernist Painting," *Art and Literature* 4 (Spring 1965): 193–201.

51. Kenworth Moffett, "Abstract Art and the Present Situation," *Moffett's Artletter* special supplement 1 and 2 (March 1986), excerpted in Roger H. Boulet, *Graham Peacock: Paint, Process, and Spirit* (Edmonton: Edmonton Art Gallery, 1988), appendix.

52. For a now-classic statement on the "crisis" of painting in the early 1980s, see Thomas Lawson, "Last Exit: Painting," *ArtForum* (October 1981): 40–47.

53. Boepple, interview, 12 March 1994.

54. Ibid.

55. Karen Wilkin, "Introduction," in *Triangle Artists' Workshop Yearbook 1983,* ed. Anthony Caro and Ferriel Waddington (New York: Dieter Blume, 1983), 6–10.

56. David Koloane, interview, 1 September 1995. In the 1983 Triangle yearbook, Karen Wilkin related the passport story in this way: "Only one discordant note marred the two weeks. The painter, David Koloane, one of our two artists from South Africa, lost almost ten days of the workshop because his government took four months to grant his passport. (Ian Redelinghuys, the South African sculptor, who is white, received his passport in five days.)" Wilkin, "Introduction," 8.

57. This paragraph collates details from my interviews with Peter Bradley, David Koloane, Randy Bloom, and Sholto Ainslie. The last sentence is Bloom's.

58. Koloane, interview, 1 September 1995.

59. Ibid.

60. According to Thupelo records, the following artists were selected to attend Triangle: David Koloane and Ian Redelinghuys (1983); David Koloane (1984); Garth Erasmus and Bill Ainslie (1985); Dumisani Mabaso (1986); Ian Redelinghuys and Lionel Davis (1987); Sholto Ainslie and Anthusa Sotiriades (1988); Durant Sihlali and Patrick Mautloa (1989); Chabani Cyril Manganyi (1990); Sam Nhlengethwa (1991); and Madi Phala (1992).

61. This was a common phrase used by Caro to describe Triangle; see, for instance, his introductory comments in *Triangle Artists' Workshop 1989 Yearbook*, ed. John Cross and Sue Johnson (New York: Triangle Arts Trust, 1989), 6.

62. Durant Sihlali, interview, 3 October 1995. It is unclear whether Sihlali was

referring here to the Golden Acrylics Company that sponsored Triangle, or merely stating that the quality of materials was at the highest standard—or both.

63. Ibid.

64. Loder, interview, 7 October 1994.

65. Ibid.

66. Boepple, interview, 12 March 1994.

67. Koloane, interview, 1 September 1995. Bongi Dhlomo also recalled that she used to work at night with her art laid flat on her bed, and that this was her "studio." Bongiwe Dhlomo, interview, 27 July 1995. This was the common situation for black artists. Louis Maqhubela recalled that his "studio" was the floor of the family dining room in their small Soweto home, after the others had gone to sleep, adding that it seems remarkable now that some of the best and most intense work was produced under those conditions. Louis Maqhubela, interview, 8 January 2007.

68. Sihlali, interview, 3 October 1995.

69. Rankin, *Images of Metal,* 40.

70. Elsbeth Court, "Pachipamwe II: The *Avant Garde* in Africa?" *African Arts* 25, 1 (January 1992): 98n10.

71. Koloane and Powell, "In Conversation," 265.

72. Koloane, interview, 1 September 1995.

73. David Koloane, "The Thupelo Art Project," in *Art From South Africa,* ed. Pamela Ferris and Janet Moore (Oxford: Museum of Modern Art, 1990), 84.

74. Koloane, interview, 1 September 1995.

75. The Rorke's Drift alumni who attended Thupelo sessions included Kay Hassan, Patrick Mautloa, Bongiwe Dhlomo, Anthony Nkotsi, Dumisani Mabaso, Lionel Davis, Sam Nhlengethwa, Paul Sibisi, Eric Mbatha, Velile Soha, and Vuminkosi Zulu. Durant Sihlali had also attended classes at Polly Street, and Mautloa studied at Polly Street's successor, the Jubilee Art Centre.

76. Lionel Davis, interview, 2 May 1995.

77. Tragically, Bill Ainslie was killed in a car accident in 1989. He had just attended Pachipamwe, a workshop modeled after Thupelo and held at Cyrene in Zimbabwe. The mission school where he had first encountered the workshop concept that would become his lifelong passion also became, in the end, his last studio. Helen Sebidi and David Koloane were driving with Ainslie that day, but they survived the accident.

78. For discussion of the wider network of Thupelo-type workshops in Africa, see Robert Loder, "An International Workshop Movement," in *Persons and Pictures: The Modernist Eye in Africa,* ed. Ricky Burnett (Johannesburg: Newtown Galleries, 1995); and Court, "Pachipamwe II."

79. Sidney Kasfir, *Contemporary African Art* (London: Thames and Hudson, 1999), 84–89. For a critical perspective on what he considered the "tired" abstract expressionist strategies in preponderance at the Senegalese workshop, see Yinka Shonibare, "Jean-Michel Basquiat, Please Do Not Turn in Your Grave, It's Only TENQ," *Third Text* 28–29 (Autumn–Winter 1994).

80. In 1990 regional branches of Thupelo were set up, and since 1995 a revamped "Thupelo" has been held, sporadically, based on the Cape Town branch. This postapartheid version was not part of my research. As was also the case with Triangle after 1987, many of the artists originally associated with the workshops in Johannesburg had moved on to other projects by 1994. During December 2006, the "Cape Town" version of the

Thupelo workshop was held at Rorke's Drift in an effort to revitalize the site of the historic art school.

81. Koloane, interview, 1 September 1995; and Loder, interview, 7 October 1994.

82. Tamar Mason, *The Bag Factory: Fordsburg Artists' Studios* (Johannesburg: Artists' Press, 1999), 6.

83. These included David Koloane, Durant Sihlali, Helen Sebidi, Patrick Mautloa, Kay Hassan, and Sam Nhlengethwa.

84. The original Bag Factory mission was "To provide affordable communal studio spaces for professional artists; To provide studio space for developing artists; To provide a collective, cultural ethos for the sixteen permanent artists working at the studios. These artists form a vital link into the major art and cultural networks within South Africa; To be an educational and career development source, where artists, away from the main centers, can seek advice, support and encouragement; To run a residency programme with the aim of facilitating cultural exchange and debate nationally and internationally; and To be a focal point for visiting curators, artists, academics and collectors from within South Africa and abroad." Mason, *The Bag Factory,* 2.

85. John Dewar, "Kinetic Art Show Is an Experience," *Star,* 2 February 1983, 19.

86. Anon., "Reviews of the Exhibition 'Art Towards Social Development' and the Fuba Collection," *MEDU Art Ensemble Newsletter* 5, 1 (1983): 21.

87. Ibid., 22–23. Caro's words here were quoted from an unspecified issue of the *Rand Daily Mail.*

88. "Art and Statements," *Financial Mail,* 6 May 1983.

89. Caro expressed private reservations about the future of the collection even before it was sent to South Africa. Greenberg had himself toured South Africa (including a visit to Rorke's Drift) in 1975, and donated one of his own artworks to the FUBA collection. He advised Caro that his "charitable effort over South Africa" was "misguided." In a letter to Greenberg, Caro agreed, noting his worries about the perceived demagoguery and questionable financial motives of FUBA director Sepamla. Jo Thorpe to Clement Greenberg, letter dated 18 November 1975; and Anthony Caro to Clement Greenberg, letter dated 8 February 1981; Clement Greenberg papers, Archives of American Art, Smithsonian Institution.

90. Several of the personalities involved with both Thupelo and FUBA were the same (including Ainslie, Bongiwe Dhlomo, Koloane, and Sihlali). Some references to Thupelo even called it the "FUBA-USSALEP-Art Foundation" project. That said, in practice Thupelo was more aligned with Ainslie's nonracial approach at the Art Foundation than it was with the separate "black education" program at FUBA.

91. These details on the FUBA Collection were collated from Sipho Sepamla, interview, 10 October 1995; Sandy Summerfield, interview, 1 August 1995; P. Oppelt, "Art Meant to Inspire Ends Up Paying the Rent," *Sunday Times* (Johannesburg), 12 September 1999; Sapa, "Landlord to Sell Art Treasures for Rent"; Matthew Burbidge, "Art Collection Sold for a Song," *Independent Online,* 19 October 1999 [20:37:15] through the archive at www.iol.co.za; and Australia Broadcasting Corporation, p.m. broadcast transcript, 12 November 1999.

92. Lyn Soudien, personal communication, 4 June 2001.

93. The details of this story were gleaned from my interviews with Peter Bradley, Durant Sihlali, Sandy Summerfield, Sipho Sepamla, and Sholto Ainslie.

94. Bradley, interview, 26 June 2001.

95. Sholto Ainslie, interview, 23 July 2001. Sholto added that after meeting him in New York, David Koloane had been keen to throw Bradley's confrontational personality into the mix of the Johannesburg art world.

96. The arrangements for Bradley to work at the university were made by Fieke Ainslie (Bill's wife). Bradley, interview, 26 June 2001.

97. Ibid.

98. Ibid. Bradley claimed further that Archbishop Desmond Tutu, a major personality in the UDF movement, dedicated the artist's sculpture *Silver Dawn* when he donated it to the Johannesburg branch of USSALEP.

99. Rankin, *Images of Metal,* 40.

100. Ibid.

101. Cited in Marilyn Martin, "Is There a Place for Black Abstract Painters in South Africa?" (paper presented at the thirty-third annual meeting of the African Studies Association, Baltimore, Md., November 1990), 6. This paper appeared in *De Arte* 44 (September 1991): 25–39.

102. Sholto Ainslie, interview, 23 July 2001.

103. Gavin Younge, a sculptor, received his early art training at Bill Ainslie's studio. He was a cofounder of the Community Arts Project in Cape Town, was a leader in the cultural politics of the UDF during the 1980s, and later became head of the Fine Art Department at the University of Cape Town.

104. Clement Greenberg, "The Art of Prairie Canada," *Canadian Art* 94 (May–April 1963).

105. All quotations in this paragraph are from Gavin Younge, *Art of the South African Townships* (New York: Rizzoli, 1988), 70.

106. See, for instance, the 1930s debate between Ernst Bloch and Georg Lukács, anthologized in Fredric Jameson, ed., *Aesthetics and Politics* (New York: Verso, 1980).

107. Barbara Ludman, "Art," *Tribute* (August 1987): 164.

108. Cited in Charlene Smith, "Black Artists: We're Fed Up with Political Labels," *Weekly Mail,* 31 October–6 November 1986, 18.

109. David Craven, "Abstract Expressionism and Third World Art: A Post-Colonial Approach to 'American' Art," *Oxford Art Journal* 14, 1 (1991): 63.

110. Martin, "Is There a Place?" 7.

111. Rob McLeod, "Bleaching or Teaching? The Issue of Cultural Domination in the Art Education of Black People with Reference to Some Johannesburg Art Schools and Centres," in *Art and Social Change: South African Association of Art Historians Second Conference, 17–19 July 1986* (Johannesburg: University of the Witwatersrand, Department of Art History, 1986), 140.

112. Powell, ". . . us blacks . . . ," 19.

113. Cited in Martin, "Is There a Place?" 12.

114. Cited in Smith, "Black Artists."

115. Colin Richards, "Alternative, Abstract Art? It's All in His Mind," *Weekly Mail,* 23–29 October 1987, 21.

116. Colin Richards, "Peripheral Vision: Speculations on Art Criticism in South Africa," in *Art Criticism and Africa,* ed. Katy Deepwell (London: Saffron, 1996), 85–86nvi.

117. Ibid.

118. Richards, "Alternative, Abstract Art?"

119. Ibid.

120. Ibid.

121. Ibid.

122. Ibid.

123. One such "private contract agency" was the Council on Leaders and Specialists of the Experiment in International Living, which brought Japanese artists to the United States during the 1960s. Yukio Kawamoto to Clement Greenberg, letter dated 26 September 1967, Clement Greenberg papers, Archives of American Art, Smithsonian Institution. Greenberg occasionally assisted such visitors and also toured India and Japan for the Department of State.

124. Later Thupelo workshops were supported by the British Council, by the Swedish International Development Agency (SIDA), and by local businesses. (See note 6.)

125. See Eva Cockcroft, "Abstract Expressionism, Weapon of the Cold War," *Artforum* 12, 10 (June 1974); Max Kozloff, "American Painting during the Cold War," *Artforum* 11, 9 (May 1973); and the anthology edited by Francis Frascina, *Pollock and After: The Critical Debate* (New York: Harper and Row, 1985).

126. Serge Guilbaut, *How New York Stole the Idea of Modern Art: Abstract Expressionism, Freedom, and the Cold War,* trans. Arthur Goldhammer (Chicago: University of Chicago Press, 1983).

127. Paul Stopforth, interview, 29 July 2000.

128. Koloane, "The Thupelo Art Project."

129. Steven McDonald, letter to the author, 13 June 2001.

130. According to McDonald, USSALEP's connections were more with leaders of the struggle than with leaders in office in South Africa. It is worth noting that the United States Congress also held a perspective on South Africa roughly in opposition to the Executive Office (and the State Department) during the Reagan years. For a chronicle of that period, see Pauline Baker, *The United States and South Africa: The Reagan Years* (New York: Ford Foundation and Foreign Policy Association, 1989).

131. If "liberation" was an intended theme of USSALEP's sponsorship of Thupelo, it was not foregrounded in the organization's publicity. This may have been a strategy to attract the widest possible sources for further funding. The 1987 brochure for Thupelo (Plate 3) included nonobjective artworks from the workshop artists Dumisani Mabaso (Untitled—painting, 1986), Durant Sihlali (*Blue Haze*—painting, 1986), Tony Nkotsi (Untitled—steel sculpture, n.d.), Lionel Davis (*African Sunset*—painting, 1987), David Koloane (*Fragments*—painting, 1986), Philip Malumise (Untitled—painting, n.d.), and Garth Erasmus (*Playground*—painting, 1985). Nevertheless, art with liberation and socially conscious themes *was* produced by Thupelo artists and is discussed in chapter 6.

132. Franklin Thomas, ed., *South Africa: Time Running Out.* The Report of the Study Commission on US Policy toward Southern Africa (Berkeley and Los Angeles: University of California Press, 1981), xxii.

133. Ibid., 439–40.

134. Ibid., 444.

135. Cited in Baker, *The United States and South Africa,* 53.

136. Lodge, *Black Politics in South Africa since 1945,* 301–6. Rob Nixon also discusses the gradual distancing of ANC links with the South African Communist Party, and the softening of the SACP's own militant propaganda after 1990, in his chapter "The Retreat from Communism," in Nixon, *Homelands, Harlem, and Hollywood.*

137. Gottschalk, "United Democratic Front," 196–97. In 1990, and thus quite early

in the transition to democracy, the head of the South African Communist Party and leader of the military wing of the ANC, Joe Slovo, stated this directly: "We accept the reality and necessity that our post-apartheid economy will be a mixed economy." From an intervention excerpted and published as "Socialist Aspirations and Socialist Realities," *African Communist* 124 (First Quarter 1991): 13.

138. Bradley, interview, 26 June 2001.

139. Homi Bhabha, "Beyond the Pale: Art in the Age of Multicultural Translation," in *Cultural Diversity in the Arts: Art, Art Policies and the Facelift of Europe,* ed. Ria Lavrijsen (Amsterdam: Royal Tropical Institute, 1993), 30.

140. Owen Kelly, *Community Art and the State: Storming the Citadels* (London: Comedia, 1984), 50–51.

141. David Koloane, personal communication, 24 July 2001.

142. Conny Braam and Fons Geerling, "Towards New Cultural Relations," in *Culture in Another South Africa,* ed. Willem Campschreur and Joost Divendal (New York: Olive Branch Press, 1989).

143. Ivor Powell, "Corner of the Cultural Blanket Lifted," *Weekly Mail,* 30 June– 6 July 1989, 21.

144. Sachs's essay is reprinted in Ingrid de Kok and Karen Press, eds., *Spring Is Rebellious: Arguments about Cultural Freedom by Albie Sachs and Respondents* (Cape Town: Buchu Books, 1990).

6. These Guys Are Heavy

1. Lionel Davis, interview, 2 May 1995.

2. Bongiwe Dhlomo, interview, 27 July 1995.

3. Es'kia Mphahlele, "Artists and Revolutions," *Tribute,* May 1988, 144.

4. Njabulo Ndebele "Redefining Relevance," in *Rediscovery of the Ordinary: Essays on South African Literature and Culture* (Johannesburg: COSAW, 1991), 65. That essay is a follow-up to one written in 1986 that announced a similar theme, "The Rediscovery of the Ordinary," anthologized in the same volume.

5. Powell and Koloane, "In Conversation," 265. See also Ivor Powell, "Heroic Regressions," *Ventilator* 1, 1 (1994): 60–61.

6. Powell and Koloane, "In Conversation," 265.

7. "Reflecting a Spectrum of Concern—Koloane," *New Nation,* 7–13 September 1990, 8.

8. A portfolio of these works is reproduced in the *Kalahari Review* 1 (Winter 1992): 22–27.

9. See Sol Makgabutlane, "Talented and Taciturn," *Tribute,* June 1989; and Jennifer Crwys-Williams, "Stick Up Sam," *Star Sunday,* 8 July 1990.

10. The title of this work is cited as *May '76 Kwa-Thema Bus Boycott* in Makgabutlane, "Talented and Taciturn," 113.

11. Ibid. Nhlengethwa says Ainslie showed him Bearden's work after he had already begun his own experiments with collage at Rorke's Drift, and that he was excited to discover the commonality of technique between him and the famous post–Harlem Renaissance artist.

12. Cited in Hill, "The Changing Legacies," 31. Hill's source is Hilda Bernstein, *No. 46-Steve Biko* (London: IDAF, 1978), 20.

13. Oliphant, "A Human Face," 258. See chapter 2.

14. Steven Sack, "In The Name of Art," in Campschreur and Divendal, *Culture in Another South Africa,* 77–78.

15. DaimlerChrysler AG, *Kay Hassan* (Ostfildern-Ruit: Hatje Cantz Verlag, 2000), 107.

16. See Mautloa's comments in the documentary series on South African artists produced for South African television: *Seeing Ourselves* (video), dir. Wayne Barker and Susan Glanville (Johannesburg: The Project Room, 1999).

17. Richards, "Peripheral Vision," 86.

18. Martin, "Is There a Place?"

19. *Staffrider,* (December–January 1980–81): 46–47.

20. "Petals of Blood" may be a reference to the novel of the same name by Ngũgĩ wa Thiong'o. Ngũgĩ wa Thiong'o, *Petals of Blood* (New York: Dutton, 1978).

21. Léopold Sédar Senghor, "Femme noire" (1945), *The Collected Poetry,* trans. Melvin Dixon (Charlottesville: University of Virginia Press, 1991), 270–71.

22. Ibid., 8–9.

23. Serote, *Yakhal'inkomo,* 20.

7. Resurfacing

1. This chapter is dedicated to Durant Sihlali and would not have been possible without his generosity during formal interviews (October 1995 and November 1997) and over the course of many casual conversations, as well as his sharing of personal notes and reminiscences in our written and telephonic correspondence from 1995 to 2004. Unless otherwise noted, all biographical details are from my interviews with Sihlali, or from notes shared by the artist.

2. Later he was sent to live with his maternal grandparents in Tarkestad, near Queenstown, where he admired the murals on South Sotho homes.

3. For similar comments on Sihlali's early years, see Elza Miles, "Durant Sihlali: Recorder of Memories and Lived Lives," in *Durant Sihlali: Mural Retrospective 1960–1994* (Johannesburg: Alliance Française, 1994), 8; Colin Richards, "Cross Purposes: Durant Sihlali's Art of Allegory," in *Contemporary South African Art: The Gencor Collection,* ed. Kendell Geers (Johannesburg: Jonathan Ball, 1997), 94; and Elizabeth Rankin, *Images of Metal,* 170. Further biographical details can be found in Elizabeth Rankin, *Images of Wood: Aspects of the History of Sculpture in 20th-Century South Africa* (Johannesburg: Johannesburg Art Gallery, 1989), 163; Durant Sihlali, *Discovering My True Identity* (Johannesburg: Skotaville, 1989); David Koloane, "The Polly Street Art Scene," in Nettleton and Hammond-Tooke, *African Art in Southern Africa;* and E. J. de Jager, *Images of Man: Contemporary South African Black Art and Artists* (Alice: Fort Hare University Press, 1992), 52–56.

4. Keith Beavon, *Johannesburg: The Making and Shaping of the City* (Pretoria: University of South Africa Press, 2004), 121.

5. Ibid.

6. According to Beavon (ibid., 122–23), the black population of Johannesburg doubled between 1936 and 1948—from 229,122 residents to an estimated 455,000. Industrial expansion related to the Second World War was one factor, since urban areas restrictions and pass laws for blacks were eased during this period so that factory jobs

could be filled. The National Party succeeded in winning popular support during the postwar years, in part by playing up the *swart gevaar,* the "black peril" of the tide of black migration to the cities that the nationalists claimed would threaten the security of jobs held by working-class whites.

7. During my research in South Africa, friends in the township, when inquiring about what party to go to, would often use a further term of endearment, asking where we were going in the township on a Friday night, "So, we' to, John?"

8. Durant Sihlali, notes sent to the author, 19 July 1999.

9. "In '53 we began even to know about the existence of Polly Street, which at that point in time became our focal point, saying to ourselves, 'Right. We are here, we are a small group, and here we see in *Zonk!* magazine artists winning medals. So how about us searching for this place.' We then began researching and began to know where Polly Street was and what was happening there." Sihlali, interview, 3 October 1995.

10. Koloane, "The Polly Street Art Scene," 218.

11. Kumalo was appointed as Skotnes's assistant in 1958, and he taught outreach classes in the black townships. The Polly Street art classes were moved to the Jubilee Social Centre in 1960. Skotnes resigned to work as a full-time studio artist in 1966, and the directorship was given to Kumalo. Ezrom Legae taught at Jubilee beginning in 1965 and directed the center from 1968 to 1969.

12. "Immediately after the students had been exposed to my work, the group then were more keen to study under me. So, I began to have a very big class of Polly Street students working with me on Sundays. We did outdoor painting of farmland, [and] of the township." Sihlali, interview, 3 October 1995.

13. With regard to his knowledge of the earlier black modernists, according to his notes (in a letter dated 19 July 1999), Sihlali had seen the graphic work of Cape Town artist Peter Clarke in magazines in the 1960s, and met him later, when he was painting District Six in 1972, finding him on "the same wavelength as me." He knew of George Pemba's book illustrations when he was young and was given a catalogue of the work of George Bhengu by a "white friend from Durban" in 1968. Regarding Sekoto, he noted, "I only got to know him by seeing some of the paintings at the Adler Fielding Galleries in the early sixties, mainly oil paintings of interiors and Sophiatown street scenes . . . I was very moved by his handling of color." He also worked alongside Mohl (whose earliest work dated to the 1930s), selling art outdoors at Artists Under the Sun during the 1960s.

14. Louis Maqhubela, interview, 8 January 2007. Maqhubela also noted that Sekoto's work was in oil, an expensive medium by his own standards at the time, and that this gave him confidence that he, too, might be able to make a living as an artist.

15. Sihlali, interview, 3 October 1995.

16. Sihlali also painted rural areas, miners and other black workers, as well as a range of other scenes. He was adamant about this point in his conversations with me: he was busy recording *everything* he saw that interested him, not just life in the black townships.

17. Richards interpreted these same formal effects as contributing to a feeling of "disintegration" in the scenes depicted. Colin Richards, "Cross Purposes," 86.

18. Sihlali, interview, 3 October 1995.

19. Louis Maqhubela, interview, 8 January 2007.

20. In this, Sihlali echoed the words of John Mohl decades earlier: "I am an African and when God made Africa, He also created beautiful landscapes for Africans to admire

and paint." Mohl, cited in Tim Couzens, *The New African: A Study of the Life and Work of H. I. E. Dhlomo* (Johannesburg: Ravan Press, 1985), 254.

21. Joy Kuhn, *Twelve Shades of Black* (Cape Town: Don Nelson, 1974), 54.

22. Watercolor, like printmaking—that other medium revitalized out of necessity by black South African artists—was a relatively affordable medium for struggling artists of Sihlali's generation. Over the course of his long career, Sihlali also produced paintings in oil, a variety of types of unique and multiple prints, sculpture in wood, metal, and marble, and mixed-media and installation pieces.

23. Constantin Guys was Charles Baudelaire's celebrated "Painter of Modern Life" during the 1850s. See Charles Baudelaire, *The Painter of Modern Life, and Other Essays,* trans. and ed. Jonathan Mayne (London: Phaidon, 1964). For Baines, see Jane Carruthers and Marion Arnold, *The Life and Work of Thomas Baines* (Vlaeberg: Fernwood Press, 1995).

24. Rankin, *Images of Metal,* 170–71.

25. For the term "internal diaspora," see Sarat Maharaj, "Fatal Natalities: The Algebra of Diaspora and Difference after Apartheid," *Photofile* 57 (October 1999).

26. Sihlali, interview, 3 October 1995.

27. During this period, the artist also made watercolor sketches of Kliptown, Moroka, Nancefield, and other older neighborhoods in Soweto as they underwent renovation or destruction, as well as of Alexandra Township, Johannesburg, and District Six in Cape Town.

28. Kuhn, *Twelve Shades of Black,* 52.

29. Beavon, *Johannesburg,* 77.

30. The former Brickfields area today corresponds to the Newtown cultural district, the Market Theatre, and the MuseuMAfricA complex of buildings.

31. Beavon, *Johannesburg,* 127.

32. Julian Beinart, "Patterns of Change in an African Housing Environment," in *Shelter, Sign, and Symbol,* ed. Paul Oliver (London: Barrie & Jenkins, 1975), 160.

33. Ibid.

34. Pauline Morris, *Soweto: A Review of Existing Conditions and Some Guidelines for Change* (Johannesburg: Urban Foundation, 1980), 55.

35. Sihlali, interview, 3 October 1995. See also Rankin, *Images of Metal.*

36. Kuhn, *Twelve Shades of Black,* 61.

37. Ellen Hellmann, "Urban Areas," in *Handbook on Race Relations in South Africa,* ed. Ellen Hellmann and Leah Abrahams (London: Oxford University Press, 1949), 229–30.

38. According to Foucault, subjugated knowledge is "a particular, local, regional knowledge, a differential knowledge incapable of unanimity and which owes its force only to the harshness with which it is opposed by everything surrounding it." Michel Foucault, *Power/Knowledge: Selected Interviews and Other Writings 1972–1977,* ed. Colin Gordon (New York: Pantheon, 1980), 82. A similar claim is made for the 1940s paintings of Sophiatown by Gerard Sekoto, in Okwui Enwezor, "The Enigma of the Rainbow Nation: Contemporary South African Art at the Crossroads of History," in *Personal Affects: Power and Poetics in Contemporary South African Art,* ed. Sophie Perryer (New York: Museum for African Art, 2004), 27. Sekoto's scenes of black urban life made in South Africa, before he chose to leave for Paris in 1947, constitute a de facto alternative archive (and a trenchant one). Anitra Nettleton questions the degree of Sekoto's political involvement in the 1940s in "'. . . In what degree . . . (They) Are Possessed of

Ornamental Taste': A History of the Writing on Black Art in South Africa," in Nettleton and Hammond-Tooke, *African Art in Southern Africa*.

39. Rankin, *Images of Metal*, 171.

40. Richards, "Cross Purposes," 88.

41. Kuhn, *Twelve Shades of Black*, 61.

42. Richards, "Cross Purposes," 85–86. These remarks were consistent with what the artist told me in 1995. See also Kuhn, *Twelve Shades of Black*.

43. Sihlali, interview, 3 October 1995.

44. Ibid.

45. "I remember in . . . '76, '77 I got carried away by a beautiful landscape out near Potchefstroom. . . . That was now immediately after the June riots. It was not my first time to go and paint that landscape; I had painted it some years earlier. This time I felt I wanted to paint it because I enjoyed painting one spot, at times up to ten paintings." Ibid.

46. Perhaps most notoriously, photojournalist Peter Magubane was repeatedly jailed, placed in solitary confinement, and banned for his images of the South African townships during the 1960s and 1970s.

47. This story is related in Richards, "Cross Purposes," 85. See also Kuhn, *Twelve Shades of Black*, 61.

48. Elza Miles also notes: "He considers his artistic career in terms of a dichotomy between what he was forced from a commercial standpoint to paint in order to survive and what he would express spontaneously." Miles, "Durant Sihlali," 9.

49. This was the case, even if much of that audience was made up of "white liberals" who were generally sympathetic with the struggle for black liberation.

50. The same phrase was used by the painter, teacher, and cofounder of Artists under the Sun, John Koenakeefe Mohl. It was a way of referring to work made more for sale and less for art's sake. Mohl's last and most famous student was Mmakgabo Helen Sebidi. Sebidi, who herself once sold work at Artists under the Sun, also used this phrase during our interviews in 1995.

51. Sihlali, interview, 3 October 1995.

52. Miles ("Durant Sihlali," 7) states that these flooring tiles came from the renovation of the old market building, in advance of the transfer of the old Africana Museum collections (formerly located on the top floor of the Johannesburg Central Library) to the newly named MuseuMAfricA. Richards ("Cross Purposes," 94) is more ambiguous about whether the tiles came from the old market building or the old library. I suspect this material became available when the Thupelo workshop was held in the old market building in 1988. Whatever their original location, one might consider the kinds of historical revisionism performed today by the MuseuMAfricA (where the history of South Africa is told in a series of dioramic displays) to be a populist (and more literal) analogue of what Sihlali's own late work achieved with great subtlety.

53. These prints are illustrated in Sihlali, *Durant Sihlali*, 50–51.

54. Jackson Pollock, too, was interested in allying his art with indigenous (in his case, Navajo) healing arts, and one might conclude that Sihlali was likewise engaged in a search for ways to heal the scars of apartheid through his references to traditional art. San rock art was also a significant touchstone for the artist.

55. *Discovering My True Identity* (1989) is the title of the monograph on Sihlali that was published following his return from France.

56. Ibid., vi. "White" here refers to spirituality, not race.

57. Ibid., vii.

58. Barbara Ludman, "Durant Sihlali: Art of Africa," *Tribute* (December 1988): 188.

59. Ibid.

60. My emphasis. Sihlali, interview, 3 October 1995. He continued, stressing the disconnection between what he witnessed as a child and what he was later introduced to as art: "For me those [rural house designs] were massive canvases. The beauty of looking at the scrawls or graffiti or whatever they were doing . . . Those were the early years . . . coming back to Johannesburg I . . . was forced to focus on what I found was an established 'art' culture: drawing images from life and so forth, having to do still life and landscape and things."

61. Cited in Richards, "Cross Purposes," 94.

62. "My grandparents placed in my care the tending of lambs and whilst carrying out my duty I had the opportunity to observe very closely the young married women showing their skills at colour and design when they decorated the family homestead with their murals." Durant Sihlali, "Re-claiming the Significance of Murals," in *Durant Sihlali*, 13–14.

63. Louis Maqhubela, interview, 8 January 2007. Maqhubela recalled that Sihlali, full of inspiration from his stay in Nice, worked nonstop during his stay in London.

64. Richards, "Cross Purposes," 93–94.

65. This was also noticed by Joy Kuhn when given a tour of Sihlali's studio in the early 1970s. See Kuhn, *Twelve Shades of Black*, 61.

66. As Sidney Kasfir reminded me, Sihlali also made paintings and sculptures of black miners and other male workers during the period following his father's death in 1977. For discussion of his sculptures of workers, see Rankin, *Images of Metal* and *Images of Wood*. The recurring image of women and women's art formed only a portion of the artist's oeuvre, which also included allegorical paintings, still life, unpopulated landscape studies, and nonobjective abstraction.

67. He later taught part time in Soweto during the 1970s and full time at the FUBA school in Johannesburg during the 1980s.

68. Sihlali, interview, 3 October 1995.

69. Ibid.

70. Sihlali, "Re-claiming the Significance of Murals," 14–15. For an early example, see *Fossilized Ants I* (1968), reproduced in the same book on page 21. In 1989 the artist claimed that already as a young man his "contact with the *Idlozi* [ancestors] had found expression in my art. But I did not show these paintings to the gallery owners. While I was being dictated to by my ancestors the gallery owners were being governed by commercial whims and white people's perceptions of black art." Sihlali, *Discovering My True Identity*, vi.

71. See chapter 1.

72. See chapter 1.

73. According to Amanda Jephson, "Western techniques were combined with a fresh inquiry into appropriate [sic] African art forms [at Polly Street]. Engagement with indigenous art forms included reviewing the sculptural traditions of Pedi and Tsonga-Shangaan woodcarving, Ndebele and Nguni beadwork, pottery, basketwork and mural painting, as well as examining Central and West African sculptural forms and their subsequent absorption into Western art in twentieth century cubism." Amanda Jephson, "Aspects of Twentieth century

Black South African Art—Up to 1980" (MFA thesis, University of Cape Town, 1989), 103. Jephson's source for this passage is S. Van Rensburg, "Sydney Kumalo en ander Bantoekunstenaars van Transvaal" (MPhil thesis, Pretoria University, 1970).

74. Elizabeth Rankin, "Teaching and Learning: Skotnes at Polly Street," in *Cecil Skotnes,* ed. Freida Harmsen (Cape Town: South African National Gallery, 1996), 67.

75. See Miles, *Polly Street.*

76. Ibid., 29; *Zonk!* special issue on black artists (October 1951): 3, 11–15, 25.

77. Sihlali, *Discovering My True Identity,* vi.

78. Sihlali, "Re-claiming the Significance of Murals," 15. Clive Dyer defines *mvelinqangi* differently, as "the a priori originator," that is, the ineffable creator. Clive Dyer, "Narrating the Katlehong Murals," *Staffrider* 8, 1 (1989): 57, 67. Sihlali's use of the term appears to syncretize it with the idea of a Christian Holy Trinity.

79. Miles, "Durant Sihlali," 10.

80. This and the following story are from the artist's notes.

81. See Annette Loubser, "Mural Art for South Africa," *Art* 3 (February 1989); Annette Loubser, "Contemporary Mural Art: Urban Dislocation and Indifference," *Staffrider* 9, 4 (1991); and Franco Frescura, ed., *From San to Sandton: A Pictorial Survey of Southern African Wall Graphics through the Ages* (Port Elizabeth: University of Port Elizabeth, Department of Agriculture, 1989).

82. For a survey of mural projects in South Africa, especially after 1994, see Sabine Marschall, *Community Mural Art in South Africa* (Pretoria: UNISA Press, 2002). Marschall discusses the problems arising from Sihlali's White City project on pages 60–61.

83. Miles, "Durant Sihlali," 9.

84. They may have been members of the Hlubi group, a branch of Nguni-language speakers related to the Ndzundza Ndebele, who moved south to the Eastern Cape during the first decades of the nineteenth century and became known as Mfengu. For debates on the nature of the *mfecane,* see Carolyn Hamilton, ed., *The Mfecane Aftermath: Reconstructive Debates in Southern African History* (Johannesburg: Witwatersrand University Press, 1995); and Julian Cobbing, "The Mfecane as Alibi: Thoughts on Dithakong and Mbolompo," *Journal of African History* 29, 3 (1988).

85. Richards, "Cross Purposes," 94.

86. Jacques Derrida, *Archive Fever: A Freudian Impression,* trans. Eric Prenowitz (Chicago: University of Chicago Press, 1996), 11.

87. Ibid., 2.

8. Censorship and Iconoclasm

1. See Irwin Manoim, ed., *You Have Been Warned: The First Ten Years of the Mail & Guardian* (London: Viking, 1996), 64; and Anton Harber, "Censorship," in *The Legacy of Apartheid,* ed. Joseph Harker (London: Guardian, 1994).

2. Williamson, *Resistance Art in South Africa,* 100–105. Zylla's Cape Town project was published as a book: Manfred Zylla, *Manfred Zylla and the Community Art Project Invites You to Inter-action, a Public Event* (Cape Town: Manfred Zylla, 1982). The book was promptly banned.

3. See chapter 3.

4. Freedberg sees these destructive acts as analogous to the kind of writing about

art that desexes the image through an overanalytic, formalist approach to the object. David Freedberg, *The Power of Images: Studies in the History and Theory of Response* (Chicago: University of Chicago Press), 1989.

5. Taussig, *Defacement*.

6. Dario Gamboni, *The Destruction of Art: Iconoclasm and Vandalism since the French Revolution* (London: Reaktion Books, 1997). See also the omnivorous compendium on images and their destruction: Bruno Latour and Peter Weibel, eds., *Iconoclash: Beyond the Image Wars in Science, Religion, and Art* (Cambridge, Mass.: MIT Press, 2002).

7. Here I refer broadly to the years just preceding and just after the first democratic elections in 1994.

8. My own interest in this chapter has been to keep a close focus on a precise topic, but the subject of censorship in South Africa comprises a minor literature. For an introduction to the larger issues at stake, see Nadine Gordimer, "Apartheid and Censorship," *Index on Censorship* 1, 3–4 (Winter 1972); Christopher Merrett, *A Selected Chronological Bibliography on Censorship and the Freedoms of Information and Expression in South Africa* (Pietermaritzburg: University of Natal Library, 2003); Merrett, *A Culture of Censorship*; André Brink, *Mapmakers: Writing in a State of Siege* (London: Faber and Faber, 1983); and J. M. Coetzee, *Giving Offense: Essays on Censorship* (Chicago: University of Chicago, 1996). For a discussion of Thupelo, see chapter 5.

9. For the Situationists' own extended definitions of *détournement*, see Guy Debord and Gil J. Wolman, "Methods of Detournement," and n.a., "Detournement as Negation and Prelude," in *Situationist International Anthology*, ed. and trans. Ken Knabb (Berkeley, Calif.: Bureau of Public Secrets, 1981), 8–14 and 55–56. See also Asger Jorn, "Detourned Painting," in *On the Passage of a Few People through a Rather Brief Moment in Time: The Situationist International 1957–1972*, ed. Elisabeth Sussman (Cambridge, Mass.: MIT Press, 1989). The most succinct and often cited formulation of *détournement* was originally printed in the journal *Internationale Situationniste #1* (June 1958), and is reproduced in Knabb, *Situationist International Anthology*, 45–46. It reads: "Detournement: Short for detournement of preexisting aesthetic elements. The integration of present or past artistic production into a superior construction of a milieu. In this sense there can be no situationist painting or music, but only a situationist use of these means. In a more primitive sense, detournement within the old cultural spheres is a method of propaganda, a method which testifies to the wearing out and loss of importance of those spheres." This definition is close to the ideas behind the acts of symbolic iconoclasm performed by South African artists.

10. Wayne Barker, interview, 1 July 2002. Unless otherwise noted, all subsequent quotations are from this interview. For further background on Barker, see Charl Blignaut, *Wayne Barker: Artist's Monograph* (Johannesburg: Chalkham Hill Press, 2000).

11. Berman, *Art and Artists*, 330.

12. Pierneef derived his aesthetic ideas from the later impressionists, from the prismatic art of Feininger and Delaunay, and from the decorative art theory of Willem Van Konijnenburg. See Berman, *Art and Artists*, 329; and Rina de Villiers, *J. H. Pierneef: Pretorian, Transvaaler, South African* (Pretoria: Pretoria Art Museum, 1986), 11. For an overview of the artist's work, see *J. H. Pierneef: His Life and His Work* (Cape Town: Perskor, 1990); and N. J. Coetzee, *Pierneef, Land and Landscape: The Johannesburg Station Panels in Context* (Johannesburg: Johannesburg Art Gallery), 1992.

13. De Villiers, *J. H. Pierneef,* 12.

14. Berman, *Art and Artists,* 328.

15. Ibid. "Ox wagon" is a reference to the mythology of the Great Trek, the mass migration of Dutch-speaking farmers from the Cape Province in their ox-drawn covered wagons, in order to escape from British rule after 1835. The Great Trek is the pivotal national narrative for the Afrikaner people, an assertion of their independent spirit, and of their rights to the land they settled.

16. Begun in the late nineteenth century, the culmination of the effort to create a national mythology for the Afrikaner *volk* was the establishment of a secret society, the Broederbond; the standardization of Afrikaans grammar and spelling; the institution of the Great Trek and the Day of the Vow as legitimizing narratives of the Afrikaners' divine right to settle the "empty" land of the South African interior and to bring God and civilization to the native people; and the development of the ideas of "separate development" and "separate amenities" for the different "races" into a political ideology after the Afrikaner National Party came to power in the elections of 1948. Broederbond members included most South African prime ministers, Afrikaner university and corporation chairmen, and heads of the South African Broadcasting Corporation and the parastatal weapons contractor ARMSCOR. For a detailed account of this history, and analysis of the contradictions inherent in the myth of Afrikaner purity, see Leonard Thompson, *The Political Mythology of Apartheid* (New Haven, Conn.: Yale University Press, 1985).

17. For the nineteenth-century Voortrekkers, the *laager* was a tight circle of ox wagons lashed together, a way of defending themselves against attacks by those native people upon whose land they were encroaching.

18. Cited in Thompson, *The Political Mythology of Apartheid,* 43.

19. For a history of the Ndzundza Ndebele and their mural art, see Schneider, "Paint, Pride, and Politics." See also chapter 1.

20. This idealized absence in Pierneef's other Pretoria landscapes is noted by de Villiers, *J. H. Pierneef,* 10. The Union Buildings were designed by Sir Edward Baker and completed in 1913. They were originally intended to house the Public Service offices for the Union of South Africa (1910–61) when South Africa was nominally ruled by the British Crown. Today they house the offices of the president.

21. See Shula Marks and Stanley Trapido, eds., *The Politics of Race, Class, and Nationalism in Twentieth-Century South Africa* (London: Longman, 1987), 20.

22. For an insightful discussion of the ideology of landscape art that brings the essays in W. J. T. Mitchell's *Landscape and Power,* 2nd ed. (Chicago: University of Chicago Press, 2002), and J. M. Coetzee's *White Writing: On the Culture of Letters in South Africa* (New Haven, Conn.: Yale University Press, 1988) to bear on recent South African art, see Ashraf Jamal, "Zero Panoramas, Ruins in Reverse, Monumental Vacancies: Contemporary Perceptions of Landscape in South African Art," in Geers, *Contemporary South African Art.*

23. Jamal, "Zero Panoramas," 162.

24. Barker saw the panels in the train station when he was a child. In 1980 the panels were moved to a museum built for them near the train station and to the Johannesburg Art Gallery.

25. The artist's notes rephrase this idea: "They were in a sense the first South African 'pop images' created for commuters on their way to and from work. At this time the majority of the population (being black) could only travel 3rd class and could not sit or stand in the 'whites only' areas." Wayne Barker, unpublished notes, artist's scrapbook, n.d.

26. Anthea Bristowe, "Barker's Energy Now Focused," *Business Day*, 28 September 1992.

27. Jamal, "Zero Panoramas," 158–59.

28. Barker, unpublished notes, artist's scrapbook, n.d. My emphasis.

29. Ibid. My emphasis.

30. Cited in Ivor Powell, "Catching SA Art with Its Pants Down," *Daily Mail*, 16 July 1990. My emphasis.

31. Ivor Powell, "Scraping Up Art from the Hidden Nooks of Jo'burg," *Weekly Mail*, 9–15 June 1989, 23.

32. Freedberg, *The Power of Images*, 390.

33. Ibid., 368.

34. My gratitude to Anton Kannemeyer, who worked on this issue of *Loslyf*, for assistance in translating the idiomatic Afrikaans in the text. Tracey Rose and Abrie Fourie made additional suggestions.

35. This is the less subversive direction the magazine has in fact taken in recent years, according to Mark Green, editor of *Loslyf*, in an interview with the author, 10 January 2003. Green also explained that this first issue of *Loslyf* sold out quickly, ultimately topping eighty thousand in sales. Annie Coombes claims she is not aware that this particular issue of the magazine had much impact (though this is not critical to her argument). Annie Coombes, "Translating the Past: Apartheid Monuments in Postapartheid South Africa," in *History after Apartheid: Visual Culture and Public Memory in a Democratic South Africa* (Durham, N.C.: Duke University Press, 2003), 49. I can say from experience in the South African art scene, and from the editor's numbers, that Dina's iconoclastic spread in particular had enormous impact. My recollection, having lived in Johannesburg at that time, was that everyone spoke of the magazine but few could get a copy (because it had sold out). In recent years, according to Green, sales have evened out around twenty thousand copies sold per issue. Green attributes this to having lost some of the novelty factor in the market to numerous other new pornographic magazines. Ryk Hattingh, the founding editor, left the magazine after the first few issues.

36. See Bafana Khumalo, "Tales from the Heartland," *Weekly Mail*, 20–26 September (1996).

37. Ibid.

38. Coombes, "Translating the Past." I am sympathetic toward Coombes's larger project, which goes beyond the scope of this discussion. Although our concerns are largely parallel, there is one major difference: for Coombes it is the trajectory of the official discourse on culture that is the primary object. My aim in this chapter is to uncover the mechanisms of subversion through art.

39. Here Coombes adapts Homi Bhabha's formulation of the term "hybridity." See Homi Bhabha, "Signs Taken for Wonders: Questions of Ambivalence and Authority under a Tree Outside Delhi, May 1817," in *The Location of Culture* (New York: Routledge, 1994). For Bhabha, "Hybridity reverses the *formal* process of disavowal so that the violent dislocation of the act of colonization becomes the conditionality of colonial discourse" (114).

40. Coombes, "Translating the Past," 38.

41. Coombes (ibid., 40–43) notes the complex relation of the Afrikaner to the natural landscape as part of the ideology of stewardship of the African land.

42. These beehive-shaped structures are still standing today in the garden below the monument.

43. Coombes, "Translating the Past," 42.

44. Alfred Gell, *Art and Agency* (Oxford: Clarendon Press, 1998), 100.

45. Brink, *Mapmakers*, 247.

46. Lauren Shantall, "Feathers Fly at Feast," *Mail and Guardian*, 9–16 April (1998).

47. Unless otherwise noted, all quotations are from an interview between Tracey Rose and the author, 8 January 2003. That interview took the form of a casual, but intense, conversation whose tone I have endeavored to replicate in prose. For background on the artist, see *Fresh/Tracey Rose* (Cape Town: South African National Gallery, 2003); Clive Kellner, *Vice Verses* (Linz: O.K. Center of Contemporary Art, 1999); and Rory Bester, "Tracey Rose," in Lundström and Pierre, *Democracy's Images*, 90–93.

48. Tracey Rose and Abrie Fourie reconstructed the event for me, with the help of photographs and a diagram of the scene drawn by Rose. As Carrie Lambert pointed out to me, my own textual reconstruction based on these recollections is itself a record, and a reenactment, as well as an interpretation of the performance by Rose.

49. Freedberg, *The Power of Images*, 386–89.

50. Beral Madra makes a similar claim in *Mediterranean Metaphors II: Contemporary Art from Lebanon* (Istanbul: Borusan Culture and Art Center, 2000).

51. For other examples of the destruction of "anxious" monuments from the ex-Soviet world, and discussion of their significance within the frame of symbolic contradiction, see Gamboni, *The Destruction of Art*, 55–67.

52. Ibid., 56, 68, and 71. Here Gamboni relies on Albert Boime, "Perestroika and the Destabilization of the Soviet Monuments," *ARS: Journal of the Institute for History of Art of the Slovak Academy of Sciences* 2–3 (1993).

53. Laura Mulvey and Mark Lewis, dir., *Disgraced Monuments* (London: Cinema Guild, 1993). See also Laura Mulvey, "Reflections on Disgraced Monuments," in *Architecture and Revolution: Contemporary Perspectives on Central and Eastern Europe*, ed. Neil Leach (New York: Routledge, 1999).

54. Taussig, *Defacement*, 28.

55. Gamboni concludes similarly, that artistic actions against Soviet monuments that left the originals whole, but somewhat shifted from former positions, were perhaps the most successful and least likely over time to reproduce the repressive function of the original monuments. Gamboni, *The Destruction of Art*, 71.

56. Bruno Latour, "What Is Iconoclash? Or Is There a World beyond the Image Wars?" in Latour and Weibel, *Iconoclash*, 26.

57. Ibid., 27.

9. Shadows

1. I owe a debt of gratitude to Omar Badsha for his critical reading of a draft of this chapter. Catherine Soussloff also made decisive comments. Although in most instances the term "black" refers to the descendants of the indigenous African peoples of southern Africa, throughout this chapter, as in the rest of the book, "black" refers more broadly to these groups as well as to the South Asian, so-called colored or mixed-race, Malaysian, and other subject communities of South Africa. The roots of this inclusive terminology lie in the collective alliance of all non-European groups in the wake of the Black Power movement of the 1960s.

2. Jean Sagne, "All Kinds of Portraits: The Photographer's Studio," in *The New History of Photography*, ed. Michel Frizot (Cologne: Könemann, 1998), 103.

3. "While this relationship [of colonial power in white-settled lands] was in many cases tempered at an individual level with a genuine desire for a sympathetic understanding of peoples in human terms, such intentions were inevitably confronted by the intellectual difficulties of such an endeavor, and the unequal relationship was sustained through a controlling knowledge which appropriated the 'reality' of other cultures into ordered structure. Photography was in many ways symbolic of this relationship. It represented technological superiority harnessed to the delineation and control of the physical world, whether it be boundary surveys, engineering schemes to exploit natural resources, or the description and classification of the population." Elizabeth Edwards, "Introduction," in *Anthropology and Photography 1860–1920*, ed. Elizabeth Edwards (New Haven, Conn.: Yale University Press, 1992), 6.

4. The region of the Cape of Good Hope, at the southernmost tip of Africa, was mostly inhabited by people related to the pastoral and hunting and gathering San cultures, but they were progressively exiled, enslaved, or decimated after the Dutch East India Company created the first European settlement at Cape Town in 1652. The British occupied the Cape Colony, the precursor to today's Republic of South Africa, in 1806. Here and below, the notes on nineteenth-century photographs have been gleaned from Karel Schoeman, *The Face of the Country: A South African Family Album 1860–1910* (Cape Town: Human and Rousseau, 1996); and Marjorie Bull and Joseph Denfield, *Secure the Shadow: The Story of Cape Photography from Its Beginnings to the End of 1870* (Cape Town: Terence McNally, 1970). According to Bull and Denfield, commercial daguerreotyping in South Africa began when Jules Léger, an itinerant photographer, arrived in Port Elizabeth in 1846. Among the earliest commercial studios in Cape Town were that of A. W. Roghe, a calotypist, established in 1849, and James Cameron, a daguerreotypist, in 1850.

5. The other tools were the missions, the schools, and the imposition of colonial and apartheid laws.

6. Schoeman, *The Face of the Country*, 15.

7. Bull and Denfield, *Secure the Shadow*, 41.

8. The image of a sitter holding another photograph was a common self-referential device in early photography.

9. Naomi Rosenblum, *A World History of Photography*, 3rd ed. (New York: Abbeville Press, 1997), 62–73.

10. Schoeman, *The Face of the Country*, 17. See also W. H. I. Bleek and L. C. Lloyd, *Specimens of Bushman Folklore* (London: George Allen, 1911).

11. Schoeman, *The Face of the Country*, 17. See also Pippa Skotnes' recent work.

12. See Christraud Geary, "Different Visions? Postcards from Africa by European and African Photographers and Sponsors," in *Delivering Views: Distant Cultures in Early Postcards*, ed. Christraud Geary and Virginia Lee–Webb (Washington, D.C.: Smithsonian Institution, 1998); and Virginia Lee-Webb, "Fact and Fiction: Nineteenth-Century Photographs of the Zulu," *African Arts* 25, 1 (1992).

13. Santu Mofokeng, "The Black Photo Album," in *Anthology of African and Indian Ocean Photography*, ed. Pascal Martin Saint Léon and N'Goné Fall (Paris: Éditions Revue Noire, 1999), 70.

14. Ibid.

15. Schoeman, *The Face of the Country,* 69.

16. Ibid., 68.

17. The term "kaffir" (Arabic for "infidel") in South Africa derived from its use in eastern Africa. It was used by Islamic peoples on the Swahili Coast to refer in a derogatory way to the "unbelievers" of the African interior. In South Africa, "kaffir" was applied first to the Xhosa-related people of the Eastern Cape and later as a synonym for "savage" in reference to all black people, especially those with a more traditional orientation.

18. For instance, Hilda Beemer (later Kuper) introduced the Swazi, and David Hammond-Tooke wrote the preface to the volume on the Nguni. See A. M. Duggan-Cronin, *The Bantu Tribes of South Africa: Reproductions of Photographic Studies,* vols. 1–4 (Kimberley: Alexander McGregor Memorial Museum, 1928–54).

19. D. H. Reader, *The Black Man's Portion: History, Demography and Living Conditions in the Native Locations of East London, Cape Province* (Cape Town: Oxford University Press, 1961), 104.

20. Ibid., 106.

21. Owen Crankshaw and Susan Parnell, "Interpreting the 1994 African Township Landscape," in *Blank: Architecture, Apartheid and After,* ed. Hilton Judin and Ivan Vladislavic (Rotterdam: NAI, 1998), 439. (See Figure 26.)

22. Ernest Cole, *House of Bondage* (New York: Random House, 1967).

23. David Goldblatt and Nadine Gordimer, *On the Mines* (Cape Town: Struik, 1973); David Goldblatt, *Some Afrikaners Photographed* (Johannesburg: Murray Crawford, 1975); Omar Badsha and Andrew Verster, *Letter to Farzanah* (Durban: Institute for Black Research, 1979). See also David Goldblatt, *David Goldblatt Fifty-One Years* (Barcelona: ACTAR and MACBA, 2001); and Omar Badsha and Patricia Hayes, *Narratives: Rituals and Graven Images* (Pretoria: South African History Online and UNISA Press, 2007).

24. Paul Weinberg, "Apartheid—A Vigilant Witness: A Reflection on Photography," in Campschreur and Divendal, *Culture in Another South Africa,* 63.

25. Ibid., 65.

26. Abigail Solomon-Godeau, "Who Is Speaking Thus? Some Questions about Documentary Photography," in *Photography at the Dock: Essays on Photographic History, Institutions, and Practices* (Minneapolis: University of Minnesota Press, 1991), 178–79.

27. For a concise history of social documentary photography in South Africa, see Pierre-Laurent Sanner, "Comrades and Cameras," in Saint Léon and Fall, *Anthology of African and Indian Ocean Photography.*

28. Omar Badsha, ed., *The Cordoned Heart: Twenty South African Photographers* (Cape Town: Gallery Press, 1986); and Iris Tillman Hill and Alex Harris, *Beyond the Barricades: Popular Resistance in South Africa* (New York: Aperture, 1989). Badsha was instrumental in both projects, and, along with Gideon Mendel and Paul Weinberg, selected the photographs for *Beyond the Barricades.*

29. An earlier Carnegie Commission on the Poor White problem in South Africa has been credited with fomenting the rise of Afrikaner nationalism during the 1920s. This second commission, in part, sought to redress that history.

30. This essay was later expanded and published as a separate book: David Goldblatt, *The Transported of KwaNdebele: A South African Odyssey* (New York: Aperture, 1989). In *The Transported,* the same image carries a different caption: "Marabastad-Waterval route: About 8:30 p.m.; an hour still to go." *New York Times* writer Joseph Lelyveld accompanied Goldblatt in his research on KwaNdebele, and the story of the night riders is

recounted as chapter 5, "Forced Busing," of Lelyveld's book, *Move Your Shadow: South Africa in Black and White* (New York: Times Books, 1985).

31. See Marinovich and Silva, *The Bang-Bang Club.*

32. David Bunn and Jane Taylor, "Editor's Introduction," in "From South Africa: New Writing, Photographs, and Art," special issue of *TriQuarterly* 69 (Spring–Summer 1987): 29.

33. Here I borrow the term "empty space in representation" from Ed Guerrero's discussion of media stereotypes of African American men. Ed Guerrero, "The Black Man on Our Screens and the Empty Space in Representation," in *Black Male: Representations of Masculinity in Contemporary American Art,* ed. Thelma Golden (New York: Whitney Museum, 1994).

34. Paul Alberts, "Rhodes: Some Women Photographed," in Bunn and Taylor, "From South Africa," 153.

35. Ibid., 152. This term is similar to the nickname given to early informal settlements in Soweto, "Vukuzenzele," "get on and do it for yourself." See chapter 7.

36. A survey of this work has been published as Chris Ledochowski, *Cape Flats Details: Life and Culture in the Townships of Cape Town* (Pretoria: South African History Online and UNISA Press, 2003). A selection of images is also available online at www.sahistory.org.za.

37. Santu Mofokeng, "Lampposts," in *Santu Mofokeng* (Johannesburg: David Krut, 2001), 27–28. "China" is a South African term of endearment, derived from Cockney rhyming slang for "mate": "China is a mate, precious like a china plate."

38. Cited in Lauri Firstenberg, "Cityscape Johannesburg," *Flash Art,* October 1999, 69.

39. Ndebele, *Rediscovery of the Ordinary,* 68–69. See also chapter 6.

40. This "intervention in the everyday" is claimed for the work of Omar Badsha in a biographical essay by Particia Hayes, and I extend it here to his colleagues. Badsha and Hayes, *Narratives,* 234.

41. Crossroads is also notorious within South Africa because of the bloody clashes between Xhosa traditionalists (who were backed by police) and supporters of the African National Congress during the mid-1980s. For a fuller account of this history, see Steven Robins, "Bodies Out of Place: Crossroads and the Landscapes of Exclusion," in Judin and Vladislavic, *Blank,* 457–70.

42. Crankshaw and Parnell, "Interpreting the 1994 African Township Landscape," 441.

43. The honor is also dubious, since the essay on his work is less than half the price of papers on Western subjects. See http://www.term-paper.net/lib/essay/11_4.html. Look for term paper number 056628.

44. Bongi Dhlomo, "Zwelethu Mthethwa Talks about His Photographs," in *Liberated Voices: Contemporary Art from South Africa,* ed. Frank Herreman (New York: Museum for African Art, 1999), 69.

45. Michael Godby, "The Evolution of Documentary Photography in South Africa as Shown in a Comparison between the Carnegie Inquiries into Poverty (1932 and 1984)," in Lundström and Pierre, *Democracy's Images,* 37.

46. Lynne Stuart, "Zwelethu Mthethwa Interviewed by Lynne Stuart," *ADA* 13 (1996): 15.

47. Sean O'Toole, "In Conversation with Zwelethu Mthethwa," in the Artthrob

archive for July 2004, accessible via http://www.artthrob.co.za. Mthethwa continues: "When I studied at Michaelis they did not have colour facilities. Then I won a Fulbright Scholarship and went to Rochester Institute of Technology (RIT). The headquarters of Kodak are situated right there. At RIT we had 22 colour darkrooms as well as nine black-and-white labs to ourselves. That was when I started to study colour."

48. Michael Godby, "The Drama of Color: Zwelethu Mthethwa's Color Photographs," in *Zwelethu Mthethwa* (Turin: Marco Noire, 1999).

49. Cited in Dhlomo, "Zwelethu Mthethwa," 75.

50. O'Toole, "In Conversation with Zwelethu Mthethwa."

51. Solomon-Godeau, "Who Is Speaking Thus?" 176.

52. On this point, see also Coombes, *History after Apartheid*. Her chapter "New Histories for Old: Museological Strategies" traces the shack-as-symbol idea through a variety of institutional contexts, including a significant section on Mthethwa (189–93).

53. Cited in Dhlomo, "Zwelethu Mthethwa," 75.

54. Coombes, *History after Apartheid*, 190.

55. Ibid.

56. Cited in Stuart, "Zwelethu Mthethwa Interviewed by Lynne Stuart," 15.

57. According to the Web site for the South African media conglomerate Media24, "*Sarie* is Media24's oldest women's magazine and the biggest Afrikaans glossy for independent and sophisticated women, inspiring them at both work and at play. The magazine seeks to empower, encourage, advise, support and inform its readers, inspiring them on all fronts, be it with beauty tips, the latest fashion trends, recipes, handicraft, fiction, health or the knowledge they need to make informed decisions. *Sarie* fulfils the needs of today's woman: the Afrikaans woman who seeks to keep abreast with the times and celebrate her womanhood."

58. Arjun Appaduarai, "Grassroots Globalization and the Research Imagination," in *Globalization,* ed. Arjun Appadurai (Durham, N.C.: Duke University Press, 2003), 6–7. See also Arjun Appadurai, *Modernity at Large: Cultural Dimensions of Globalization* (Minneapolis: University of Minnesota Press, 1996).

59. Cited in Dhlomo, "Zwelethu Mthethwa," 75 and 79.

60. O'Toole, "In Conversation with Zwelethu Mthethwa."

61. Godby, "The Drama of Color."

62. Coombes, *History after Apartheid,* 192.

63. Coombes is more hopeful, claiming that more performative kinds of black-and-white photography hold the potential to "break the mold" of the struggle documentary style. Ibid., 193.

64. Okwui Enwezor, *Snap Judgments: New Positions in Contemporary African Photography* (New York: International Center of Photography, 2006). This series is also featured in Jean-Hubert Martin, ed., *Africa Remix: Contemporary Art of a Continent* (Ostfildern: Hatje Cantz Verlag, 2005).

65. Nancy Princehall, "Forty Ways of Looking at a Stranger," *Art in America,* December 2003, 43.

66. "My brother bought a farm in Umzinto, which is south of Durban. I went there to visit him and he showed me around the farm. I saw that the men harvesting the sugar cane were wearing long skirts and had fancy hairdos. Their wrists had pieces of cloth wrapped around them. They looked very funky to me. With the machetes they carry I saw samurai warriors . . . When I spoke with the people I found out that the baggy clothing served a purpose, to protect their bodies from the sugar cane leaves." Mthethwa, cited in

O'Toole, "In Conversation with Zwelethu Mthethwa." The artist comments further that originally the images were meant to be faceless—with the heads of the farmers cropped from the picture—in order to better call attention to their unusual attire. Examples of these early versions were published in the magazine *Chimurenga*.

67. Steve Hilton-Barber, "The Savage Noble and the Noble Savages: Photography and an African Initiation," in *Deslocação: Imagem & Identidade. África do Sul*, ed. Daniela Tilkin (Maia: Forum da Maia, 2002).

68. Tlali is well known in South Africa for her short stories and her series of interviews with "common people" published in *Staffrider* during the 1980s.

69. Maria Grazia Tolomeo and Teresa Macrì, *Zwelethu Mthethwa: Sacred Homes—Mother and Child* (Turin: Marco Noire Editore, 2000).

70. Solomon-Godeau makes a similar appraisal of the work of FSA photographer Dorothea Lange, who she claims further distinguishes between the "worthy" and "unworthy" poor, while obscuring the larger economic order that contributed to their misery. Solomon-Godeau, "Who Is Speaking Thus?" 179.

71. See Sean O'Toole, "A Formidable Terrain of Difficulty," a review (accessible via the archive at http://www.artthrob.co.za) of Olu Oguibe's *The Culture Game* (Minneapolis: University of Minnesota Press, 2004).

72. Mofokeng, "The Black Photo Album," 72.

73. Santu Mofokeng, personal communication, 24 October 2007. In 2004 he returned to the caves pictured in *Chasing Shadows*, this time with his brother Ishmael, who was seeking spiritual succor in his battle with HIV/AIDS. The series is reproduced in part in Sabine Vogel, "Santu Mofokeng: Ghost-Hunting in the Blue Mountains. A Photo Safari to the Heart of Darkness—Searching for the New South Africa," *Camera Austria* 56 (1996): 59–64.

74. The Kingdom of Lesotho, earlier called the British Basotholand Protectorate, has been the traditional kingdom of the South Sotho people since their consolidation under the charismatic leadership of King Moshweshwe during the early nineteenth century. For a moving account of the relations between Lesotho and South Africa, as seen through the verbal art of migrant laborers, see David Coplan, *In the Time of Cannibals: The Word Music of South Africa's Basotho Migrants* (Chicago: University of Chicago Press, 1994).

75. Gary van Wyk includes some stunning pictures of the same place, referring to it by its Afrikaans name, Saltpeterkranz, and discusses its history and current use in Gary van Wyk, *African Painted Houses: Basotho Dwellings of Southern Africa* (New York: Harry Abrams, 1998).

76. Cited in Rory Bester, "Santu Mofokeng," in Lundström and Pierre, *Democracy's Images*, 109.

77. Ibid., 108.

78. For an introduction to the complex problem of the "African" reception of photography, see Anne Maxwell, *Colonial Photography and Exhibitions: Representation of the "Native" People and the Making of European Identities* (London: Leicester University Press, 1999); Paul Landau and Deborah Kaspin, eds., *Images and Empires: Visuality in Colonial and Postcolonial Africa* (Berkeley and Los Angeles: University of California Press, 2002); and Wolfram Hartmann, Jeremy Sylvester, and Patricia Hayes, eds., *The Colonising Camera: Photographs in the Making of Namibian History* (Athens: Ohio University Press, 1999).

79. Mofokeng, "The Black Photo Album," 72.

80. This scenario has been memorialized in the play *Woza Albert!* See the film by Percy Mtwa and Mbongeni Ngena, *Woza Albert!* (Wilmette: Films Incorporated, 1982).

81. Mofokeng, "Appropriated Spaces," in Judin and Vladislavic, *Blank,* 68.

82. Cited in Bester, "Santu Mofokeng," 109.

83. John Tagg, *The Burden of Representation: Essays on Photographies and Histories* (Minneapolis: University of Minnesota Press, 1988), 11.

84. Cited in Bester, "Santu Mofokeng," 109.

85. Tagg, *The Burden of Representation,* 164–65.

86. Cited in Bester, "Santu Mofokeng," 109.

87. Cited in Lauri Firstenberg, "Cityscape Johannesburg," *Flash Art,* October 1999, 69.

88. Santu Mofokeng, correspondence with the author, 29 April 2000.

INDEX

John Peffer is editor of *Critical Interventions: Journal of African Art History and Visual Culture*. He teaches at Case Western Reserve University in Cleveland.